SCULPTURE OF THE ROCKIES

97 Contemporary and Traditional Artists

FROM THE EDITORS OF **SOUTHWEST ART**

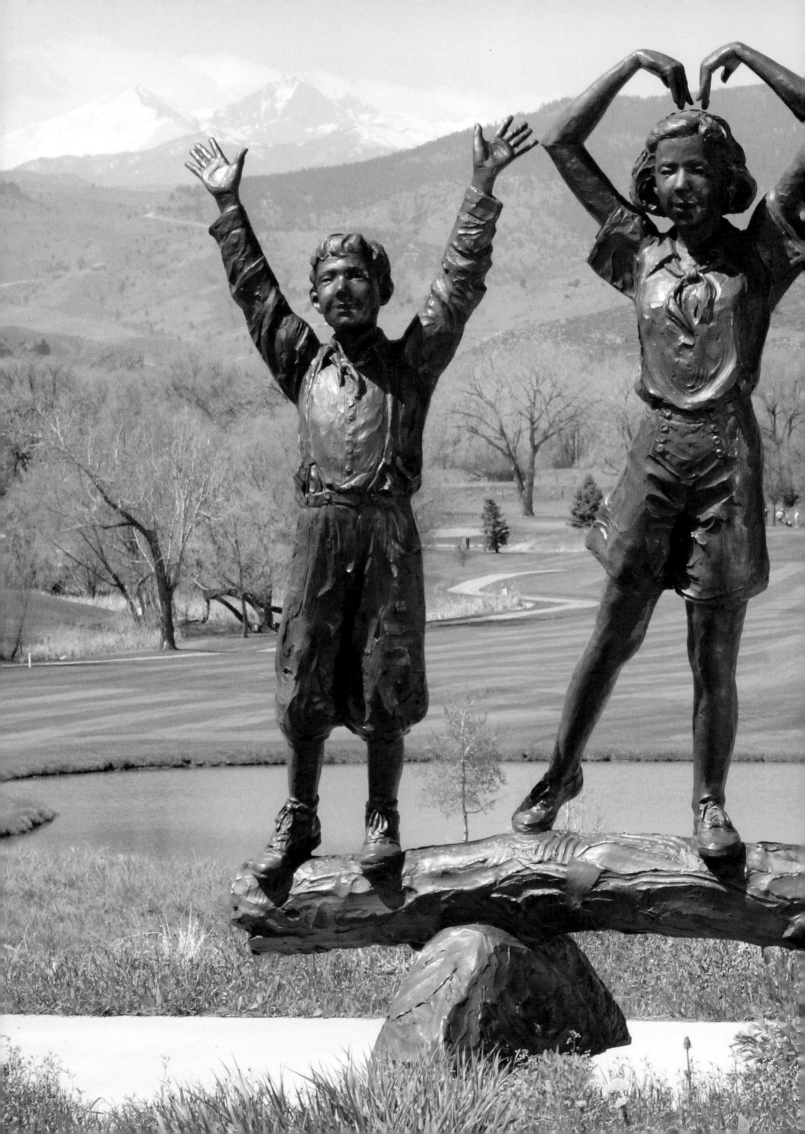

13 12 11 10 09 5 4 3 2 1

DISTRIBUTED IN CANADA BY FRASER DIRECT

100 Armstrong Avenue

Georgetown, ON, Canada L7G 5S4

Tel: (905) 877-4411

DISTRIBUTED IN THE U.K. AND EUROPE BY DAVID & CHARLES

Brunel House, Newton Abbot, Devon, TQ12 4PU, England

Tel: (+44) 1626 323200, Fax: (+44) 1626 323319

Email: postmaster@davidandcharles.co.uk

DISTRIBUTED IN AUSTRALIA BY CAPRICORN LINK

P.O. Box 704, S. Windsor NSW, 2756 Australia

Tel: (02) 4577-3555

Library of Congress Cataloging in Publication Data

Sculpture of the Rockies : 97 contemporary & traditional artists / from the editors of

Southwest art. -- 1st ed.

 p. cm.

 ISBN 978-1-4403-0314-2 (hardcover : alk. paper)

 1. Sculpture, American--Rocky Mountains Region--21st century. 2. Sculpture,

American--Pacific and Mountain States--21st century. I. Southwest art. II. Title:

Sculpture of the Rockies : one hundred contemporary and traditional artists.

 NB225.S38 2010

 730.978--dc22

 2009034475

ART ON FRONT COVER:

TOPAZ LACE Andi Mascareñas

Fired Clay/Metal Finish 34" × 23" × 23" (86cm × 58cm × 58cm)

photo courtesy of Havey Alexander

ART ON BACK COVER:

WIND SYMPHONY Lyman Whitaker

Copper and Stainless Steel 148"-238" × 16"-74"

ART ON SPINE:

MAMA BEAR Eli Hopkins

Bronze 9" × 6" × 7" (23cm × 15cm × 18cm)

ART ON TITLE PAGE:

SPIRIT OF THE YMCA Jane DeDecker

Bronze 88" × 120" × 36" (223cm × 305cm × 91cm)

photo courtesy of Jafe Parsons

ART ON OPPOSITE PAGE:

photo courtesy of Mike Bucher

Artist introductions written by **Layne Vanover**

Edited by **Layne Vanover**

Designed by **Jennifer Hoffman**

Production edited by **Layne Vanover** and **Jacqueline Musser**

Production coordinated by **Matt Wagner** and **Mark Griffin**

Special thanks to the editors of *Southwest Art* magazine:

Kristin Hoerth, Bonnie Gangelhoff, Suzanne Venino and Courtney Carpenter

Metric Conversion Chart

TO CONVERT	TO	MULTIPLY BY
Inches	Centimeters	2.54
Centimeters	Inches	0.4
Feet	Centimeters	30.5
Centimeters	Feet	0.03
Yards	Meters	0.9
Meters	Yards	1.1

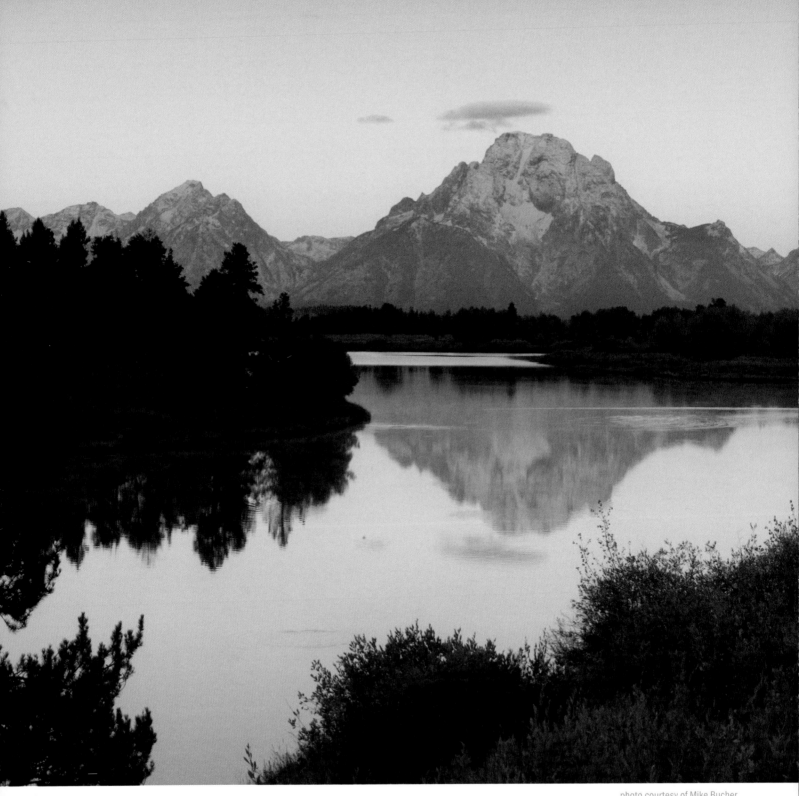

photo courtesy of Mike Bucher

By any measure, the Rocky Mountain region of the American West is a major center for sculpture. Visit the small town of Loveland, Colorado, in August during the annual Sculpture in the Park and Loveland Sculpture Invitational shows, and you'll have no doubt. During this weekend event, more than 500 sculptors come together to showcase their recent works to thousands of visitors, ranging from serious collectors to art lovers to tourists. And it's no accident that this annual extravaganza happens in Loveland; the town, and the surrounding area, are home to numerous sculptors, foundries and public sculpture installations.

The sculptors you will meet in the following pages all make their homes in the Rocky Mountain states: Colorado, Idaho, Montana, Utah and Wyoming. Their works range from traditional to contemporary, and from representational to abstract, in order to best showcase the broad range of artistic expression that can be found in the region. Some of the artists showcased here are established masters. They have already achieved long and accomplished careers, completed important commissions around the country and taught cadres of aspiring students who have now become successful artists themselves. Other sculptors featured in these pages are in earlier stages of their careers and are just beginning to make their mark on the art world, having earned entry into important exhibitions and galleries. All are creating works that merit attention, and all are a part of the great sculpture movement in the Rocky Mountains.

LORRI ACOTT-FOWLER

It wasn't until she reached her mid-twenties that Lorri Acott-Fowler discovered her natural talent for sculpting. Like many aspiring young artists, she had tried various two-dimensional mediums throughout her youth, but never felt comfortable or successful with the outcome. "I believed that you had to be able to draw to be an artist, so I never saw myself as having artistic talent," she recalls. But just when she thought her artistic ambitions would never be realized, Lorri discovered sculpting and realized she could no longer allow her fear of failure to get in the way of her dreams. Within a month, she joined a class, and was astounded by what she discovered. "When I started sculpting," Lorri says, "I couldn't believe how easy it was to get a good likeness of my subject." From that moment, she was hooked.

After achieving great success with portraitures, Lorri started to feel like she wasn't saying anything with her art. Thus began a long and challenging journey to develop her unique sculptural voice. She soon discovered a method using paperclay that allowed her to finish sculptures quickly and cost effectively, giving her the freedom to sculpt the pieces she longed to create. *Peace* exists as one example of Acott-Fowler's unique way of capturing abstract feelings in a permanent three-dimensional form.

What inspired this piece?

When I read the call for entry to place a sculpture at a hospice, I was passionate about getting the commission. My brother had died of brain cancer fourteen years previously, and hospice brought peace and healing to our family as we navigated through that difficult time. To capture this essence, I drew symbolic inspiration from a book called *Sadako and the Thousand Paper Cranes* by Eleanor Coerr. It tells the story of a young girl in Japan who died of radiation poisoning after the war, and how folded paper cranes came to represent peace and hope for the future. For this work, I also gave the figure long legs to express our ability to rise above life's challenges.

What prep work and techniques went into this sculpture and how did they contribute to the success of the finished piece?

As I began work on this piece, I made several maquettes to guide me in the creation process. I took them to school (Poudre High School in Fort Collins, where I teach art) and asked my students to critique them. It was wonderful to hear them using the artistic terms that I taught them to discuss the pieces! I took their feedback and created a new piece that combined components of the best aspects of all the maquettes.

What was your greatest challenge in creating this piece?

One of my challenges was to make cranes that looked folded and, at the same time, reflected the sculpted texture of my piece. The solution came to me one day when I was looking at a towel. I realized that I could dip fabric in wax and then fold it into an origami crane as the wax hardened. After the cranes were made, more wax was added to create the texture that I wanted.

Did this sculpture turn out the way you had envisioned, or were there some unexpected yet pleasant surprises?

When I *plan* my work, I am not going for a specific visual image, but instead a specific feeling or emotion. This allows me to move and change the piece in response to my reactions. When the piece *feels* the way I want it to, then I know it is finished. With this sculpture, I was clear on the emotion I wanted to express: The uplifting feelings of hope and peace. Everything I did as I sculpted worked toward that end.

What does this sculpture mean to you personally?

All of my work is deeply personal and universal at the same time. It was an amazing awareness the first time I realized that the more personal my pieces are, the more people can relate to them. It's as if the deeper we go inside ourselves, the more connected we are to each other.

PEACE Lorri Acott-Fowler *Bronze* *152" × 60" × 36" (386cm × 152cm × 91cm)*
commissioned by Art Forthe Mountain Community and installed at Mount Evans Hospice and Home Health Care, Evergreen, Colorado

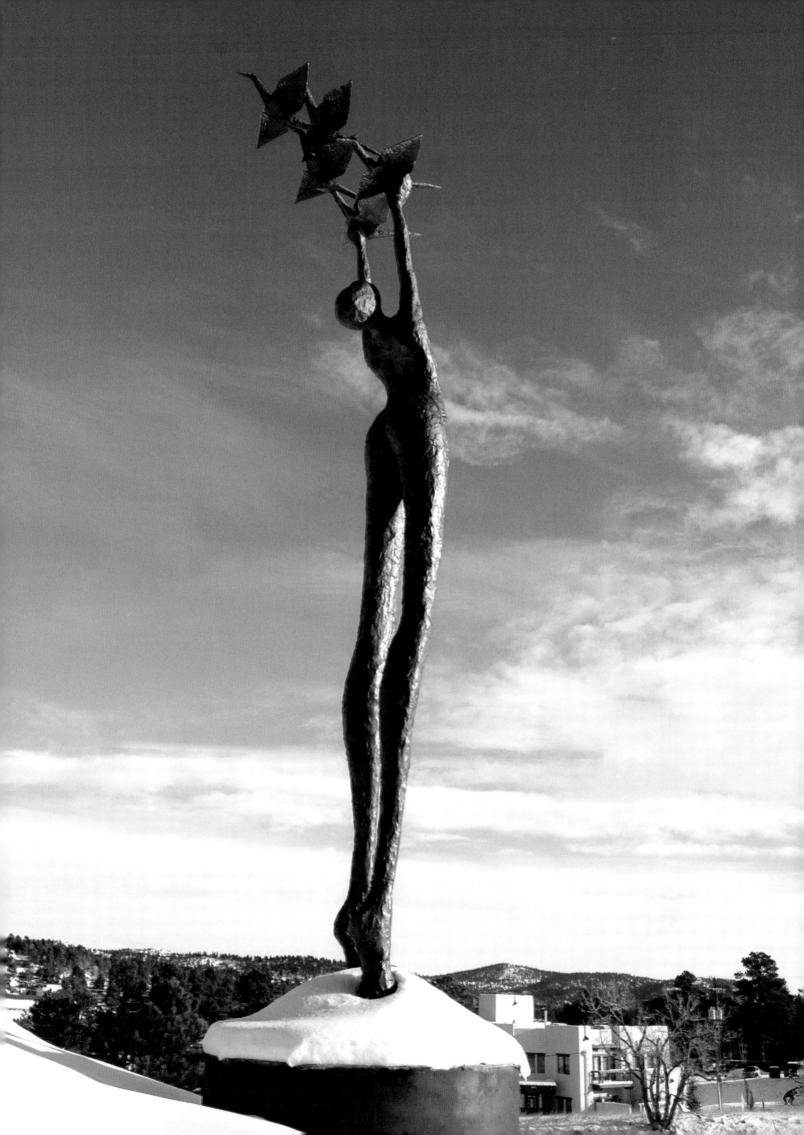

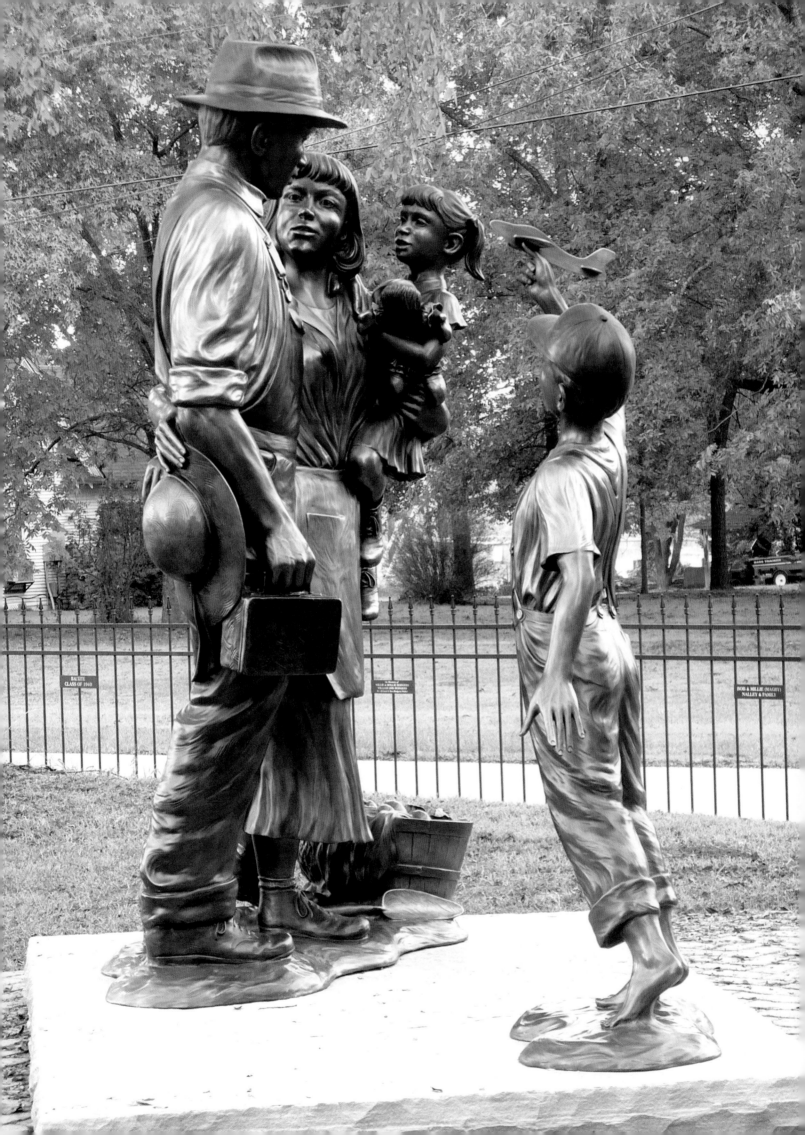

GARY ALSUM

Gary Alsum began his artistic journey dabbling with painting and other two-dimensional media while in high school. However, he credits college professor Jo Alberda for helping him discover his true creative voice. "My last year of college," says Alsum, "she urged me to continue developing as an artist, even though I hadn't really done much at that point. Without her belief in my potential, I doubt I would have ever pursued art as a career." Because Alsum assumed he would end up a painter, he was pleasantly surprised to discover his talent for shaping three-dimensional forms. Consequently, Gary decided that sculpting was a more logical choice of career.

Though Alsum got his start in the business making a series of plaster-cast sports figures for the gift market, he would later move on to finish his first bronze in 1988. He found this transition to be both natural and rational: "Living in Loveland, a sculptor, by default, will create in bronze. I am able to stop in at the foundry on a daily basis, and I usually do my own metal chasing, which has allowed me to be a full-time artist." Alsum also felt that this medium better suited his style, as most of his commissions, including *Unsung Heroes*, require fairly complex depictions of the human form—something that Gary feels translates quite effectively in bronze.

What inspired this piece?

As has been the case for most of my sculptures in recent years, *Unsung Heroes*, along with the companion piece, *Flight of Fancy*, was a commission. The sculpture is placed in front of the Bauxite Historical Association and Museum in Bauxite, Arkansas, and honors the efforts of the town's miners during World War II. The majority of the aluminum the United States used in the war effort came from the mines in Bauxite. The sculpture depicts the husband/father coming home from work and being greeted by his wife, who has been working in the victory garden. The boy with the toy glider (*Flight of Fancy*) ties to this piece by suggesting the importance of aluminum in aircraft production.

Before the maquette for this commission was approved, the concept for this piece was also presented to the town of Brighton, Colorado. They settled on the piece because of the significant contributions blue-collar workers have made to the area's economy over the years. To give this piece a personal touch, I added a toy steam engine in the boy's left hand to tie in with the importance of railroads in Brighton's history.

What was your greatest challenge in creating this piece?

The greatest challenge in creating *Unsung Heroes* was building the armature. I transport the finished clay sculpture to a mold maker, and this necessitates the use of a very sturdy armature so the sculpture doesn't collapse en route. I have done enough large pieces to realize that any extra time spent on building a good armature is usually time well spent. About half of my time spent on this piece was in preparing the armature alone.

What is your favorite part of this piece and why?

My favorite thing about this sculpture is reflected in its title, which honors everyday people who did what they had to in assisting the country and supporting their families.

Why do you consider this one of your most significant works?

There were more people in tears at the dedication of *Unsung Heroes* than at any other dedication I'd previously attended. Obviously, the descendants of these mining families were moved by the thought that their ancestors would be honored with such a lasting tribute.

What does this sculpture mean to you personally?

I am always honored when someone trusts me enough to create a remembrance of people they love and respect. Creating commissioned work is different than coming up with something on my own; the satisfaction comes from taking someone else's idea and creating an image that touches others.

UNSUNG HEROES Gary Alsum *Bronze* 85" × 54" × 35" (216cm × 137cm × 89cm)
installed and photographed alongside Alsum's *Flight of Fancy*

GERALD BALCIAR

Artists like Gerald Balciar are a rare breed, to be sure. In his experience, one mustn't rely on moments of genius to create: "I don't need anything to inspire me to create; I don't need to be in a special mood. I can be creative any time or place." When Balciar first began sculpting forty-seven years ago at the age of nineteen, he spent hours pouring over every painstaking detail of his subject. His almost pedantic attention to such minute details as eyelashes—what he himself calls the *nonessentials*—has evolved over the years into a freer, more expressionistic style. Today, Balciar spends more time trying to convey a feeling or mood in his sculptures rather than attempting to re-create exact replicas of the subject at hand. In fact, he finds that some of his best works are born from demonstrations and quick draws, those moments when he can create while interacting with the viewer. "I find that I get better results when I am being distracted," Balciar says.

Gerald completed his first bronze, a cougar, in 1964. "I just grabbed a ball of clay and made a sculpture," he recalls. And though he can't quite explain why or how he came to do this, he is certain of one thing: Sculpting just felt right. What's more, the cougar would go on to become one of his most beloved subjects. *Silent Descent* is just one of Balciar's many tributes to this brilliant beast.

What inspired this piece?

While hiking in Colorado, I would find cougar tracks all over. I knew they were watching me, but I never saw them. So, with this piece, I wanted to convey the thought that they were present but would not expose themselves. Besides that, the cougar has exactly the right shapes to its body to make a sculptural form. With its strong muscular body, long heavy tail and beautiful sleek head, you already have a piece just waiting to be made.

What prep work and techniques went into this sculpture and how did they contribute to the success of the finished piece?

For anatomical studies, I have casts made of the actual body of a cougar, as well as several death masks. I also worked from several hundred photos of cats in order to get an accurate depiction of the animal. While observing cougars at the zoo during my research, I noticed they behaved more or less like oversized house cats. So whenever I would see my own cats posed in an interesting position, I would take snapshots I could refer to during the sculpting process.

What was your greatest challenge in creating this piece?

I can't say there were any technical challenges in making this sculpture, as I have done so many cougar sculptures in the past. Maybe the challenge remains to make each new piece better than my previous pieces.

What is your favorite part of this piece and why?

I feel that this piece successfully captures the silent, sneaky characteristics of this cat as he descends the rocks unseen. My vision did not change from start to finish. In fact, I had the title before I started the piece, and I feel the end result is the perfect portrayal of the title chosen. Not only was I successful in capturing the gesture and feeling of the cougar, but I also ended up with a solid composition complete with a strong silhouette and good use of shape. The position of the cougar is just so typical of the species—it's perfect.

What does this sculpture mean to you personally?

If you couldn't already tell, I enjoy cats and feel this sculpture is indicative of their sly, stealthy nature. Like almost all cats, the cougar is a solitary animal, stalking his prey from the shadows. *Silent Descent* is my homage to this deft hunter.

What do you hope it says to the viewer?

I hope the viewer feels I have captured one of the many sides of the cougar's personality. He has so much character that it might take a thousand different sculptures to cover the spectrum. This piece merely aims to illustrate one of his many facets.

SILENT DESCENT Gerald Balciar *Bronze* 20½" × 12½" × 7" (52cm × 32cm × 18cm)

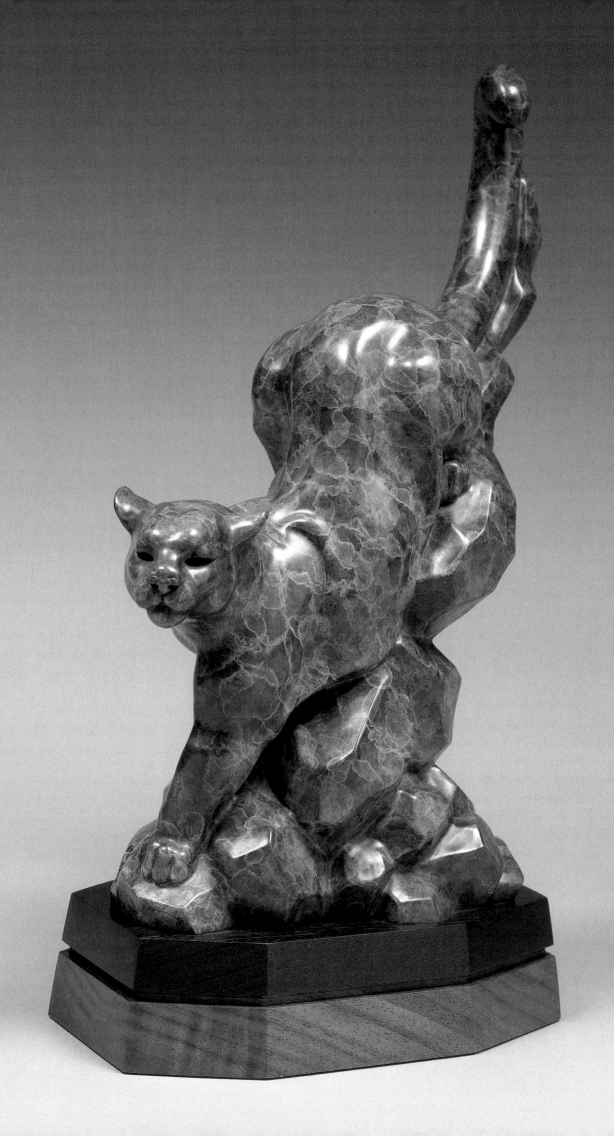

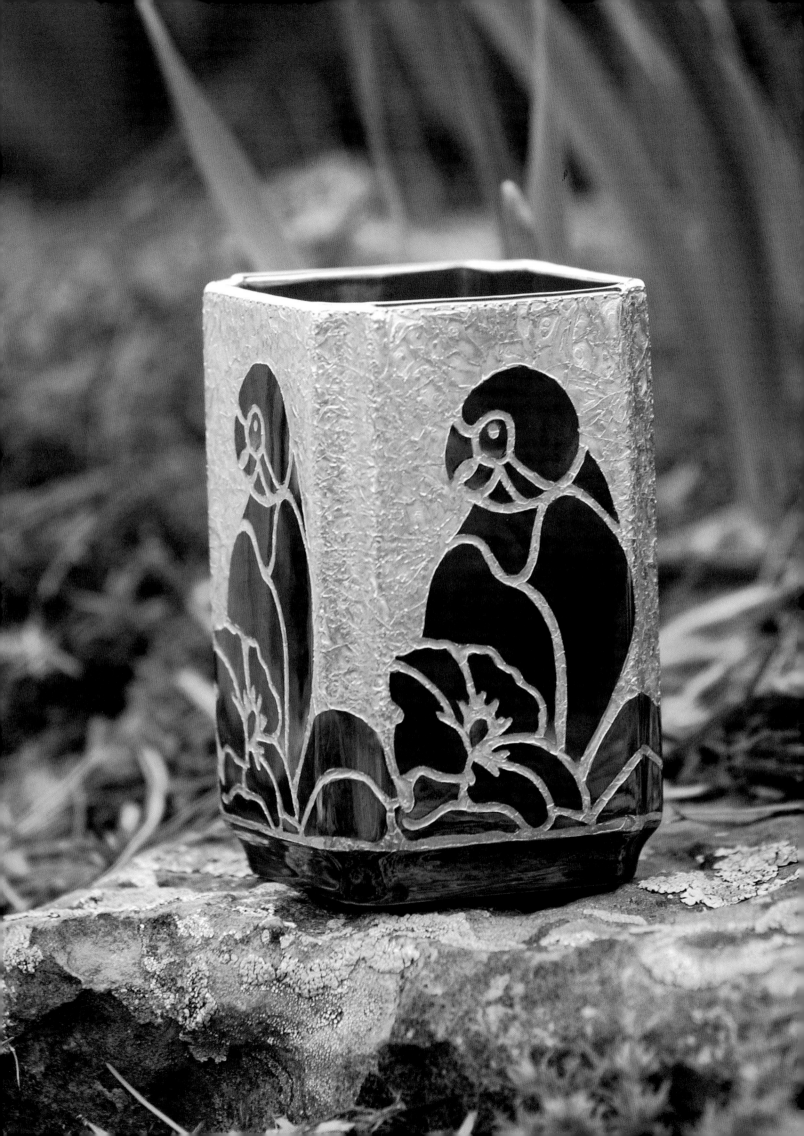

CAROLYN BARLOCK

If you ask Colorado native Carolyn Barlock what draws her to porcelain, she will tell you that she's always been captivated by the medium's enduring history and lasting quality. Though she started her formal art education at the age of nine, studying drawing at the Colorado Institute of Art, it wasn't until the spring of 1969, when Carolyn was twenty-one, that her interest in art history and antiques led her to an extensive study of porcelain. "I began painting flowers, fruits, scenes, animals and portraits before moving on to master the secrets of enameled art dating from the Chinese Ming Dynasty," recalls Barlock. "I instantly knew that I had found my medium of choice."

By the mid 1980s, Carolyn had perfected the Ming Dynasty form, earning high praise and worldwide recognition for her body of work. Eventually though, she grew restless with just how easy the enameled art technique became. Consequently, Barlock set out in search of a new form with more depth, contrast and linear precision. This scholarly journey into the world of ancient porcelain techniques ultimately led Carolyn to the ninth century Persian lusters she uses in her work today. *Pretty Girl! Pretty Girl!* is just one of the many fine sculptures crafted in this elaborate and labor-intensive style.

What prep work and techniques went into this sculpture and how did they contribute to the success of the finished piece?
Once I worked out the design—deciding what would be chiseled away and what would be added to create the texture and depth—I had created the underlying form that dictates the piece's movement and grace. However, it is the finish that truly catches a collector's eye. For a bronze it is the patina, and for my porcelain it is the 24 karat-gold and ancient Persian luster made from gems. Using centuries-old techniques that I have mastered over the last forty years, I re-created the brilliant depth of the gem color in the bird and flowers. I then added my own Florentine gold finish over the chiseled porcelain exterior, as well as inside of the piece. This required many firings, with each new firing adding substance to the piece.

What was your greatest challenge in creating this piece?
As with any piece, my greatest challenge is the chiseling. Porcelain is a uniformly thin medium compared to wood or stone, and the precision of my designs does not allow for anything except exactitude of line. Outright breakage when chiseling a piece is disappointing. However, more devastating is a microscopic stress crack that can result from the chiseling process, causing the piece to break during firing. Even after twenty-five years of chiseling, pieces sadly break as a result of this process. Luckily, I was able to avoid these issues with this vase.

What is your favorite part of this piece and why?
Although I draw from many historic styles, Art Nouveau is a special favorite of mine. *Pretty Girl! Pretty Girl!*, a square-shaped vase, created a visual mirror that lent itself to this style, combining flowers and nature with a certain charm that invokes the delicacies of romance. I particularly like how the harmony and balance of the bird and the flowers are enriched by the depth of the Persian luster and gold.

Did this sculpture turn out the way you had envisioned, or were there some unexpected yet pleasant surprises?
With Persian lusters and gold, where even the slightest degree in firing can change the depth and color, there can always be surprises. The gods where smiling when it came to *Pretty Girl! Pretty Girl!*, creating illustrious leaves that capture the elusive blue that occurs only in the finest emerald gems.

PRETTY GIRL! PRETTY GIRL! Carolyn Barlock *Porcelain* 5½" × 3½" (14cm × 9cm)

MIKE BARLOW

Mike Barlow's passion for wilderness and wildlife manifested itself through artistic expression early in life. Even as a boy of six-years-old, Mike was able to channel his love of the natural world into three-dimensional forms. He would spend his days hunting and fishing in the Wyoming wilderness, then eagerly return home to model his observations in clay. This enthusiasm for the great outdoors continued to grow as Barlow got older, eventually leading him to a long and successful career as a wildlife photographer.

Though Mike immensely enjoyed the opportunities that being a traveling photographer afforded him, something deep within beckoned him to return to the sculpture he loved so dearly in his youth. Ten years ago, he finally followed this intuition, making the leap to become a full-time sculptor. Barlow has no regrets about this decision. "I have always loved sculpture above every other art form," he recalls. "I see things now I would have never noticed ten years ago—I see such great harmony in nature, and have grown to appreciate the beauty and symmetry in creation." Now Barlow strives to show the world what he sees in the animal kingdom through the medium of sculpture, creating pieces like *High Country Ram* to reveal what he believes to be the true nature of wildlife subjects.

What inspired this piece?

This sculpture was inspired by a trip I took to Jasper, Canada. I spent several days in the Canadian Rockies photographing Bighorn sheep. Among the herd was the largest ram I had ever seen. I wanted to capture his essence forever in bronze, and so I made him the subject of my next work.

What prep work and techniques went into this sculpture and how did they contribute to the success of the finished piece?

To prepare myself for the piece, I spent a few days watching and observing these sheep at close range (ten to twenty feet away). This meant hiking several miles up a steep slope each day. I would carefully approach the sheep until they became comfortable with my presence. I made sure to photograph them in as many poses as possible, and I also made a small clay model while observing the sheep so I would have a reference to work from in the studio.

What was your greatest challenge in creating this piece?

For me, it was the shape and size of the horns. I wanted the piece to be as lifelike and as accurate as possible, so I worked from a set of sheep horns I was able to bring into the studio. This helped tremendously with creating an authentic look.

Why do you consider this one of your most significant works?

I've always been fascinated with animals, and I wanted to observe Bighorn sheep in the wild for as long as I can remember. I even recall studying for college exams every November, wishing instead that I was with the sheep on the Whiskey Basin in Wyoming. It is significant because the subject means so much to me.

What does this sculpture mean to you personally?

It is satisfying when the gesture or attitude of what the subject is doing tells a story. In this case, I wanted to tell people what a Bighorn sheep means to me, and that meant creating something majestic. I was very pleased with the outcome. This sculpture conveys an image of a creature secure in what he is, just as I feel secure with myself and my portrayal of wildlife.

What do you hope it says to the viewer?

I want people to see that this is an animal in the prime of its life, but I also hope they might gain an appreciation for wildlife and creation in general. Perhaps I would be happy if *High Country Ram* inspired someone who has never seen a Bighorn sheep to travel to the Rocky Mountains and observe them in all of their glory.

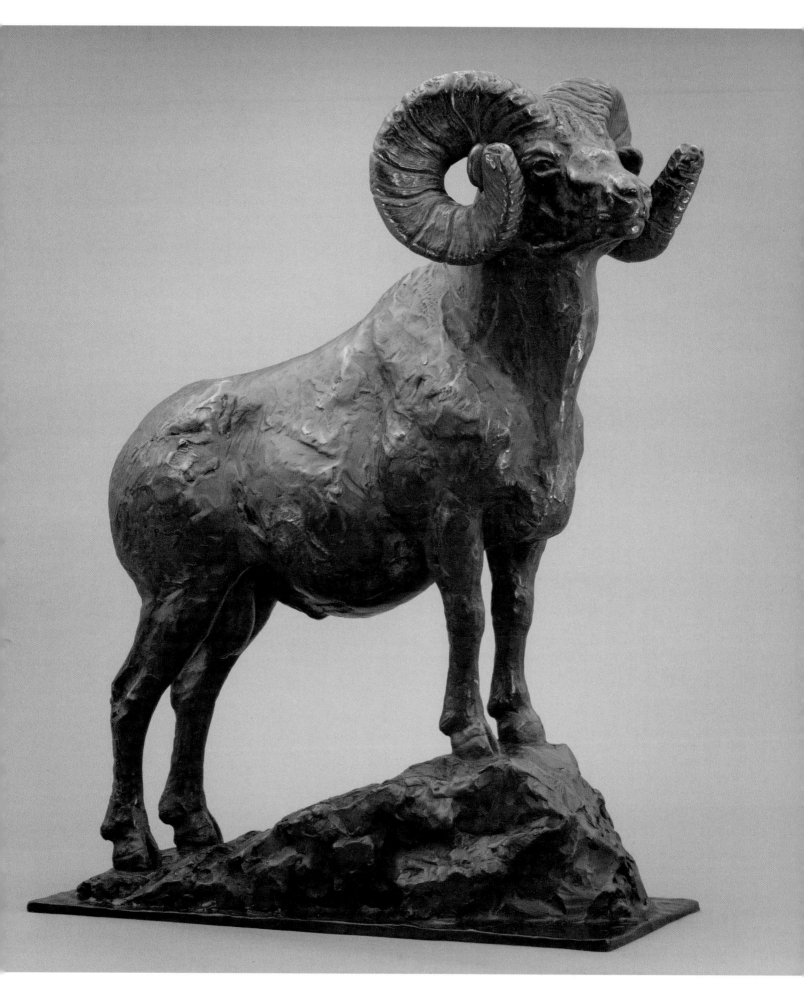

HIGH COUNTRY RAM Mike Barlow *Bronze 26" × 21" × 11" (66cm × 53cm × 28cm)*

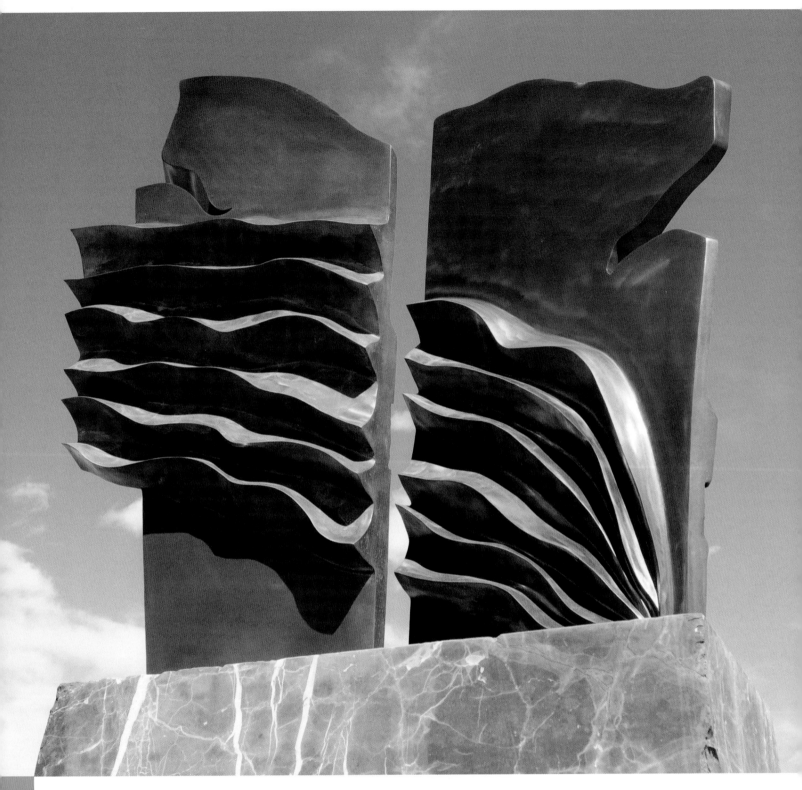

EMBRACING THE STREAM Errol Beauchamp *Bronze 68" × 36" × 20" (173cm × 91cm × 51cm)*

ERROL BEAUCHAMP

Influenced by the age-old adage "the simplest pleasures are the ones we hold on to," Errol Beauchamp's mission is perhaps one of the most unique in abstract sculpture today. Through his work, Beauchamp aims to create a window that looks out from the architectural world people live in—one that reveals the contrasting forms, details and surprises of our natural environment, and helps the viewer enjoy the beauty that exists therein.

Though he's only been sculpting for seven years, it's clear that Errol's rich and varied job experiences have been guiding him toward this creative endeavor his entire life. Time spent working in a heat treating plant and with a titanium manufacturer exposed Beauchamp to the process of combining raw materials to create beautiful metal. Even his career as a graphic designer primed him for a life in three-dimensional art, as the chance to create brand identity for the Celebrate Colorado Artist Festival led Beauchamp to enroll in classes. "I wanted to learn the materials, tools and processes that would guide my minimalist design style in creating sculpture," he says. Now, every form and movement he sees translates into a line for a new sculpture. Works like *Embracing the Stream* are a collection of these simplified lines, and help illustrate the undulating motion Beauchamp envisions in his mind.

What inspired this piece?

I found inspiration for *Embracing the Stream* in Walnut Creek—a creek that flows in and around the community of Westminster, Colorado and near the business park where my commissioned sculpture would be located. The personal story is centered in the complete freedom that the owner of Walnut Creek Business Park offered me. The creativity began flowing in spontaneous graphite sketches of the natural environment in motion, and only grew from there.

What was your greatest challenge in creating this piece?

My greatest challenge was creating the final bronze in two contrasting processes. My previous work utilized an additive and subtractive process in clay that allowed me the freedom of limitless changes until I was convinced that's it. By welding flat sheets of bronze, and cutting and bending curved shapes with rollers, I had to be confident that the full-sized cardboard mock-up would accurately tell the story. Only then did I place the cast textures and waves of water on the smooth iconic forms to mark their placement. The process became a matter of trusting my instincts without reservation.

What is your favorite part of this piece and why?

My favorite part of this work is connecting the observer's eye and mind across two separate forms divided by a narrow space, and then creating a surprise with the changing viewpoint as they move incrementally around the piece. The bold forms and transparent patina colors help connect the piece to the natural environment, providing a nice contrast to the architectural space the sculpture occupies.

Did this sculpture turn out the way you had envisioned, or were there some unexpected yet pleasant surprises?

Though this piece was generally realized the way I had envisioned, I was pleasantly surprised by the striking presence of the waves. In order to make them discernible from a moving vehicle, the scale needed to be amplified. In doing so, the textures and beauty that so heavily relied on proportional relationships came alive. This, coupled with the appeal of the translucent red patinas and blue reflections in the waves, helped the piece achieve "belle artes" status.

What does this sculpture mean to you personally?

This sculpture has reconnected me to my childhood fascination with the simplicities of life. As a five-year-old, I enjoyed sneaking away to the nearby woods and streams to discover my natural world. As I got older, my passions shifted to abstract sculpture and clean architectural lines. Years later, I've circled back to the fancies of my youth, rediscovering the natural world as a sculptor.

JIM BUDISH

"I've always had a need to artistically produce the images that float around in my head, appear out of the corner of my eye or hit me in the face," exclaims Jim Budish, a self-proclaimed lifelong sculptor. Even while pursuing other careers in order to raise a family, Budish remembers being more drawn to the sculpting stand than the office. Then, in the 1990s, with his children grown and moved away, Budish finally had the opportunity to follow his dream of sculpting professionally full time.

For the past two decades, Jim has pushed himself to grow as an artist, both intellectually and technically. Even so, he holds fast to the simple innocence of his work. Continually inspired by the humor and foibles that surround him, Budish hopes his sculpture can serve as a catalyst in helping the viewer *lighten up.* "I never want to grow to a point where I begin to overthink what I'm creating," Jim says. "The world has changed so dramatically since I started sculpting professionally . . . I feel we all just need to take a moment to smile. I'm confident there are enough sculptors whose mission will be to seriously represent the world through sculpture." This blithe and optimistic approach to the arts has yielded numerous successful pieces, including one of Jim's most beloved works, *Chauncey.*

What inspired this piece?

I have always been inspired to draw, sculpt and paint the multitude of creatures that surround us. *Chauncey* was originally inspired by an encounter with a desert hare that I observed in the Arizona desert. He appeared to be curious, contemplative, gentle and confident, while possessing a bit of attitude.

What prep work and techniques went into this sculpture and how did they contribute to the success of the finished piece?

As with most of my work, I studied the movement of the subject, and the nuances of the subject's gesture and behavior. I then created an aluminum armature, shaping it in such a way that would capture the motion and gesture that I was attempting to achieve. Covering the armature with oil-based clay, I proceeded to sculpt the features (or lack thereof), re-working the clay until I was certain that I had accomplished the features, form and gesture that I had envisioned in my mind.

What was your greatest challenge in creating this piece?

Capturing the essence of the subject in a piece is sometimes the greatest challenge to me as an artist. In the case of *Chauncey*, that part seemed to come easily.

What is your favorite part of this piece and why?

My favorite part of the piece is the air of contemplation that *Chauncey* seems to project. I also enjoy being able to watch the response of the viewer upon initially seeing this sculpture. I've seen such varied reactions, ranging from an incredulous "Is that some kind of weird Jackalope?", to uproarious laughter, to thoughtful meditation followed by a warm smile. As an artist, I find satisfaction in each unique response to my work, as it means I've succeeded in evoking emotion.

Did this sculpture turn out the way you had envisioned, or were there some unexpected yet pleasant surprises?

No sculpture ever turns out the way I envision it! Until I walk away from the first casting (and sometimes not even then), any new piece that I create is a work in progress all the way to the point of completion. I have had sculptures go through three rounds of casting before realizing that I needed to go back to the clay and work further on the piece. It's always a surprise.

What does this sculpture mean to you personally?

That's irrelevant. I would ask the question of anyone who views the piece or has collected the piece. Art is indeed what the beholder makes of it. What *Chauncey* means to me changes as often as the number of times that I look at him.

CHAUNCEY Jim Budish *Bronze* 68" × 24" *(173cm × 61cm)*

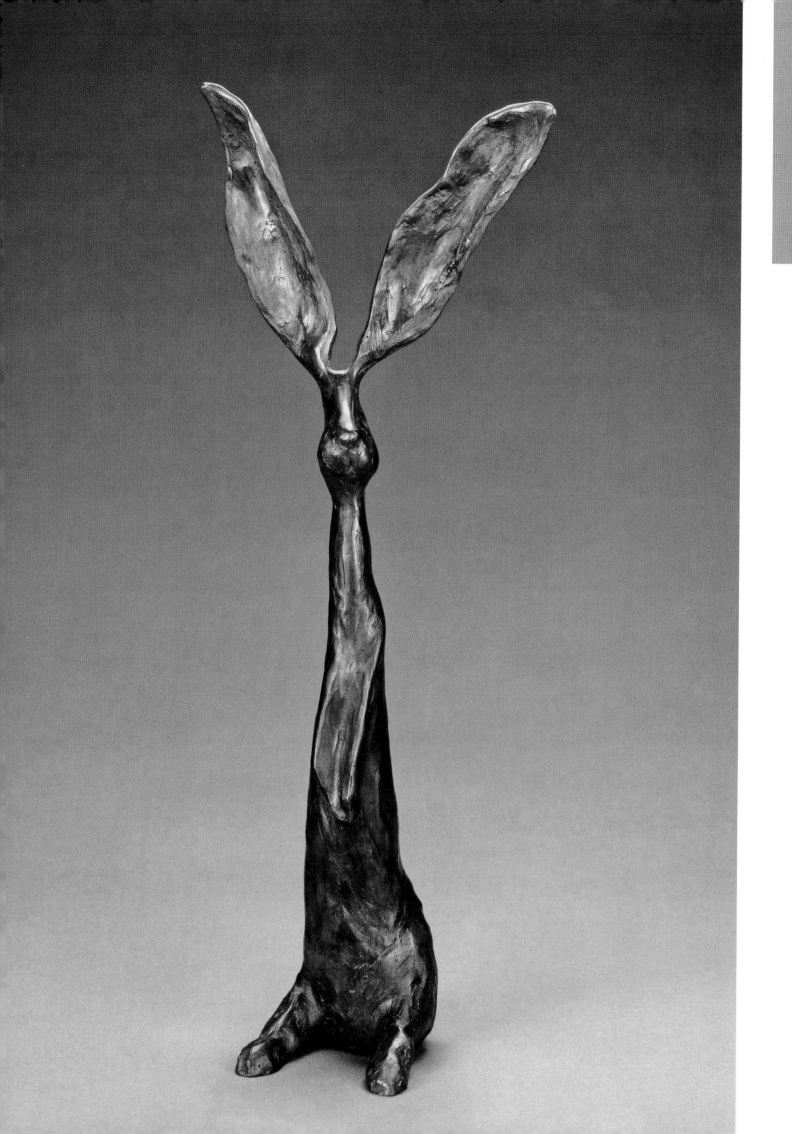

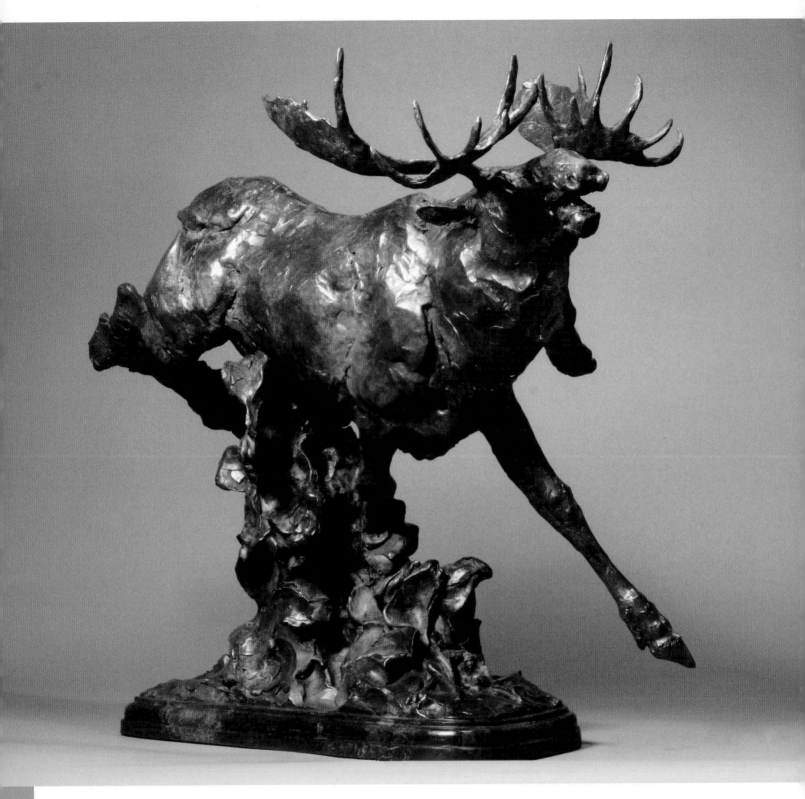

EMERGENCE George Bumann *Bronze 19½" × 12" × 16" (50cm × 30cm × 41cm)*

GEORGE BUMANN

George Bumann can't remember the exact moment he began sculpting, but he does know that it's always been a part of his life. The son of a sculptor, George grew up surrounded by clay, pastels, stone and chisels. In fact, he recalls his mother putting these very tools in his hands from the time he was coordinated enough to hold them. But as much as he enjoyed the arts, Bumann knew firsthand just how challenging the life of an artist could be; thus, he decided to pursue a degree in ecology instead.

While at college, George experimented with pen and ink illustration and watercolors, but eventually came back around to sculpture when helping his mother with a project. It was then he discovered that this was his calling, and that his two passions—ecology and art—didn't need to be mutually exclusive of each other. "Sculpture was something that I could literally grab ahold of. It wasn't an illusion like drawing—I was re-creating the subject itself. Here was a direction I could pursue that would allow me to enjoy both of my lives at once," Bumann explains. It is this perfect blend of scientific accuracy and artistic integrity that make works like *Emergence* so powerful, instilling the viewer with a sense of just how awe-inspiring nature really is.

What inspired this piece?

My interest in doing this sculpture was sparked by a fellow artist's observations of an unusual bull moose at Grand Teton National Park in Wyoming. Though it is often difficult to see particular bulls from year to year, we set aside a week during the mating season hoping to find the bull we came to know as "Shovels." He was dubbed so due to a very unique set of palms on the brow tines of his antlers, which is unusual among the Shiras subspecies of moose here in the Rockies. About halfway through our stay, we had identified eight different bulls, but not Shovels. Not until we hiked out to sketch and photograph the cow and calf did we hear the classic "uhgg, uhgg" calls of a bull closing in. Willows began snapping and the hollow, resonating sound of antlers on wood became louder and louder. The cow returned with a whiney call of her own which sent the bull into a frenzy. Then, without warning, Shovels burst straight out of the willows at a distance of twenty-five yards and closing! The bull looked larger than life looming above us—it was an idea I had to pursue.

What was your greatest challenge in creating this piece?

My greatest challenge with this piece was sculpting the willows from which Shovels burst forth. I often envy painters in their ability to imply certain things in two dimensions that become troublesome when the third dimension is added. My solution came about tangentially. The whole drive to do the sculpture was the moose, adding other forms would detract from the intention of the work. I sculpted the moose, still undecided about what to do regarding the willows. I then laid a ribbon of clay where I wanted the willows to begin, and that was enough! It remains this way in the final sculpture.

What is your favorite part of this piece and why?

I love the forward momentum of the piece and strove to evoke the radiating energy in that moment. With the outstretched foreleg, flared nostrils, projecting antler points, and the negative space and shapes in the plinth or base, I sought a sort of visual analogy to the forceful sound a trumpet might make.

Why do you consider this one of your most significant works?

This piece embodies the energy of the moment in a visceral, rather than a cerebral, sort of way. I commonly visit carcasses of dead animals to take measurements and make plaster casts of their bodies to use for reference. In this case, I chose to leave most of my science background out of the process in favor of what felt right. I see the outcome as freer in its execution, and the textural qualities work better for the purpose of reflecting light in an interesting way.

BLAIR BUSWELL

Widely known for his sports figures and other exemplary bronzes, artist Blair Buswell is a prominent presence in today's sculpting scene. Buswell traces his lifelong love of art back to his childhood, when he would spend countless hours making his own toys from clay. By the time he reached junior high school, he realized that art was a viable occupation, and thus decided to pursue his passion professionally. When it came time to enroll in college, Blair settled on illustration as his major, but shortly thereafter, he had a change of heart that forever altered his artistic course. "Illustration and design taught me a lot about how the eye travels through a painting or drawing," he says, "but when I discovered I could do the same thing with three-dimensions, I was convinced I could be a sculptor."

Though partial to the medium of clay, Buswell doesn't feel the materials used for his work are critical in communicating his message. "If the composition is strong, the message will be conveyed regardless," he says. As for subject matter, Blair has been forever fascinated with the human figure, and enjoys the challenge of capturing the gesture, mood and expression of a subject. His evocative piece *How Many More…* perfectly illustrates his uncanny ability to suggest powerful emotion through the use of the human form.

What inspired this piece?

I started this piece at the "Quick Draw" for the Northwest Rendezvous art show. The idea came from a model I saw in one of my wife's fashion magazines. I really liked the mood portrayed in the photograph. The abstract shapes of her gesture and the way her hair flowed down and around her head intrigued me, so I thought she would make an interesting subject. I liked the feeling in the photo, but the challenge was to make it work from all angles in the round.

What prep work and techniques went into this sculpture and how did they contribute to the success of the finished piece?

I made a small study the night before the event, trying to decide what to do the next day. As I was working on the maquette, I wanted to continue the line and shape of the hair, so I added a ribbon of clay on top of the head. That ribbon became a feather and the piece ended up as an Indian. The maquette helped me to think abstractly and transfer what I saw in the two-dimensional photograph into a three-dimensional sculpture.

What was your greatest challenge in creating this piece?

My biggest challenge was to maintain the freshness in texture and mood without changing the basic design. I didn't want to get caught up in the details; but instead, to concentrate on the basic forms and design.

What is your favorite part of this piece and why?

From start to finish I was working with abstract shapes and the feelings I got from the mood and expression. Over time, the piece slowly evolved from a woman with long hair into an Indian. When most people look at this piece they see all of the detail. When I look at it, I see simple design elements and abstract shapes.

Why do you consider this one of your most significant works?

I feel this is one of my strongest pieces because I was able to bring together different elements I enjoy working with into one piece. I enjoy the basic abstract design elements that help carry the eye around the piece and simultaneously frame the face. I also love what I call thought poses—poses that make you wonder what the subject is thinking or feeling. I try to capture this through the gesture, mood and facial expressions. In *How Many More…* these elements came together very well.

What do you hope it says to the viewer?

This Plains Indian man is deep in thought, wondering how many more hard winters, long battles or wagon trains he'll have to endure. I hope the viewer will see his concern and depth of thought.

HOW MANY MORE . . . Blair Buswell *Bronze* 19½" × 9" × 10" (50cm × 23cm × 25cm)

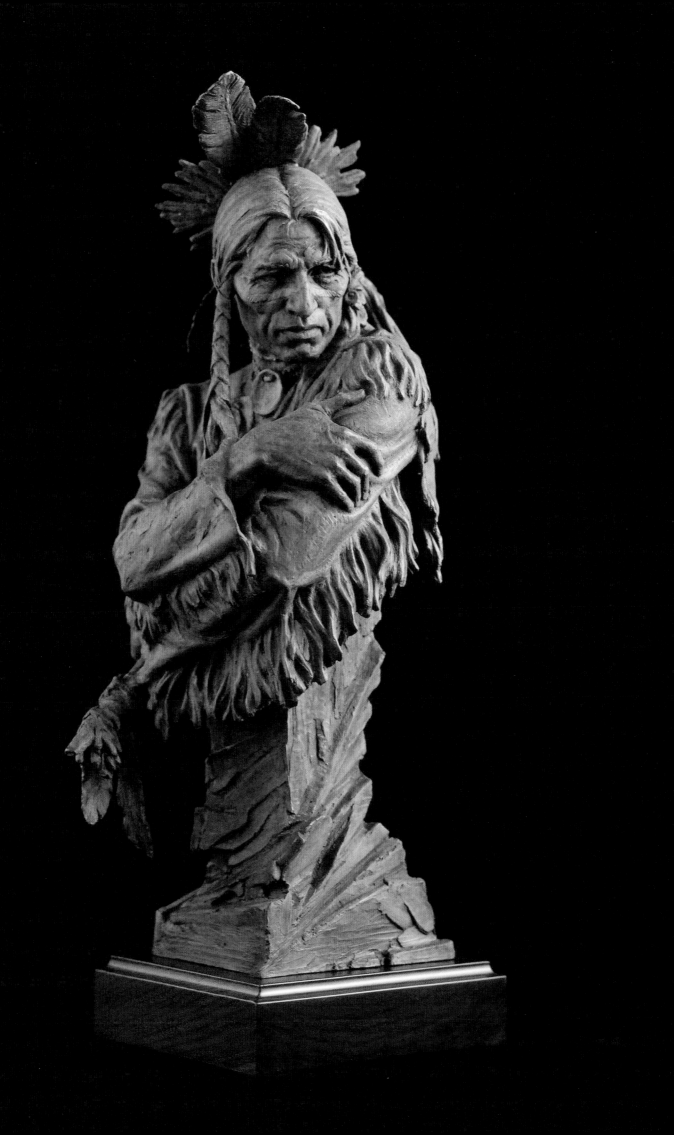

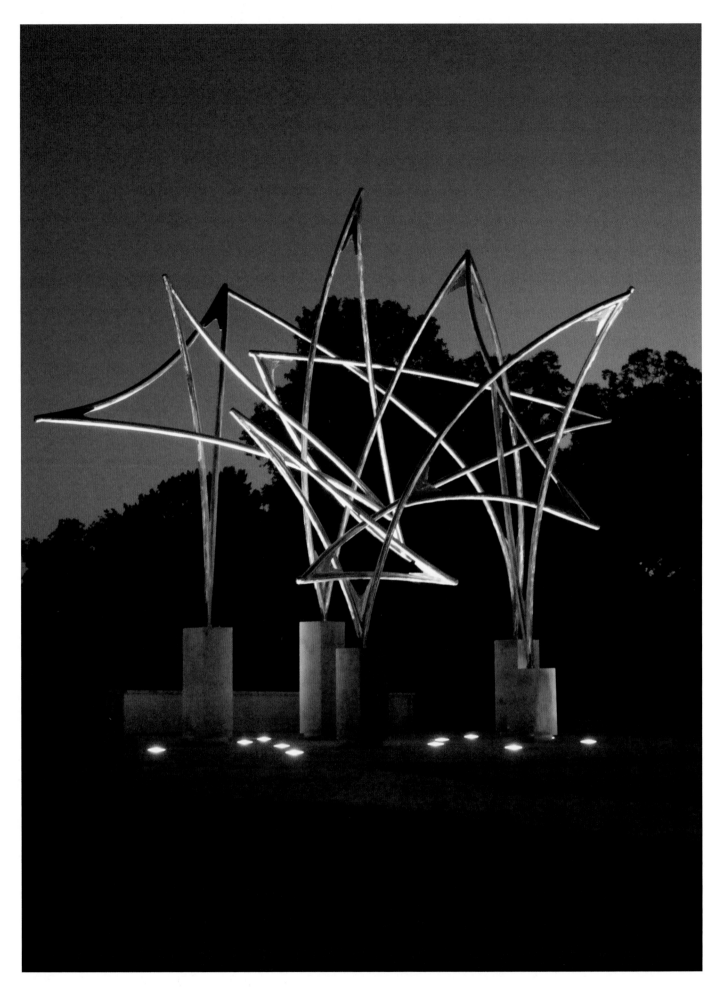

STARS & STRIPES Kathleen Caricof *Stainless Steel and Granite* *432" × 480" (11m × 12m)*

war memorial for Stadium Trust, Little Rock, Arkansas

KATHLEEN CARICOF

As Kathleen Caricof will tell you, she thoroughly enjoys every part of creating a sculpture; however, with a background in industrial design, Kathleen can't help but find particular delight in the design process. Working with a concept in a designated space to create the most complete account of that concept is both the challenge and thrill of Caricof's career. Her love affair with sculpture began in 1985, shortly after she quit her corporate job to raise a family. Caricof knew she needed something to stimulate her intellect and creativity; it was by chance that she found the perfect outlet in sculpture. "Sculpting has enabled me to experience loving and living my work," Kathleen proclaims. "You have to live your work to be an artist. I truly believe we are all destined to do certain things; I was gifted with this creativity, and I just happen to be lucky enough to get to use it."

Working with a vast array of natural stone, Caricof enjoys the physical nature of carving. At the same time, though, material choice isn't an arbitrary process to this gifted designer. "You must pick the best material to express the idea," she says. To Kathleen, nothing could convey the emotion of *Stars & Stripes* better than stainless steel. Every time someone stops to appreciate this piece, it isn't hard to see that Caricof was right.

What inspired this piece?

Stars & Stripes is a public art sculpture commissioned by the War Memorial Stadium Trust in Little Rock, Arkansas, to honor military veterans. The stadium was originally dedicated September 18, 1948, in honor of the 4,634 Arkansans who lost their lives during World War I and World War II. As part of the stadium's sixtieth anniversary, officials re-dedicated the space to Arkansans who have served or are serving our country since that time, honoring them with the newly-constructed Sturgis Veterans Plaza in 2008. The committee approached me looking for something patriotic that was, at the same time, a departure from the typical iconography of a war tribute. With this in mind, I designed my sculpture. The five stars represent both the individual and the collective— the stars of our military [each individual who has served] and the five branches of our military. The stars interact with each other as one moves around the piece, illustrating how the branches work together as one unit. The granite pavers and columns are the stripes, supporting the stars.

What prep work and techniques went into this sculpture and how did they contribute to the success of the finished piece?

While many of my pieces incorporate a great deal of design, this particular sculpture required extensive design work and engineering due to the compound curves in the design. The process involved concept drawings, a scale model, engineering and fabrication. The sculpture was fabricated in Denver, then cut into thirteen pieces for transport, where we reassembled and finished it on-site.

What was your greatest challenge in creating this piece?

Because this piece required the involvement of so many hands—my team included members in Colorado, California, Georgia and Arkansas— I found the challenge to be coordinating each aspect so that the overall design reflected what I had envisioned in my mind. Great communication leads to great coordination, and as a result of everyone's hard work and dedication, we have a sculpture that we can all be proud of.

Why do you consider this one of your most significant works?

I consider this one of my most significant works not only because of its scale and complexity, but also in part to the scope of its reach as a tribute. The sculpture relates to my other work through its use of strong line— a quality that ties together each of my pieces. And while this is not one of my personal sculptures, it does reflect my respect for the military. I was deeply honored to be the artist selected to do this piece. Art is my way of contributing or giving back to those who protect and serve us, which is one of the reasons I enjoy creating memorials.

GEORGE CARLSON

Forty-five years ago, George Carlson began sculpting in an attempt to improve his drawing skills. "My intention was to be a painter, not a sculptor," George recalls. With this goal in mind, Carlson set out to sculpt head studies, convinced that physically feeling the curve and shape of the head would help him capture the essence of the form in his drawings. "I felt that if I could understand the elements of volume and mass, then I could achieve better success in my two-dimensional works," Carlson says. Though these sculpting experiments imparted invaluable lessons that could easily be carried over into drawing and painting, the seed had already been planted: George knew he had to sculpt.

Though he derives great satisfaction from getting his fingers into wax, Carlson has always felt the need to keep learning and exploring as an artist. Trying his hand at various subjects, from voluminous Native American forms to the delicate curves of a ballerina, has helped George maintain a certain freshness in his point of view. Regardless of the subject, Carlson hopes his sculpture, including his well-received piece *The Greeting*, reflects the vitality of life while speaking of the wonderful diversity of organic and inorganic forms abound.

What inspired this piece?

Harrison Eiteljorg commissioned me to work up an idea that would welcome the public to his new museum in Indianapolis, Indiana. Since the museum would showcase examples of Indian cultures, particularly those of the West, I decided on a North Plains Indian. In my mind, this had to be a person of nature who loved the land and held it in deep respect—the same respect he hoped the pioneers and settlers would have for his ancient lands.

What do you hope it says to the viewer?

I hope the viewer feels the intended gesture of welcoming.

What prep work and techniques went into this sculpture and how did they contribute to the success of the finished piece?

Researching the costuming and settling on a body gesture were both of equal importance. The knotted forelock on his forehead, for example, indicates he is a beholder of a medicine bundle. As a leader to his people, he would be both steeped in the traditions of his culture and yet simultaneously aware of the fact that new roads needed to be taken in order to peacefully co-exist alongside new inhabitants. As for creating the perfect design, I felt the forms should appear almost rock-like, giving the piece an organic quality. The extended arms encased with the buffalo robe serve to give the sculpture mass and weight.

What was your greatest challenge in creating this piece?

Originally, the composition was without the eagle wing, so it felt lacking in monumentality. But when the wing was added, all of a sudden, the figure soared. I decided to loosely suggest a pyramid shape with the piece, visually starting at the base in a broad form, then ascending to the thin tip of the eagle wing. I was relieved with the solution.

What is your favorite part of this piece and why?

As much as the whole sculpture was developed with natural and somewhat rock-like shapes in mind, I really developed this even more in the back view of the sculpture. This is personally my favorite part of *The Greeting*, as I feel it contains some of the more interesting abstract shapes.

Did this sculpture turn out the way you had envisioned, or were there some unexpected yet pleasant surprises?

The lure of each new work seems to hold the promise of meeting some expectation. However, from vision to creation, it doesn't always coincide. Frustration is what keeps me working. If nothing else, I can say that this sculpture was a breakthrough for me as far as understanding volume and mass, and simplifying design.

THE GREETING George Carlson *Bronze* *55" × 32" × 18" (140cm × 81cm × 46cm)*

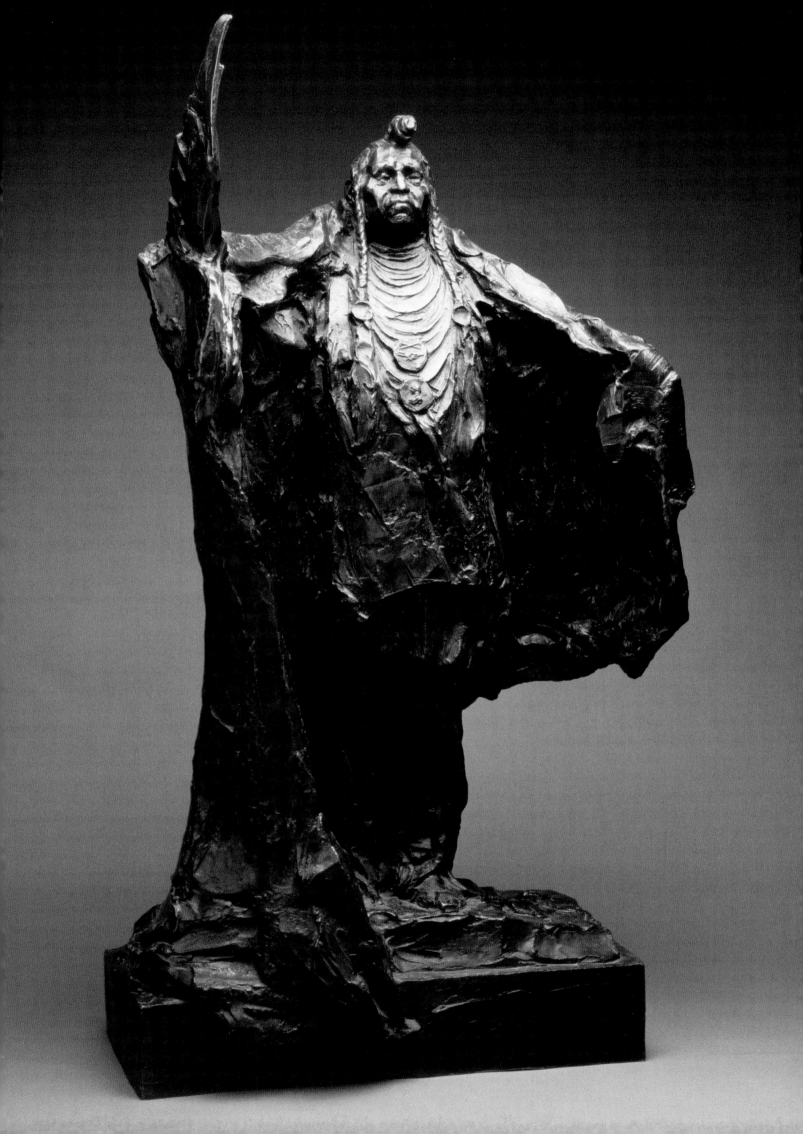

30

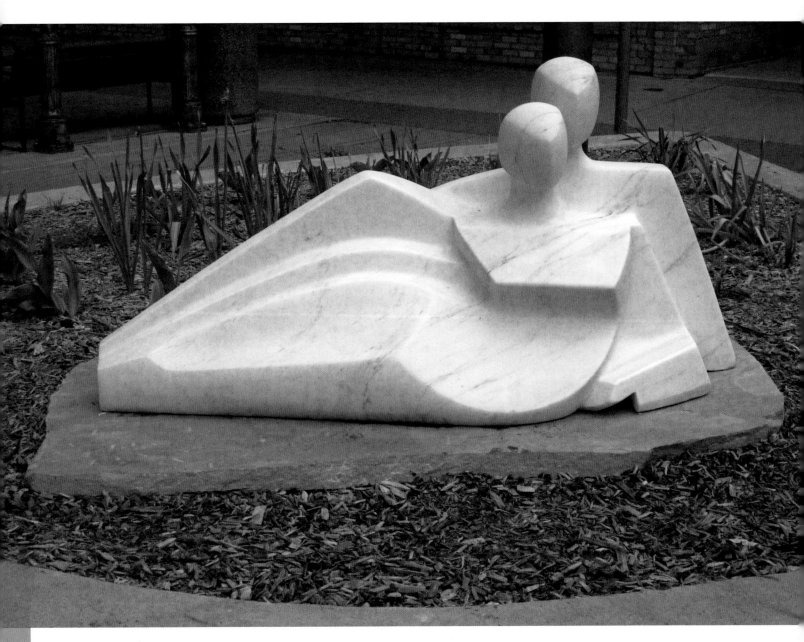

AT THE PARK Reno Carollo *Colorado Yule Marble* *32" × 60" × 20" (81cm × 152cm × 51cm)*
owned by the city of Grand Junction, Colorado

RENO CAROLLO

Sculptor and goldsmith Reno Carollo has spent his life living and creating art in Colorado. While studying fine arts and art education at the University of Northern Colorado, Carollo had the opportunity to participate in an exchange program with the Academy of Fine Arts in Florence, Italy. This experience would certainly change his life, both as a human being and an artist, profoundly influencing the direction of his work. When reminiscing about this time of artistic discovery, Reno recalls, "I became enamoured with the work of the cubists—especially Archipenko, Zadkine and Liptchitz—and I wanted to contribute to this wonderful expression in sculpture." Though his goals evolve with each new piece, Carollo's work still feeds from this abstract vein.

Now seeing the world through a more figurative lens, Reno aspires to create pieces that are reflective of the human condition. "I am building a body of work with life statements spoken in an abstract language," Carollo says. His commitment to portraying the human form in new and provocative ways, while leaving the essence of what the human figure is, remains a hallmark of some of Carollo's most compelling pieces. *At the Park* is just one example of Reno's ongoing study of the figure and the powerful emotions associated with being human.

What inspired this piece?

At the Park was inspired by a personal relationship of mine, and helped launch the *Lovers* series I produce. It is about the time we need to give to each other, those quiet moments of togetherness when we can relax and momentarily escape the stress of our busy lives.

What prep work and techniques went into this sculpture and how did they contribute to the success of the finished piece?

The carving techniques I use are a hybrid of the U.S. "slash and burn" method and the more meditative, pensive style of Italian systematic carving. I work from a model to achieve the desired form and to capture the essence I'm after.

What was your greatest challenge in creating this piece?

Working on a horizontal scale as opposed to my usual vertical scale was my biggest challenge. Rather than focus on the difficulty of this transition, I approached it as though it were a learning experience or opportunity for me to branch out in a previously unexplored direction. In viewing the challenge as a positive rather than a negative, I was ultimately able to achieve success.

What is your favorite part of this piece and why?

I'm especially drawn to the expression of the heads. The visual empathy that is created by the positioning of the two figures is also intriguing. The way they lean toward each other expresses a sense of tangible closeness in a physical way, but also an emotional closeness in that they relate to each other and possess an understanding of what the other figure feels.

Why do you consider this one of your most significant works?

This was my first reclining piece in the *Lovers* series and only my second life-size carving. I feel it is significant because it shares my growth as a sculptor with the public.

What does this sculpture mean to you personally?

This sculpture reflects something important in the life of any man: Relationships take work, and they need to be nurtured. It's important to make time for your partner, and this is the essence of *At the Park*.

What do you hope it says to the viewer?

I hope that the many viewers passing by can relate to this piece and connect with the emotions it projects—love, closeness, connection and understanding.

VANESSA CLARKE

Like many young artists in search of their niche, Vanessa Clarke found herself drawn to the thriving creative communities of Colorado. It was fourteen years ago, after attending a carving symposium in Marble, Colorado, that Clarke felt the urge to relocate to Denver—a place where she felt she could develop her talents more fully with the support of like-minded artists. Instantly she knew she'd made the right decision. "The natural beauty of Colorado artistically inspires me every day," she says. "I love the outdoors, and the peace, splendor and independence I feel here continue to make it feel like home."

Today, Clarke works as a direct stone carver, often combining various types of stone into a single work. She says of her craft, "I've always been drawn to the overwhelming possibilities of stone. I am constantly searching for different colors, shapes, textures and uniquely-marked stones that will allow me to express what I have in mind." She finds particular gratification in fusing multiple stones into one sculpture. "The stones come together like the pieces of a puzzle," she says. "Carving them to appear as one stone is a rewarding challenge." Clarke makes overcoming this challenge seem effortless in pieces like *Confrontation*—a sculpture that captivates the viewer's senses by presenting various stones, textures, colors and shapes in one seamless, unified form.

What inspired this piece?

This sculpture represents (and was inspired by) conflict in a personal relationship of mine. I wanted to convey both the unity and the depth of the connection I feel with this individual through the continuous movement and alternating stones that come together in a single circular form. The interruption of the form with the pin represents two things: The white marble in the middle symbolizes the disagreement, and the black granite on either side symbolizes the intensity each of us feels during the struggle for dominance. The overbearing angle of the taller side looming down over the lower side represents how I feel as a non-confrontational person suddenly caught in the throes of argument and debate.

What prep work and techniques went into this sculpture and how did they contribute to the success of the finished piece?

I always utilize different stones in my carvings to create multiple dimensions and layers, but for this piece they had to be seamless and uninterrupted. The end result was the culmination of years of experimentation in carving sculptures that incorporate different stones. I used epoxy and stainless steel pins to bind the four different types of raw stones into the fundamental shapes I was trying to create. I chose to carve in this way after many years of trial and error with binding, pinning, gluing and joining different types of stone into single sculptures. This technique was crucial in creating the flow and singularity I was trying to convey in the piece.

What is your favorite part of this piece and why?

Although the steel elements were the most overriding and complex aspect of the sculpture, they are my favorite features. The steel lent itself so perfectly to the emotion and intensity I was trying to convey: It represents the symbolic space between two deeply connected individuals, it serves as the space holder of conflict, it acts as a bridge for the entire connection and it exists as an interesting textural contrast to the stone. I knew I had to incorporate it into the piece to achieve my vision.

What does this sculpture mean to you personally?

The inspirations for my sculptures are drawn from the well of my everyday life. *Confrontation* is personally significant to me because it symbolizes the gap that can come between myself and someone I love dearly when conflict arises, and it illustrates how this conflict is dealt with during confrontation. As an artist, *Confrontation* was a major breakthrough and conceptually, it provides me with a platform for future sculptures.

CONFRONTATION Vanessa Clarke *Green and Black Granite, Colorado Yule Marble, Cippolino and Steel* 24" × 17" (63½cm × 43cm)

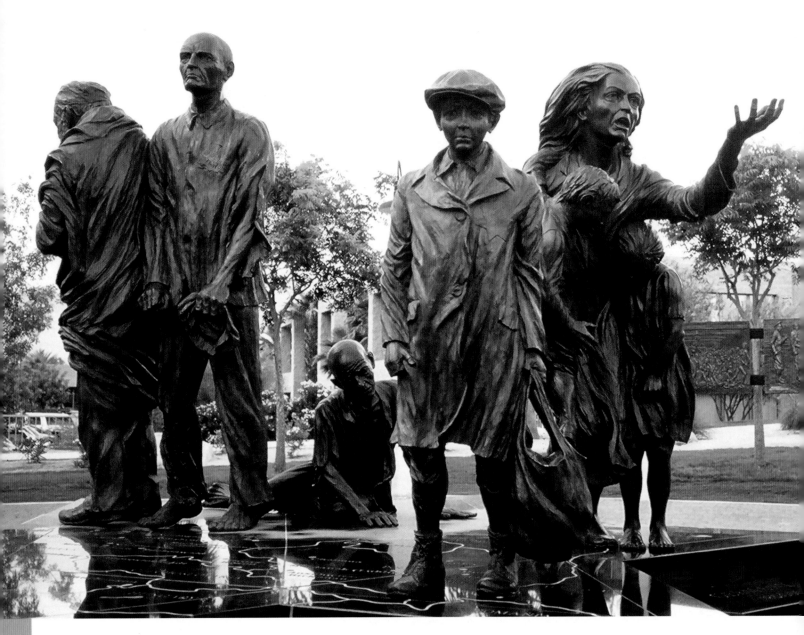

DESERT HOLOCAUST MEMORIAL Dee Clements *Bronze* *105" × 540" (267cm × 1371cm)*
seven figures surrounded by eleven bas-reliefs

DEE CLEMENTS

"One of the most wonderful and fascinating things about sculpture is the diversity of its purposes," exclaims Dee Clements, a multi-faceted sculptor of innumerable subjects. He continues, "My work over the years has covered many areas: Some pieces are for beauty, some tell of our heritage, some tell of my own history and some are just depictions of interesting images." Clements recalls creating his first sculpture while an art student at the University of South Dakota. Right away, he was captured by the medium's expressive power, and sensed that he had found his passion. Now, as an established sculptor, Dee feels it's his responsibility to create three-dimensional stories. He couldn't be happier with this job description.

From a philosophical standpoint, Clements believes his life and art are inextricably connected. "Looking at history and current events has changed my view of the human situation," he says, "and I've come to the conclusion that working for peace in our world is our only hope for the future." This message lies at the heart of one of Dee's many commissioned projects, *Desert Holocaust Memorial*. He explains, "On close examination of the experience of the Holocaust one can lose hope. But by looking at history, we can teach the empathy, love and tolerance needed to create a better future."

What inspired this piece?

I have always been a reader of history and first became aware of the Holocaust through a book I read in high school titled *Auschwitz*. Since then, that period of history has been a focus of mine. The question is, "How could such an advanced culture be reduced to genocide?" I have always wanted to make a statement about genocide through my art. That opportunity came when I was chosen to create the *Desert Holocaust Memorial*. Since then, I have worked on four such projects. I believe the value of these memorials is not only to commemorate the victims but also to make a statement against intolerance and genocide both then and now.

What prep work and techniques went into this sculpture and how did they contribute to the success of the finished piece?

Initially, I created this piece for a competition. My wife Julia and I worked for a month to develop our design and concepts for the memorial. The client was a survivors group in Palm Desert, California, who wanted to create an educational memorial. We added to their ideas and intended direction to develop our design. There are seven 1.25 scale figures in the central sculpture. Enclosing the site, suspended between replicas of the Auschwitz border posts, are eleven Bas-reliefs that tell the story of the Holocaust.

What was your greatest challenge in creating this piece?

One of the greatest challenges in doing a Holocaust piece is walking the fine line between being honest to the reality of history and simultaneously creating a thought-provoking piece of art. If the sculpture portrayed too accurately the horrific images of the Holocaust, no one would be able to look at it. Likewise, if it were softened in any way, it would not be true to the reality of genocide. I tried to work around this by portraying only the victims and not the perpetrators.

What is your favorite part of this piece and why?

I believe the central figures in the memorial are some of my best work. Each of the characters is based on an actual victim of the Holocaust. The comment that meant the most to all of us that worked on the memorial was that, when it was finished, it had the *sense of hallowed ground*.

Why do you consider this one of your most significant works?

This piece is an attempt to use art to create a greater awareness of intolerance and hatred, and to teach empathy as a means of avoiding such tragedies in the future. It is significant both in subject matter and the volume of artwork involved. I always focus much of my effort on showing the individual's emotion through his face, hands and movement. I brought this effort to these figures.

WILL CLIFT

In Will Clift's experience, sculpture exists as the only medium. Unlike the majority of his colleagues, Clift never explored two-dimensional art forms—he simply never saw a reason to. Sculpture always captivated his attention, it's physicality and tangibility resonating with his hands-on nature. Clift explains, "My childhood was spent in rural New Mexico—exploring arroyos, turning over rocks, getting dirty, cut up and bruised. Working with my hands just came naturally." Will's passion for art in three-dimensions started when he was just a young boy, stacking wooden blocks in various configurations to create towers. As Will grew older, this fascination slowly evolved into more refined constructions like making animals out of scrap wood and designing sculptural furniture, all of which ultimately gave way to his current abstract style.

As an artist, Clift feels it's his job to look at the world more closely, not allowing himself to become desensitized to the tiny details that serve as the basis for his creations. However, he remains determined to leave his work open to interpretation, refusing to assign them with specific titles. *Four Pieces Waving* is the perfect example of this intentional vagueness. "One reason I title my works as I do," Clift says, "is that I don't want to limit the viewer to any single reaction, interpretation or conclusion."

What inspired this piece?

I put the first lines on paper for this sculpture almost five years before I actually finished it. The first sketches didn't interest me at the time, but when I came across them later I was drawn to them in a way that I hadn't been previously. Even after my interest was renewed, I worked on it over such a long period that I had no recollection of the original inspiration. For me, this piece has come to be about a gesture or feeling rather than an interpretation of an object.

What was your greatest challenge in creating this piece?

I'm often asked if achieving the physical balance in a sculpture like this is the most difficult part of the work. This isn't the case at all. Once the drawn form is satisfying to me, I already know the piece in and out, balance and all. The hardest part with this form was to decide on its scale. Most of my previous work had been up to three feet in the largest dimension, but I realized that this form had so much motion suggested in it that it needed more height to express itself. That really marked the start of an ongoing study of the effect of scale on my work.

Why do you consider this one of your most significant works?

Four Pieces Waving was somewhat of a departure for me. It was one of the largest pieces that I had done to that point. Perhaps more importantly, though, before that period of time, I worked mostly with horizontal forms. This sculpture helped me become familiar with expressing strong vertical forms in my own vocabulary, which didn't always come naturally.

Did this sculpture turn out the way you had envisioned, or were there some unexpected yet pleasant surprises?

This sculpture surprised me at the last possible moment—the opening of the exhibit in which I first displayed it. The event was well-attended, and the room was over a large basement, which had the effect of amplifying all of the footsteps. At some point during the evening, my shoulder was tapped and I followed a pointing finger to my piece, which was swaying noticeably to and fro from the vibrations! This movement was like a sudden physical response to its surroundings. It was like the motion suggested in the form was suddenly manifesting itself!

What does this sculpture mean to you personally?

The form reflects a state that I've experienced at various points in my life, but have difficulty putting into words. It's a representation of something intensely personal, expressed in a language all my own. But because the piece can convey something to the viewer without words or an intellectual explanation, it is a success.

FOUR PIECES WAVING Will Clift *Mahogany* 54" × 14" × 2" (137cm × 36cm × 5cm)

COMING TO THE CALL Michael Coleman *Bronze* *23½" × 12" × 30" (60cm × 30cm × 76cm)*

photo courtesy of J. N. Bartfield Gallery

MICHAEL COLEMAN

Born and raised in Provo, Utah, wildlife artist Michael Coleman is no stranger to the outdoors. He spent his boyhood hunting, fishing and trapping throughout the Rocky Mountains, often taking a sketchbook along to capture his observations. This time spent in the wilderness gave Coleman such a deep appreciation for wildlife that he knew early on his life's work would involve the study of animals. It wasn't long before he decided to pursue a career in the arts, an occupation that would provide him an outlet to express his love of wildlife. Michael studied art at Brigham Young University, and during this time, traveled broadly to observe animals in their natural environments.

By 1978, Coleman had become a prominent figure in the Southwestern art scene. Since then, he's earned numerous accolades and high praises from collectors and critics alike. Though better known for his wildlife paintings, Michael delights in the chance to create three-dimensional works like *Coming to the Call*. "Molding clay with my hands and wielding a paintbrush are two very different experiences," Coleman says. "I am more observant of things that I want to sculpt. I study behavior and movement more since I need to make sure it can be conveyed through the sculpture. It's something I enjoy immensely."

What inspired this piece?
There is no better time than September in the Rockies. A bull elk in the rut is a very vocal entity this time of year. You can sometimes hear him from miles away. It's such a mesmerizing sound—it always captures my attention. I wanted to create a sculpture that would embody the beauty of this creature and his call. *Coming to the Call* was the product of this inspiration.

What prep work and techniques went into this sculpture and how did they contribute to the success of the finished piece?
My studio is filled with wildlife trophies, often used as models for my work. When I want to sculpt a subject, I study the models and photos I've taken from numerous trips, hikes and hunts. I also do a good deal of reading to learn as much as I possibly can about the behavior of the subject I'm working on. Once I have a complete understanding of the subject, it's time to sculpt. I use oil-based clay, small instruments, and my steady hands to help me bring my visions to life.

What was your greatest challenge in creating this piece?
The biggest challenge was not only getting the subject to look like it should, but also to feel like it should. A successful sculpture is more than a picture-perfect representation of the subject at hand. Consequently, I wanted to give the elk life and character so it wouldn't feel static and boring.

Why do you consider this one of your most significant works?
I believe the size and feel are very strong in this piece, making it a significant contribution to my body of work. I also like the way movement is conveyed. I think this adds an extra element of visual interest to the piece.

Did this sculpture turn out the way you had envisioned, or were there some unexpected yet pleasant surprises?
Nothing is ever as good as I think it's going to be, but that's why I get up in the morning—to make the next one better. Rarely do I start with an idea that ends the way I had planned it to.

What does this sculpture mean to you personally?
My sculptures are a reflection of things that I love and relate to. I have always enjoyed the outdoors and wildlife, and every day I feel fortunate for the chance to paint and sculpt.

What do you hope it says to the viewer?
I love wildlife, and I enjoy connecting with other people who have similar feelings. It's such a pleasure to share my passion.

MELISSA COOPER

Though she's always had a passion for creating art—whether it be still life pencil drawings or tole painting for crafts—Melissa Cooper experienced an awakening of sorts when she discovered sculpting. It was nearly twenty years ago that she decided to sculpt a vase as a Christmas present for her father. At the time, sculpting was uncharted territory for Cooper. She describes the surprise she felt when she realized that a present made for someone else would end up being such a gift in her own life. "I had no idea how much I would love the feel of clay, the three-dimensions of sculpture and seeing the finished piece," Melissa recalls. "To envision, to build and to construct something with my hands . . . that's pure joy and satisfaction."

Though she has settled on West clay and bronze as her materials of choice, Cooper's body of work has greatly evolved over the years. Her earliest works were, as she puts it, "a little stiff." But now that she feels more confident with the medium, and understands the limitations of working with bronze, Melissa feels she's improved threefold. Luckily for Cooper, there is no shortage of inspiration—she finds beauty in everything around her, including the birds that visit her garden, and she credits these creatures with being a huge part of her creative process. One such bird is elegantly portrayed in *Yellow Warbler*.

What inspired this piece?

The Yellow Warbler itself was my inspiration for this piece. I was also driven by the challenge to set the Warbler apart from the rest of the sculpture and make it stand out. Personally, this piece pushed me to stretch the integrity of the bronze structurally in order to make it both graceful and strong.

What prep work and techniques went into this sculpture and how did they contribute to the success of the finished piece?

In preparing for any sculpture, I always have to have a good idea of what my finished piece will look like before I begin. Once I knew that I wanted to place the Warbler on a branch, creating an armature that would successfully carry the weight of the clay used for the bird became my focus. It was crucial that this framework be both strong and balanced so I didn't lose the piece. It would have been a tragedy if the armature collapsed, so I went to great lengths to avoid such a calamity.

Why do you consider this one of your most significant works?

I think this is one of my favorite works because of its simplicity. My eye never stops moving from the bird to the vase to the leaves and back to the bird again—which means the composition is a successful one. Right now, it stands as the most personally significant piece in my body of work, but I am working on some new sculptures that rival my excitement for *Yellow Warbler*.

Did this sculpture turn out the way you had envisioned, or were there some unexpected yet pleasant surprises?

This is one of those fortunate occasions when the sculpture turned out better than I had originally planned. Initially, I wasn't sure about the integrity of the bronze and how it would carry the bird on a branch that was so tall, but I was very pleased with the end result. I think the balance turned out quite well, too. It's simplicity was surprising. I guess I learned that sculpture doesn't always have to be a massive undertaking to be a success.

What do you hope it says to the viewer?

I sculpt for the pure joy of it. There's nothing like the satisfaction I get out of accomplishing a vision and seeing it come together in the bronze. I hope my work conveys the thrill I get from the subject I'm sculpting, and the joy I get from someone admiring its form.

YELLOW WARBLER Melissa Cooper *Bronze* *14" × 12" (36cm × 30cm)*

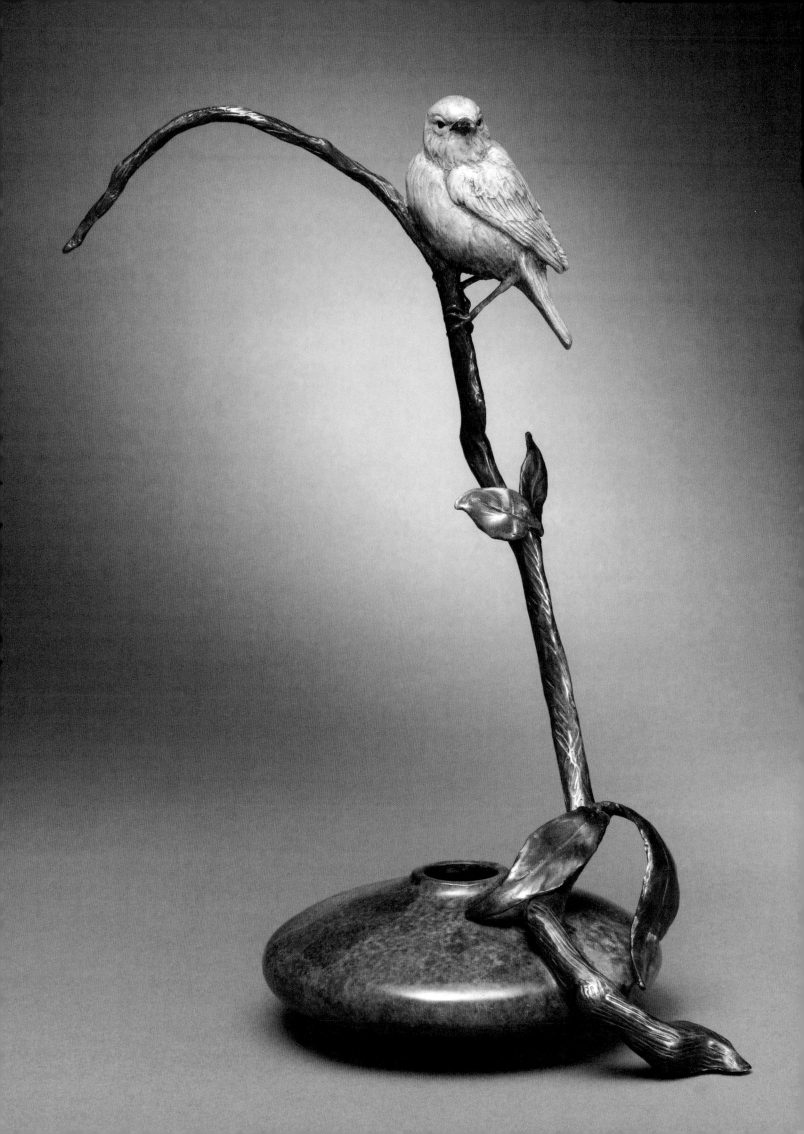

QUIET CHANGES Silvia Davis *Wood 72" × 48" × 32" (183cm × 122cm × 81cm)*
from the collection of the Utah Museum of Fine Arts
photo courtesy of Borge B. Andersen & Associates

SILVIA DAVIS

By the age of four, Silvia Davis was already building things on her own. "I was a very self-motivated child," she recalls. "I would wander off on my own and find a quiet place to create something." This love of building was solidified when she enrolled in art school, where she took a sculpting class that forever altered her artistic course. "I thought I'd end up majoring in painting or drawing," Davis says, "but when I took this class, I knew I was a sculptor. Making sculpture was an extension of the way I played as a child. It was home for me." Thirty-three years later, Davis is still sculpting, searching for clear ways to reduce and reassemble the chaos and complexity of her subjects.

Working primarily in wood, Silvia feels her choice of medium provides a necessary resistance that forces her to clarify, simplify and filter a given form. "Wood always feels alive to me, and it gives life to my work," Davis says. "I sense that it never stops breathing." Silvia finds that animals, like the horse in *Quiet Changes*, make particularly heroic subjects. She pushes herself to look for ways to expose the grace, integrity and individuality of the animals, revealing their true form as seen through her own eyes. The end result is nothing short of spectacular.

What inspired this piece?

My studio is in a small, rural town. One day I heard the sound of pounding hooves nearby; I turned to see a colt that had escaped from its pasture running excitedly up and down the street in front of me. The colts' beauty captured me completely. Something inside me said that I needed to take a closer look; as a result of this experience, I created several colt sculptures.

What prep work and techniques went into this sculpture and how did they contribute to the success of the finished piece?

I began the process by sculpting this piece entirely in water-based clay. I worked in a life-size scale and tried to resolve the anatomy, proportion and expression. The flexibility of the clay allowed me to make changes and push the piece around until it came together. I used this clay study as a model for the wood sculpture.

What was your greatest challenge in creating this piece?

The biggest challenge for me was getting the colt's expression exactly right. I visualized how to laminate the blocks of wood in an interesting way that would serve the expression of the animal. I thought about strength, form and color. As the work evolved, I adjusted its proportions and anatomy, particularly in the head and the legs. I repeatedly cut off and planed down sections of the sculpture, rebuilt sections of the block, and carved it over and over until it felt natural.

What is your favorite part of this piece and why?

I like the balance between the naturalism of the animal and the artifice of the material. I strove for a feeling of reserve in the expression to bring a sense of calmness to the work.

Why do you consider this one of your most significant works?

As a young sculptor, I built a block of wood, carved it and then painted it. There was a clear beginning and end to the process. This piece, however, marked a turning point for me. I began working wood in a more flexible, back-and-forth kind of way. For example, if the head isn't working I might cut it in half, plane it down to square, and add a block back to it that is a slightly different color or has been laminated a different direction or thickness. This new process allows for opportunities of surprise and improvisation. I find a freedom in adding and subtracting from start to finish. In this way the struggle, the mistakes and the moments when I feel like it's a failure have an opportunity to participate in the complexity of the works' surface. After making this sculpture, I felt confident to destroy and rebuild a piece in a constant way. I began trusting and giving value to the destruction and started to believe the work could only come back stronger using this process.

JANE DEDECKER

Jane DeDecker has been a major contributor to the world sculpture scene since 1986. Since her start more than twenty-four years ago, DeDecker has created over 250 original sculptures, sixty of which are life-size, and eight one-of-a-kind monuments. She has been published in magazines reaching global circulations, and has been sought out for her artistic integrity by numerous organizations, corporations and individuals. Even with all of this success, Jane will tell you that she didn't become an artist simply because she could create; rather, she pursued a life in the arts because she *had* to—without it, she would be miserable. She likens her talent to that of an author or storyteller. "In sculpture, the viewer must read the piece and see if the tactile writer [sculptor] speaks to him. It is my job to stimulate a direct relationship between the art, myself, and the audience," Jane says.

Working three-dimensionally has allowed DeDecker the opportunity to describe and explore the multiple facets of her life, providing each new sculpture with an inner voice of its own. The commissioned piece *Spirit of the YMCA* is no exception to this rule. Here, Jane has deftly captured the true voice of an organization that has served our nation's children for over ten decades, proving that her works really are one-of-a-kind.

What inspired this piece?

An old school friend contacted me to let me know that she was working at the YMCA of the Rockies in Estes Park, Colorado, and that they were in the preliminary planning stages for renovation and capital campaign for their upcoming centennial celebration. She asked if I would consider designing a piece to help commemorate this extraordinary milestone, and I gladly accepted.

What prep work and techniques went into this sculpture and how did they contribute to the success of the finished piece?

We started the discussion about this commission by thinking about the history of the organization. It was amazing to realize just how many generations had attended the YMCA of the Rockies and had integrated the establishment into their summer experience. The board wanted to represent children from each of these different eras in the same sculpture; so, my initial challenge was to bridge the gap between these generations. We collected images from the Y's library that spanned the ages, fashions and genders. The concept came together easily from there.

What was your greatest challenge in creating this piece?

One of my many challenges was to take the renowned institute of the YMCA, and the universally known song that supports the spirit of the Y community, to a new dimension. I wanted to bring to life these two essential elements of the YMCA by combining the essence of its civic message and capturing the team spirit derived from the 1970s pop song. Another challenge was to create a piece of work that would live up to this stalwart organization. I wanted the entire YMCA community, worldwide, to connect with this piece and to walk away knowing that this was an iconic image representing their mission.

What is your favorite part of this piece and why?

Working with the people at the YMCA was my favorite part of making this sculpture. They are dear souls who love their jobs and have a deep pride in their company. In my opinion, this is the true sign of a successful enterprise.

What does this sculpture mean to you personally?

The ultimate reward is seeing the images sent to us from YMCAs around the country, with children climbing all over the sculpture and imitating the gestures. Each visiting group takes a memento photo, too!

SPIRIT OF THE YMCA Jane DeDecker *Bronze* *88" × 120" × 36" (223cm × 305cm × 91cm)*

photo courtesy of Jafe Parsons

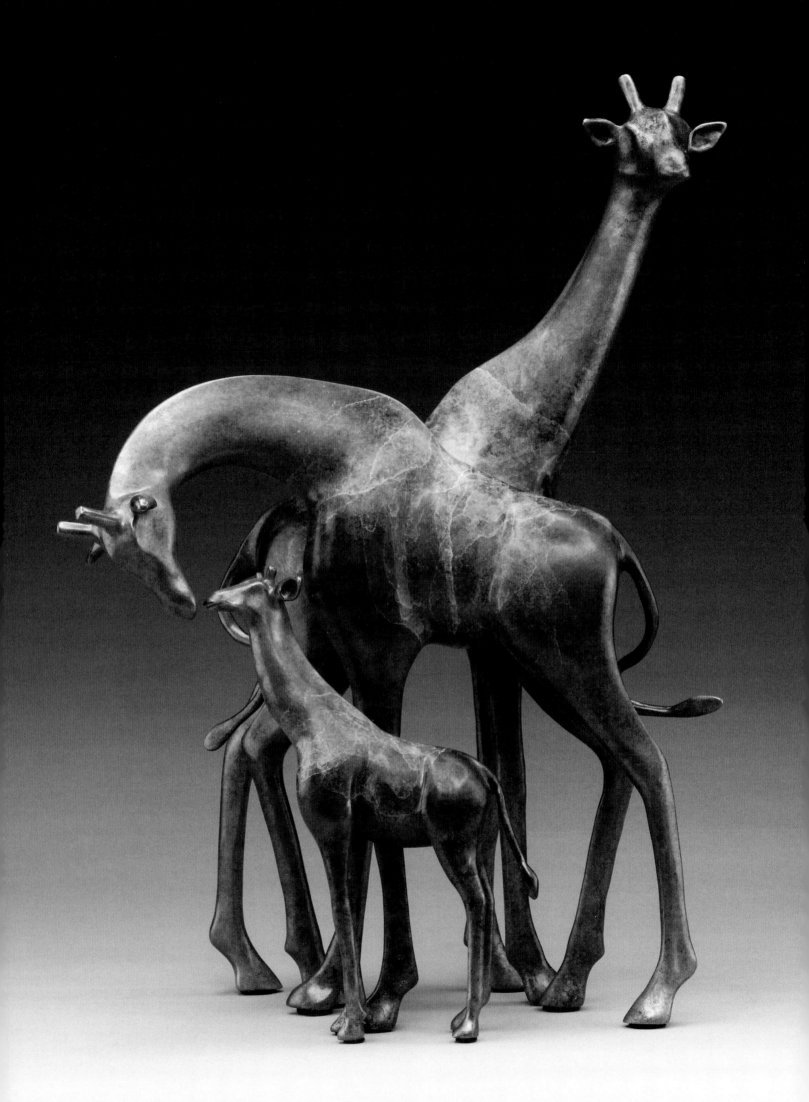

ROBERT DEURLOO

When Robert Deurloo saw a sculpture of a bronze bison in the Buffalo Bill Museum thirty-five years ago, he knew he had to have it—or at least something like it. Since stealing was out of the question, Deurloo decided he'd have to make one of his own. And just like that, without any formal training or background in other media, Robert dove headfirst into sculpting and never looked back. Now, if asked how he feels about this serendipitous discovery of his innate talent, Robert replies, "I work with clay. How many people are fortunate enough to make a living dabbling with clay?"

Living along the Salmon River near the largest wilderness area in the lower forty-eight states, Deurloo is surrounded by the animals that inspire him to sculpt. As he describes it, "This postcard-perfect chunk of Idaho is an ideal place of inspiration for a professional wildlife artist." He has also had the distinct privilege of extensively traveling through South America and Africa, exploring landscapes that exposed him to natural habitats and wildlife he would have only seen in books or magazines otherwise. *It Takes Two* was the result of one such excursion, where Robert was fortunate enough to spot a family of giraffes while visiting an African game park.

What inspired this piece?

Although I was raised in the "Wild West," it took a trip to the vast game parks in Africa for me to truly appreciate the balance of nature. There, man participates in the environment rather than trying to dominate it.

What was your greatest challenge in creating this piece?

Getting the right patina proved to be a great challenge for me. Knowing the right patineurs and having years of experience ultimately helped me get fantastic results. I didn't want to *paint* the piece so that it would exactly replicate a giraffe, but I also wanted a patina with character. To me, the chosen patina suggests exactly what I was looking for: It implies the brown and white patterns of the giraffe, but is also translucent enough that the beauty of the bronze underneath shows through.

What is your favorite part of this piece and why?

The expression of the family bond. The pose that evolved depicts the mother nuzzling the baby while the father looks into the distance. It shows the strong mother and baby bond, but also depicts the father's involvement, albeit on a more detached level. He is the protector, and she is the nurturer.

Why do you consider this one of your most significant works?

This work is different from my others because it features a family grouped together rather than an individual animal. I wanted to immerse myself in the exploration of the family dynamic and the relationships that existed between the members of the group. Whenever you put two or more individuals together, it is fascinating to study their interactions. The focus shifts toward the interpersonal and away from the intrapersonal. A society is always more complex than its individual parts.

What does this sculpture mean to you personally?

Travels to the expansive parks in Africa would change most people's perspectives on nature and life. Throughout time, man has been just a minor part of nature's puzzle. Sometimes we fail to realize this in our quest for domination over our environment. Being in the open spaces of Africa, I felt as though I had returned to nature as it has traditionally existed, and this reminded me of man's true place in the grand scheme of things. For most beings here, life is very tenuous—every day is filled with constant danger. Thus, I believe that wild animals are much more *alive* than domestic ones, including man himself.

What do you hope it says to the viewer?

The title I chose for the piece says it all: It takes two—to make three.

IT TAKES TWO Robert Deurloo *Bronze* 18" × 24" (46cm × 61cm)

FLOYD DEWITT

Though Floyd DeWitt spent his early days in Wolf Point, Montana, painting and drawing scenes of the Wild West, he credits his exposure to the European continent with sparking his interest in sculpture. DeWitt was first introduced to the wonders of Europe while stationed in Germany with the U.S. Army. It was here that Floyd acquired what he calls "a deep appreciation for fine art and creative thinking." It quickly became clear that art was his life's calling, so upon completion of his military service, DeWitt immediately enrolled at the Minneapolis School of Fine Art.

Shortly thereafter, an overwhelming desire to return to the continent that had so greatly inspired him led DeWitt to the Royal Academy of Fine Art in Amsterdam, where he would ultimately study for six years. It was during this time that he fell deeper in love with three-dimensional art. "While visiting the great monuments and museums of Europe, I realized that sculpture was a very limited yet powerful means of expression," DeWitt recalls. "I knew I had to learn more." Today, at the age of seventy-five, Floyd still continues his artistic journey, creating pieces of great symbolic value through the suggestive power of metaphor. *Joy at the Symphony* is the perfect example of this unique approach, beautifully capturing DeWitt's passion for classical music.

What inspired this piece?

I have always loved classical music. I trained and worked in Europe for twenty-five years before returning to the United States. Having settled in Bozeman, Montana, I was delighted to find there was a symphony orchestra. Although executed mainly by non-professionals, the performances became dynamic when a new conductor from the East coast, Matthew Savery, was hired. When he stepped on board, I felt as if the organization had been overtaken by a storm! I asked Mr. Savery if I could come to rehearsal sessions to sketch the orchestra. The sculpture I call *Joy at the Symphony* is the result of these experiences. I suspect it was inspired by the music of Ludwig Von Beethoven. In this piece, I see man's desire to give wings to his dreams and fantasies, which in my case, goes hand in hand with the joys of music.

What is your favorite part of this piece and why?

What I like most about *Joy at the Symphony* was the opportunity to express, through the use of a three-dimensional form, the magical wonders of listening to Beethoven. I'm partial to this particular piece because I succeeded in capturing both the spirit of joy the music provokes and the tension expressed by the conductor. It is not easy to create a sculpture that suggests flight while simultaneously being rooted to the ground; but, I feel the pose and the positioning of the piece are successful in creating such an energy.

Did this sculpture turn out the way you had envisioned, or were there some unexpected yet pleasant surprises?

Because I never have much of a preconceived notion before I start sculpting, this piece had but one course to follow: To become what it wanted to become. There were many pleasant turns along the way, as well as a share of unexpected difficulties. I always have trouble deciding when a sculpture is complete, so I often make three or more different molds of a piece before selecting the final one. Consequently, I am always surprised by the end result. It is forever new.

What does this sculpture mean to you personally?

The great sculptor Jacques Lipschitz once said that if he could talk about his work he would not have to make it. I feel much the same about my own sculpture. I draw great strength from the magnificent sounds of music; it inspires me daily to look at the binary oppositions at work in the universe. Birth and death; consonance and dissonance; crescendo and decrescendo; all of these opposing elements peacefully coexist in a piece of music. I find meaning in observing these complex relationships, and to me, this work eulogizes these eternal issues through the use of symbolism and metaphors.

JOY AT THE SYMPHONY Floyd DeWitt *Bronze* 22" × 7" × 6" (56cm × 18cm × 15cm)

JIM DOLAN

A resident of western Montana for nearly forty-four years, Jim Dolan recalls his first visit to the state as an eleven-old-boy; even then Dolan says he knew he was "destined" to call Montana home. He explains, "The wildlife, the outdoors . . . Montana is an expansive inspirational studio." Although Dolan earned his degree in agriculture, he's always enjoyed the arts—especially sculpture—and began pursuing his interest with serious intent while still in college. Two years later, in 1972, Jim made the decision to devote himself to sculpting full time, a choice he still celebrates today. "I absolutely love what I do, and it just gets better," Dolan says. "It's more fun to create sculpture now than at any other time in my life."

Now, thirty-seven years after the start of his career, Dolan works mainly in steel and found materials. Still, Jim doesn't want to restrict his artwork by limiting the possibilities. "I've learned that my art keeps evolving," he says. "Subject matter, style, materials— I can't imagine sculpting the same subjects or using the same materials all the time." And while his creations range in scale from life-size to epically monumental, Dolan's sculpture somehow manages to retain the true essence of his subjects. *Great Blue Heron* is one such example. "This sculpture expresses that one can take a subject, expand it five-times life-size and still end up with a piece that compliments the live model," muses its creator.

What inspired this piece?

My studio is situated alongside a river and several ponds, and the blue heron is a common visitor to these bodies of water. I've always felt it expresses such serenity and peace in its composition and in the way it carries itself. As such, I felt compelled to sculpt a blue heron as it lifts off the water and takes flight.

What prep work and techniques went into this piece and how did they contribute to the success of the finished piece?

This piece was made with stainless steel and welded with individual feathers. The feathers were cut out of a sheet of steel. To keep them in place, I set barbs into the steel with a grinding wheel.

What was your greatest challenge in creating this piece?

Powder coating—a dry finishing method of applying a decorative and protective finish to one's sculpture—is always a great challenge. The Blue Heron was powder coated with six different colors. Each color was applied separately (one at a time), and then heated to 400 degrees (204°C) in an oven. Once heated, the charged particles fused into a smooth coating and were left to cool down before moving on to the next application. I repeated this process five more times to achieve the effect I was going for. The end result was a consistent, resilient finish. Though more challenging than a painted finish, I find powder coating significantly more attractive and well worth the effort.

What is your favorite part of this piece and why?

My favorite part of this piece was my experience sculpting it. The chance to participate in the process of molding such large sheets of stainless steel into the bird I had imagined in my mind's eye was a rewarding journey. The fourteen-feet wingspan made working with the dimensions I wanted a challenge. But I improvised where necessary, stretching certain parts like the neck, ultimately creating a more pleasing piece.

Did this sculpture turn out the way you had envisioned, or were there some unexpected yet pleasant surprises?

My sculpture always evolves throughout the creation process. I kind of give up control once I start and let the metal guide me. I find my works always have a life of their own—it's exciting and sometimes surprising to watch them take shape.

What do you hope it says to the viewer?

I hope *Great Blue Heron* makes the viewer smile and inspires him or her to feel some sense of peace or serenity.

GREAT BLUE HERON Jim Dolan *Stainless Steel* *60" × 168" (152cm × 427cm)*

BARRY EISENACH

A graphic designer by trade, Barry Eisenach discovered his affinity for bronze sculpting in 1980. In the midst of personal turmoil, Eisenach was hoping to find something that would prove relaxing. It was by chance that he stumbled across several bronzes in a magazine. Shortly thereafter, he began sculpting. Though he managed to complete several pieces, he was forced to put sculpting on hold when he started his own graphic design and illustration business. It wasn't until sixteen years later, when visiting Paris, that Barry realized he needed to return to the sculpting stand.

Today, after thirteen years of professional sculpting experience, Barry credits his background in design with helping him succeed as an artist: "Drawing is the most important skill an artist can have; it is the foundation for everything else. Brilliant technique can't compensate for poor draftsmanship." He also believes that sculpting those subjects that fascinate him most has contributed to his success. Barry has always been entranced by the human form and the landscape of the human face, as he so superbly illustrates in his piece *Fancy Shawl Dancer*. He exclaims, "I am first and foremost a figurative artist; depicting Native Americans, cowboys or dancers is a vehicle through which I am able to capture the beauty of the human form."

What inspired this piece?

Several years ago I was commissioned to do a historic painting of the Ute "Council Tree" in Delta, Colorado, and was asked to meet the person requesting the painting at the annual Council Tree Pow-Wow. While waiting for him, I was watching the Shawl Dancers and taking photos. The elder women, with their beautiful shawls, do a slow, graceful, swaying dance, while the younger girls are very animated with a swirling, foot-pounding dance. I happened to get a couple of shots of this young girl in the background (though they were just side shots) and thought what a nice sculpture she would make.

What prep work and techniques went into this sculpture and how did they contribute to the success of the finished piece?

Any time a vertical piece has a large mass extending away from the figure—in this case, the shawl—it is essential that the armature is designed properly to hold not only the clay, but also the weight of the rubber mold. Many a sculptor has had to modify or abandon their vision because they weren't able to create a solid foundation. Luckily, I was able to build just the armature I needed for this piece.

What was your greatest challenge in creating this piece?

Ideally when sculpting, the sculptor has a model in front of him and is able to view his subject in the round. I had only a side view of the dancing girl, so the challenge was to figure out what was happening with the parts I couldn't see, along with suggesting the drapery of her dress and the shape of the shawl while she was spinning. I think years of figure drawing from life and having watched the dance firsthand were essential in my being able to *guess* what was going on.

What is your favorite part of this piece and why?

The movement of the shawl, the attitude of her body and the innocent joy on her face.

Why do you consider this one of your most significant works?

I think it works on several levels: The movement, the abstract qualities of the shape from all angles and the sheer joy of youth. Most of my Native American work is historic, concentrating on the time period from 1800 through the 1860s; this is the only contemporary Native American piece I've done. I hope the human emotion comes through no matter the viewer's ethnicity or culture—we all laugh and cry in the same language.

FANCY SHAWL DANCER Barry Eisenach *Bronze* 20" × 18" × 18" (51cm × 46cm × 46cm)

from the collection of the Montana Historical Society

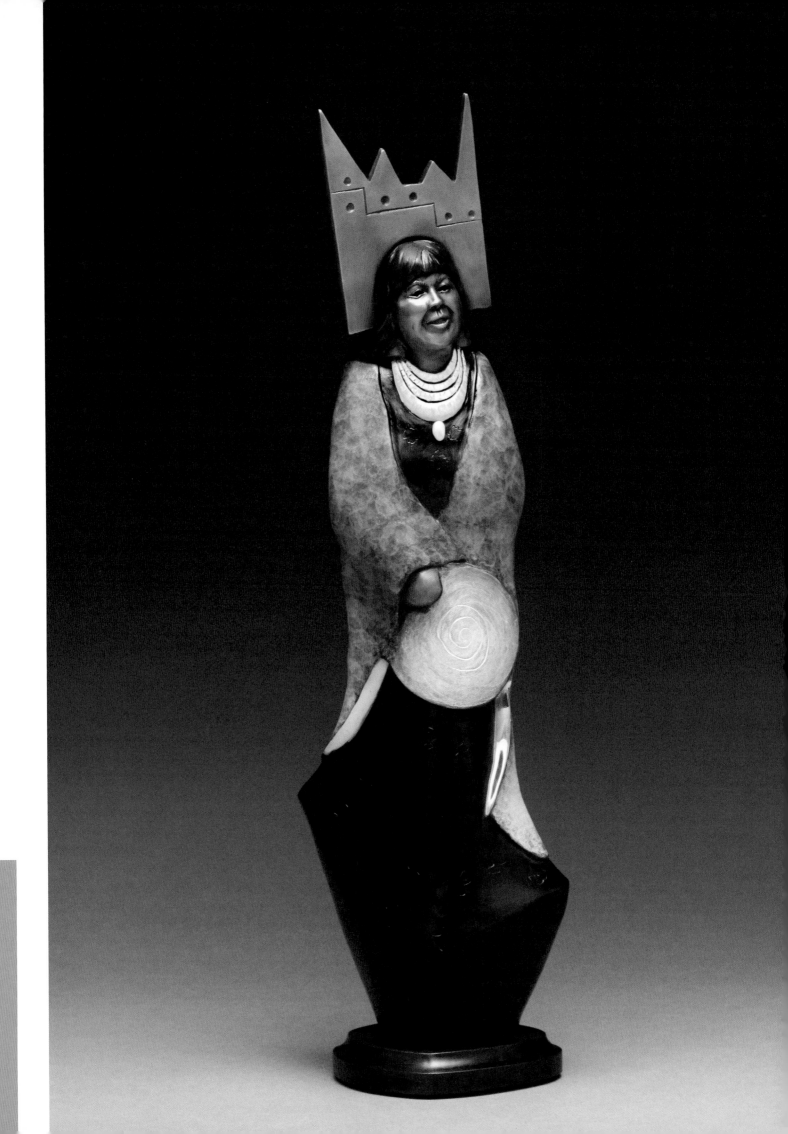

FELICIA

Whether it was acrylics, oils, woodcuts, silk screens, handmade cast paper, commercial art—you name it—Felicia has tried it. "When looking back on my early career," she recalls, "I remember how I struggled to find a connection with one medium and stay with it. It took years of going from one medium to the next before I finally found my creative niche in bronze sculpture." But finding the perfect medium was only half of Felicia's battle. Next came learning the ins and outs of this complicated material, and recognizing the limitations that come along with working in bronze. But Felicia persevered, growing through an extensive process of trial and error, until, finally, she felt her work was good enough to share with the world.

Though she began sculpting thirty-one years ago in New York, she didn't begin depicting the Native American form until five years later, after a trip to Santa Fe inspired her to explore this subject matter. "Making this change was a logical move for me," Felicia says, "It made sense to eternalize these figures in bronze, since it was they who started it all for us. Native Americans should be remembered, and I feel my work is a tribute to their way of life." *The Dancer*, in all of its graceful, flowing style, is just one of many fine pieces that speak to Felicia's passion for our Native American forefathers.

What inspired this piece?

In general, I am inspired by individuals. I work from life 80 percent of the time, mainly women and children, because it's what I know best. I enjoyed this dancer's look and personality, and something told me it would be interesting to sculpt her. This piece is my interpretation of the dancer.

What prep work and techniques went into this sculpture and how did they contribute to the success of the finished piece?

I worked in clay first. When I finished the image, I made a rubber mold, followed by a plaster mold. Then I removed the clay and poured wax into the mold before sending it to the foundry, where the piece was cast into bronze. I feel bronze is the Bentley of metals: It's beautiful, lasting, strong and possesses an heirloom-like quality. I also enjoy the innovative patinas that go hand in hand with this classic medium.

What was your greatest challenge in creating this piece?

For starters, I try to capture a very strong likeness to the person, so that's always a challenge. In terms of the technical process, I would say welding the headdress on (known as a Tablita) in just the right spot was the most difficult part of making the piece. I work with the foundry very closely, so I can carefully explain exactly what I desire and be there to assist them if they have questions.

What is your favorite part of this piece and why?

I am always looking for a well-designed image that is full of simplicity and elegance. When finishing a sculpture, I add high polish lines and paint beads to enhance the design. It's been a signature of mine for twenty-six years. In the case of *The Dancer*, the entire design came together wonderfully. I particularly enjoy her face—she is so beautiful and happy.

Did this sculpture turn out the way you had envisioned, or were there some unexpected yet pleasant surprises?

From the very first time I sit down to start a new image, it undergoes many changes. I start with a few sketches, then move to a clay thumbnail, then I try a smaller sculpture, which eventually is enlarged. By the time the image is complete, it has deviated from the original course numerous times. I am, however, always very pleased with the end result; otherwise, I would not cast it.

What does this sculpture mean to you personally?

This piece means happiness, joy and inspiration. I happen to love dance, and this is *The Dancer*.

THE DANCER Felicia *Bronze* 26" × 8½" × 8" *(66cm × 22cm × 20cm)*
from the collection of Kathy and Don Carlin, Northfield, Illinois

KENDRA FLEISCHMAN

Kendra Fleischman lives for channeling creativity into relevant and meaningful artwork. She has always enjoyed utilizing a wide variety of mediums, but when she discovered stone, she found herself instantly seduced by the tactile quality of the three-dimensional form. "Most mediums don't include the intimate experience of touching that sculpture does," Kendra explains. "The challenge, then, is to create a work that is interesting from every angle and begs to be touched."

Before working in stone, Fleischman was a Realist. It was carving in this medium that would open the door to abstraction as a powerful tool of expression. "This break from Realism allowed me to portray motion and emotion in an engaging way. I began to look at the overall body without the details, simplifying angles, following curved lines, and using the least amount of information to evoke a desired feeling," she says. After ten years of carving stone, Kendra felt she'd grown past the medium; thus, she turned her attention toward bronze. Fleischman believes that bronze has allowed her to create works that incorporate more dance-like movements, such as those depicted in *Attraction*. "I still love the qualities of stone," she muses, "but the sense of interaction between my figures is achieved with greater impact in the bronze medium."

What inspired this piece?

When I create, I am inspired not only by the relationships and experiences of life, but also the lines, movement and expressive qualities of the human body. For this piece, I used a jazz-inspired pose to create tension between two figures as they bend toward each other. The tension present in the negative space between the figures seeks to portray the anticipation and excitement between two people who are about to meet for the first time. There is an expectation and hesitation in a first meeting, especially if an attraction exists.

What was your greatest challenge in creating this piece?

My greatest challenge was not a technical one. The real obstacle was reaching a point in my career where I could afford to create such a large piece on speculation. The enlarging, mold-making and casting process is very expensive, as it is a team effort to create large works in bronze. To overcome this, I started small and worked my way up in size and price. Over several years of creating and selling works, I reached a point where I could personally fund the size of this sculpture.

Why do you consider this one of your most significant works?

Attraction is part of a series of works that explores relationships. I feel this piece succeeds in my goal of depicting the magnetic connection between two people and the excitement they feel early on in a relationship. Not to mention, the two figures are over eight feet tall, making them the largest single sculptures I've yet to create.

Did this sculpture turn out the way you had envisioned, or were there some unexpected yet pleasant surprises?

During the sculpting process, I was pleasantly surprised at how rhythmically the two figures worked together, despite the fact that they were created separately on different armature platforms. I did not fit them together in a final pose until they were cast. I was a little concerned about the final placement and whether they would fit together with the negative space between the hands. Happily, though, it worked out wonderfully.

What does this sculpture mean to you personally?

Attraction was my personal way of capturing a fleeting moment that we all experience and freezing it in time so it can be continually savored and contemplated. Eye contact, body language, flirtations—these are all ways we signal to a person that we are interested in meeting him or her. It is very much a dance of anticipation, and once the meeting takes place, the magic and excitement is either prolonged or dashed away. I really like the idea of delighting in the anticipation forever.

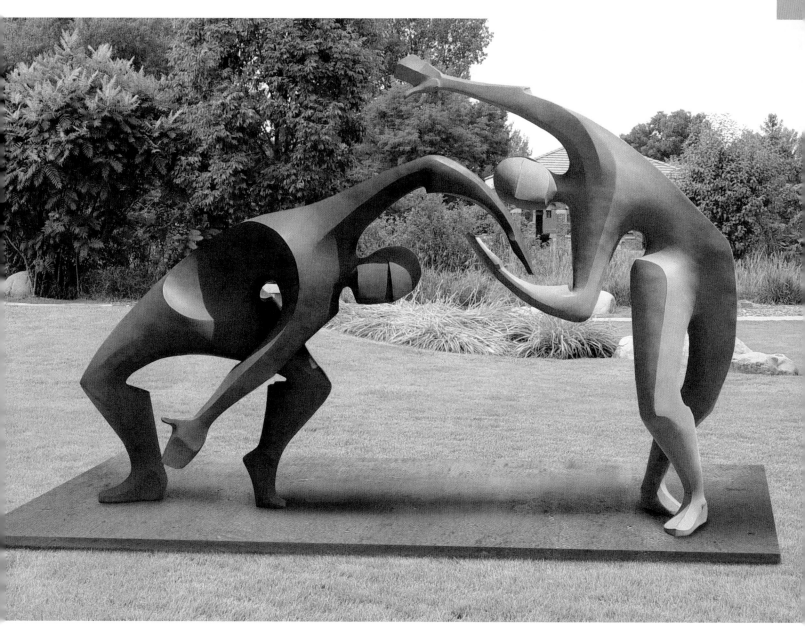

ATTRACTION Kendra Fleischman *Bronze 96" × 156" (244cm × 396cm)*

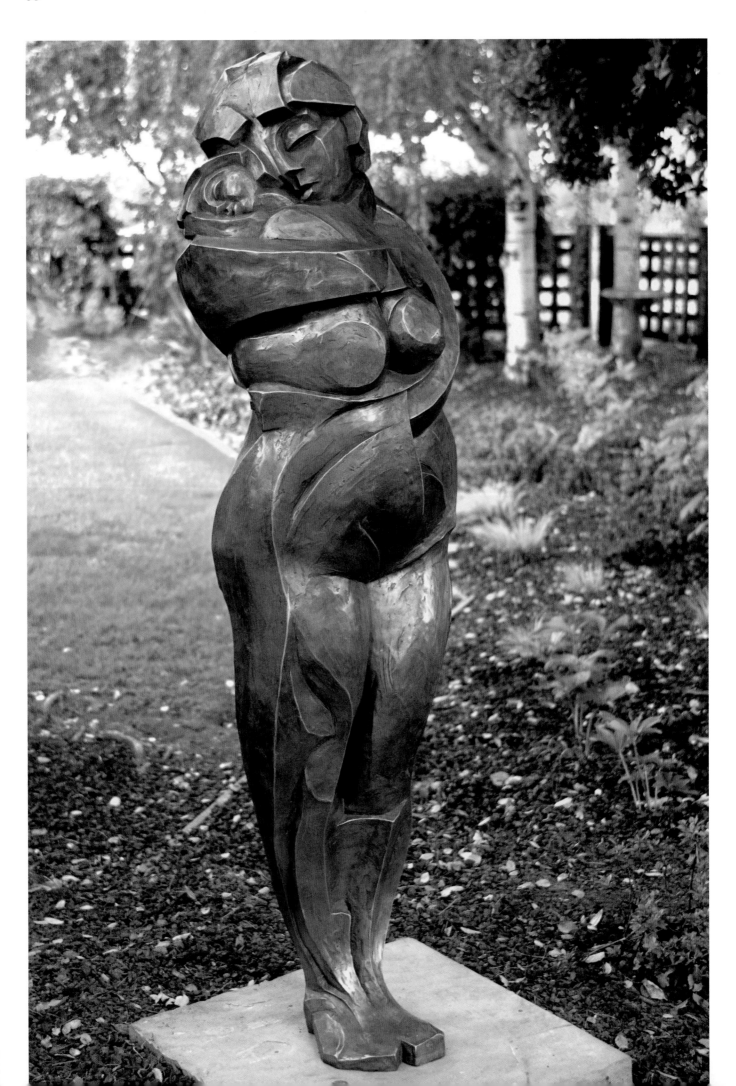

GAIL FOLWELL

It was fourteen years ago that artist Gail Folwell experienced a creative reinvention of self. Already a successful graphic designer with her own business, and often an adjunct faculty member for Metro State of Denver and Denver University, Folwell decided to try a one-day Intro to Sculpture class at the Art Students League in Denver. Instantly, everything changed, including Gail's career path. Now, an acclaimed sculptor celebrated nationwide, Folwell's work serves as a catalyst to "express physical and emotional energy through the abstraction of the human form."

Prior to this career move, Gail was no stranger to the arts, creating in any and all mediums at her disposal. But sculpting struck a chord within her that no other medium had. "The difference that so affected me in this art form [sculpture] was the direct line it had to my thoughts and concepts," Gail says. "I didn't need to wonder who to paint or what to draw, I just had all of these ideas I needed to convey." Though she began with a more traditional style while still getting comfortable with the sculpting process, Folwell's approach isn't nearly as conscious now. "The information is all there," she says, "but sculpting is more like meditating." The conception for *Me and Thee* came to Folwell in this natural, nearly effortless way, yielding a stunning end result.

What inspired this piece?

Me and Thee was inspired by my daughter, Taylor. When she was younger, she would wait for me to carry her from room to room every morning, just so she could wrap herself around me with all her tiny might. She did this every day for years. There was nothing like it.

What was your greatest challenge in creating this piece?

This connection between us, how she held me and how it made me feel, was so profound and powerful to convey, that I was inspired to include some symbolic imagery in the piece. This was unusual for me, and it remains unique to this piece when compared with all of my other works. It wasn't a challenge as much as it was a new but necessary ingredient I needed to achieve the right taste. Loosely interpreted, they both have hair swept around their heads like a halo, in regard to the divine nature of this connection. The mother figure is shaped like a chalice, and the connections at their hearts and at the mother's womb create a five-petaled rose, historically a religious symbol of Venus, womanhood and fertility.

What is your favorite part of this piece and why?

My favorite part of *Me and Thee* is the feeling it recalls, and similarly, how it affects others who relate to it's tenderness.

Why do you consider this one of your most significant works?

Different works are each significant for unique and varied reasons. They hold a moment in time, embodying an experience or a passion for something that I've recorded in clay. The resulting bronze is like a page in a diary, forever available for me to revisit. *Me and Thee* is an experience I want to relive indefinitely.

Did this sculpture turn out the way you had envisioned, or were there some unexpected yet pleasant surprises?

I'm always surprised at the end result, probably because I find that most of the process is not a conscious means to an end, but a journey. I know, loosely, the gesture and silhouette of a piece when I begin, but there is an evolution that transpires that is not predictable.

What does this sculpture mean to you personally?

It means Taylor.

What do you hope it says to the viewer?

I've carried a note from a fortune cookie around for a few years. It says, "You have the ability to profoundly affect a lot of people." I hope I can do that with this piece.

ME AND THEE Gail Folwell *Bronze* *72" × 36" × 36" (183cm × 91cm × 91cm)*

EDWARD J. FRAUGHTON

Best known for his works that eulogize the American West, veteran sculptor Edward J. Fraughton has been creating both monumental sculpture and individual collector editions for nearly forty-three years. Though he began his formal education as a civil engineering student at the University of Utah, he soon changed his major to sculpting when he realized it was his life's passion. This decision paid off for Fraughton in a major way, and by 1973, he was well on his way to national recognition, earning his first gold medal at the National Academy of Western Art.

Since this time, Fraughton has continued to progress and grow as a sculptor, refining his literal and realistic approach and applying it to a broad spectrum of human and animal subjects. "I have always been a creative and innovative thinker," says Fraughton, "but experience and constant study have improved my ability to see. I'm now able to analyze what I observe in terms of how it will help my hands carry out what my brain envisions." What's more, Fraughton is one of those artists that finds inspiration in nearly everything he sees, both good and bad. "Everything about life is worth memorializing," he explains. He is particularly drawn to conveying the universal human spirit, something that is expertly portrayed in his piece *The Last Farewell*.

What inspired this piece?

Human passions are universal. Too often, we are patronizing in our consideration of the Native American family. Their feelings and expressions of love, fear, longing and personal creativity are the same as our own. This is what I hoped to portray in *The Last Farewell*.

What prep work and techniques went into this sculpture and how did they contribute to the success of the finished piece?

I wanted the scale of this piece to make a profound statement. It was intended as a working model for a heroic-sized monument. Thus, most of the prep work involved for this piece pertained to achieving the perfect scale.

What was your greatest challenge in creating this piece?

The greatest challenge was creating an electric spark between the male and female figures. In order to achieve the dynamic I was looking for, the series of compositional lines, triangles and planes needed to direct the viewer's attention and interest to this focal point from all possible angles.

What is your favorite part of this piece and why?

I love the passion that exists between these characters. Not only is it visually stimulating, but it also provides the onlooker with an up close view of a rather intimate moment in this family's life—the time for bidding farewell. It tells such a beautiful story of the emotions each figure is experiencing at this precise moment in time. The conveyance of this emotion is what makes the piece so powerful—all viewers can resonate with the myriad emotions one feels when saying goodbye.

Did this sculpture turn out the way you had envisioned, or were there some unexpected yet pleasant surprises?

It turned out almost exactly as planned, although part of my technique is to allow the clay to take on a life of its own, and to feel and observe the spontaneity as it takes place.

What do you hope it says to the viewer?

If a picture is worth a thousand words, a piece of sculpture should be worth ten thousand. In every new lighting condition, the piece transforms, and from every conceivable angle, the picture changes to reveal something previously undiscovered. I believe the sculpture speaks to every viewer in a universal way, no matter what their ethnic, religious or cultural origin.

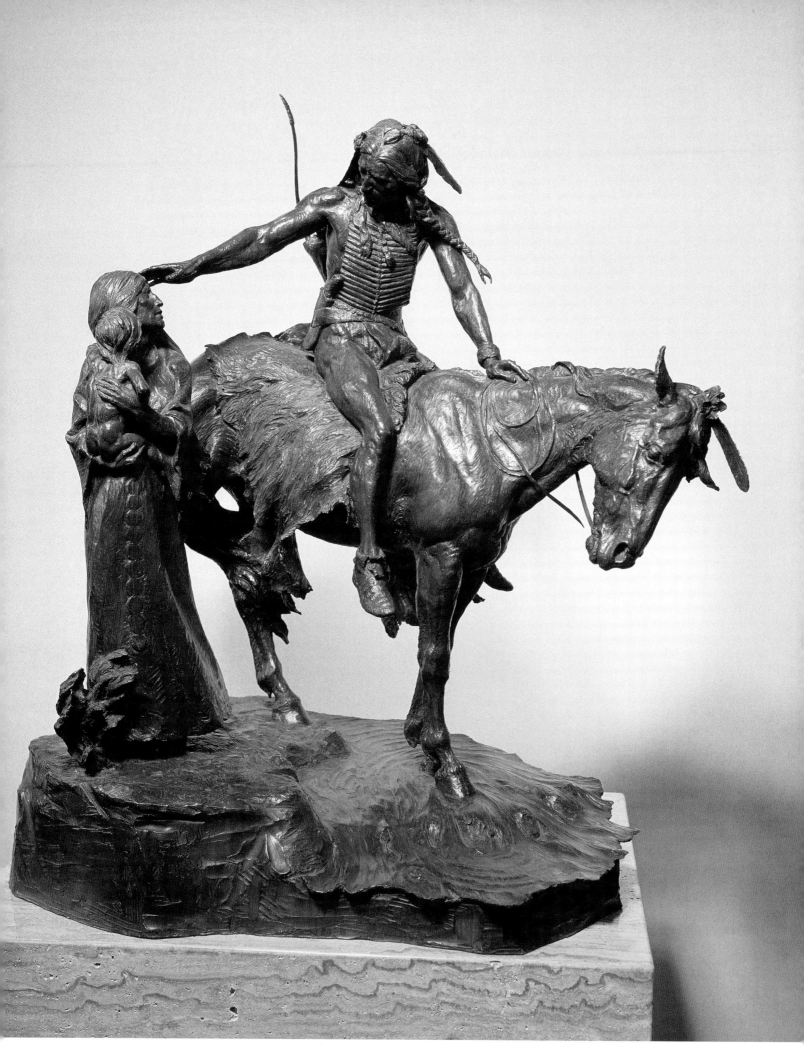

THE LAST FAREWELL Edward J. Fraughton *Bronze 37" × 32" × 25" (94cm × 81cm × 64cm)*

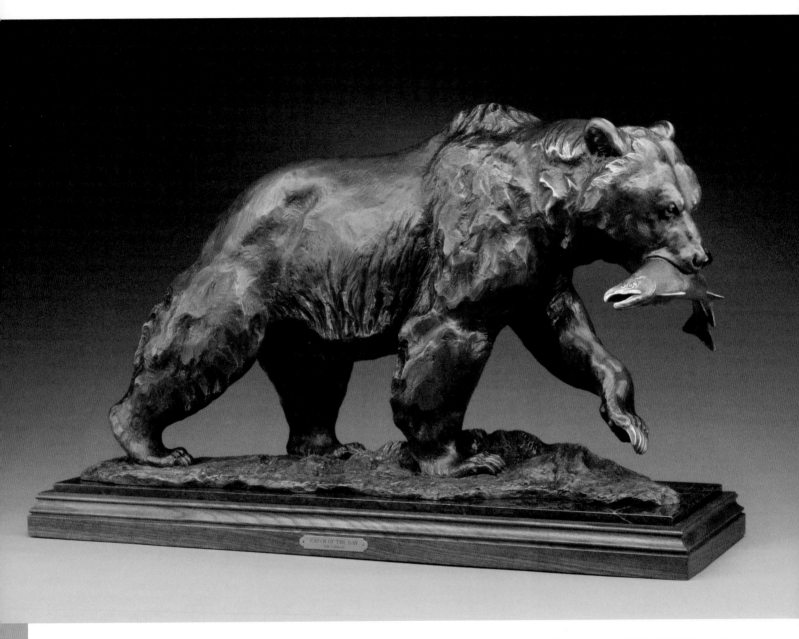

CATCH OF THE DAY Jim Gilmore *Bronze* *17½" × 28½" (44cm × 72cm)*

photo courtesy of Jafe Parsons

JIM GILMORE

Wildlife artist Jim Gilmore believes that an in-depth knowledge of anatomy and animal behavior is crucial to success in his field. He firmly asserts that extensive firsthand experience with wildlife is what helps him depict a given animal or bird with a sense of authenticity—something Gilmore takes great pride in accomplishing. "In my art, I strive to share with others the love and respect I have for nature," Jim says. "Living in the Rocky Mountains, I've had many extraordinary experiences. Memories of an elk's bugle echoing through a canyon, or two black bear cubs exploring their new world—these are the things that inspire my work."

Professionally sculpting for the last twenty-five years, Gilmore uses oil-based clay for his works. He feels that this material lends itself well to his self-proclaimed realistic style, giving him the freedom to change, add or take away as needed. His ultimate goal is to create a work that is not only true to the animal's form and character, but also to inform viewers about the natural world at large. "I hope that having my work in someone's home or office will bring a bit of nature into his or her life, as well as instill a desire to help protect our natural environment," Jim explains. *Catch of the Day* is just one of the many shining examples of Jim's desire to convey the delicate balance of life.

What inspired this piece?

While on a ten day float trip down Alaska's Tikchik River, I observed many grizzlies catching salmon. Their seemingly playful attitude while catching the salmon, and their proud attitude after it was caught, inspired this piece.

What prep work and techniques went into this sculpture and how did they contribute to the success of the finished piece?

I always carry a small sculpting kit with me in the field. I did a small wax model of this piece on the banks of the Tikchik River. I feel that when you are inspired to create a piece it is very crucial to be able to sculpt the model on the spot. This helps me better capture a particular moment in time.

What was your greatest challenge in creating this piece?

The challenge with this type of piece is to create an interesting composition, along with a sense of movement. I tried to achieve this by extending the bear's rear leg back and raising the front leg as though it is in midstride. Along with showing movement, this created an arc, which I utilized again in the shape of the salmon.

What is your favorite part of this piece and why?

I was pleased with the bear's expression, which displays his sense of accomplishment as he heads off to enjoy his catch.

Did this sculpture turn out the way you had envisioned, or were there some unexpected yet pleasant surprises?

I left the surface texture of this piece looser and more impressionistic than I traditionally do. I was well pleased with the result when I first saw it in bronze, so ultimately, I was happy with my choice to experiment.

What does this sculpture mean to you personally?

To me *Catch of the Day* brings back memories of the sights, sounds and smells of my time spent on the Tikchik River, where my friends and I were surrounded by thousands of acres of wilderness with no one else within a hundred miles.

What do you hope it says to the viewer?

I hope all my pieces will remind the viewer of the wildlife with which we share the planet, and of the interdependency of all things in nature, including humans.

DANIEL GLANZ

Expression of character is the heart and soul of each piece sculpted by Daniel Glanz. "I strive to convey the essence of my subject through subtle gestures," Glanz explains. "An intense gaze, a toss of the head, even a static pose—all of these things can be revealing."

Daniel's interest in art began early in life, when he would spend hours rendering objects from both his surroundings and his imagination. This led to a career doing scientific illustrations, a form known for its tight parameters. It was the discovery of sculpture that helped Glanz achieve a sense of spontaneity in his art. "Sculpture has allowed me to loosen up my style immensely, while still maintaining a classic representational approach that ensures my work will read correctly as a composition," he says.

During the early years of his sculpting career, Daniel worked exclusively in wood, which only allowed for the removal of material. He made the switch to clay fifteen years ago, finding satisfaction in its simultaneously additive and subtractive nature. It is this material that helps Glanz best communicate how he feels about the natural world, leading to works like *Winter's Paws*. "I have a need to educate people so that they can appreciate nature and the creatures therein. My art is the best way I've found to accomplish this goal," he says.

What inspired this piece?

The lynx has always fascinated me. It's such a powerful, reclusive and beautiful creature, yet it's so dependent on its prey and the need for space. Colorado has a great program of reintroducing the lynx to our high country. It's good to have them back in our forests. We had a bobcat that lived by our home for some time several winters ago. She was kind enough to provide the pose that I used in this lynx interpretation.

What prep work and techniques went into this sculpture and how did they contribute to the success of the finished piece?

The use of oil-based clay allows for the creation of wonderful textures as I push through it with my fingers and thumbs. I also utilized rake tools to define large shapes and creases, adding to the loose textures in the sculpture. Combined, the textures allow the viewer to appreciate the large forms and the composition as a whole without being distracted by overwhelming details.

Did this sculpture turn out the way you had envisioned, or were there some unexpected yet pleasant surprises?

I never enjoy getting bogged down with details, except to pull the viewer into the facial expression. I think the complete lack of detail in the body of the piece moves the viewer's eye to the face. This was somewhat unexpected, yet most welcome.

What was your greatest challenge in creating this piece?

Cats in general have great flexibility. Finding that curve of the feline spine in a more or less static pose was more difficult, though. The turn of the head and lean of the shoulder creates that flex in the lynx's body.

What is your favorite part of this piece and why?

I favor viewing the sculpture from just behind the left rear leg. From this perspective, the curve of the spine and shape of the body and head forms a wonderful composition. I'm also proud of how the whole piece draws the viewer into the cat's eyes.

What does this sculpture mean to you personally?

Besides the fact that the subject matter is personally interesting and important to me, I feel this piece reflects a growing direction in my sculpting, as it makes greater use of spontaneity in texture. I really enjoy how this impulsive, somewhat experimental texture relates to the composition.

What do you hope it says to the viewer?

The lynx is a ghostly, aloof figure that is seldom seen by the human eye in his natural habitat. I wanted the viewer to feel that presence to some extent, and to be awed by it.

WINTER'S PAWS Daniel Glanz *Bronze* *27" × 20" × 12" (69cm × 57cm × 30½cm)*

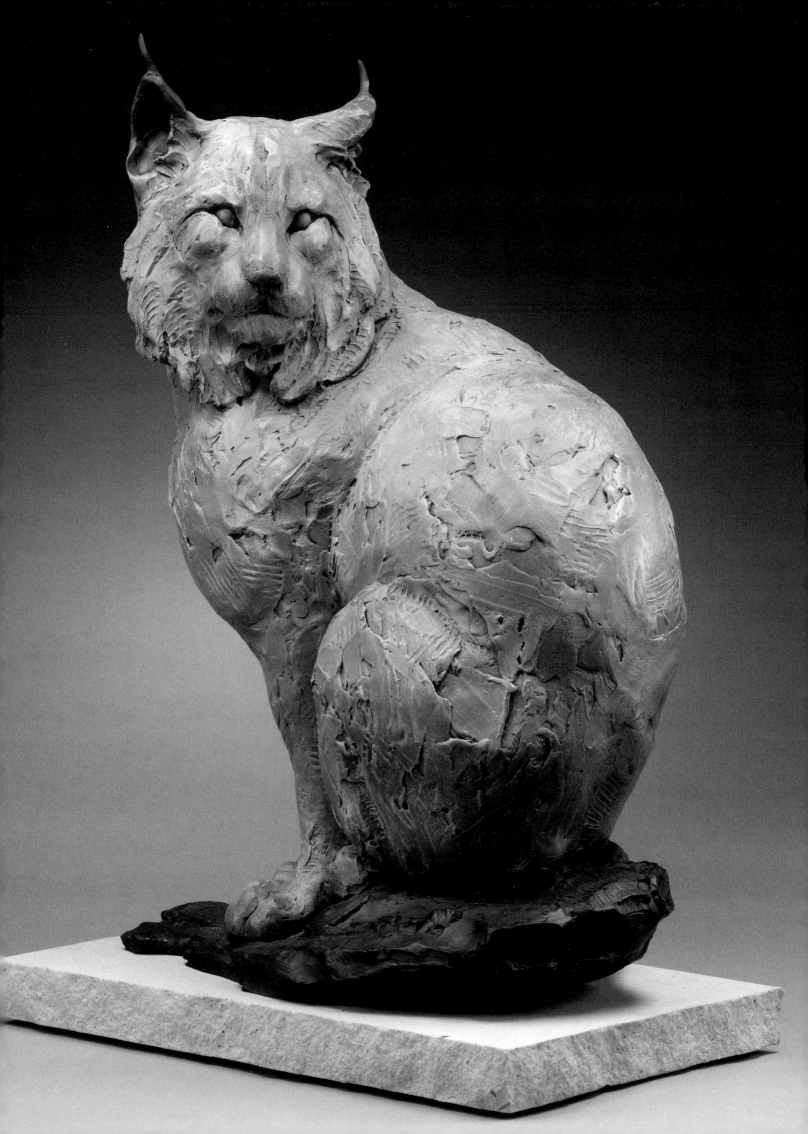

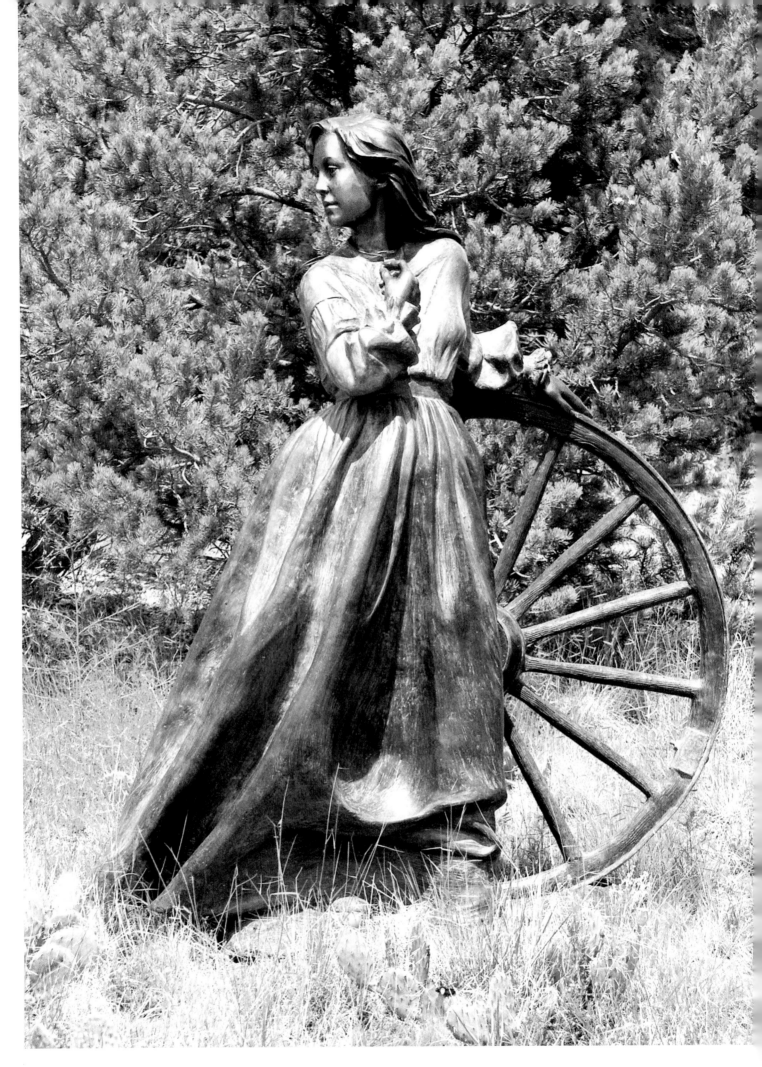

NO TURNING BACK Veryl Goodnight *Bronze 66" × 52" × 28" (168cm × 132cm × 71cm)*

VERYL GOODNIGHT

Sculptor Veryl Goodnight possesses an intense passion for those things she memorializes in bronze. Portraying Western women since the 1980s, Goodnight goes to great lengths to make her artwork as realistic as possible. In order to achieve this effect, she sculpts from life, using models as the inspiration for her pieces. "People often tell me that my work looks so lifelike. When I am successful in capturing reality, it is simply because I had a good model, backed up with a good foundation in anatomy," she says.

In addition to her pursuit of creating realistic figures and forms, Veryl also takes strides to ensure that each of her pieces tells the personal story of the subject at hand. Sometimes this includes writing poems or verse to help a piece express its inner voice, adding complexity to the emotion or sentiment captured in three-dimensions. This is the case with No Turning Back, the first sculpture in Veryl's Trail Trilogy. She explains, "In the early 1840s, the westward expansion of the United States became a flood of ox-drawn wagons. Lands were opened for homesteaders willing to risk the dangers of crossing the plains and the Rocky Mountains to find prosperity in the fertile soil out West. Women were very much a part of this experience, and I wanted to portray that with this piece."

What prep work and techniques went into this sculpture and how did they contribute to the success of the finished piece?

The preparation for *No Turning Back* included research of the clothing worn during the Western migration of the 1860s. I had a dress made that was an exact replica of something common during this era. I also had to locate a model of the right age, whose demeanor echoed that of a young woman starting West.

What was your greatest challenge in creating this piece?

Creating this piece, from start to finish, went beautifully well, with no technical or inspirational challenges of note. My model, Jessica LaCasse, really helped me capture the mood of the piece through suggestive and expressive gesturing. She fell into the roll of a young woman forging into the unknown by placing her hand at her throat, perfectly re-enacting the apprehension one might have felt before making such a journey.

Why do you consider this one of your most significant works?

No Turning Back is perhaps the most successful Western woman sculpture I have created. The composition with the wind blowing the dress and the arm on the wagon wheel all came together to create a brilliant end result. It is also, without a doubt, one of my most significant works. Arizona Highways used an image of the sculpture on the cover of a book titled *Stalwart Women*; every

major Western art magazine has showcased the image; and it has even been reproduced on the cover of a CD album on which a song was composed from the accompanying poem I wrote (see below).

What does this sculpture mean to you personally?

My poem says it all:

Too young and naive
to think they could fail
Too full of visions
for the end of the trail
They stored their silk dresses
and donned calico
To join in the cry
of Westward Ho
Their diaries tell
of the endless hours
The vast sea of grass
and bounty of wildflowers
They tell of children
Conceived and born
And of those who were buried
in the gray silent morn

Still the wagons rolled on
and the ruts got deeper
The column moved westward
as the route got steeper
Teams dropped from exhaustion
in the summer heat
As the emigrants pressed on
defying defeat
They met Indians who were friends
and many that were foe
They saw days of drought
and blinding snow
Only one thing was certain
along this wagon track
There was absolutely
No Turning Back.

RICHARD GREEVES

Drawn to the beauty of the Wind River Mountains and the Native peoples living there, Richard Greeves knew this was the place for him, even at the age of fifteen. To live amidst this awe-inspiring landscape soon became Richard's ambition, and he worked tirelessly to make this dream a reality. Now, over sixty years later, Greeves still resides among the Eastern Shoshone, drawing endless inspiration from their time-honored traditions and the breathtaking backdrop of the surrounding natural elements.

Richard can't remember a time in his life when he wasn't creating art. "I was sculpting when I was waiting in line to be born," Greeves jokes. "I came from a large family of Italian artisans, so it was only natural that I began sculpting as a small child." With each new sculpture, Richard believes he is taking another step forward in his lifelong journey as an artist. He turns to iron, clay, wood, stone—whatever material is needed—to help him realize a piece as he envisions it, and to ensure the sculpture conveys the story he wishes it to tell. His incredible devotion to communicating the message at hand is clear in the monumentally-sized *Washakie*, named after the Eastern Shoshone Chief it depicts. "The response I receive from those who view it is rewarding to me," says Greeves, proving that it pays off to be passionate about one's work.

What inspired this piece?

I live among the Eastern Shoshone people. Chief Washakie was the last chief of the tribe, and he resided here until he died at the age of one hundred.

What prep work and techniques went into this sculpture and how did they contribute to the success of the finished piece?

It's always necessary to start with a strong armature. I studied numerous black-and-white photos of Washakie, and this, combined with my knowledge of the human form, helped me construct a sturdy framework. From there, it was just a matter of building the sculpture around the base until I was satisfied with the end result.

What was your greatest challenge in creating this piece?

The challenge was to show the chief in a monumental way—he was, after all, a monumental human being. It was a process of a making exact measurements until I achieved the grand form I had envisioned.

What is your favorite part of this piece and why?

I am particularly proud of what this sculpture means to the Eastern Shoshone people. It stands in front of my studio at Fort Washakie, across the road from Chief Washakie's grave site. It is a great source of pride for the Shoshone to see their fierce leader represented in such a way—it is an immortal visualization of his courageous spirit.

Why do you consider this one of your most significant works?

I have lived on the Wind River Reservation for my entire adult life. As such, I feel intimately connected to the native people and their practices. In fact, the Shoshone are so intricately woven into my existence, that I felt just how important Washakie was to his people. I was honored by the chance to create a monument for this great leader, and it was a joyous day in both my career and my life when the sculpture was permanently installed at the Buffalo Bill Historical Center.

What does this sculpture mean to you personally?

I envisioned this sculpture for many years before I embarked on its creation. I didn't take on *Washakie* until I reached a point in my life when I personally felt I was up to the task. It forever remains one of my proudest accomplishments.

What do you hope it says to the viewer?

Chief Washakie was a brave and benevolent leader. I hope the viewer sees this in my sculpture, but I also hope he or she is able to see a living, breathing human being who was loved by his people.

WASHAKIE Richard Greeves *Bronze* *126" × 48" × 36" (320cm × 122cm × 91cm)*

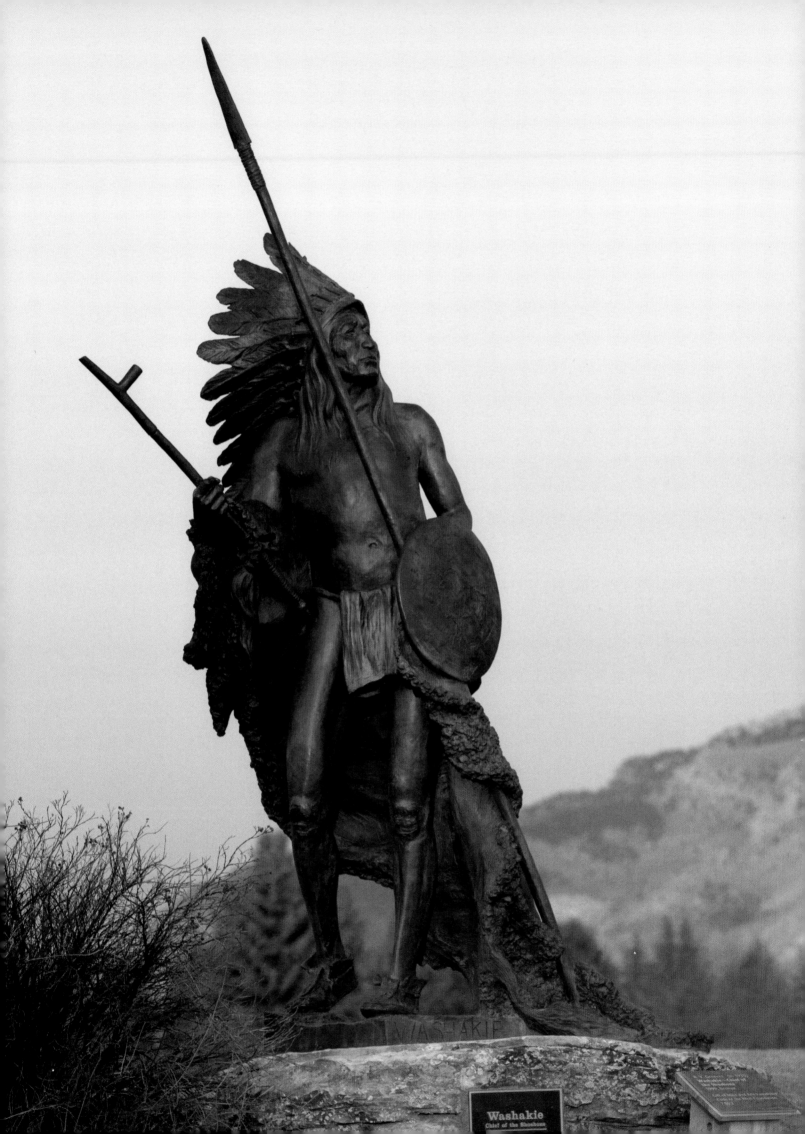

Washakie
Chief of the Shoshone

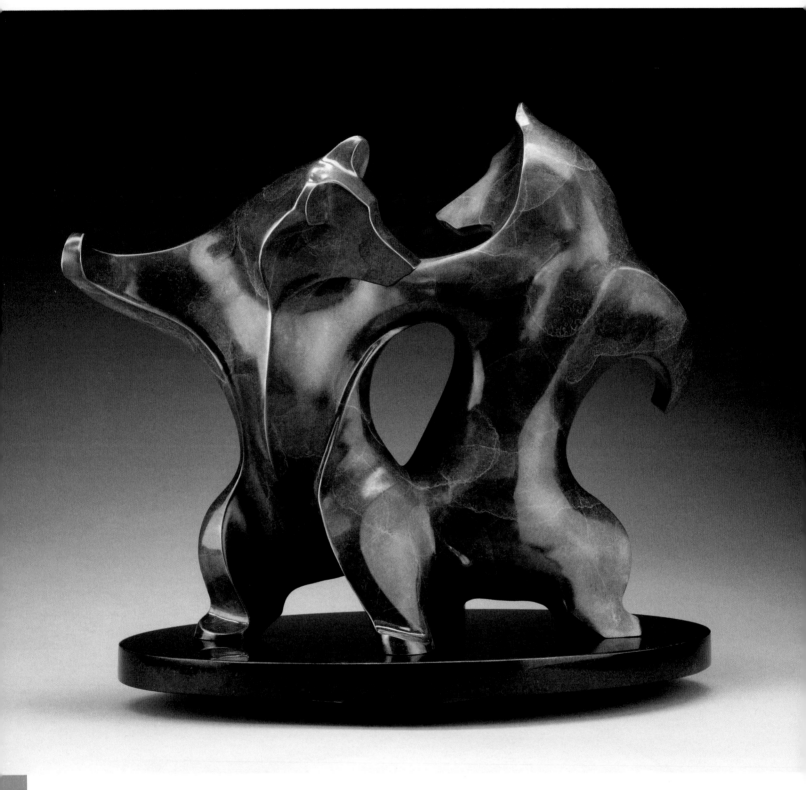

BEAR BUMP Laurel Peterson Gregory *Bronze 12½" × 15" × 7½" (32cm × 38cm × 19cm)*

LAUREL PETERSON GREGORY

"When I start working on a new piece, I try to picture the expressions people might have the first time they see it," says Laurel Peterson Gregory, an artist who employs her love of life and sense of humor in every sculpture. "I envision the way their faces might light up, and the ensuing giggles or dances that might result. It always brings a smile to my face." When asked how she got her start in sculpting, Peterson Gregory wittily replies, "Do you really want to hear about that bar of Ivory soap I carved in grade school?" It is this very sense of humor that Laurel pours into her sculpture, attempting to bring joy and laughter to the world one piece at a time.

Though she's always loved the arts, filling her free time with sewing, painting and ceramics to name a few, Peterson Gregory didn't begin professionally sculpting until the age of thirty-nine. Now, working exclusively in oil-based clay, a medium that provides her with the flexibility to adapt her vision as she goes along, Peterson Gregory creates lighthearted works that bring joy to the lives of so many. *Bear Bump*, a piece from her *Dance* series, is just one example of the successful marriage between Laurel's medium and message. "It's got it all," she says, "movement, balance, power, whimsy and its very own patina called Honey Bear. It's just a very yummy piece!"

What inspired this sculpture?

Bear Bump is inspired by a dance almost everyone has done at some point in his or her life. It's an ageless dance that spans generations and cultures, and the thought of it makes me smile. The bears themselves are about power at play. They project such a strong image for so many cultures, that I just wanted them to have some fun. I love to laugh and my goal is to bring my pieces to life by suffusing them with the healing power of laughter. Not every piece is a gut-buster, but they are always infused with some form of love and whimsy.

What prep work and techniques went into this sculpture and how do they contribute to the success of the finished piece?

I do quite a bit of research before starting a new piece. I meditate on the animal I want to sculpt and what I want the piece to express, and then decide which dance move is most appropriate. I also get images of the skeletal system of the animal so I can analyze potential moves. From there, I do sketches from various angles to see if my mental concept will translate into a viable piece. Typically, I start with a maquette, which helps me design the flow and balance. Dance is all about line, so I work diligently to get the eye moving with the lines. Besides creating uplifting work, my goal is to sculpt pieces that contain real motion even though they are obviously static. My sculptures are truly to be seen in the round, which is an offshoot of proper line development and balance.

What was your greatest challenge in creating this piece?

The greatest challenge with a majority of my pieces is getting them perfectly smooth. The general public is unaware, as I was in the beginning, how difficult it is to produce smooth work. Outside of that technical aspect, the challenge was figuring out how to express the fullness of the bear face within the confines of my clean style. Showing the balance, the shifting of weight, and the projected expressions, all within the boundaries of stylized art, is a perennial challenge. There are no eyes to point, no eyebrows to lift; it's the tilting of the head, the weighting of the paws and the movement of the massive bodies that has to convey my intent.

What is your favorite part of this piece and why?

I enjoy the broad, round, smooth expanses. I love exploring round volumes and figuring out how to transition that effect into line. I also love the simple playfulness of the piece. It is a metaphor for the dance of life, the dance we do in our marriages and all of our relationships. In fact, our relationship with the world as a whole is big, rich and round. Don't they call it the *bumpy* road of life?

PLANCHE Bruce Gueswel *Rocks, Steel and Wood* 45" × 77" × 23" (114cm × 196cm × 58cm)
from the collection of The National Sculptors Guild-Columbine Galleries, Loveland, Colorado

BRUCE GUESWEL

A third-generation native Coloradan, sculptor Bruce Gueswel's passion for natural materials was ignited by the diversity of the geological landscape that surrounded him. "I love the geology here," he says. "Exposed layer upon layer of ancient history, each with its own story—it's a full palette of colors, expressing character in its unending destruction through erosion." As a boy, Bruce would spend time with his grandmother, who often giddily pointed out rock formations that looked like the faces of old men, begging dogs or a woman praying. "Personifying the rocks, imagining them as living forms—this brought to life a fantasy world within me," Gueswel recalls.

This vivid imagination still lives inside of Bruce today, as he gathers both natural and manmade materials to create uniquely thought-provoking and stimulating sculpture. Though he never knows exactly how things will resolve themselves when making a new piece, Bruce remains confident that the materials will manifest the feeling he seeks to evoke. "In many ways, the materials I love to use—rocks, old burned wood, rusted mechanical steel—are integral to my messages," Gueswel explains. He utilizes all of these materials to celebrate the organic beauty of decay and chaos in *Planche*, a life-size sculpture of the human form.

What inspired this piece?

I have recently been exploring the forms of the human figure in various yoga poses. Yoga requires the practitioner to embody sculpturally interesting postures that emphasize balance. Studying these postures has provided me with poses that are new to me, more geometric than traditional studio modeling, and that incorporate athletic tension without the frozen action of typical sporting depictions. This piece was my first attempt to marry these new explorations with the assembled natural materials that I have been in love with for years.

What prep work and techniques went into this sculpture and how did they contribute to the success of the finished piece?

My preparation and technique defy any brief explanation and are generally impossible to convey to anyone who doesn't have a solid understanding of pattern making. Actually knowing exactly how the piece was made is somewhat like learning a magician's secrets; it can take the fun away. In brief, I have been using computer-aided design programs and CNC automated cutting systems instead of more traditional sculpture techniques.

What was your greatest challenge in creating this piece?

This piece required insane patience. Hundreds and hundreds of cobbles, stones and pebbles each necessitated a perfect fit.

What is your favorite part of this piece and why?

My favorite parts of this piece, as with many of my earlier sculptures, involves the attention to specific details like the fingers and toes, kneecaps and muscle groups.

Why do you consider this one of your most significant works?

Most of my previous work involving assembling stones and other materials have been, by the requirements of the materials, more pyramid-shaped and grounded by the perception of gravity. By employing this steel cage, I was able to elevate the mass up off the ground, giving it much more presence in its defiance of gravity.

What does this sculpture mean to you personally?

Although this particular yoga posture is slightly beyond my current ability, yoga practice has been very valuable to my personal health, helping me overcome some long-standing spinal issues.

What do you hope it says to the viewer?

Power and strength! I also hope it conveys the idea that we are all made out of smaller parts—organs, muscle groups, cells, etc.—which are all held together in a web or net of skin.

DENNY HASKEW

Denny Haskew's desire to learn and create led him to an art career that began in 1987. It was at this time that he "attended" what he affectionately dubbed "Fritz University," completing a one-year apprenticeship with expert sculptor Fritz White. "Before working with Fritz," Haskew recalls, "I had attained many skills which required hand-eye coordination, such as woodworking, carpentry and guiding. While these skills certainly helped me in making the transition to sculpture, it was Fritz's careful eye and critique that really helped me shape my style."

Partial to depicting the female figure, Haskew is attracted to using both bronze and stone in his sculptures. "I like stone for its magnificence when left in its natural color and state, and the way it stands on edge to show structure," he explains, "while bronze is appealing in its ability to suggest movement, appear soft and even float if necessary." He also enjoys the challenge of making bronze surfaces appear as though they are stone, a method Haskew utilized when creating *White Deer of Autumn*. "I feel that in creating the illusion of a stone surface, this piece exhibits the steadfast strength that exists in women," Haskew says. "At the same time, the bronze contributes to the flowing movement of the piece, which speaks of her inner beauty."

What inspired this sculpture?

Inspiration for this piece came from the desire to do a work using planes and planar surfaces, while still retaining a realistic feel to the sculpture. I was also attracted to an Edward Curtis photograph of a figure in a white robe coming out of a dark forest.

What prep work and techniques went into this sculpture and how did they contribute to the success of the finished piece?

I began my work for *White Deer of Autumn* with small ink and watercolor sketches. I find it helpful to first look at my ideas and conceptualizations in a two-dimensional form where I am free to make changes as I go along. I then made a 14-inch clay maquette to allow myself a three-dimensional view of the form I'd settled on, and to see the work I'd envisioned on a small scale. Both steps were important in helping me make decisions about the monument itself.

What was your greatest challenge in creating this piece?

My greatest challenge was in the finish of the monument. I wanted it to resemble sandstone, and through a drawn-out process of trial and error (as well as drawing from past works), I was able to develop a finish I was happy with. By using a combination of chemicals and applications, the desired effect finally came into being.

What is your favorite part of this piece and why?

My favorite part of the piece is the face of the figure. I used a reference model in combination with my own thoughts and ideas to create the expression. I really like the feeling of serenity and thoughtfulness—or emptiness—that it portrays.

What do you hope it says to the viewer?

Upon initial observation, I hope the viewer first thinks the piece is made of stone, and that nature, while comprised of the strongest materials, still possesses a softness. As they get closer, I hope they feel the movement and the lightness of the cloth, and that the figure's face relates a peacefulness that is, at the same time, vacuous and empty. Most importantly, I hope they recognize the interconnectedness of all the elements and the visual deception at work. In other words, something that appears stonelike is actually a figure all cast in bronze, which is the true palpable medium.

WHITE DEER OF AUTUMN Denny Haskew *Bronze* 72" × 32" *(183cm × 81cm)*

TURTLE AND POND WEED Tony Hochstetler *Bronze 9½" × 17" × 6½" (24cm × 43cm × 17cm)*

photo courtesy of Jafe Parsons

TONY HOCHSTETLER

After spending three years in a foundry learning the different aspects of working with bronze—including waxworking, metalworking and patination—Tony Hochstetler had finally sold enough of his own works to finance his dream of becoming a full-time sculptor. From that moment on, there has been no turning back for Hochstetler, who has enjoyed a rewarding career as a professional sculptor for twenty-four years now.

Focusing specifically on reptiles, amphibians, insects, birds and marine life, Tony exerts a great deal of time and patience working on the minute, sometimes infinitesimal details of his subjects. "I almost always sculpt in wax," he says. "My sculptures tend to have a lot of thin, fragile areas, and I find wax to be more flexible and durable than clay during this process." When sculpting his piece *Turtle and Pond Weed*, Hochstetler even went as far as sculpting the turtle separately in order to capture every miniscule detail of its form, only adding it to the main piece once it was finished. "Working with wax allows me to take such liberties," he explains. "I like the opportunity to use soldering irons to help me form the delicate areas of my sculpture. Small drops of wax placed correctly form tree frog toes or turtle eyes—the details really make all the difference."

What inspired this piece?

Summer fly-fishing in one of the local lakes inspired this piece. It was late afternoon, and I was standing hip-deep in the water in a large patch of pondweed with painted turtles surfacing to breathe all around me. They would gently float to the surface and poke their heads above the waterline. The water was clear and the wind was still, so I could see the weightlessness that their bodies had below the surface as they floated there. After observing them for the rest of the afternoon I went back to the studio and started work on this sculpture.

What prep work and techniques went into this sculpture and how did they contribute to the success of the finished piece?

For me, there were two important processes in preparing to sculpt this piece: Working from real life and starting with a good armature. As much as possible, I like to work from live animals in my studio. For this piece, it involved setting up a large aquarium in the studio and bringing in a turtle that I could observe and take anatomical measurements from. Next was forming a strong armature that would allow me to sculpt the turtle and weeds. The stems of the weeds were formed over thick aluminum wire and the leaves were formed over much thinner steel wire.

What is your favorite part of this piece and why?

My favorite aspect of this sculpture is the feeling of weightlessness that the turtle portrays. This piece is a continuation of my use of botanicals to form the main compositional elements in a sculpture. The turtle is the subject, but the plants are what present it to the viewer.

Did this sculpture turn out the way you had envisioned, or were there some unexpected yet pleasant surprises?

Sometimes when I work on pieces they are free to evolve and change as they are being sculpted. On occasion, I start out with no more than a subject and an emotion that I want to convey, or a particular arc of design. But in most cases, by the time I sit down to sculpt, I have a pretty firm idea of what it's going to look like in the end. This was one of those pieces.

What do you hope it says to the viewer?

When I work on a piece I'm not concerned with what the viewer is going to see or what the piece might say to them. I sculpt for myself. I strive for three things: A strong composition, good anatomy and the feel that I get from a particular animal or plant. Everyone views art differently based on the collected experiences they bring along with them. Hopefully, when I finish a piece there is something another person can relate to, but that certainly isn't my primary concern when sculpting.

ELI HOPKINS

Though Eli Hopkins can't quite define exactly what it is that drives him as an artist, he can't deny his deep need to create. "I think we [artists] tend to cope with life through our art to sort through our feelings," Hopkins says. "Artists sometimes find it difficult to express themselves verbally, but through their art, they get across whatever it is they need to say." Hopkins knows that he's no exception to this rule, which is why he so relies on creating art to communicate his message with the world.

Son of renowned sculptor Mark Hopkins, Eli grew up surrounded by sculpture, often watching his father in the throes of the sculpting process. But it wasn't until later in life that he would find his own artistic calling in sculpture. He recalls, "When I was a kid . . . I sometimes played around with sculpture. But it was about eight years ago that something just clicked. I realized how much I enjoyed it, and that I had a talent for it, so I decided to get serious about it." In this time, Hopkins feels he's grown immensely as an artist, his life experiences contributing to his depth of character, allowing him to be truly expressive in his art. He often uses his burgeoning talent to depict his love of nature and family, as he so craftily communicated in his piece *Mama Bear*.

What inspired this piece?

I love nature, especially wildlife. Bears in particular are a fun combination of ferocity and tenderness. In *Mama Bear*, I wanted to concentrate on the softer side of these creatures, of course.

What prep work and techniques went into this sculpture and how did they contribute to the success of the finished piece?

To prepare for this piece, I carefully studied the anatomical structure of bears and read up on their behaviors. I wanted to make sure I fully understood how they interact with their young before attempting this sculpture.

What was your greatest challenge in creating this piece?

The greatest challenge for me with this piece was portraying the weary patience that mothers often show their offspring, while the young themselves remain mostly oblivious to her weariness. I overcame it with plain old hard work and patience—sometimes that's the only thing that works when sculpting.

What is your favorite part of this piece and why?

I think I like the gentle hold these bears have on each other. Humans don't often think of bears as gentle creatures, so I loved the chance to show a different side to the bears' personalities. I also admire the facial expression I was able to achieve on the mother's face. Some people think she looks contented,

others think she's grumpy. Maybe this ambivalence defines motherhood, to a certain extent.

Did this sculpture turn out the way you had envisioned, or were there some unexpected yet pleasant surprises?

I think *Mama Bear* turned out pretty much as I expected, perhaps even better than I hoped. I was pretty pleased with the endearing interaction conveyed between the mother and her cubs.

What does this sculpture mean to you personally?

I think I mostly appreciate the idea of family, whether human or animal. I adore my family, and I'm forever grateful that my wife is such a wonderful mother to our children. *Mama Bear* reminds me of the bond we share as a family.

What do you hope it says to the viewer?

I hope this piece expresses the same universal sense of family that it conveys to me. Nature holds many awe-inspiring wonders, and I hope this piece helps us appreciate them even more.

MAMA BEAR Eli Hopkins *Bronze* 9" × 6" × 7" *(23cm × 15cm × 18cm)*

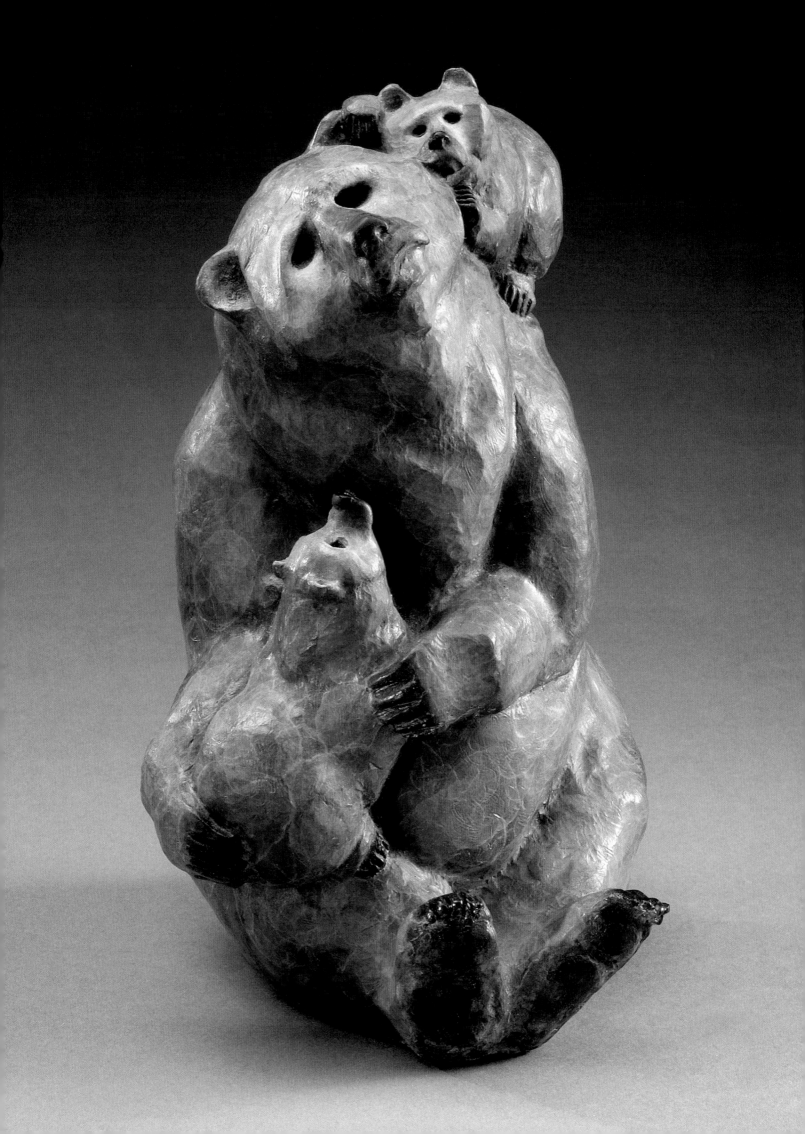

MARK HOPKINS

Celebrated sculptor Mark Hopkins believes an artist's true gift lies in his ability to see more in the world around him. "Our hands work just like everyone else's hands," he says, "but I think our eyes somehow take in more of the depth, shape and beauty of the things we see." Hopkins draws from this inherent gift in his attempts to reproduce and sometimes expand upon what he observes, yielding a wide array of brilliantly sculpted pieces. If you ask Mark when he got his start in the business, he'll tell you: "I've been sculpting since before I was born—or at least it seems that way. My older brother was artistic, and encouraged me to try it out. I took to it immediately." The rest, as they say, is history.

In 1988, Mark started a foundry with the goal of producing inexpensive bronze sculpture made accessible to the masses. At this facility, Mark works in the ancient lost wax process. He finds that wax holds a much more crisp, clean line than clay. It's also strong enough to support more interesting designs without a lot of armature, providing greater freedom for flexibility and creativity. This ancient technique is deftly illustrated in a piece Mark calls *Wyatt*—a work that expresses what Hopkins feels is the very heart of the emotion at hand by simply focusing on the face and hands of his subject, Western legend Wyatt Earp.

What inspired this piece?

I love history and, of course, the stories of the old West. Like most little boys, I grew up feeling drawn to the days of lawmen and outlaws. Wyatt Earp is the quintessential lawman: A good guy, that at the same time, possessed a raw and untamed power. I had fun doing the piece.

What prep work and techniques went into this sculpture and how did they contribute to the success of the finished piece?

When I sculpt figures from the past, a lot of the work is in studying the history of the period, along with photos or historical drawings of the character. I also like to listen to background music that conveys the mood of whatever I'm working on. I pretty much immerse myself in that place and time.

What was your greatest challenge in creating this piece?

Probably the greatest challenge with this piece was the same challenge I always face when sculpting: Trying to portray my character as clearly as possible without revealing too much information. I love the challenge of leaving just enough mystery to let the viewer's imagination fill in the blanks.

What is your favorite part of this piece and why?

I really like that I was able to achieve what I was trying to do with as little material as feasible. I think I expressed Wyatt's wild masculinity dressed up in civilized clothing. I like the contrast of the bow tie and classy hat with his gun and the menacing look on his face.

Why do you consider this one of your most significant works?

I think *Wyatt* fits right in with my other historical figures. On the other hand, it also stands out because of the incongruity between violence and civilization in one piece. This makes Wyatt special among my body of work.

What does this sculpture mean to you personally?

I think every piece I do expresses some part of me. In this case, my passion and interest in history is showcased. As an artist, I find it both exciting and invigorating to transport myself back in time to a place where remarkable men lived—it's great fun to experience (vicariously through my sculpture) another life besides my own.

What do you hope it says to the viewer?

I want the viewer to feel like he or she has gleaned a look into the past, but also sense the hope that, ultimately, the good guys are going to win over the bad guys.

WYATT Mark Hopkins *Bronze* *18" × 15" × 15" (46cm × 38cm × 38cm)*

KARRYL

With an endless well of inspiration at her fingertips, wildlife sculptor Karryl is able to represent something different and unique with each subject, bringing the subtle nuances of animal behavior to the forefront of her original designs. Direct observation and interaction with her subjects help bring out the joy that she feels for the natural world around her. "Sometimes I'll see an attitude or behavior, or maybe just the shape of an animal's form, and it will spark a sculptural idea," she says. "I spend hours watching animals. They often bring a smile to my face, and I infuse some of this humor into my work. If I make you smile, it's a good day."

Karryl seriously delved into the professional world of sculpting over twelve years ago, when a friend asked her to create a wolf sculpture. Before this time, Karryl had never cast anything, but the result was so successful that the piece went on to sell out. Working with clay over a flexible armature, Karryl is able to achieve a loose style that concentrates on capturing the spirit of the moment rather than perfectly recreating every anatomical detail. It is this signature style that sets her work apart, helping her create a plethora of well-received pieces, including this representation of a kiwi chick entitled *Nosing Around*.

What Inspired this sculpture?

A few years ago the National Zoo had the first hatching of a kiwi chick in twenty-five years. They named him Manaia, meaning "guardian of the earth and sky." I had the privilege of being behind the scenes when he was only a few days old. Kiwi are unique in the bird world in that their nostrils are at the end of their long beaks. I couldn't help but be amused by this charming little chick as he nosed around exploring his new world like a little puppy.

What prep work and techniques went into this sculpture and how did they contribute to the success of the finished piece?

The little kiwi presented so many different poses, the trick was which to choose. I started by creating a dozen or so little clay sketches using pieces of toothpicks for legs and beaks. This allowed me to see various ideas. From there I created an armature of flexible aluminum wire attached to a rigid rod to provide stability during the working and molding process. This is all attached to my wood work block. I am then free to build the form up with clay. I work loosely, so the direction of the clay pieces are dictated by the form and structure of the animal as well as the movement and mood I wish to portray.

What was your greatest challenge in creating this piece?

The challenge here was to stay simple, capturing the essence of a kiwi chick without getting too cute or cartoon-like. I immersed myself in my reference materials, trying to absorb as much information as possible. My photos remained accessible, but my initial work was done from what I had internalized. I did as much as possible in one work session to maintain a consistency of mood and style.

What is your favorite part of this piece and why?

My favorite part is its attitude. When I look at the piece it brings back the smile that I couldn't contain while visiting with the little chick. I love the feeling of the kiwi that resulted from the loose work of the clay. It seems alive to me.

Did this sculpture turn out the way you had envisioned, or were there some unexpected yet pleasant surprises?

The sculpture actually started out as a study. The plan was to take the quick mini sketches I had done and enlarge a few with the thought of using that as reference for a completed piece. The study ended up being so strong in itself that I realized I had created my finished piece! Sometimes you have to be able to step back and see what you are doing. Sculptures often take on a life of their own.

NOSING AROUND Karryl *Bronze 5" × 6" × 4" (13cm × 15cm × 10cm)*

GREG KELSEY

The son of an art teacher, Greg Kelsey grew up drawing and painting from the time he was old enough to hold a pencil or brush. But it wasn't until his mid twenties, while studying at Fort Lewis College in Durango, Colorado, that Kelsey would experience three-dimensional art for the first time. From the moment he began, though, Greg knew that he had found his medium. "When I stuck my hands in clay for the first time," Kelsey recalls, "it had a very familiar feeling. I was amazed at how my mind seemed to transfer visual information to the round so naturally."

Now, eleven years later, as Kelsey continues to develop and refine his artistic voice, he has slowly begun to view both his life and his art through a different lens. "I believe we are all born creators—but creators of what is the question," he says. "Not only do I live a lifestyle that inspires me, but I enjoy learning and understanding more about my subjects—I thrive on it. There is always more to learn, see and do. The quest is never-ending and lends itself to constant inspiration for my art." With a fervent passion for horses, Greg approached the creation of his piece *A Little Time Off* with this very philosophy, aiming not only to capture the beauty and essence of the horse, but also to gain a better understanding of its being.

What inspired this piece?

I am a constant daydreamer, always looking out into my pasture and studying my horses—they are a giant part of my daily life. I believe you can know your horse just as you know a family member or friend, and for me, being around these creatures always inspires self-reflection. I am continually trying to know them better and discover more about how they think, react and learn. What they have taught me about myself is invaluable; I'm a better person for every minute I have spent around them.

What prep work and techniques went into this sculpture and how did they contribute to the success of the finished piece?

When trying to convey a living form it is best to use a live model. From the beginning, I knew that this piece would create itself if I could just gather up five of my horses and let them *be* horses. All I needed to do was sit back and observe. The rest of what happened was the natural transfer of information from my eye to my brain, and then out of my hands.

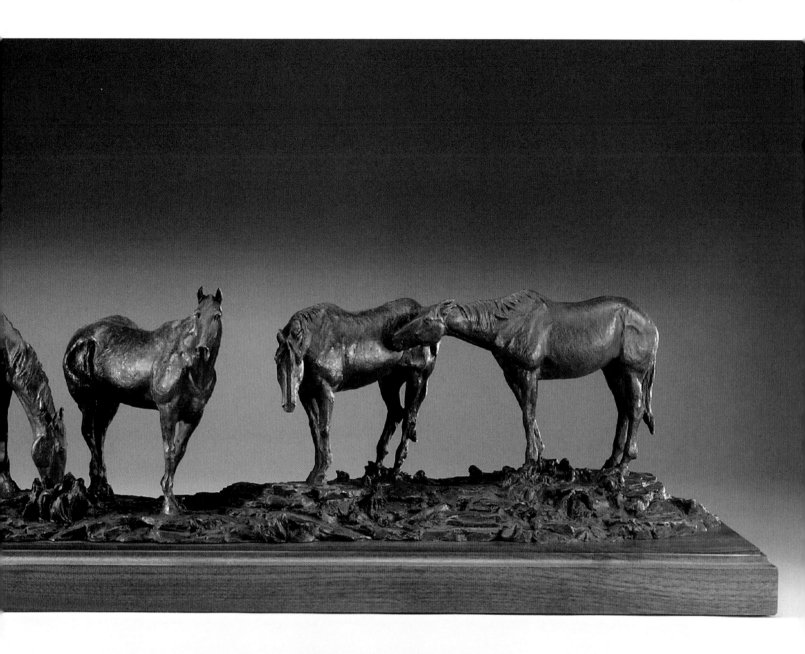

What was your greatest challenge in creating this piece?

Mentally capturing the equine in his natural loafing state can be a challenge. Transmitting those observations into bronze in a believable way, while still paying close attention to the natural rhythms that their behavior and physical forms create, was a big undertaking. I believe that in all things living, a natural beauty exists. As an artist, my job is to find what that essence of the form is, and celebrate it rather than re-create it.

What is your favorite part of this piece and why?

Obviously, horses have four legs that touch the ground. Visually speaking, this can make a piece feel stagnant, heavily grounded, or stiff as a result of all the hard vertical lines. But, if the artist is careful to notice the bend of the leg as it is bearing weight, softening these hard vertical lines with the simple nuances and curvature of the natural leg, he can overcome this problem. Even with twenty legs in this piece, I notice the rhythm of the horses' heads and top lines more than the vertical lines.

What does this sculpture mean to you personally?

Next to my family and God, my relationship with my horses is the greatest I have. Without my horses there is no Greg Kelsey. There is nothing better for the inside of a cowboy like the outside of a horse. I ride every day, dang near, and *A Little Time Off* allowed me to bring across the affinity that I have for this animal. The horse has taught me more about myself than any human being ever has.

A LITTLE TIME OFF Greg Kelsey *Bronze* *12" × 48" (30cm × 122cm)*
photo courtesy of Mel Schockner Photography

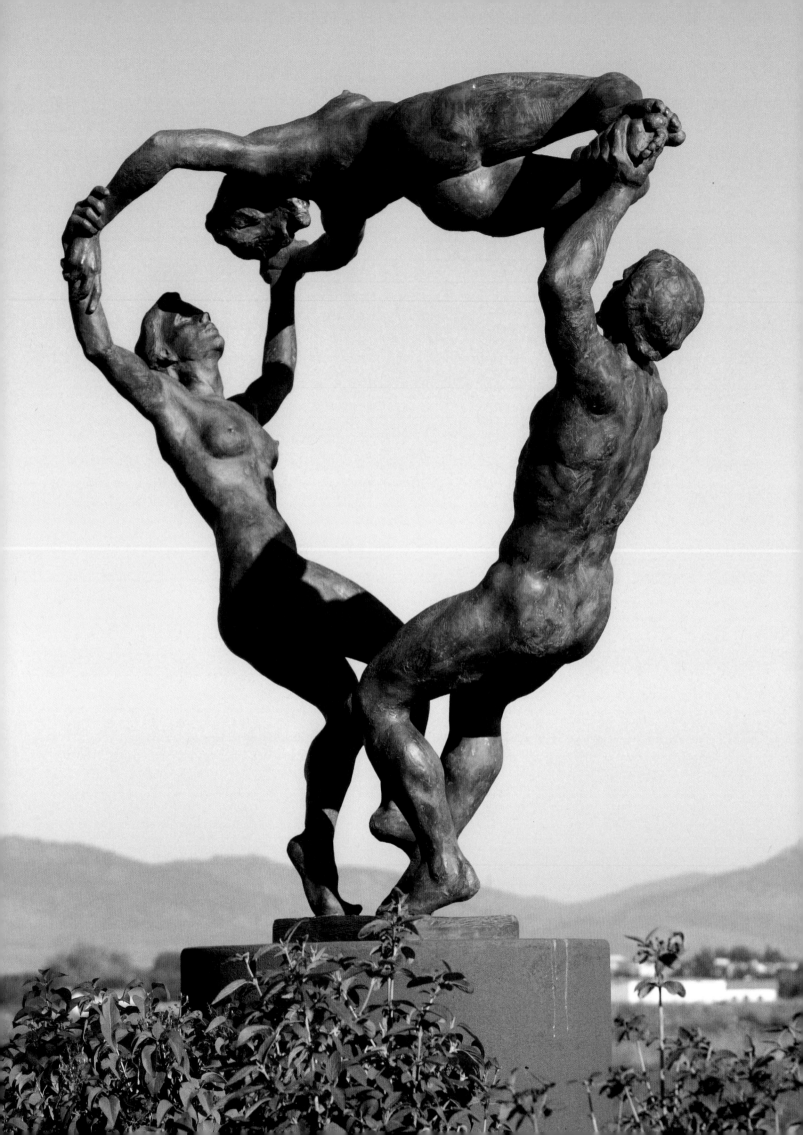

KIRSTEN KOKKIN

Originally hailing from Oslo, Norway, sculptor Kirsten Kokkin relocated to Colorado in 1986. Surrounded by the glorious peaks of the Rocky Mountains and the endless brush of the nearby plains, Kokkin feels she's found the perfect backdrop for artistic inspiration. Sculpting since the age of seventeen, Kirsten has always strived to achieve forms reminiscent of the best in art history. Her works reflect the European tradition of such figurative sculptors as Michelangelo, Bernini and Rodin. Though she aspires to accomplish the level of precision and beauty attained by these greats, Kokkin's work retains a sense of originality and strength, often expressing a sensual yet energetic quality.

Working exclusively with clay—both oil- and water-based—Kirsten loves the flexibility this medium affords her. "I love using clay because it ensures that I can work quickly while still creating exciting, expansive designs," Kokkin says. She finds this especially true when creating figures in motion—something Kokkin executes with exquisite attention to detail. *The Triangle*, a monumentally-sized sculpture created on a commission, is merely one of the many stunning examples of Kirsten's painstakingly accurate approach to portraying the human form.

What inspired this piece?

I created this sculpture for a large company in my native Norway. They wanted a piece to display in the workplace that would symbolize health, environment and safety, hence the title of the piece, *The Triangle*. To me, this sculpture is a representation of how we must support each other in order to build societies, as the three elements are constantly feeding from and into one another.

What prep work and techniques went into this sculpture and how did they contribute to the success of the finished piece?

I made many maquettes before producing this large sculpture, sometimes using live models, and sometimes working from my imagination.

What is your favorite part of this piece and why?

I enjoy the layers of symbolic meaning *The Triangle* has to offer. The complexity between the intricate design and composition, and the expression of the individual figures is what strikes me most. Male energy exists as the "pillar of strength," or the builder of the society. This is the main support of the structure. Female energy is present both in the more lean and muscular female that also supports the structure, and the woman on top that is a supported arch.

What was your greatest challenge in creating this piece?

I found it rather difficult to complete the complicated composition while, at the same time, attempting to keep the look of the piece natural. Making the figures true to life proved to be the greatest challenge involved in this process.

What does this sculpture mean to you personally?

This sculpture means a great deal to me personally, both in the sense that it was an accomplishment to craft something so large and that it received such warm praise from critics and viewers alike. However, I have to say that in all honesty, it is no more important to me than the other pieces that comprise my body of work. All of my sculptures are a picture of who I am, and they often reflect my state of mind at the precise moment of creation, making them self-portraits of sorts. For this reason, they are all equally valuable to me.

What do you hope it says to the viewer?

When the viewer looks at *The Triangle*, I hope that he or she is interested in the complexity of the sculptural language, particularly in the way the body and design/movements come together. To me, the point where these elements collide creates a sort of music to the eye.

THE TRIANGLE Kirsten Kokkin *Bronze* *152" × 104" (386cm × 264cm)*

DARLIS LAMB

Whether depicting people, nature, landscapes or still lifes, sculptor Darlis Lamb endeavors to portray "elusive moments captured in time, both real and imagined." She says of her varied subjects, "From a purely artistic standpoint, I find working with subjects I have chosen to be a focus on beauty, form and design in the most classical sense, in that all forms, including those in human anatomy, relate to shape." Already established as a professional painter and printmaker, Lamb started sculpting in 1982 when she was drawn to the idea of three-dimensional work after taking clay pottery classes. "Getting my hands into clay made me realize I wanted to sculpt," she says. "It's an addictive art form." Shortly thereafter, Darlis went on to seriously study sculpting.

Working in terra cotta and oil-based clay, Lamb creates works that are so realistic, the viewer often gets a sense of the original model. As she continually pushes herself to grow and evolve as an artist, Darlis has drawn on her past as a painter and other artistic endeavors, bringing them into her sculpture. Such was the case for *Madame Rose*, a piece from Lamb's *French Lessons* series. "My bronze still lifes are the result of having been a painter, and feeling that still lifes could be accomplished much the same way in sculpture," she says.

What inspired this sculpture?

This piece is from my *French Lessons* series which was inspired by beautiful organic forms that one might use when painting a still life.

What prep work and techniques went into this sculpture and how did they contribute to the success of the finished piece?

I knew I wanted to sculpt an apple, so I went shopping for the "perfect specimen." It turned out to be a Pink Lady, which translates to *madame rose* in French. I have done other sculptures of individual fruits, such as pears on small holders, so I designed a tower holder for the apple. A crucial part of the finished piece was the addition of dried wildflower impressions on the fourth side of the tower. I gathered these flowers from my yard when I lived in the Rocky Mountains, so this addition also holds personal value.

What was your greatest challenge in creating this piece?

The biggest obstacle I faced was making this sculpture unique. I aimed to create something original by making the apple detached from the rest of the form, allowing the viewer to pick it up. Additionally, the tower is soft in style with no sharp edges, which lends itself to the appeal of the bronze.

What is your favorite part of this piece and why?

The detached apple is my favorite part of this piece. Its sensual shape is emphasized by the vibrant red color, which plays up the sensuality by virtue of its symbolic strength.

Did this sculpture turn out the way you had envisioned, or were there some unexpected yet pleasant surprises?

Madame Rose did take some unexpected turns in that it had a spontaneous, unplanned quality to it. However, my original vision of this bronze did not change dramatically during the sculpting process, even though that often happens when I'm in the throes of creating.

What does this sculpture mean to you personally?

The addition of the wildflower impressions are personal. They reflect the time I lived in the mountains in a beautiful, large contemporary house. During that time I found twenty-three varieties of wildflowers in my yard and spent a summer drawing, drying and photographing them into a portfolio. I think they relate to the apple in that they ended up resembling tree forms.

MADAME ROSE Darlis Lamb *Bronze* 9¼" × 4¼" × 4¼" *(23cm × 11cm × 11cm)*

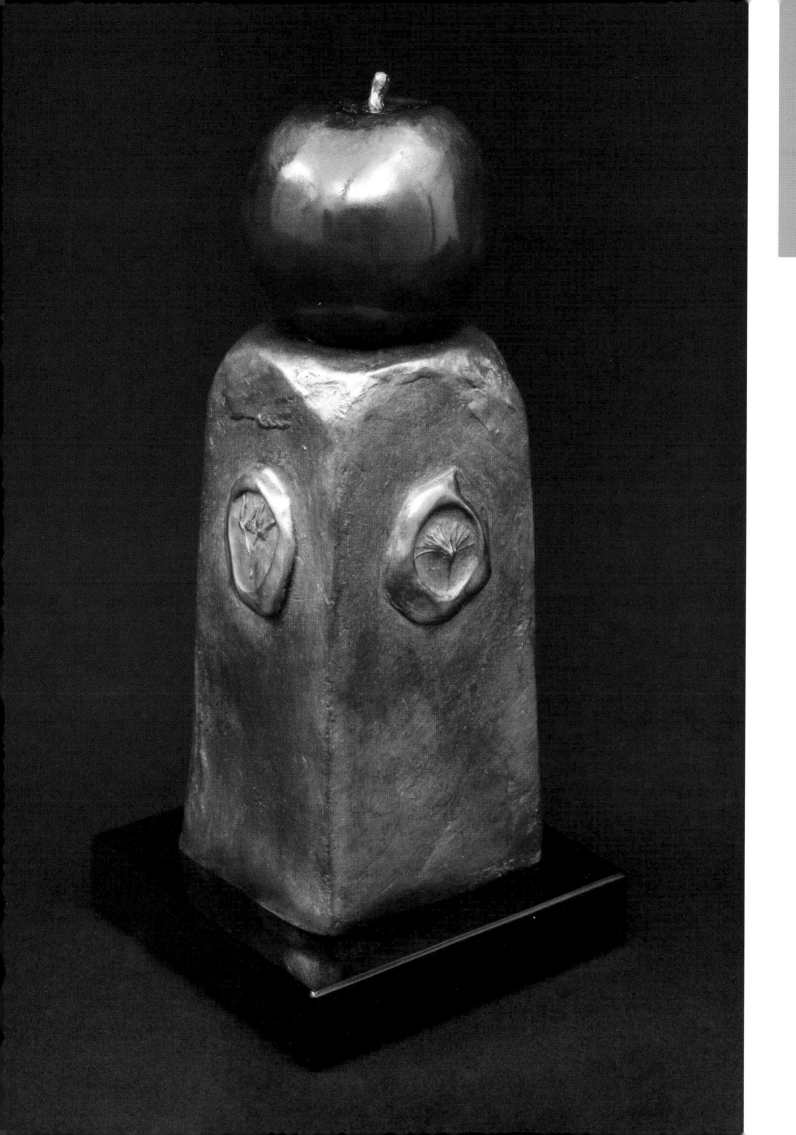

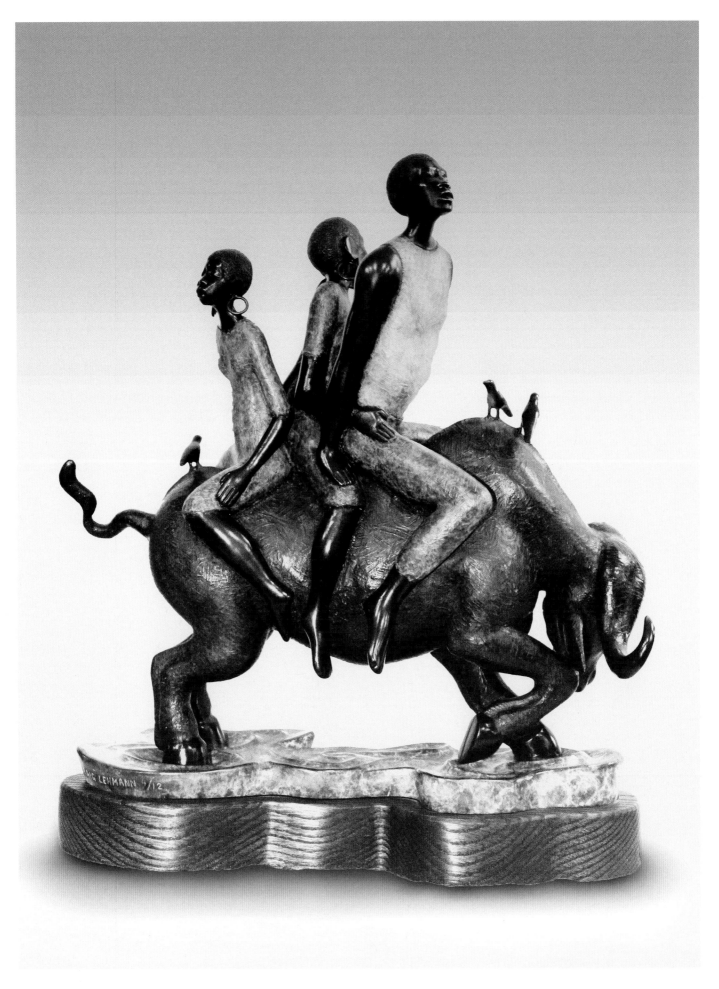

DELTA RAIN Craig Lehmann *Bronze 17" × 19" (43cm × 48cm)*

CRAIG LEHMANN

"The visual poetry of sculpture is a way of fulfilling a need to express myself," says artist Craig Lehmann, a sculptor whose works possess an exquisite sense of form heightened by a lingering mystical quality. Lehmann continues, "Just as I don't know all the mysteries of life, there are things about my work that I cannot explain—and these are the things I find most interesting." Regardless of whether or not these qualities can be verbalized, Lehmann's sculptures ensnare the viewer's attention, telling a different story from every angle.

Upon completion of his M.A. in sculpture from Adams State College, Lehmann embarked on a seventeen-year career at Shidoni Art Foundry in Santa Fe, New Mexico. It was here that Craig would hone his talent, working with world-class artists while mastering the skills of all phases in the production process. In 1997, Craig made the decision to leave Shidoni, devoting himself entirely to his own art. Eleven years later, he still credits his time at the foundry as being a major factor in his growth as a sculptor. Typically working in bronze, Lehmann finds the permanency of the medium alluring. He's also drawn to the wide variety of colors that can be achieved through patination, as well as the innumerable surface textures a piece can take on, both of which are beautifully demonstrated in Craig's piece *Delta Rain*.

What inspired this piece?

I have always been attracted to the dreamy visual images of Africa, perhaps from seeing pictures in books and magazines as a child. The dichotomies are astounding; not only can the ecosystem be lush and exotic at times, but it can also be desolate and barren during the dry season. I always imagined that after enduring long periods of drought, both man and animal would look forward to the coming of the rains, but at the same time, dread being caught in the storm. In sculpting *Delta Rain*, I wanted to capture the anxiety felt by both man and beast as they must press on through the downpour.

What prep work and techniques went into this sculpture and how did they contribute to the success of the finished piece?

I like to make small, spontaneous sketches in clay to help clarify my vision before making an armature for the larger sculpture. Because of the weight and malleability of clay, a wire armature is necessary. I chose aluminum because it is pliable. I started with the water buffalo's legs, inserting wire into three holes in a board, and then pushed wires into the buffalo where the riders are seated.

What is your favorite part of this piece and why?

I like the calm and stoic facial expressions of the figures and the gesturing of their bodies. The riders are looking upward and outward at their surroundings, interacting with nature (particularly the rain) while at the same time existing as part of nature. I also appreciate the action and movement of the piece. The ripples in the water permeate outward from the hooves of the buffalo and swirl back around and inward. The people are thrown from side to side, their arms interconnected as they attempt to maintain their balance. This balances the piece visually and creates interesting lines as well as positive and negative spaces.

What does this sculpture mean to you personally?

On a literal level, this piece reminds me of man's intimate connection to nature. On an intimate level, this sculpture urges me to persevere no matter the challenge I may be facing. It expresses the ebb and flow of life with man swirling like the river, trying to keep his balance, but also knowing the storm will eventually pass.

What do you hope it says to the viewer?

I hope the sculpture conveys a feeling of dependency, connectivity and trust between man and nature/God. The focal point of this piece is not physical but spiritual. The buffalo and the people's eyes are closed, hopefully turning the viewer thoughtfully inward.

MARK LEICHLITER

A native of Loveland, Colorado, Mark Leichliter feels the surrounding sculpture and casting industries so prevalent in his community were highly instrumental in turning his artistic talents toward the three-dimensional form. Completing his first sculpture in 1983, while still a high school student, Leichliter felt a magnetic pull toward this medium above all others. "I enjoy drawing or painting when I get the chance," he says, "but the attraction of solid forms that exist in their own space and speak their own language is the most powerful lure to me." Not to mention the physical act of sculpting helps Mark occupy his hyperactive energies, bringing necessary calm to his life. "Pushing paint around just doesn't have quite the same effect," Leichliter jokes.

Over the years, Mark has carved stone and wood, cast bronze, made assemblages and fabricated bronze, steel polymer and stainless steel. "The only driving force behind my selection of materials is meeting the needs of the environment into which a piece will be placed," Mark says. In creating his sculpture *Meme*, Leichliter chose stainless steel to help him convey his visual conceptualization of Dawkins' socio-anthropological term. This selection of material adds an unexpected element of visual impact to Mark's design, encouraging the light to play on the surfaces between the sections.

What inspired this piece?

This idea, or at least the seed of it, floated around inside my mind's eye for quite a while. When I finally had the tools to make it a reality, I was pretty damn excited. It is meant as a symbolic treatment of Richard Dawkins' *meme* concept. A meme, by definition, consists of any unit of cultural information, such as a practice or idea, that gets transmitted verbally or by repeated action from one mind to another. Examples include thoughts, ideas, theories, practices and habits. Memes have the ability to spread themselves, moving through a culture in a manner similar to the behavior of a virus. This piece plays on such propagation in the form of a concentric ripple—an idea moving from mind to mind like a wave, spreading out from it's origin and altering the energy state of other ideas within the culture. It also employs the imagery of a matrix, or lattice, to illustrate the memeplex being made up of individual, discrete consciousnesses experiencing a collective and individual transformation through the propagation. I think of this process when I analyze the steady progress our species is making from one cultural paradigm to the next, as ideas like liberty, responsibility and reason spread virally and replace those of dominance, exploitation and superstition. As more minds begin to cohere, constructive interference amplifies these waves, and everything gets just a little bit better.

What prep work and techniques went into this sculpture and how did they contribute to the success of the finished piece?

All my work is an examination of utilizing computer-aided design to produce sculptural form. In *Meme*, I used slices of a solid shape that had been deformed to resemble a droplet and it's subsequent ripples through a body of water. I'm pretty sure that arriving at anything vaguely similar to this piece without the use of computer modeling would be impossible.

What was your greatest challenge in creating this piece?

The greatest challenge to this design was locating and placing all the slots in each section so that each intersection between a horizontal piece and a vertical one allowed the sections to dovetail together at just the right depth, producing the correct shape. There are over 300 such slots.

Why do you consider this one of your most significant works?

I consider this piece my best work to date, primarily because the technology used to create it is intrinsic to it's success and yet allows the beauty of the form to shine out. Most people respond enthusiastically to the sculpture without having a clue as to how it came about. I like work that can be appreciated on multiple levels.

MEME Mark Leichliter *Stainless Steel* *51" × 18" (130cm × 46cm)*

BETS HOLLAND LUNDEEN

From the stick figure drawings of her childhood to her most recent works in bronze, multi-genre artist Bets Holland Lundeen has always been passionate about creating art. With interests spanning the spectrum, Bets draws upon her extensive experiences in other creative arenas to express the movement and drama present in her three-dimensional works.

Spending her days as a young woman traveling through Europe and studying numerous disciplines, Lundeen became proficient in various techniques. In her experience, an interdependence exists among these assorted art forms—something that helps Bets achieve success in each unique artistic expression. She explains, "I continue to work in all mediums, as each individual medium helps to refine my technique in others."

When it comes to sculpting, Bets prefers to work in clay. "When I manipulate the clay, it is warm and actually seems to breathe—there is something quite sensuous about creating a figure in clay," she says. When sculpting said figures, Lundeen aims to weave the constant thread that connects the genres—including dance, theater and painting—through the soul of the viewer. Her bronze *Comedy & Tragedy* is the perfect culmination of these genres, expressing Lundeen's passion for the many art forms present in her life.

What inspired this piece?

I believe that a true artist dabbles in many forms of expression. For me, that has included the performing arts—namely, theater, dance and choreography. Shortly after I moved from Kearney, Nebraska, I was commissioned to do this piece. I drew inspiration from my personal experiences as both a director and a thespian to create a powerful expression.

What prep work and techniques went into this sculpture and how did they contribute to the success of the finished piece?

I used a model to help with the human element of *Comedy & Tragedy*. I photographed him in the desired stance and worked from these reference photos. To create the mask, I made sketches from my imagination until I found the perfect design. Then, I combined the two elements and made a maquette to help prepare for the life-size piece.

What is your favorite part of this piece and why?

On a surface level, I enjoy the contrast between the actor's expression and the mask he carries. Even more fascinating, though, is the level of deceit involved. When the actor wears his mask, the audience observes his expression and immediately feels a sense of sadness and loss— the emotions we associate with tragedy. However, when he removes the mask, we see that he has all along been hiding beneath a facade, and that he is indeed happy— an emotion we associate with comedy.

What was your greatest challenge in creating this piece?

Achieving a lifelike facial expression was a great challenge, but it was also the greatest joy in creating this character.

Why do you consider this one of your most significant works?

I consider this piece a true part of who I am, and I feel that the formation of this sculpture represents my desire to express emotions within. I find truth in the Shakespearean quote, "All the world's a stage, And all the men and women merely players." More often than not, we present a mask to the world which we rarely remove. When we do, it is in front of those we trust to take care of our emotions.

What does this sculpture mean to you personally?

This sculpture was created at a crossroads in my life. I was moving away from a community in which I found great joy, and this evoked a sense of sadness or loss. At the same time, though, I was becoming a part of new community where I could further my sculpting career, which brought happiness and fulfillment. At that particular moment in my life, I was both happy yet sad, which is the very nature of *Comedy & Tragedy*.

COMEDY & TRAGEDY Bets Holland Lundeen *Bronze* 28" × 26" × 18" (71cm × 66cm × 46cm)

CAMMIE LUNDEEN

A member of one of American sculpture's greatest dynasties, wildlife artist Cammie Lundeen grew up drawing from the time she was a small child, a passion that would eventually lead her to pursue a career in the arts. And, with an enthusiasm for animals that matched her desire to create, it was only natural that Cammie chose wildlife as the primary focus of her work. Once she began working in clay, arriving at the conclusion that she was first and foremost a three-dimensional artist, Lundeen made the choice to relocate to Loveland, Colorado. "I wanted to be a part of the strong artistic community and have access to its first-rate foundries," she recalls. As fate would have it, she would also meet her husband here, established bronze sculptor George Lundeen.

When talking about her work, Cammie exclaims, "I always say you never know a subject until you try to sculpt it. You really have to observe and study an animal to sculpt life into it." Consequently, most of Lundeen's subjects are animals that she has worked with firsthand, particularly horses. "Equines are a big part of my recreational life," she explains. "I feel like I really know and love these animals, and think this is reflected in my work." This is certainly the case with her sculpture *Maude and Lottie*, a piece inspired by Cammie's real life love affair with horses.

What inspired this piece?

The inspiration for this piece came from my experiences driving draft horses on Mackinac Island, Michigan, an island that exists without the distraction of automobiles. Here, one can experience a true and intimate connection with both nature and horses. During our drives, when we would stand and let the teams rest, they would often nuzzle and rub against each other. Watching the horses interact in such an affectionate and endearing way inspired me to create *Maude and Lottie*.

What prep work and techniques went into this sculpture and how did they contribute to the success of the finished piece?

In addition to photographing the draft horses, I had to bring a set of harnesses into my studio for reference. I wanted the piece to be a realistic rendering of the subject, so keeping references on hand helped me achieve accuracy.

What was your greatest challenge in creating this piece?

The casting was the most complicated part of the sculpting process. Most of the intricate harness parts had to be cast separately and welded back on. This required a great deal of patience and precision.

What is your favorite part of this piece and why?

I like the warm emotions and feelings the mares have for each other, and the way they choose to exercise this affection. I also like the nostalgic feelings it stirs within when I look at the draft horses. Many people experience a similar reminiscence when viewing this piece, as it reminds them of a team of horses they may have grown up with on the farm.

Why do you consider this one of your most significant works?

Maude and Lottie was the first large sculpture I produced, and as such, will always carry significance in the weight of this accomplishment. I also love the fond memories it evokes from a particular time of my life—this sculpture not only shows my love of horses, but the subtle things they do that always make me smile.

Did this sculpture turn out the way you had envisioned, or were there some unexpected yet pleasant surprises?

It turned out the way I envisioned because I had done a small maquette that was very successful. However, I never could have anticipated the strong impact the life-sized version would have on the viewer.

What do you hope it says to the viewer?

I hope the viewer feels good about the friendship that exists between the animals, as well as his or her own special connection to these creatures.

MAUDE AND LOTTIE Cammie Lundeen *Bronze* *43" × 36" × 40" (109cm × 91cm × 102cm)*
photo courtesy of Fabrice Dolegowski

DEPARTURE George Lundeen *Bronze* 48" × 84" × 48" (123cm × 213cm × 123cm)

photo courtesy of Fabrice Dolegowski

GEORGE LUNDEEN

Joining the Loveland, Colorado art scene in 1976, sculptor George Lundeen has been an instrumental force in making the community what it is today. Not only have his many artistic contributions helped to make this area what some would consider the sculpture capital of the American West, but his breathtakingly detailed and highly-polished figurative work is responsible for drawing an entire new generation of aspiring artists to Loveland.

A native of Holdrege, Nebraska, Lundeen studied art at Hastings College before moving on to pursue a masters in fine arts from the University of Illinois. "As a student, I experimented with many mediums, "Lundeen recalls, "but once I began using clay, all the others became mute." In awe of both the physical beauty of the human form and the captivating presence of the human spirit, George uses people as the subjects of his work. Striving to capture lifelike accuracy while still conveying the emotion of an inspiring scene, Lundeen never leaves home without the necessary "tools." He explains, "I use pencils, paper, clay, photos—anything I can—to help me expedite an idea that arises from an observation." Today, he is internationally celebrated for his sentimental, life-size figure groupings, like the one depicted in his stunning piece *Departure*.

What inspired this piece?

Late one night, while waiting in the terminal of a Rome train station, I spotted a couple on a bench nearby. I was immediately drawn to their presence, and began sketching the couple, completely captivated by the clear expression of love and tenderness the two showed for one another. A few years later, I finally got the chance to use the sketch when modeling this sculpture.

What was your greatest challenge in creating this piece?

As is the case with each of my works, the greatest challenge lies in telling the story of the subject. I like for my sculptures to evoke an exact emotion upon viewing. With this particular piece, I needed to portray a certain sense of sadness the two lovers felt in having to say goodbye. There is an urgency to the affection being expressed, as they know they will soon be separated. The bag by his side suggests that he will be the one to depart, leaving his beloved behind. I feel confident that this piece successfully depicts the story and emotion I wanted to capture, and I believe the narrative resonates with all that view the sculpture.

What is your favorite part of this piece and why?

My favorite parts of this piece are the faces and hands, which in most figurative sculpture, carry the weight of the piece. Many drawings, pictures and sittings were required to render these elements with a lifelike exactness.

Why do you consider this one of your most significant works?

I cannot say that *Departure* differs a great deal form any other work I've completed in the past; in fact, the subject and techniques used are much the same. However, this was one of my first attempts at creating a life-sized sculpture, and I was very pleased with the outcome.

What does this sculpture mean to you personally?

This piece embodies the very feeling of intimacy and love. I believe that everyone can relate to the emotion of *Departure*, as we've all had to say goodbye to someone we've held dear at some point in our lives. During such moments, we often wish we had more time to show our love for each other, or the chance for a "long goodbye." That's one of the reasons the beauty of this piece goes so far beyond the surface of the design—the lovers' goodbye has been frozen in time, forever immortalized in bronze. In this way, they never have to depart.

MARK LUNDEEN

Often credited as a natural born storyteller, sculptor Mark Lundeen builds his work around the life stories of the characters he portrays. Working in a highly detailed, realistic style, Lundeen has a remarkable knack for capturing the authentic emotion of his subjects, while still leaving just enough room for each viewer to arrive at his or her own conclusion.

After earning his Marketing degree from the University of Nebraska, Mark's ambitions quickly turned to the arts when extensive travel throughout Europe inspired him to make sculpture his life's work. With this new goal in mind, Lundeen relocated to Loveland, Colorado in 1982, where he would learn all phases of sculpting before embarking on a highly successful career. Now, when asked to reflect on how he's progressed as an artist, Mark admits, "Sculpting has made me a much more patient person. You just can't rush the process."

To create the fluid lines, integrity and balance his work is so well known for, Lundeen says, "I work in traditional materials: Clay and bronze. No other media could bring my visions to life quite the same way." It is this signature style that has led to the placement of many of Mark's life-size and monumental sculptures across the U.S., including his rendition of our nation's 16th president, simply titled *Lincoln*.

What inspired this piece?

As a longtime admirer of President Lincoln and the principles by which he firmly stood, I thought our sixteenth president would make a compelling subject for my sculpture. Some people mistakenly assume that I was commissioned to create this piece. On the contrary, this sculpture was a personal vision of my own that I gladly saw to fruition. I was pleasantly surprised when approached by the Lincoln Presidential Library and Museum about installing the life-size version of this sculpture in Springfield, Illinois.

What was your greatest challenge in creating this piece?

The greatest challenge in creating *Lincoln* was to make him look as everyone perceived him. I find research to be a crucial part of the process when depicting any historical figure, so I first turned to books and other references to help me create an authentic representation. At the same time, though, I wanted to instill a sense of repose. In past portrayals, Lincoln was never shown with a smile; rather, he always displayed a reserved, serious, and at times pensive expression. My aim was to make him look more relaxed and serene, showing another side of his personality.

What is your favorite part of this piece and why?

I was quite pleased with the expression of serenity and peace that I was able to capture. He seldom had a moment to experience either during his years in the presidency.

Why do you consider this one of your most significant works?

This piece remains significant because the first production of the life-size edition is installed outside of the Lincoln Presidential Library and Museum in Springfield, Illinois.

What does this sculpture mean to you personally?

Abraham Lincoln was the greatest president in U.S. history, overcoming a tremendous measure of adversity in troubled times to become president not once, but twice. In his right hand he is holding his second inaugural address, which I believe is one of the greatest orations in history. It states, "With malice toward none; with charity for all; with firmness in the right, as God gives us to see the right, let us strive on to finish the work we are in, to bind up the nation's wounds; to care for him who shall have borne the battle, and for his widow and his orphan, to do all which may achieve and cherish a just, and a lasting peace, among ourselves and all nations." These beautiful and moving words resonate with people from all walks of life, stirring emotions they were unaware they even possessed.

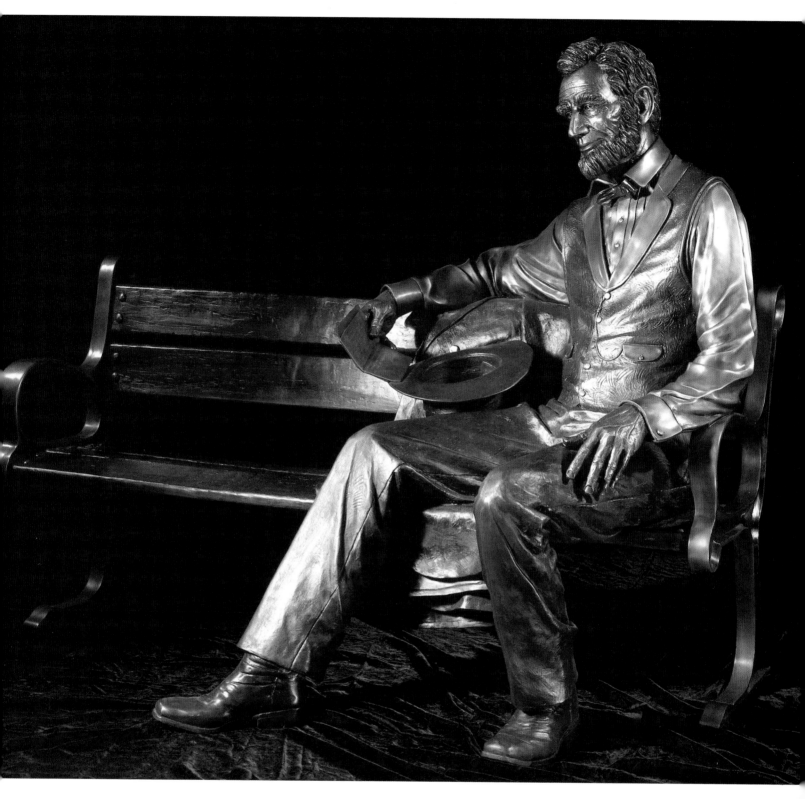

LINCOLN Mark Lundeen *Bronze* 57" × 68" × 42" *(145cm × 173cm × 107cm)*

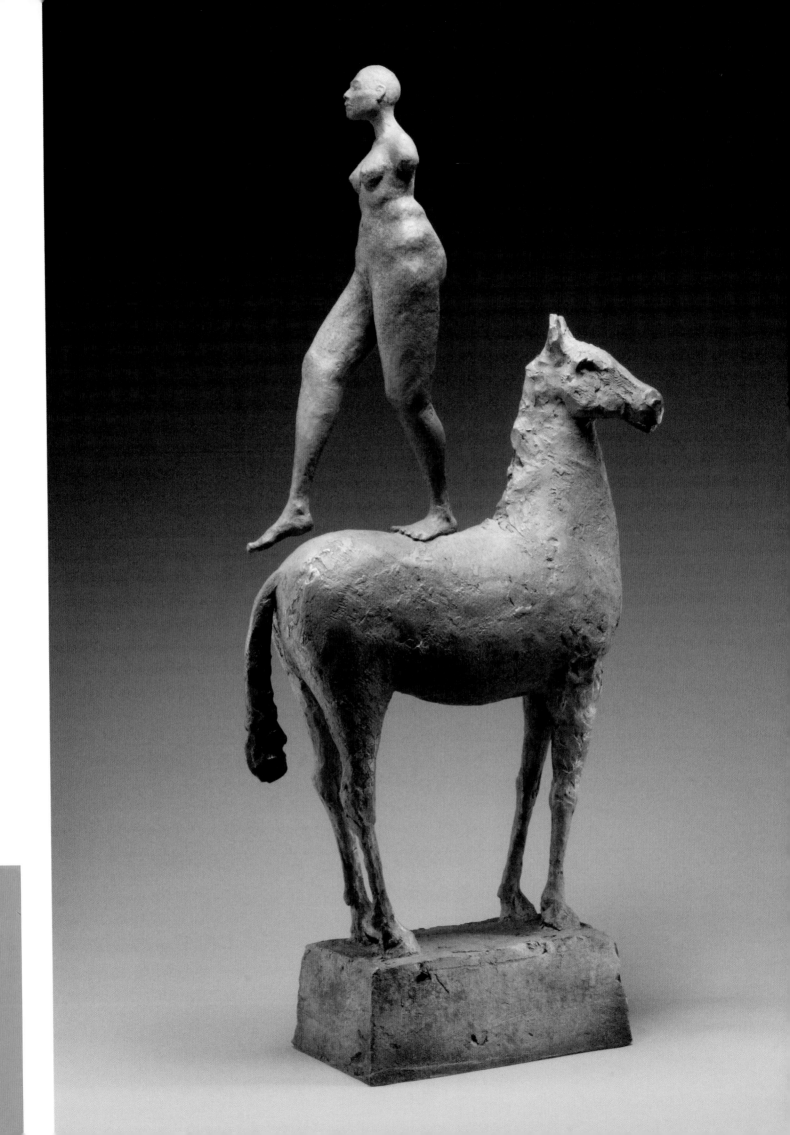

PHILIP MAIOR

With a body of work that is largely symbolic, artist Philip Maior's sculpture often leaves the viewer entranced, mystified and searching for meaning. "I'm interested in the idea of how narratives inform a culture," Maior says. "My art is my way of participating in the narrative, a way of feeling like I'm alive." Certainly, after viewing one of Maior's creations, it's easy to see he lives by this very principle, crafting art in direct emotional response to the events of his own life, resulting in a personal, original and raw style. Still, while his sculpture may arise from his own experiences, the finished creations possess an archaic quality akin to classical or mythological artifacts. It's this unnameable quality, reminiscent of past cultures, that gives Maior's art the strong sense of mystery for which it is so well known.

Since moving to Colorado thirty-five years ago, Maior has developed his talent in all stages of the sculpture process, from casting to patina to the finishing process. Though he most often prefers to work in water-based clay, he found oil-based clay the key to capturing the essence of his striking piece *Horse and Rider*—Maior's attempt at creating a metaphor for a metaphor. The end result not only embodies Maior's desire to contribute to the human story, but it also demonstrates his technical skill and prowess.

What prep work and techniques went into this sculpture and how did they contribute to the success of the finished piece?

I'm most familiar with clay, so I chose to use this as the base for my original. And, because I work in a foundry, it made the choice to cast in bronze an easy one. I started with the horse, building a welded steel armature from a ¼-inch steel rod and wrapping it with chicken wire to support the clay. The figure had a similar armature, but I had to resort to using oil-based clay—a medium I usually avoid due to it's demanding nature—because the water-based clay was drying out too quickly. Though I feel that water-based clay seems more alive, I found it easier to get more detail with the oil-based clay.

What is your favorite part of this piece and why?

I like the feeling I get when I look at it. The image produces a sense of ambiguity and equivocacy—I honestly have no idea what it's about, but I am intrigued all the same.

Did this sculpture turn out the way you had envisioned, or were there some unexpected yet pleasant surprises?

What I envisioned changed dramatically as I went along, taking many unexpected turns. But then again, my sculptures always do. For this piece, I originally imagined a woman with three legs. I worked on this vision for two or three weeks before finally giving up on the idea. It just looked too ridiculous. So then my vision shifted toward a two-legged woman without arms. I liked this concept, but felt it needed something more. This is what prompted me to add the horse. I made three horses before I got the one I wanted. The moral of the story: I've never made anything that ended up looking like my original idea. I believe ideas are just that—ideas. They only serve to get you started. Then you have to let go and follow wherever your hands may take you.

What does this sculpture mean to you personally?

The truthful response is that it doesn't mean anything. What it expresses is what I do: The thinking, the creative processes I go through, the aesthetic choices I'm capable of given my limitations. What's important is to try to *make* art.

What do you hope it says to the viewer?

I don't care what it says to the viewer; I believe a person's emotional response is his or her own business. Usually, when I finish a piece I'm glad to be done with it and to move on to the next thing—the viewer's interpretation is far from my mind at that point.

HORSE AND RIDER Philip Maior *Bronze 42" × 12" × 8" (107cm × 30cm × 20cm)*
from Gallery 1261, Denver, Colorado

JAN MAPES

Working from a studio situated in the picturesque Great Plains of Colorado, Jan Mapes draws inspiration from the living, breathing beauty of her surroundings. Residing in the West for most of her life, Mapes' innumerable intimate encounters with nature—many experienced from the saddle of a horse—continually surface in her work. Whether it be the endless clear skies, the rugged terrain, or the animals that populate the plains, Jan never ceases to be amazed with the wonders of her environment.

Though her artistic talent blossomed during childhood, it was only after visiting an art gallery on her honeymoon that Mapes felt the zeal to create. Sculpting full time since 1994, Jan chooses the nature and animals that make up the landscape of her life as her subjects. She says of her art, "It really didn't start out as a love of the West, just a love of nature." Focusing on compositional elements like flow, balance and tension, Jan shows her love of these subjects by attempting to involve the viewer in her work. "I'm trying to speak a language that I'm receiving from my subject and how it affects me, and then pass that on to you," she says. *The Gatekeepers* captures this very sentiment, pulling the viewer to a place heavy with history and legend, just like the West that Mapes holds so dear in her heart.

What inspired this piece?

I live in southeastern Colorado among the great cedars and canyonlands. In this magnificent landscape, ravens are a common sight, whether sitting on windmill towers, perching on rock ledges or soaring high above the trees. One rarely sees the raven fly alone; rather, these creatures always travel in pairs or groups. It seems as though nothing happens that they don't know about. I learned about the ravens that live at the Tower of London, and how they not only bring good luck to the monarchy, but also serve as its protectors. They are cherished and well kept as they carefully watch the comings and goings of the world at large. I named this piece *The Gatekeepers* for this reason.

What prep work and techniques went into this sculpture and how did they contribute to the success of the finished piece?

Of course I took as many reference photos as possible. But one day, I found the body of a raven who had drowned in a stock tank. In its death, the raven was a gift to me. I studied the bird even closer than I could in reference photos. This allowed me to draw, take exact measurements, and photograph the bird from numerous angles. It was these references that most informed the creation of this sculpture.

What was your greatest challenge in creating this piece?

The greatest challenge I faced was deciding on the positions and placement of the pair of birds in order to show their character. I know I wanted them to appear intimately connected, as though they shared a special bond, so I returned to my references to examine the body language that existed between pairs of ravens. On several sightings, I saw two ravens perched in this position, and right away, I knew it was exactly what I wanted for this piece.

What is your favorite part of this piece and why?

I am particularly drawn to the kinship formed by the placement of the birds. I also like the open mouth of the bird in the foreground, as it suggests he is relaying to his partner the sights he sees below. I can hear the bird squawk every time I view this sculpture.

What does this sculpture mean to you personally?

I feel this piece is a reminder of God's creativity. The vast array of creatures that exist in our world, though each unique in its own way, have many common characteristics that even humans can relate to. These birds have a special, interdependent relationship, just as we people have with one another. To me, this is both beautiful and reassuring.

THE GATEKEEPERS Jan Mapes *Bronze* 24" × 24" × 29" (61cm × 61cm × 74cm)

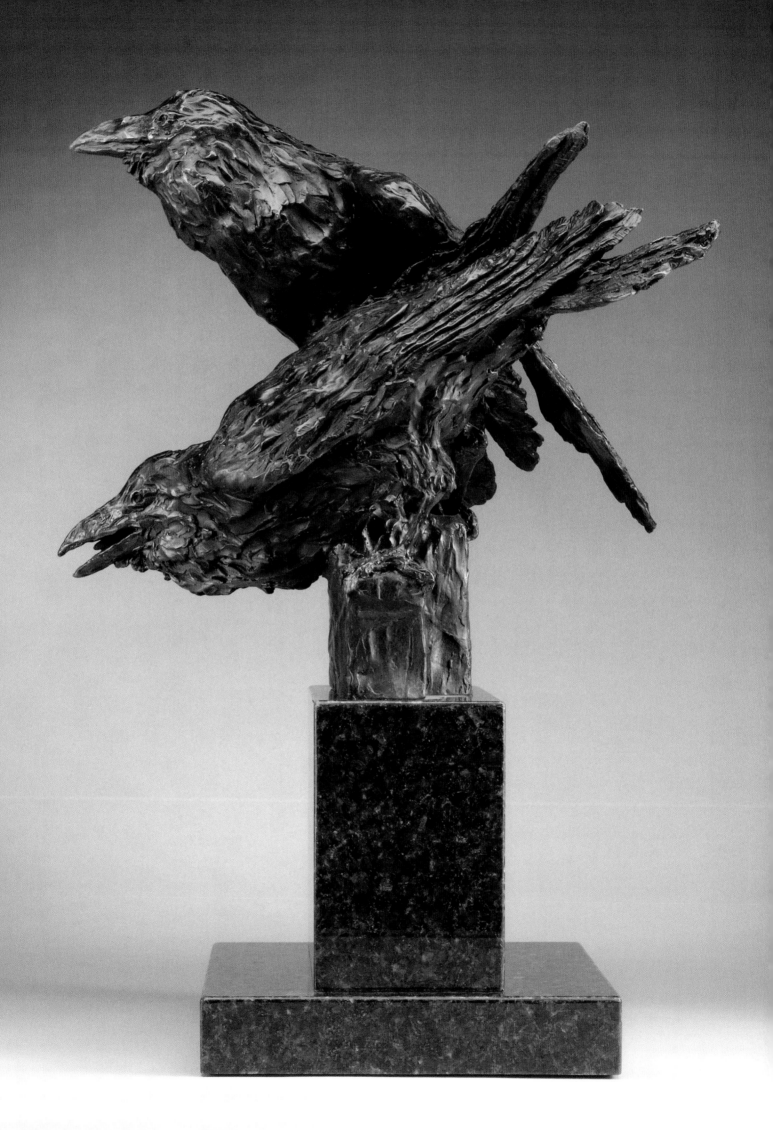

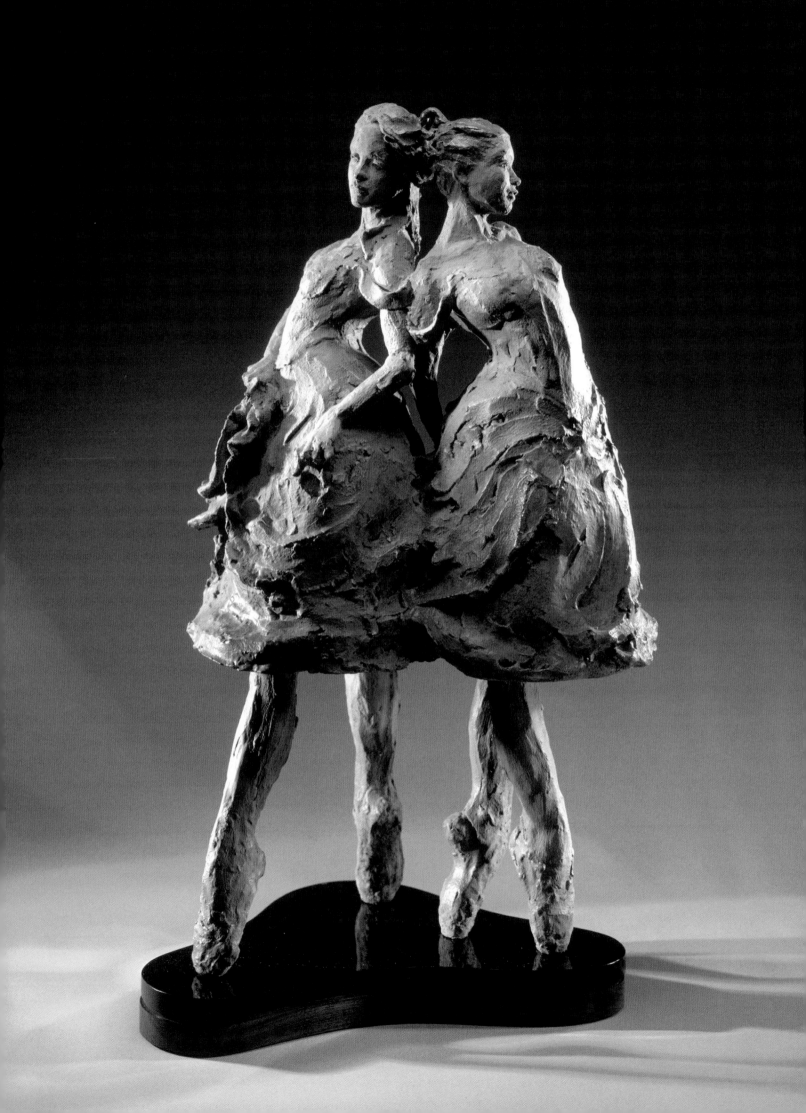

ANDI MASCAREÑAS

From the elegant, sweeping motions of classic ballet to the highly stylized choreography of modern dance, figurative movement is what most inspires artist Andi Mascareñas. In her experience, sculpture is the only way to truly capture the feeling of human figures in motion. Of course, she didn't always know this was the case. A painting and illustration major in college, Andi didn't discover sculpting until her final semester. She recalls, "I was surprised to discover how wonderful it felt to work the clay with my hands, and how amazing it was to create in three-dimensions. I soon realized how much more expanded I felt inside and how I was able to create from a whole new place—I was hooked."

To portray the fleeting scenes that speak to her artistic core, Andi sculpts on location using water-based clay. "It moves easily and responds to any movement quickly," she says. "I love merging edges, and the clay allows for that." This technique, combined with an acute sensitivity to the capriciousness of the human condition, allows Mascareñas to capture the passion and feeling of a figure in motion. *Topaz Lace* reflects this very sensibility, as the viewer infers the delicate movements of the dancers through the precision and fluidity of Mascareñas' style.

What inspired this piece?

I love the movement of dance, the energy contained therein, and how it conveys emotion. I had a couple of young ballerinas over to my studio and told them to just dance. I wanted to experience up close the silent performance, the power of the form, the playfulness and the interactions between the two dancers. This piece is about capturing the sophistication and confidence that I witnessed in those two beautiful young women.

What prep work and techniques went into this sculpture and how did they contribute to the success of the finished piece?

I prefer to sculpt in the moment, allowing the flow of inner light to guide the process. I start with a feeling about a piece, and then I trust that where I need to go will be revealed to me as I create the piece. I did not create this piece with a formula—I followed my intuition, kept it spontaneous, and remained cognizant. I simply removed myself and allowed the piece to move through me.

What is your favorite part of this piece and why?

There isn't an angle I don't enjoy about *Topaz Lace*. It is a piece in the round, so it looks beautiful from all angles. When it is placed under a spotlight, the piece pops and the sculpture comes to life.

What was your greatest challenge in creating this piece?

My biggest challenge was how to sculpt the figures using water-based clay with feet en pointe. I had to sculpt the legs separately and then attach them after I fired the piece. I turned the figure upside down, filled the bell of the dress with a hardening agent, placed the legs, and then quickly turned the piece right side up to adjust the legs before the hardening agent settled. It was a difficult piece to handle because of the weight.

Did this sculpture turn out the way you had envisioned, or were there some unexpected yet pleasant surprises?

I had a vague picture in my mind, like a blueprint; I had a feeling and followed through on it to completion. This piece was created in the moment and came about easily without effort. When it was finished, I sat back and viewed it in the light, very satisfied with the outcome.

What does this sculpture mean to you personally?

I feel *Topaz Lace* expresses beauty, just as it is. It reflects everything that I am. Sharing it with the viewer means all the world to me—that is the importance of it.

TOPAZ LACE Andi Mascareñas *Fired Clay/Metal Finish (piece also available in bronze)* 34" × 23" × 23" (86cm × 58cm × 58cm)

DIANE MASON

Diane Mason began her sculptural journey in the early 1990s, when a friend suggested she give it a try. "I had been a scratchboard artist through the 1980s, and was beginning to feel burned out on scratching," Mason recalls. "An artist friend of mine thought I might enjoy the challenge of sculpture, so I gave it a chance." Soon after, armed with a newfound love of depicting subject matter in the round, Mason drove from her Minnesota home to the Loveland Academy of Fine Art to take a sculpture workshop with famed artist Gerald Balciar; she instantly fell in love with the artistic energy and beautiful scenery of the area, and determined that this was where she needed to be.

Now, continually surrounded by the animal subject matter she loves—both wild and domestic—and living amidst what she calls "an artist's paradise,"—with a plethora of foundries at her disposal—Mason feels constantly inspired to create. Attempting to combine a high degree of anatomical accuracy while yielding an aesthetically pleasing composition, Diane says of her objective, "What is most important to me is that my work conveys my deep respect and appreciation for the animal subject." This admiration for all creatures big and small is wholly apparent in Mason's piece *Charmin' Charlie*, a tribute to one of her beloved pet roosters.

What inspired this piece?

Charmin' Charlie was inspired by my mixed-breed rooster, Charlie. He was the product of one of my Black Australorp hens and my Buff Orpington rooster. Charlie and I bonded early on when he injured his leg at the tender age of two weeks and had to be isolated in my bird room in the house while he healed. He was lonely, and I would go in and sit with him regularly. Now, ten-years-old, Charlie still wants to be held and cuddled in my lap, and he is a big, sweet-natured and very handsome fellow. When I sculpted him, he was in his prime and made the perfect model.

What prep work and techniques went into this sculpture and how did they contribute to the success of the finished piece?

The prep work involved in creating *Charmin' Charlie* was creating the basic armature of plumbing pipe to support the mass of clay, and constructing the tail feathers individually using wire, aluminum foil and a thin layer of clay. I wanted movement and some negative spacing between the longer tail feathers, and felt that the only way to support the feathers through the mold process was to have individual armatures in each one. Fortunately, it worked well.

What was your greatest challenge in creating this piece?

The greatest challenge in creating this piece was probably in the molding stage, as well as the welding and chasing. The mold maker had to cut off the tail feathers and make twenty-two separate molds. When these feathers were cast, the welder had to match up each feather to the appropriate "stub." I cannot take credit for any of this. Fortunately, I work with a lot of very talented professionals who managed to put Charlie together and make him look great!

What is your favorite part of this piece and why?

My favorite part of this piece is the essence of *personality* that it projects. The sculpture is very lifelike, and captures a lot of the real Charlie's attitude and presence.

What do you hope it says to the viewer?

"Look at me! I'm a beautiful, personable, endearing creature deserving of respect." Chickens may not be smart like dogs, but they can be affectionate, they can learn, and they do have individual personalities. They offer us much more than eggs and meat! I think of them as pets, and treat them as such.

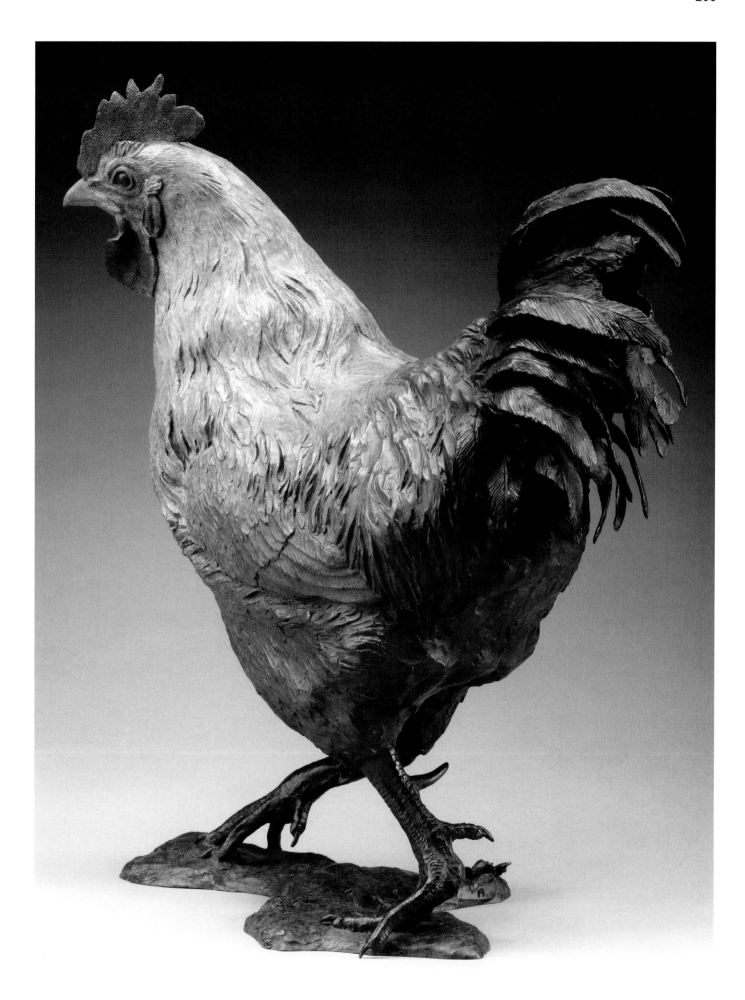

CHARMIN' CHARLIE Diane Mason *Bronze 22" × 10" × 20" (56cm × 25cm × 51cm)*
photo courtesy of Jafe Parsons

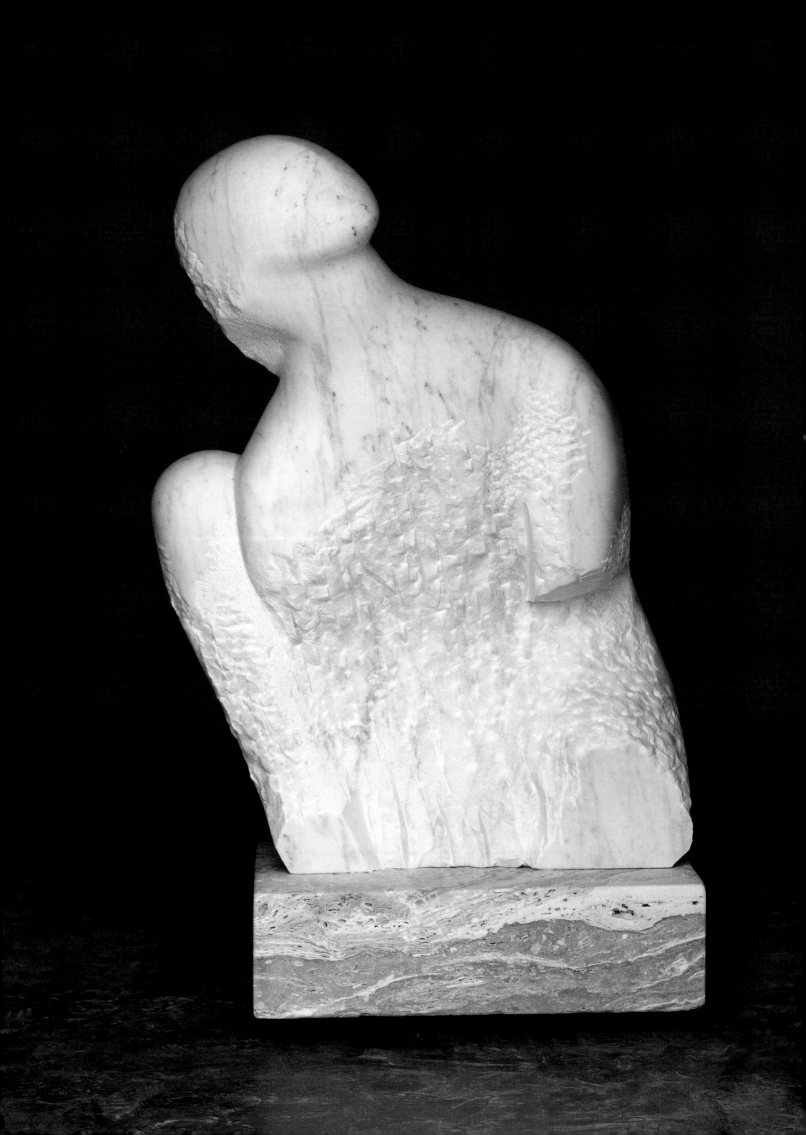

CLAIRE MCARDLE

"Making the commitment to live life as an artist was a conscious decision," muses internationally recognized sculptor Claire McArdle. "Even after the hardships and successes, it doesn't matter; what matters is the connection to my work and the continuation of my commitment." For McArdle, this connection was made at the age of fifteen, when she first discovered her passion for rendering three-dimensional forms in clay.

As she began refining her artistic voice, Claire's sculptural focus would shift from pottery and vessels to the human figure. Soon after, trips to the rock quarries and studios of Carrara, Italy, would eventually lead McArdle to discover the medium of stone. "I work clay in a subtractive technique, so the transition to stone was natural, but very challenging," she says. "Even after almost twenty years, it still challenges me with its unique properties and its ability to be both strong yet fragile, and rough yet raw." Inspired first and foremost by the process of sculpting itself, McArdle thrives on the act of manipulating her materials, whether they be lumps of clay or blocks of stone. Her uncanny ability to re-create the energy of an elegant dance move or harness the raw emotion of the human form through these media is prevalent in McArdle's ethereally beautiful piece *Saturnus*.

What inspired this piece?

This piece actually began in the mid 1990s while I was working in Carrara, Italy. Ingrid Zimmer, a friend of mine who happens to be a dancer, visited me during that period of time. We played around with choreography based on the five elements—earth, wind, fire, air and water—and inspired by Isadora Duncan. The movement of the posture represents earth, but as the figure is squatting and connecting to the earth, she is also drawn to the cosmos.

What prep work and techniques went into this sculpture and how did they contribute to the success of the finished piece?

I often work my stone sculptures from terra cotta models. I then choose a batch of pieces to enlarge and sculpt from marble. The terra cotta model of this piece was a quick gesture of the movement, but still it captured the essence of the work I wanted to create on a larger scale. During the process of roughing it out from a block, every mark of the tool becomes important to the finished work. I left the marks of the diamond blade cuts in the marble to accentuate the movement, but also to give the piece the freshness of the gesture.

What was your greatest challenge in creating this piece?

The greatest challenge was finishing the sculpture. I stared work on *Saturnus* in 1995, but for a number of reasons, whether moving studios

or completing commissioned works, I left it incomplete for thirteen years. Finally, I had it shipped from Italy to my studio on the Front Range in 2007, and I just finished the piece in 2008.

What is your favorite part of this piece and why?

She is so symbolic of my personal journey. I have a very grounded self, but I look to the cosmos for strength, understanding and connection to something greater than myself; I am humbled by the effect that the mysteries of the universe have on me.

Did this sculpture turn out the way you had envisioned, or were there some unexpected yet pleasant surprises?

I have to say, she came out better than I expected. The energy of the piece is in the texture, which happened as I worked. In the clay models, I mostly use my fingers to drag the clay and leave finger marks, so sometimes it is hard to translate that into the marble. In my opinion, had the marble pieces been too finished looking, the piece would be much duller.

What do you hope it says to the viewer?

I hope it resonates in a spiritual way, and that the viewer will have one millisecond of time in his or her frenetic life to connect with the universe.

SATURNUS Claire McArdle *Calacatta Italian Marble on NM Travertine* 55" × 35" × 33" (140cm × 89cm × 84cm)

GEORGENE MCGONAGLE

As a teacher of Biology and Mathematics at Mary Institute in St. Louis, Missouri, Georgene McGonagle never imagined that her future would involve professional artistic endeavors. "It was by chance," she recalls, "that a friend showed me a clay sculpture she had made. In that moment, I was smitten, and by the following day I had already enrolled in a class." By this time, McGonagle was already in her mid-fifties, but she knew she couldn't ignore her strong urge to create. "I've always been interested in the study of animals, both their structure and behaviors; it was a part of my studies, after all," Georgene explains. "Combining this interest with my love of using my hands in the garden—it now seems logical that I had an affinity for sculpting."

When McGonagle first started out, she used water-based clay, a medium with which she felt comfortable, as it reminded her of working in the soil of her garden. She would later move on to the more durable oil-based clay, followed by wax, with the intention of casting in bronze. "I love the permanency and texture of bronze," Georgene says, "And with its patinas, it brings my sculptures to life." This is certainly the case with *Hawk-Eye*, a piece that McGonagle created with her heart and hands, in the hopes that it might contribute to the happiness of others.

What inspired this piece?

Our neighborhood has been home to a family of hawks for many years. Watching their graceful flight, their darting for food and their soaring into the wind captured my delight.

What prep work and techniques went into this sculpture and how did they contribute to the success of the finished piece?

I wanted the wings of *Hawk-Eye* to be very thin, therefore, the armature had to be reinforced with wire and strong cardboard. The central armature held the main body, and I separated the wings individually and reinforced them again to make it easier to counterbalance the sculpture. I used oil-based clay, molding the form and readying the piece for the pouring of the bronze.

What was your greatest challenge in creating this piece?

The greatest challenge was the hope that the hawk would fly balanced on a single leg with a very small base. The weight of the bronze was such that finding the right position and balance for attaching the leg to the body of the bird was quite difficult.

What is your favorite part of this piece and why?

My favorite part of this sculpture is its gracefulness, and when turned, how the light of the patina reflects different movements.

Why do you consider this one of your most significant works?

Having begun sculpting in my mid-fifties, I brought to the table many ideas from my past experiences—my love of children and animals, and my passion for travels and education. I started studying my own children, and my work was initially realistic. Later, it evolved into more of a stylistic expression. I find my work is eclectic and constantly changing in style and subject matter.

What does this sculpture mean to you personally?

The sculpture *Hawk-Eye* reflects a certain freedom in life. Personally, it expresses my love of nature and all living things. Although my earlier animals were realistic in style, this sculpture shows my decided resolution to reach out even further in my work.

What do you hope it says to the viewer?

I hope the viewer experiences joy, is reminded of elegance, feels the motion of flight and walks away from the piece with a sparked curiosity and the desire to touch!

HAWK-EYE Georgene McGonagle *Bronze* 20" × 10 ⅔" (51cm × 27cm)

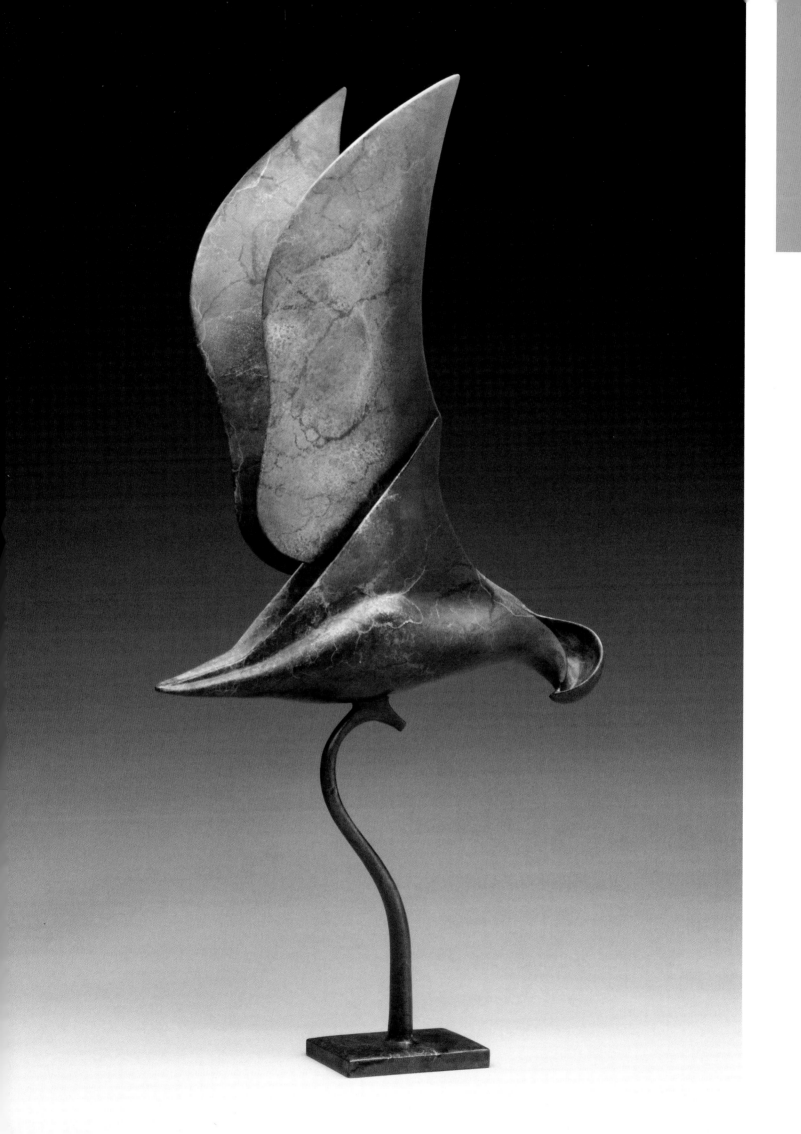

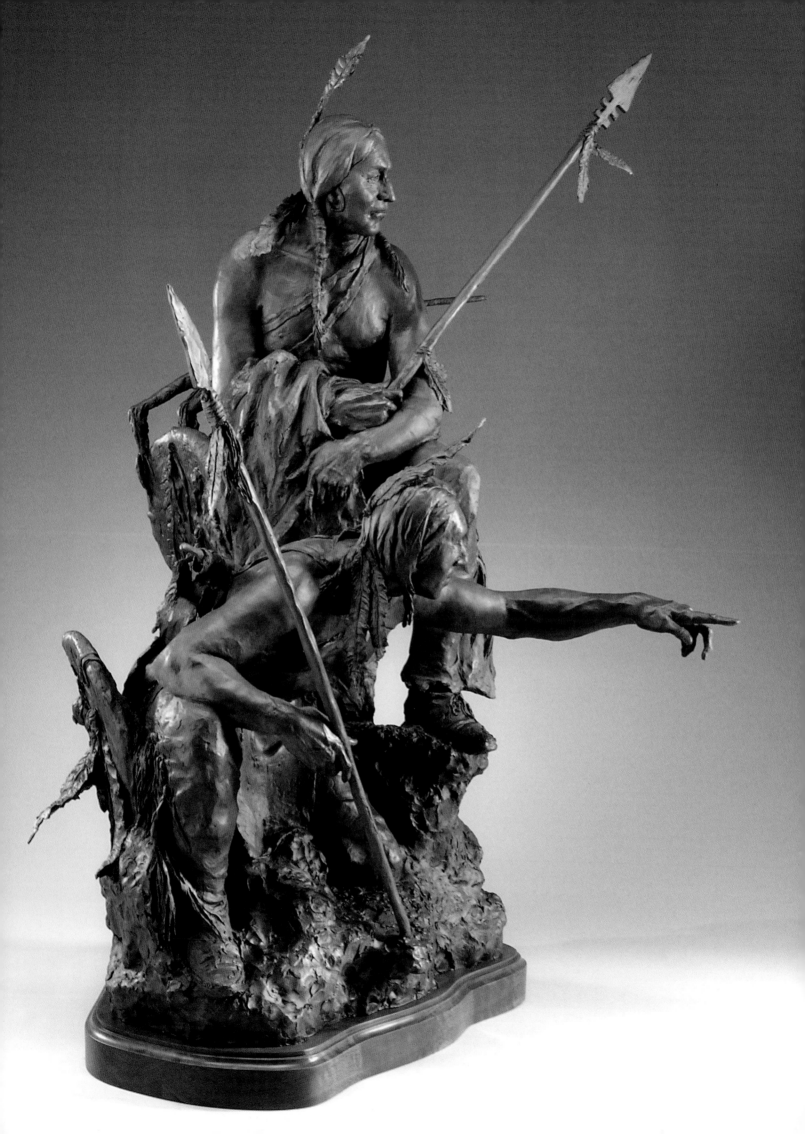

HERB MIGNERY

"An artist must be a dreamer—possessing a love and appreciation for line and form," exclaims Herb Mignery, an acclaimed figurative sculptor who discovered his talent over thirty-six years ago. "At the same time, though, he must have a nagging dissatisfaction with the world as it is. Therein lies the catalyst that propels him to attempt perfection by redefinition." Although Mignery's sculpture is often characterized as Cowboy art, he believes his work more accurately falls under the broader descriptions of Western American art or Americana. "My subjects encompass much more than cowboys and Native Americans," Mignery explains. "My themes are taken from the everyday life of our society, both past and present."

Working with classic clays, Mignery is able to capture the essence and integrity of his subjects with amazing authenticity. Though his work often depicts the struggles faced by the inhabitants of the West, these figures possess a certain cultivated beauty in their imperfections. The level of detail poured into each work—including the historically accurate clothing, weapons and accoutrements—provide the viewer with a glimpse of the subjects' lives. As such, each new sculpture, including Mignery's *Call of the Bison*, completes a piece of the larger story of life in the West.

What inspired this piece?

Call of the Bison expresses the essence of the Indians daily quest for survival. The bison played a crucial role in the Native American way of life, as they depended on these creatures to satisfy their needs for food, clothing, and in some cases, shelter.

What prep work and techniques went into this sculpture and how did they contribute to the success of the finished piece?

Because I have spent years observing human and animal anatomy and form (clothing folds, musculature emphasis, etc.), I choose not to use live models while sculpting. To do so implants a preconceived image of the finished piece, which in turn dampens the spontaneity of art. With this particular piece, the composition of vertical, horizontal and diagonal lines were used to draw the viewer's eye to the core of the piece—the two men. Outside of this center, lines were employed to draw the viewer's attention directly back to the focus of the piece; so, in effect, the viewer's eye never leaves the sculpture. This is one of the hallmarks of good design.

What is your favorite part of this piece and why?

My favorite part of this piece is the overall design achieved. The contrasting textures represented in the smooth skin, the creased clothing, the flowing quality of the hair and the rough lay of the land, creates a visual tension that not only stimulates the viewer's eye, but encourages a curiosity to touch the sculpture. The textures actually look as though you can feel them with your eyes.

Why do you consider this one of your most significant works?

I find that each piece in my body of work has its unique qualities. In this sense, *Call of the Bison* is no more significant than any other sculpture I've done. However, I do consider it a stellar example of the three-dimensional complexities of visual texture.

What does this sculpture mean to you personally?

I feel that our attitude and view of our future can only be determined by an examination of our forebearers and the societies they created. Just as a weather vane points toward the source of the wind, it must also point to the direction the wind is going. Likewise, we must focus our attention both ways to avoid losing those valuable lessons so painstakingly learned by those before us. My works attempt to capture the spirit of this attitude by glancing back on the past so that we may better understand our present and anticipate the future.

CALL OF THE BISON Herb Mignery *Bronze* 37" × 52" *(94cm × 132cm)*

EUGENE MORELLI

Artist Eugene Morelli feels that sculpture suits him well. Not only does he love the perfect blend of physicality and creative versatility, but he also loves the hands-on nature of the craft. Seriously sculpting since 1979, Eugene began exploring the medium with the encouragement of his wife, artist Joan Zygmunt. It was under her tutelage that Eugene would develop his artistic abilities. He recollects, "My desire and direction was to make musical instruments. When I began building hammer dulcimers and banjos, Joan saw the skill I had working in wood and thought it would make a good paintable medium. Shortly thereafter, sculpting became my passion and occupation."

Though Eugene has sculpted in wood, stone and hand-fabricated metals, bronze is by far his favorite medium. With it, he is able to achieve virtually limitless forms, textures and finishes, making each piece uniquely individual. Drawing his inspiration from personal experiences in nature, Morelli is particularly attracted to portraying birds, as he's always had a special affinity for their beauty, grace and strength. *Arctic Flight* echoes the kinship Eugene feels with these creatures. He says, "The Hopi Indians believe that birds connect us to God. My sculptural work is an attempt to share and communicate my joy of these experiences."

What inspired this piece?

Arctic Flight was inspired by a sighting of a white Gyrfalcon in the spring of 1979. I had just met my wife Joan, and we were on a field trip for an ornithology class that we were taking at the University of Montana. We were at a wildlife refuge overlooking ponds filled with migrating ducks and geese, when the Gyrfalcon appeared overhead. It immediately began doing aerial displays. We watched in amazement for nearly ten minutes as it did tail stalls, barrel rolls and dives that ended in sharp U-turns back skyward. It truly was the most incredible flying I have ever seen. The sight of that beautiful white bird juxtaposed against the clear, blue, spring sky is permanently etched in my mind.

What prep work and techniques went into this sculpture and how did they contribute to the success of the finished piece?

This piece was sculpted in plasticine clay over a metal armature. A strong, well-supported armature is essential to sculpting a flying bird, since it needs to withstand working on both sides of the wings and feathers. I also used a smoother surface texture than I have on other works to give the final finish a sleeker look. I felt this helped to better capture the essence of a Gyrfalcon.

What was your greatest challenge in creating this piece?

The greatest challenge in creating this piece was to capture the feeling of movement, and the power and speed of a Gyrfalcon's flight. Most of this was accomplished with the position and composition, creating a downward, angling visual pull. Also, the angle and line that the wings form, together with the turning head, give the piece direction.

What is your favorite part of this piece and why?

My favorite aspect of this sculpture is the way it projects what it is from a distance, yet has a softness of finish and detail when viewed close up. It is not always possible to achieve both at once. Moreover, falcons and eagles have always been favorite subjects for my sculpture, and a hallmark of my work. *Arctic Flight* portrays a Gyrfalcon, the largest falcon in the world. Consequently, this sculpture is significantly larger than any other flying falcon I have sculpted, and I appreciate the grand, bold statement that it makes.

What do you hope it says to the viewer?

I hope my sculpture conveys the feeling of the joy and excitement that I have whenever I see these beautiful birds. Perhaps the viewer will connect his or her own experiences to the piece, strengthening his or her realization that we are all a part of, and connected to, this beautiful creation.

ARCTIC FLIGHT Eugene Morelli *Bronze* 36" × 23" (91cm × 58cm)

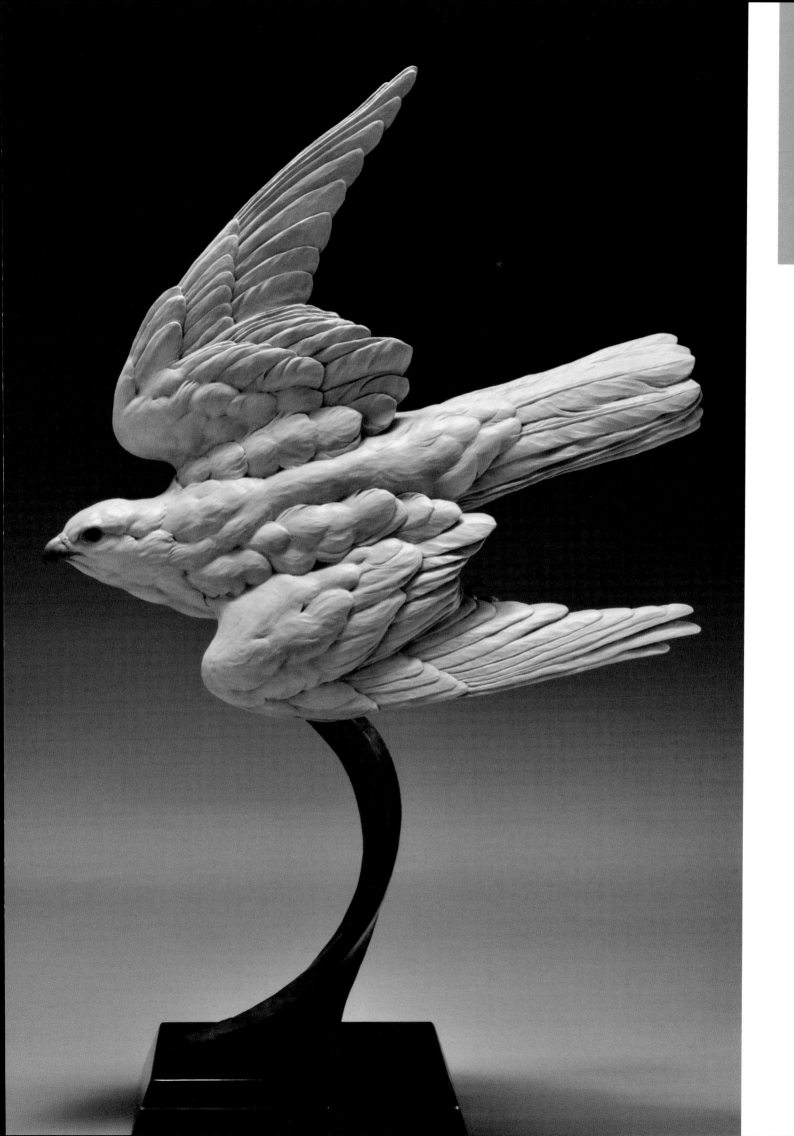

CHAMPION LANE FROST Chris Navarro *Bronze* *180" × 132" × 108" (457cm × 335cm × 274cm)*

CHRIS NAVARRO

Sculpting professionally since 1986, Chris Navarro is best known for his monumental bronze sculptures. He says of his trade, "The creation of a monument is an extremely time-consuming and labor-intensive effort, but the personal satisfaction that completion brings is very rewarding." And though sculpting is what Navarro happens to do for a living, he doesn't plan on ever retiring; his passion for the craft is too deeply rooted for Chris to ponder his life without it. Navarro happily declares, "I've found something I really love to do, and I hope others can see that through the works I've done."

A firm believer that one's experiences have everything to do with the way one sees the world, Navarro's sculptures are informed by the events of his own life. He explains, "As a sculptor, I re-create my experiences and bring to life in bronze images of the West, both contemporary and past." Chris is able to do this with an extraordinary intimacy of detail, reflecting his understanding of Western traditions. Having competed on bulls and bareback broncos himself, rodeo is Navarro's favorite subject. His firsthand knowledge of the sport greatly contributes to the authenticity and excitement captured in pieces like *Champion Lane Frost*, a tribute to one of rodeo's true heroes.

What inspired this piece?

I have always been a horseman. I started rodeoing when I was sixteen, riding bulls and bareback broncs. Today, it still remains one of my greatest passions in life. When the 1986 World Champion bull rider, Lane Frost, was killed competing at the Cheyenne Frontier Days Rodeo in 1989, I was moved to create a piece to commemorate his life. He was only twenty-years-old and at the height of his career, but he died doing what he loved to do. I found something very honorable and courageous in that, and I hoped to capture those emotions in this piece.

What prep work and techniques went into this sculpture, and how did they contribute to the success of the finished piece?

Because I couldn't create a piece of this size and stature without the necessary funds, I had to start on a smaller scale and work my way up. I created 18-inch maquettes of the proposed monument and offered these as gifts to donors who were willing to contribute $1,000 to the memorial's fund. I contacted the media to help spread the word, and over time, I was able to raise all of the money needed to begin the massive undertaking of this monument.

What is your favorite part of this piece and why?

It makes me proud when other bull riders look at my work and can tell that I, too, was a bull rider.

What was your greatest challenge in creating this piece?

There were many unexpected challenges in building this piece. First, the Cheyenne Frontier Days Committee refused my offer to build the monument because they didn't have the resources for the fundraising. After raising the funds myself, and just as I was starting to sculpt, my father passed away. Then, when I had nearly finished with the clay original, it was severely damaged in a fire. I had to scrape the sculpture and start over. But working fourteen-hour days, I somehow managed to finish the sculpture just five days before the dedication.

Why do you consider this one of your most significant works?

This will always be one of my favorite pieces. It tested me physically and emotionally like no other piece has. Every time I faced a setback, I picked myself up and persevered. As an artist and a man, it made me reach deep down inside and find out what I was made of.

What do you hope it says to the viewer?

Life only comes around once. Living it is a challenge that takes courage and perseverance. I hope this piece inspires the viewer to reach for his dreams and live life with passion and determination just as Lane Frost did.

R. SCOTT NICKELL

An unlikely combination of geophysicist and artist, R. Scott Nickell found his calling as a sculptor thanks to a birthday gift. As the owner and operator of his own oil company, Nickell spent many long and stressful days on the job. In an effort to help Scott relax, his wife Marsha signed him up for a sculpting workshop at the Hoka Hey Foundry in Dublin, Texas—a gift that would forever alter his life. Nickell says of this gift, "Sculpture changed the way I looked at the world. I could sit in a restaurant and look at everyone, studying their facial features, body types and wrinkles in their clothing and think sculpture!" Twenty-one years later, and with only three weeks of formal training beneath his belt, Nickell's bronzes are among the finest Western representations around today.

Both because Nickell is true to his medium, and because he discovered his talent in such a serendipitous way, he has never tried other mediums. "I started sculpting in oil-based clay and just loved it," he says. Focusing primarily on Native American or cowboy subjects, Scott finds inspiration from artifacts, books, and even Western films. It is his meticulous attention to details like beadwork and other trappings that make pieces like *Shadows of the Past* such valuable contributions to the heritage of America.

What inspired this piece?

This piece was inspired by the fine artistry of Native American clothing and the beautiful way it flows when in motion. *Shadows of the Past* is my attempt to capture the flowing form of a traditional dancer's clothes.

What prep work and techniques went into this sculpture and how did they contribute to the success of the finished piece?

There were two crucial phases of prep work involved with this project. First, I needed to work out, with a small clay model and a quick sketch, the motion of the sculpture. Then I conducted research on the style of clothing worn by the Crow Tribe to create a sense of authenticity and find a fashion that would best illustrate the motion of the dancer.

What was your greatest challenge in creating this piece?

Again, it was all about motion. It was challenging to capture the natural, flowing movements of the dancer while at the same time, keeping the figure from looking too stiff. I watched videos of dancers in slow motion, and with the quick sketch model, I captured the action of the dancer. I then enlarged the chosen pose for the final sculpture.

What is your favorite part of this piece and why?

My favorite part is the way the balance of the sculpture falls entirely on the dancer's left foot, creating the illusion of movement in a form that is actually stagnant. I also enjoy the negative space in and around the sculpture—particularly those spaces under the arms, around the bells on his ankles, and behind his breastplate—as they, too, contribute to the greater illusion of motion.

Why do you consider this one of your most significant works?

Everything from start to finish just felt comfortable and flowed. As an artist, when that happens, you know it will be a special piece. In most of my sculptures I spend the majority of my time crafting the standing figure and draping it in clothing, paying particular attention to design the wrinkles and folds of the fabric in such a way that the viewer can still see the figure beneath the clothing. While the same can be said for *Shadows of the Past*, it remains unique in that the figure is captured in a moment of movement. In my mind, this added element really enriches the piece.

What do you hope it says to the viewer?

I wanted to have the viewer step back in time and hear the drums. I want everyone to think about the proud heritage of the Native American people and to appreciate their traditions.

SHADOWS OF THE PAST R. Scott Nickell *Bronze 30" × 20" × 17" (76cm × 51cm × 43cm)*

SHADOWS OF THE PAST

SIESTA Dan Ostermiller *Bronze* *15½" × 14½" × 23" (39cm × 37cm × 58cm)*

DAN OSTERMILLER

Dan Ostermiller has been sculpting animals his entire life—or at least, so it would seem. The son of a famous taxidermist, Ostermiller grew up surrounded by animals, learning them inside and out. Building upon this foundation of thorough knowledge and the careful study of animal anatomy, habits and instincts, Ostermiller found the transition to sculpture to be quite natural. He explains, "I didn't have to struggle with the details like some sculptors that don't have my experience."

While Ostermiller's work is often vaguely labeled "animal sculpture," this is a gross underestimation of the range of his talent. Sculpting a vast array of animal subjects—from the barnyard to the wilderness of the great Rocky Mountains— Dan creates animal figures in context with their natural surroundings, striving to stay true to his subject while still retaining the artistic freedom to make adjustments. Bears, such as the Grizzly portrayed in the slightly abstracted *Siesta*, are one of Ostermiller's favorite animals to re-create in three-dimensions. "I love the form of bears," he says. "But sometimes my pieces aren't necessarily anatomically correct, and sometimes I stretch the truth—but you can't do that until you know the truth."

What inspired this piece?

The original inspiration for this piece came from one of the Grizzlies at the Denver Zoo. I visit twice a month to photograph the bears, which are kept in an open environment as opposed to a cage. This allows me to get pretty close to the Grizzlies, and I have a good lens on my camera, too, so it's almost as if I'm right there with them. Sometimes, I catch them when they are feeding, or afterward when they are lounging, like the subject of *Siesta*, and I think to myself "that would be cool." It's times like these when I find myself suddenly inspired that I have to head home right away and start sculpting.

What prep work and techniques went into this sculpture and how did they contribute to the success of the finished piece?

Siesta was originally created for the ten-year anniversary of the Georgia O'Keefe Museum. I wanted to create an homage of sorts to O'Keefe that would help celebrate the occasion. My goal was to blend a natural form with an inorganic form to create a recognizable composition that at the same time retained some of its abstract qualities, similar to what O'Keefe's did in her paintings. This is why the log doesn't reflect a true log, but a cylinder. I made the armature for the log out of PVC and attached it to a thin steel strip so I could suspend it and adjust the angle to create an opposing line to the base.

What was your greatest challenge in creating this piece?

Coming up with the idea was my greatest challenge. I didn't pick the animal—it picked me. I saw it and went with it; these things aren't always planned out.

What is your favorite part of this piece and why?

I am very involved in the actual design when the bronze is created. What is nice about this piece is the way it is off-balance. I find that to be the most appealing aspect of the sculpture, really. It was a feat of engineering to get the cylinder strong enough that it could support the bronze bear, but having the log barely touch the base also contributes to the aesthetic value of the piece.

Did this sculpture turn out the way you had envisioned, or were there some unexpected yet pleasant surprises?

What is interesting about this piece is that even though I started with just a cylinder, I already knew in advance what the finished product was going to look like. Most sculptors envision their pieces before they are completed, but sometimes I am still surprised when a vision is fully realized.

RICHARD PANKRATZ

For artist Richard Pankratz, sculpting grew naturally out of a career producing functional ceramics. "I began to differentiate between what I did to keep the bills paid and what I needed to do to feed my spirit," Pankratz says. "It was in the early 1990s that I finally began to consider sculpture might be what I needed to nurture my soul." Originally drawn to ceramics by the plasticity of the clay and the immediacy of the form, sculpture became the obvious counterpoint to this medium, as it required deliberation and serious thought. Not to mention, casting bronze had been near the top of Richard's list of things to accomplish for some time; he simply couldn't ignore the urge to give it a try at long last.

Today, Pankratz typically sculpts in either all bronze or a combination of bronze and ceramic. "In my mind the two materials are complimentary," Richard explains. "The rich colors available in bronze patinas mesh perfectly with the glazes I use in ceramics." In marrying these two very different materials, Pankratz finds that they often cooperate with each other, joining together to make a statement that neither could communicate without the support of the other. In the case of *Prairie Moon*, however, Richard knew he needed only bronze to express the concept he had envisioned in paying tribute to his native Kansas.

What inspired this piece?

I was raised on the prairies of Kansas and retain an appreciation for simplicity and harmony with nature. I wanted to create a large piece that would reflect this appreciation and that would make a bold statement in either a garden refuge or a public art format.

What prep work and techniques went into this piece and how did they contribute to the success of the finished piece?

As with much of my work, some parts of this sculpture are cast and some are fabricated. I wanted the smooth areas of the lower form to reflect the flatness of the landscape of the plains I knew as a boy. That meant I needed to fabricate these parts from sheet (for technical reasons) rather than cast the whole as a monolithic form. I needed to figure out how I was going to bend sheets of metal this large.

What was your greatest challenge in creating this piece?

Design is the easiest part of the process for me. There is no shortage of ideas, and themes often explode instantaneously complete. Figuring out how to physically make them is another matter. Once each part of this piece was made, they needed to be brought together and welded. The quality of the fit prior to welding needed to be accurate, so I needed to create leverage and clamping systems that would force the metal into exact position until a weld could hold it there.

What is your favorite part of this piece and why?

I like the image of the setting moon hovering over a serene horizon. In the lunar cycle, where the moon seems to be chasing the sun and losing the race, the half-moon sets in almost exactly this position. I seldom get to see it because it happens in the middle of the night, and elements like atmospheric haze, clouds, city lights, man-made structures or mountains often obscure the view.

What does this sculpture mean to you personally?

The production of this piece gave me a lot of time to think seriously about what we as humans are doing to the environment which sustains us. I feel it is time that we as a civilization think about the responsibility that comes along with the belief that we have "dominion over the earth."

What do you hope it says to the viewer?

I hope that the viewer senses the need for balance in life. Simplicity is needed to balance complexity, just as quiet is needed to balance activity, and none of it has meaning long term if we are in a state of constant confrontation and noncooperation.

PRAIRIE MOON Richard Pankratz *Bronze* 80" × 39" × 8½" (203cm × 99cm × 22cm)

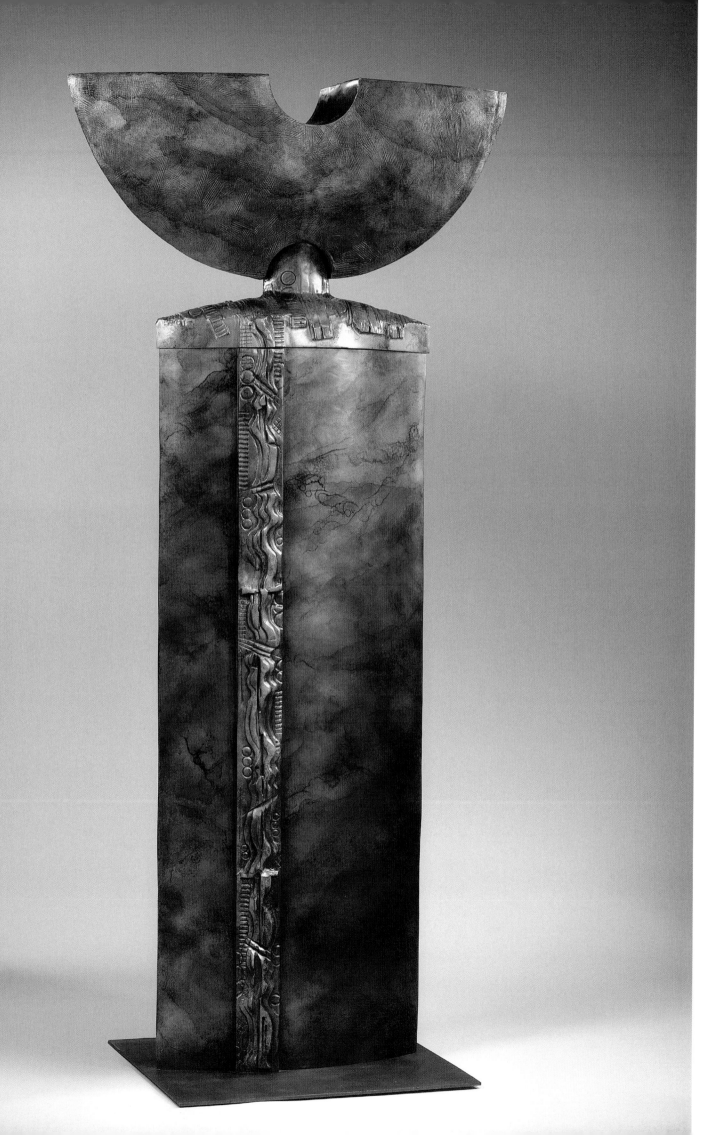

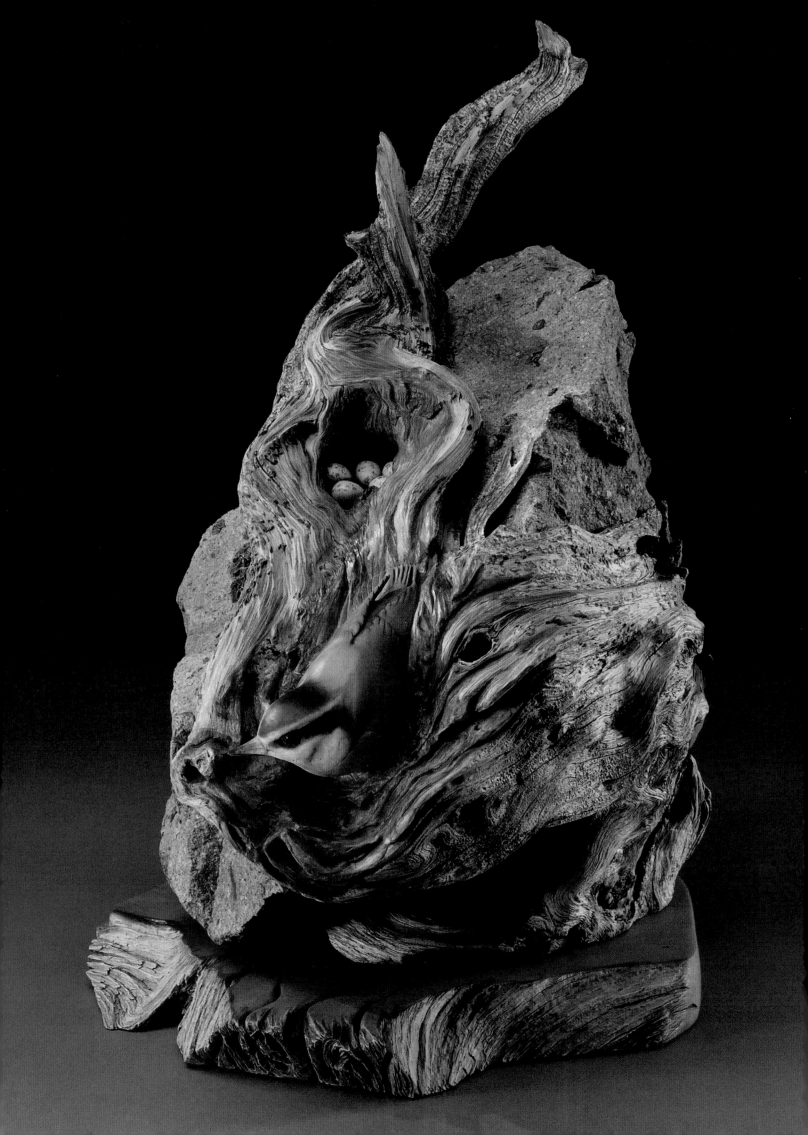

VICTORIA PARSONS

Victoria Parsons has always found herself drawn to the warmth and richness of Bristlecone pine and rare burl woods. Inspired by old gunning decoys and realistic duck sculptures that she herself couldn't afford to purchase, Parsons began sculpting from these materials in 1991, fashioning her pieces after the wildlife she so greatly admired. She continued to sculpt in relative obscurity until 2004, when she made the decision to begin marketing her work. Five years later, Victoria is now recognized as an accomplished sculptor, with works appearing in numerous prestigious tours, exhibits and shows.

Drawing from interactions with wildlife, Victoria's goal is to make a defining connection with her subject that embodies and transcends the essence of the animal. This is a process that begins early on with the selection of materials. Parsons explains, "Each medium, may it be wood, clay or stone, is chosen to portray the animal from my perspective." While she finds clay viable for its ability to suggest texture, and she enjoys the various rich colors that stone brings to her sculpture, working in wood possesses a special magic. "I find that Bristlecone pine and burls lend themselves to free-form sculptures that evolve from within, expressing the inherent beauty of animals," she says. This is certainly the case with *The Gathering*, one of Victoria's many splendid creations in wood.

What inspired this piece?

I have a deep love for animals and birds. The rare combination of a Bristlecone pine root wrapped around a lichen-covered alpine rock inspired me to create this truly special, one-of-a-kind sculpture.

What prep work and techniques went into this sculpture and how did they contribute to the success of the finished piece?

First, the rare Bristlecone pine must be collected by permit at timberline, between 11,000 and 12,000-feet elevation. This wood is one of the oldest living specimens on earth. Though I use samples that are between 1,000 and 1,500-years-old for my sculptures, there are some samples over 4,000-years-old. Once I collected the materials, I studied and researched the nuthatches and eggs, and then sculpted them in their true colors. Finally, the sculpture was accented in special oils and oil paints. All of these details were critical to the outcome of the sculpture.

What was your greatest challenge in creating this piece?

Capturing the essence and movement of the nuthatches and incorporating them into the natural flow of the wood was the biggest challenge. It also took great concentration and patience to reflect how they attach themselves, moving up and around the branches and capturing the beauty of their curved lines.

What is your favorite part of this piece and why?

I admire the way the Bristlecone root wraps around the rock so as to hold itself on the mountainside. I also enjoy the beautiful and natural flow of the wood and its coloration and texture.

Did this sculpture turn out the way you had envisioned, or were there some unexpected yet pleasant surprises?

There weren't any surprises while creating *The Gathering*, unlike many of my one-of-a-kind ventures. I suppose the only real surprise was to have the finished piece turn out completely the way I'd envisioned from the beginning!

What does this sculpture mean to you personally?

It's one of the most beloved pieces that I've created. It's a blessing to work with a medium that it so brilliant and beautiful, and it's equally wonderful to sculpt the things I hold so dear.

What do you hope it says to the viewer?

I hope the viewer grasps the story of a mating pair of nuthatches, their lives revolving solely around the protection of their eggs, nest and preparation for the birth of their babies.

THE GATHERING Victoria Parsons *Wood/Bristlecone Pine* 7" × 15" × 7½" (18cm × 38cm × 19cm)

DUSTIN PAYNE

A third-generation professional western artist, twenty-seven-year-old Dustin Payne is already seventeen years into his sculpting career. "My first bronze was cast when I was ten-years-old," Payne recalls. "My father built me a horse armature, heated up a block of Chavant clay in the microwave and turned me loose. I then began creating a little buckin' horse and a tough old cowboy aboard the bronc." Though he would take a brief detour into the world of plein air painting at the age of eighteen, Dustin soon realized that it was his fate to follow the family tradition of sculpting. He says of his attempted departure, "Though I learned a great deal from my studies in painting, I had very little confidence in my abilities. I realized that I had better stick with what I knew best, and that was sculpture."

Because everything he does seems to have sculpting in mind, Payne finds it hard to explain exactly what inspires him. As he gets older, though, he's begun to realize that inspiration can arise from almost anything in life. What makes this inspiration unique in Dustin's case is that he always finds a way to turn these ideas into Western ones. *Chisholm Trail Blues* stands out as a shining example of Payne's ability to transform the stories he holds dear into superior representations of the West, its characters and its landscapes.

What inspired this piece?

You know, my mother's father was a great fiddle player. He passed away at a young age, so I never had the opportunity to meet the man, but I grew up in awe of the stories I heard about him. Not only was he a great musician, but he was a pretty good cowboy too, and his heritage goes back to Charlie Goodnight. I thought the subject matter might have pleased him if he were still around.

What prep work and techniques went into this sculpture and how did they contribute to the success of the finished piece?

This particular piece had very little prep work besides the usual armature and things of that nature. The idea had been floating around in my head for a few years before I started with the creation process. Once I finally began the project, I got so caught up in the humor and the facial expressions that I pretty much just kept working and smiling. It was a very fun piece for me.

What was your greatest challenge in creating this piece?

The challenge I ran into with this piece was with the initial composition. In order to balance it out, I felt the banjo player needed to be a left-handed guy, so that's the way I made him.

Why do you consider this one of your most significant works?

This was the first time I had played around with using humor in one of my sculptures. I really like seeing collectors look at it, and it makes me happy to see people smile in response to something I created.

Did this sculpture turn out the way you had envisioned, or were there some unexpected yet pleasant surprises?

Because I'd spent so much time carrying this idea around with me and mulling it over in my mind, I pretty much had a solid vision of what I wanted to accomplish. I'm happy to say that it turned out pretty much the way I had originally pictured.

What does this sculpture mean to you personally?

Chisholm Trail Blues reflects a lot of the stories I was told about my granddad, so it is personal in that regard. But I was also pleased with the personality in the horses. I have spent a lot of time at rodeos sitting horseback, waiting to go. There are usually many other contestants doing the same, and the horses usually interact. I put some of this in the sculpture.

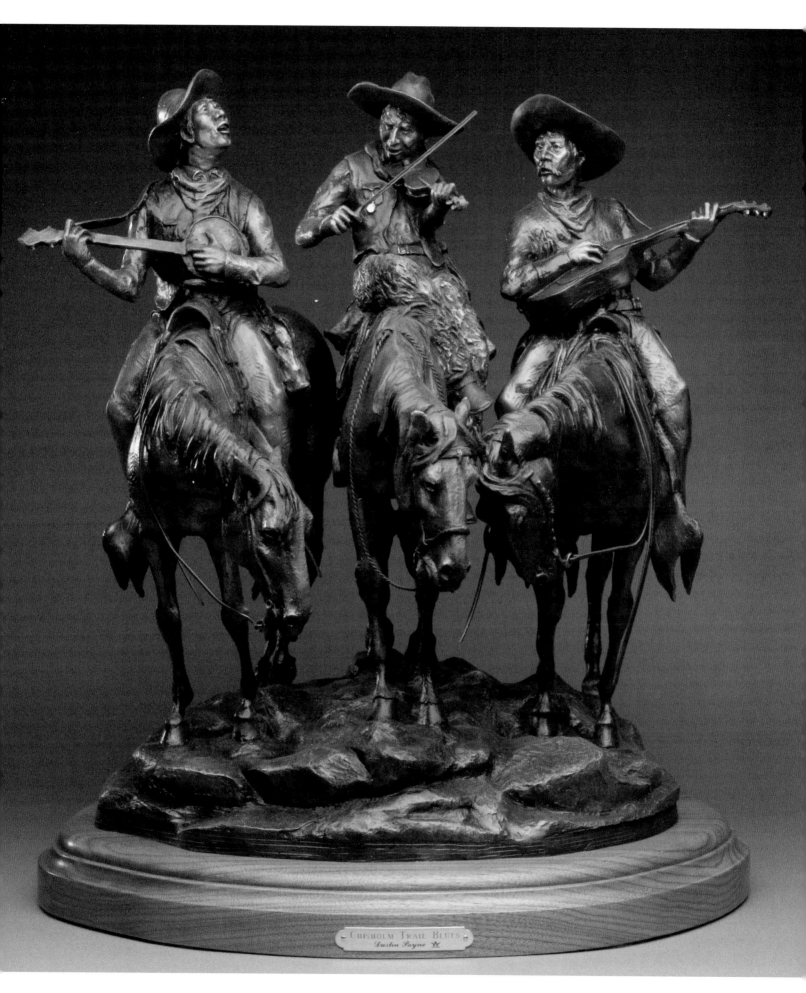

CHISHOLM TRAIL BLUES Dustin Payne *Bronze 17½" × 17" × 15" (44cm × 43cm × 38cm)*

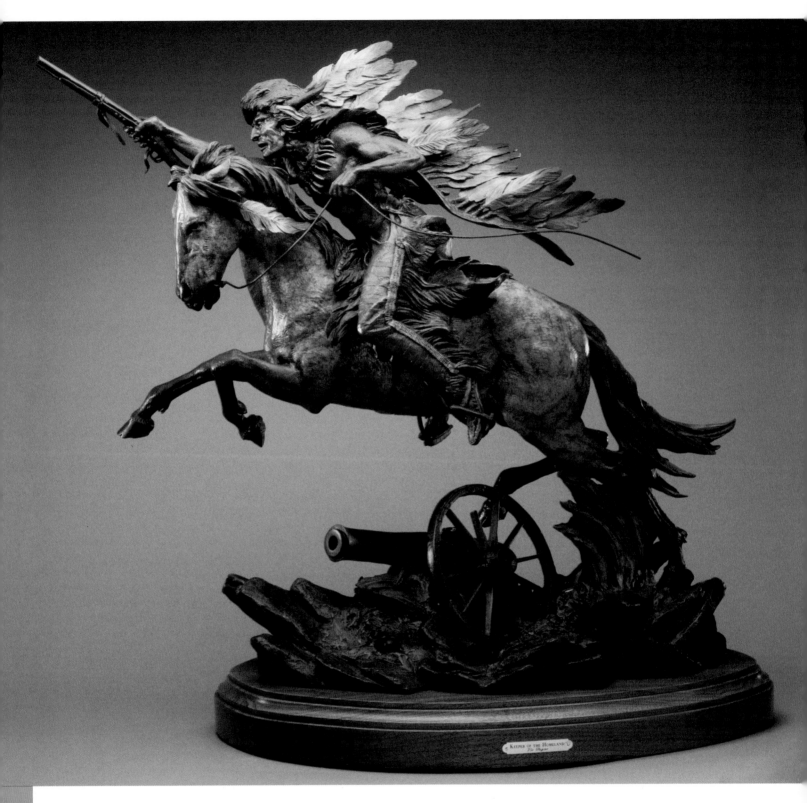

KEEPER OF THE HOMELAND Vic Payne *Bronze 28" × 38" × 13" (71cm × 97cm × 33cm)*

VIC PAYNE

In an attempt to preserve the history and spirit of the American West, sculptor Vic Payne works tirelessly to portray the landscape, wildlife and scenes of the frontier as accurately as possible. Son of western sculptor Ken Payne, Vic discovered his penchant for working with clay while employed as a truck driver, when he would sculpt to pass time in between deliveries. It wasn't long before Payne realized that his future lay in continuing his father's legacy of honoring the Old West through artistic expression.

With thirty years of experience behind him, Payne's sculpture brilliantly evokes the pioneering spirit of the land and its peoples, leading the viewer's imagination through the story his pieces tell. Known for its tremendous sense of authenticity, his work calls to mind the artifacts and reference photographs of times past. He says of his ability to capture the essence of his subjects, "I've always been inspired by the history of the American West. To do it justice, I use clay to cast my artwork into bronze, allowing me to convey my message in a detailed and accurate way." In his piece *Keeper of the Homeland*, Vic embodies this drive to create an authentic representation of history, while at the same time telling one of the West's most compelling stories—the Native American's defense of his homeland.

What inspired this piece?

For this piece, I wanted to show how the Indians might have felt when their homeland was invaded. I grew to appreciate their suffering even more than I had previously after the fateful day of September 11th when our nation was attacked. History has a way of repeating itself—this was my inspiration.

What prep work and techniques went into this sculpture and how did they contribute to the success of the finished piece?

First, I researched different historical events in Native American history, such as Wounded Knee, Sand Creek, and the artillery of the plains. I collected my armature and clay, and then sculpted a piece based on my studies of composition and anatomy; I have to do homework on every single piece. It is my goal to make each piece a dynamic sculpture.

What was your greatest challenge in creating this piece?

With *Keeper of the Homeland*, I found it challenging to get the cannon the correct size without having it overwhelm the piece. I ended up enlarging the cannon to suggest its importance, but I intentionally chose not to make it the focus of the piece. I feel this worked well.

What is your favorite part of this piece and why?

My favorite part of this piece was the inspiration behind it. *Keeper of the Homeland* forced me to think about how human beings are so anxious and willing to do anything when it comes to protecting their families, and how important security is to our survival. All nations try to protect their piece of the world and do not want outside encroachment on their homelands.

Why do you consider this one of your most significant works?

I always try to make my most recent piece my most significant work. I rely on the newest sculpturing techniques to try to make the piece I am working on better than the previous ones. By these standards, *Keeper of the Homeland* is a success.

What does this sculpture mean to you personally?

The events of September 11th evoked a great deal of personal feelings. I was merely trying to show these emotions by using a part of history that could have called to mind the same type of feelings.

What do you hope it says to the viewer?

I hope the viewer can feel the emotions I invested in this work, and that he or she also feels pride in the history of the American West.

LOUISE PETERSON

Originally hailing from Darlington, England, Louise Peterson began her artistic journey training in classical ballet at the Urdang Academy and The North London School of the Performing Arts. It was through her experiences as a dancer that Peterson first became intrigued by the idea of figurative sculpture. Later moving to the U.S. in 1984, Louise worked as a massage therapist, further developing her knowledge of human anatomy and heightening her interest in three-dimensional forms. By 1991, she finally decided to take sculpting classes to satisfy her curiosity. "I just had an idea that I'd like to try it," she recalls. Eighteen years later, it's evident that Peterson found her calling.

Although she learned to sculpt with the human figure, Louise soon found the only model available to her in the remote Colorado mountain town she now called home was her Great Dane. It was this serendipitous occasion that would ultimately lead to a successful career rendering those creatures closest to her heart. "I have a natural ability to see something and copy it in clay," she explains. "I'm inspired by what my animals do in everyday life, and my best work comes from what I observe in those I love." Both this talent to re-create her observations in three-dimensions and her love of the subject are beautifully illuminated in the heart warming *Chickadee*.

What inspired this piece?

I was inspired to create this piece when Nandi, my beloved Great Dane and first model, was caught on camera studying a fly that had landed on her. My husband has taught our wild chickadees to eat peanuts from our hands, and it isn't unusual for them to fly into my studio demanding food, or to harass us and the dogs when we are outside, landing on our hats or shoulders. A bird on the back of a Dane is a real possibility, and an amusing addition to this sculpture.

What prep work and techniques went into this sculpture and how did they contribute to the success of the finished piece?

Since animals won't just pose for sculpture, I employed a variety of reference material. The first idea for the sculpture was a photo taken many years ago. The Dane had since passed away when I came to sculpt this piece so my current Dane, Bella, was the model. I took lots of photos of her in this pose (or as close to the pose as she could get) from every angle. I also used video, and viewed it on my computer screen, which is next to my sculpture modeling stand. My Great Danes are often in the studio with me, and I referred to them for anatomy, measurements and questions about what happens to specific muscles in this particular pose. Photos and video are great, but nothing beats the real live animal, and being able to feel them with my hands.

What was your greatest challenge in creating this piece?

The greatest challenge was getting a chickadee to sit on the rear of my Great Dane. Of course, it didn't happen, but I used photos and video and the birds themselves as models. Since this was the first bird I had sculpted, I asked for the help of sculptor friends to critique the *Chickadee*.

Did this sculpture turn out the way you had envisioned, or were there some unexpected yet pleasant surprises?

The piece originated much smaller without a bird on the butt. Back then it was called *Deer Fly*. I wanted to get into the prestigious "Birds In Art" exhibition, so I decided a bird instead of an imagined deer fly might be the way to go. I sculpted it larger so it would have more presence and make a stronger statement. *Chickadee* was accepted into the exhibition, selected for the tour, featured on the poster and purchased for the Leigh Yawkey Woodson Art Museum.

What does this sculpture mean to you personally?

This piece is a reminder of my beloved dog, Nandi. She died at the age of eleven years and three months in April 2004.

CHICKADEE Louise Peterson *Bronze* 19" × 18" × 13" *(48cm × 46cm × 33cm)*

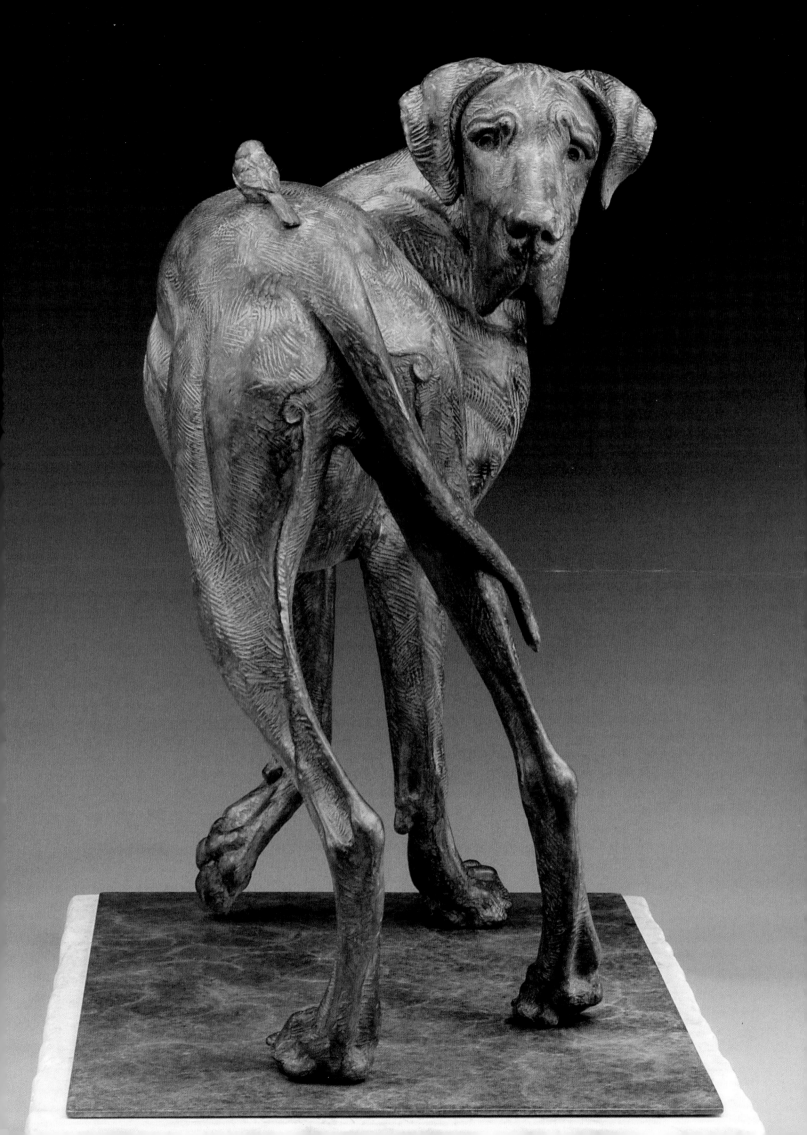

ABE LINCOLN Gary Lee Price *Bronze 54" × 70" × 45" (137cm × 178cm × 114cm)*

GARY LEE PRICE

Only in his final year at the University of Utah did painting and drawing student Gary Lee Price rediscover himself as a sculptor. He vividly remembers the moment he realized that he'd found his medium: "It was like coming into a warm, cozy house. It felt so good! Clay just made much more sense to me." Still reeling from the excitement of this discovery, Price began to focus his energies on creating figurative sculpture. Inspired by a deep fascination with people, relationships and the joys of human interaction, Gary's sculpture is successful in capturing the unique human spirit, informing the very essence of his work.

Sculpting now for thirty years, literally thousands of Gary's works can be found in collections throughout the world. Using oil-based clay that is warmed in the sunlight, his monumental and life-sized works are particularly striking, often portraying noteworthy figures. Price says of what he aims to accomplish through such work, "I hope I can assist the world in visualizing a place where fences and boundaries are nonexistent; a place where bias and prejudice are long forgotten; and acts of kindness, mutual respect and love are everyday happenings." Certainly, Abraham Lincoln strove toward much the same ends, making Price's touching portrayal of this great contributor all the more relevant.

What inspired this piece?

Abe Lincoln is the latest piece in my *Great Contributors* series, inspired by figures who have made lasting impressions on the Western intellectual tradition. Such contributors have always been a source of inspiration to me, as they represent one of the most positive messages known to man: All things are possible. Realizing that I, too, can achieve great things and help others do the same thing is an empowering discovery. And, as we are all capable of greatness, we are all connected to one another—in essence, we are one.

What prep work and techniques went into this sculpture and how did they contribute to the success of the finished piece?

For this piece, scouring the vast photo documentation of Abraham Lincoln was essential. Being the subject of innumerable photographs, he made my job a little easier. But I was also concerned with getting the *feel* of Lincoln, and this came through reading about him.

What was your greatest challenge in creating this piece?

Creating a representation of Lincoln that was extremely inviting and warm-hearted was my biggest challenge. Once again, reading was crucial to the success of this project. Learning how important relationships were to Lincoln, and how kind hearted he was, helped me capture his spirit.

What is your favorite part of this piece and why?

I like his smile. To me, this is really who Lincoln was.

Did this sculpture turn out the way you had envisioned, or were there some unexpected yet pleasant surprises?

This piece turned out exactly as I had envisioned it. My 20-inch original study was the first key to this success, and having a great assistant for the life-size piece was the second key.

What does this sculpture mean to you personally?

I feel this particular piece is a statement to which all people can relate. In spite of the chaos and confusion that life sometimes deals us, we can still choose to allow our inner peace and calm to guide us. Lincoln's life is the perfect example of this message—with all the war, tragedy and disorder that surrounded him, his inner peace, serenity and inviting personality still managed to shine through.

What do you hope it says to the viewer?

That suffering is merely denying what is. Let us not deny life, but embrace the journey.

LINDA PROKOP

When Linda Prokop moved to Loveland, Colorado, in 1985, sculpting was the farthest thing from her mind. "I got a job as an assistant secretary for a sculptor, and there was never enough for me to do," Linda recalls. "So they put me to work in the shop instead; this is where I would get my start in sculpting." Today, this experience serves as the foundation upon which Prokop's personal artistic interpretations have been built—interpretations that continue to evolve to this day. "As I grow as a human being, so does my work," she says. "It's a complicated process to be a bronze sculptor, starting at A and ending at Z. Surrounded by such wonderful artists and craftspeople, I am always learning something new. Without their talents, I could never achieve my visions."

Twenty-four years ago, when she first arrived in Colorado, the region was sculpturally dominated by realism, especially Western and wildlife themes. Linda boldly went against this grain, exerting her artistic independence by voicing personal messages through less traditional techniques. It is this loose yet intimate style that make works like *Perseverance* so exceptionally unique, pushing Prokop to utilize every artistic discipline at her disposal to convey some of the most personal experiences of her life.

What inspired this sculpture?

In 2001, the art market took a serious nose-dive as a result of 9/11. My artistic career bottomed out during that year, and I was basically unemployed. There was a real freedom in that time. I had no deadlines, expectations or self-imposed limitations, affording me with an opportunity to create several images that would ultimately redefine my sculptural direction. *Perseverance* was one of these pieces.

What was your greatest challenge in creating this piece?

My greatest challenge in sculpting this piece was letting go of my personal fear to reveal something so intimate and private for everyone to see. My work tells a story that is directly linked to the personal details of my life, so the challenge lies in determining just how closely I can or *should* put my life on display. In my experience, the more fear I have about creating a piece, the more successful the outcome.

What is your favorite part of this piece and why?

I am always content with works that allow me to transpose conventional ideas of size relationships. Consequently, my favorite part of *Perseverance* is the way the figure looks so small and insignificant in relation to the huge ball. In my opinion, the stark contrast between the size of the two objects creates a feeling of immensity. In other words, it expresses just how small and inconsequential things can seem in comparison to the universe.

Why do you consider this one of your most significant works?

Perseverance is a signature image that contains the essence of what I value in my work—simplicity. I want the message of my intention to be understood immediately by the viewer. But the sculpture within the sculpture contains a deeper meaning, and can transcend my original intent when the viewer's personal experiences and values are imposed upon it.

What does this sculpture mean to you personally?

The angst of my disheveled career after 9/11 was the driving force behind this piece. I distinctly remember the idea of this piece popping into my mind, and saying to myself on the spot, "My career feels like a huge ball that I continually push up hill." I didn't realize it at the time, but *Perseverance* became a symbol of my willingness and acceptance to continue sculpting, no matter what. Good times, bad times, I accepted that this is what I was put on Earth to do.

PERSEVERANCE Linda Prokop *Bronze 25" × 8" × 13" (64cm × 20cm × 33cm)*
photo courtesy of Jafe Parson

LINDA RAYNOLDS

A true lover of the Western landscape, sculptor Linda Raynolds' work strives to capture both the rough beauty of the natural geography and the vibrant ranching culture that thrives in her hometown of Cody, Wyoming. Originally drawn to Wyoming by its breathtaking backdrops and the animals that make their home there, Linda feels that she's found her "spiritual home." She says of Cody, "It is surrounded by wonderful desert landscapes—the climate is harsh, but even this harshness is part of its beauty to me."

Focusing mainly on the elements of shape, negative space and proportion, Raynolds prefers to work with natural substances like plaster, stone and water-based clay when fashioning her sculptures. And, though she casts limited bronze editions from her originals, Linda more often than not favors the original over the bronze. She explains, "I dislike the aspect of bronze that requires so many other hands to touch my piece. This is also why most of my pieces are smaller scale, because I like to work by myself—alone—with less compromise to my creative vision." Linda's small-scale piece entitled *Three Horse Drinking* exists as the perfect culmination of her artistic prowess and love of nature, using earthy materials to re-create awe-inspiring scenes of Western life.

What inspired this piece?

In the summertime, my husband and I ride our horses in the mountains. When we cross a stream, the horses will lower their heads and drink together. I've always loved looking down from the saddle, watching the reflections on the moving water while the horses slake their thirst.

What prep work and techniques went into this sculpture and how did they contribute to the success of the finished piece?

I used direct plaster, one of my favorite materials, for the original of this piece. This material allowed me to create a stone-like look while allowing more freedom in conceptualizing and executing the piece.

What was your greatest challenge in creating this piece?

Actually, this was one of those happy pieces where it all came together without having to surmount unexpected conceptual or technical obstacles. The different elements of the sculpture just fell into place.

What is your favorite part of this piece and why?

I like the way the different elements—the naturalistic, architectural and landscape themes—all come together. The piece is both ancient and modern, a fragment and whole, accidental and intentional.

Why do you consider this one of your most significant works?

The major themes of my artwork—nature, animals and the human interpretation of these elements—come together in a synthesis in this piece. More often, I have explored these themes individually. I don't have any other pieces quite like this one.

Did this sculpture turn out the way you had envisioned, or were there some unexpected yet pleasant surprises?

In my original conception of the piece, I had not really anticipated the way in which it could also be read as a landscape. When I recognized that element (the mountain range of the silhouette), I enhanced that aspect and made it clearer. This is part of what I love about the creative process: The way the piece itself, as it evolves under your hands, can take on new dimensions or even unexpected turns. The actual surface texture of the piece, by the very nature of the material and how I handle it, is always somewhat unexpected, as it is not a precise process. I just keep at it until I'm satisfied with how it looks.

What do you hope it says to the viewer?

I'd like the viewer to recognize the elements that I intentionally included, and yet have the freedom to discover their own interpretations of the image. This way the sculpture can have a life of its own, one that I can't anticipate or imagine.

THREE HORSES DRINKING Linda Raynolds *Bronze* 16" × 19" × 10½" (41cm × 48cm × 27cm)

from the collection of the Buffalo Bill Historical Center, Cody, Wyoming

photo courtesy of Elijah Cobb

JIM RENNERT

Working from his home studio in Salt Lake City, Utah, self-taught sculptor Jim Rennert first felt the urge to create art after selling his business nineteen years ago. Purchasing his first block of clay in 1990, armed with little more than a strong desire to learn, Rennert has since become adept at all aspects of the sculpting process. In fact, for the last six years, Jim has not only sculpted each piece, but has also cast all of his work from his studio. "Learning the process from start to finish has made me more aware of what metal can do, showing me its expressive nature and giving me an appreciation for the craftsmanship of the process," Rennert says.

Using traditional techniques to portray the modern world, Jim prefers oil-based clay and the lost wax method of bronze casting because of their metaphorical relationship to the "city" and "industry" themes prominently featured in his work. What's more, Rennert often employs the narrative power of three-dimensional art, using his sculpture to comment on the aggressive nature of the business world. Illustrating his point through metaphors that emphasize motion, sculptures like *Things Are Looking Up* certainly exist as part of this surreal commentary, as Jim both celebrates and critiques the difficulty of juggling a high-powered business career in today's technological age.

What inspired this piece?

For some time, I had wanted to do a figure juggling as part of my *Suits* series. The balls represent the various aspects of our lives and how difficult it is to keep everything going.

What prep work and techniques went into this sculpture and how did they contribute to the success of the finished piece?

Suggesting action in sculpture is difficult, but it is something I try to do in each piece. The placement and size of the balls, along with the movement of the figure, all contribute to the action of the piece. Creating the illusion that the balls are suspended in air ended up being my biggest challenge. When I started using flat plates of steel to frame the piece, creating a space for the figure to work in, it opened the door to complete my vision. By placing the balls against a stagnant background—with each ball at a different distance from the juggler—perpetual motion is implied.

What is your favorite part of this piece and why?

Because they were so challenging to create, and because of their significant symbolic importance to the piece, the balls are my favorite part of this sculpture. I like the way the figure is looking up and paying attention to what's going on. He knows that his juggling act requires great concentration to pull off, and if he looks away for even a moment, there is a distinct possibility that it could all come tumbling down. This is true of the multiple aspects of life everyone must figuratively juggle. This piece, then, serves as a literal visual representation of the anxieties associated with multi-tasking, and more specifically, is a metaphor for the demands placed on us by life's challenges.

Did this sculpture turn out the way you had envisioned, or were there some unexpected yet pleasant surprises?

The decision to use different-sized balls to represent both the larger and smaller priorities one has to manage on a daily basis came to me as I was sculpting this piece. I was very pleased with the way this decision contributed to the piece as a whole.

What does this sculpture mean to you personally?

This sculpture is my personal expression of the incredible tension I felt in being a part of the competitive world of business. When I look at *Things are Looking Up*, I am reminded of the tremendous pressures I felt I had to perform.

What do you hope it says to the viewer?

While this piece visually alludes to pressure, I hope it also relieves the viewer's own personal tensions, and that he or she finds some form of humor and optimism in it.

THINGS ARE LOOKING UP Jim Rennert
Bronze and Laser-cut Steel *39" × 15" × 10" (99cm × 38cm × 25cm)*

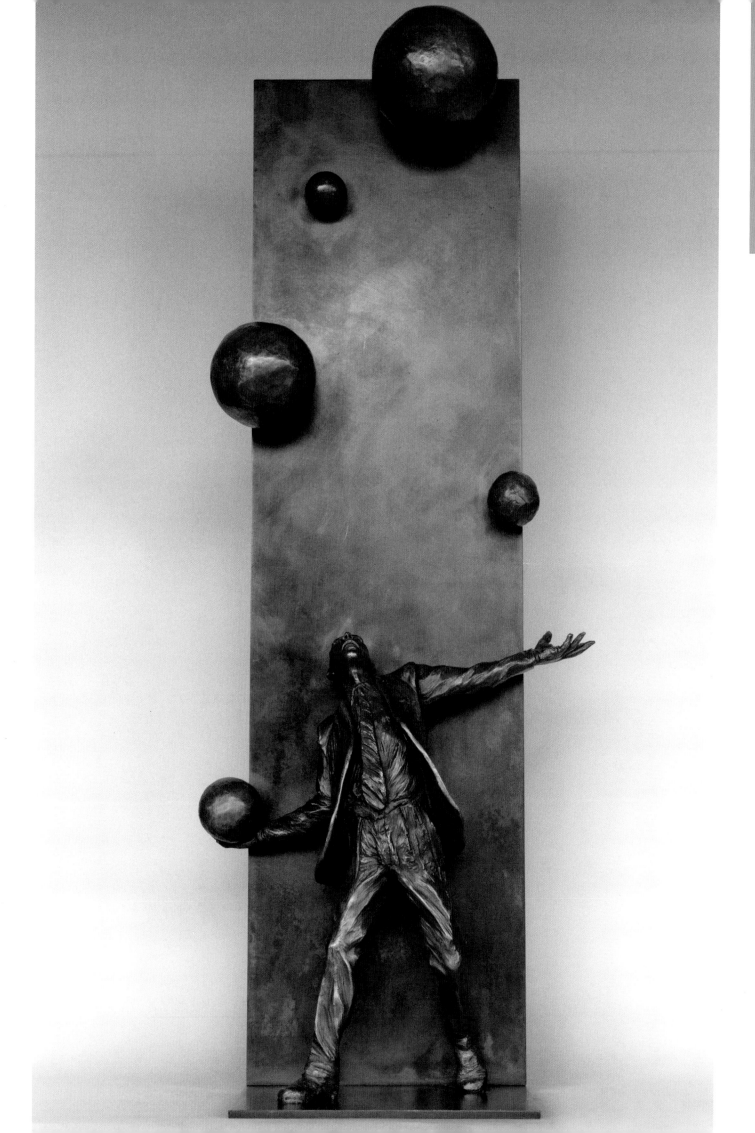

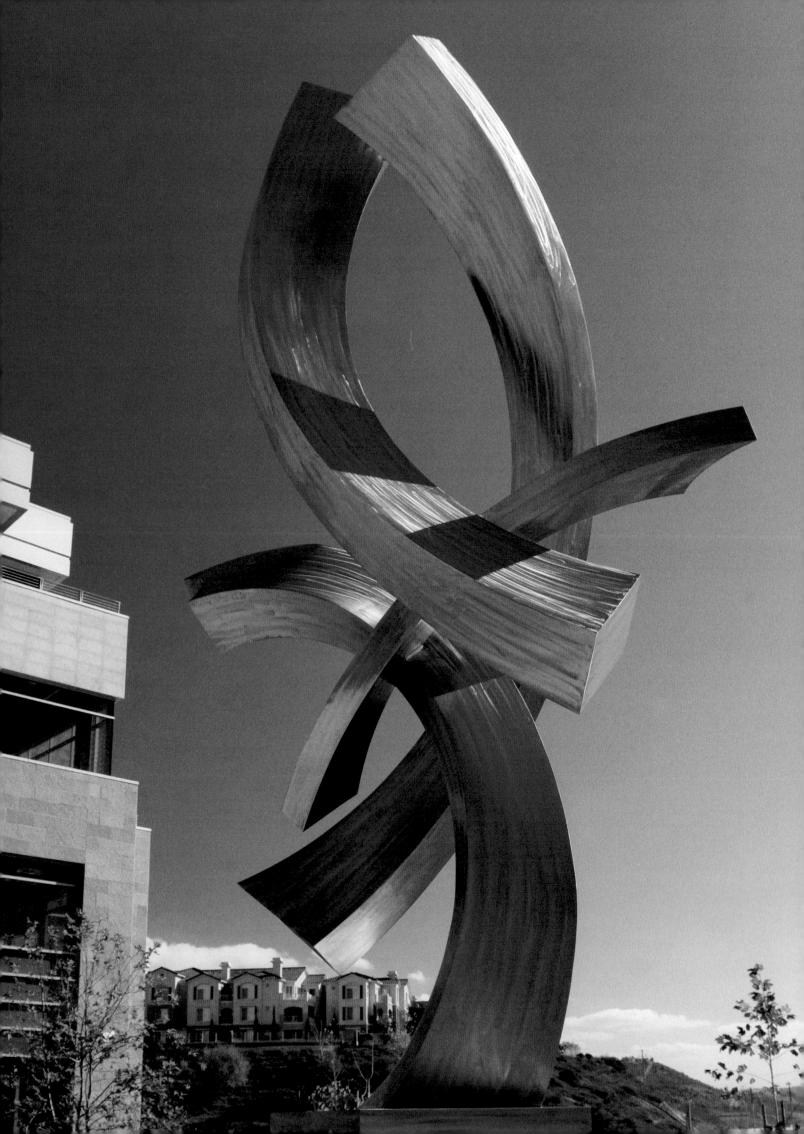

KEVIN ROBB

In 2004, after a massive stroke left artist Kevin Robb unable to speak, write, or use his right arm, he still refused to surrender his lifelong love for sculpting—a passion his wife Diane says he couldn't live without. As a result of unyielding determination, Robb has since gone on to sculpt some of his greatest works yet with the help of men hired to act as his hands. As Diane reflects on the joy that has been Kevin's artistic journey, she recalls the progression of his vision and style, something that continues to evolve to this day.

Diane credits a trip to Japan in the early 1980s with first inspiring Kevin to employ the free-flowing, almost lyrical curvature his work is so well-known for today. After his stroke, Robb would take this a step further, adding twists and turns, giving his sculpture a heightened sense of visual drama—something Diane says is enhanced by the marriage of Kevin's trademark techniques and choice of materials. She explains, "He often works in stainless steel, and loves the way metal can be formed yet still have a mind of its own. The signature brushed grind marks really make the sculptures come alive—it changes the look and feel as the sun moves around it, and the moonlight dances off the grind marks, ensuring that the sculpture lives even in the dark." This is certainly the case with *Dancing in the Sun*, a piece that holds the viewer spellbound day or night.

What inspired this piece?

This thirty feet tall sculpture was a commission that was sold based on a previous sculpture created a couple of years ago. All of Kevin's works are one-of-a-kind, so with commissions we always state the sculpture will be "similar, but not exact." The clients were excited about the basic design and the overall genre of Kevin's work. They gave him plenty of latitude in the actual creation of the sculpture.

What prep work and techniques went into this sculpture and how did they contribute to the success of the finished piece?

The prep work and techniques were determined by the sheer size of the project. It is the largest sculpture that we have created thus far and there was no way it could be manufactured in our own studio, nor in any number of fabrication shops we were familiar with. We finally located a shop in Denver that had the room, equipment and staff to manage the project. The actual welding and grinding of the individual elements was fairly easy once they understood what was expected of them. Kevin visited the worksite to assure that the quality was being produced that he has based his reputation on. The next challenge was locating a workplace that had the equipment and welders to stand the sculpture up to make sure it had been manufactured correctly. It was then disassembled into four pieces and shipped to San Diego. Once there, it was just a matter of reassembling and lifting it onto place with a large crane.

What was your greatest challenge in creating this piece?

One of the biggest challenges of this sculpture was that it had to have engineering drawings and approval and this removed Kevin's favorite part of sculpting—letting the metal speak to him as he is creating. As Kevin sculpts, he becomes one with the metal and intuitively knows the twists and turns that will be required to achieve the desired result. Working from drawings stifled his creativity.

What does this sculpture mean to you personally?

It is always the dream of a metal sculptor to create a major, larger-than-life sculpture that is commissioned and enjoyed by thousands, and this sculpture captures that dream. What makes this dream even more fulfilling is the piece was sculpted even after Kevin suffered a massive stroke and lost his ability to speak and to physically weld.

{QUESTIONS ANSWERED BY DIANE ROBB}

DANCING IN THE SUN Kevin Robb *Stainless Steel* *360" × 168" × 144" (914cm × 427cm × 366cm)*

SCOTT ROGERS

To sculptor Scott Rogers, it seems like only yesterday that he bought his first bronze from his uncle, Grant Speed—a purchase that would lead Rogers' life in an entirely new direction. He recollects of this transformational moment, "I took it home and looked at it for hours. In fact, that evening I took a sleeping bag out of the closet and lay by the piece to turn it in the moonlight. My love affair with bronze had begun." Twenty years later, Scott is still pouring his soul into the medium, using his art as a vehicle to inspire mankind to beauty and reveal to the viewer his emotional fingerprints. He exclaims, "Put a lump of clay in my hands, and a short while later you will know exactly how I feel and see into my heart."

Drawn to the spirit of the Old West since early childhood, Scott would spend hours reading of renegades, outlaws, wild men and horses, instilling in him a passion so strong that he now seeks to express it through the power of clay. Inviting all that view his work to step back a hundred years and find the spirit of the Old West, sculptures such as *The Portage* illustrate just how dedicated Rogers is to portraying the cunning, independence and courage of the Western character. "I attempt to draw the viewer in as an active participant in the moment I portray," he says—a goal he certainly lives up to.

What inspired this piece?

About ten years ago, sculpting veteran Fritz White told me an idea he had for a sculpture of an Indian portaging a canoe up a cliff. Fritz never completed the piece, so after a few years, I asked him for permission to sculpt his idea. With his blessing, I tried my hand at it, but had no luck. Another five years passed. In 2008, I was pondering what to create next. Fritz's idea popped into my head again, but this time there was a flash of inspiration, and I instantly knew what the problem had been before. With the Indian going up the cliff, the viewer could only see the bottom of a canoe and a pair of legs sticking out. So I transposed the image, now showing the Indian coming down the cliff. Suddenly, it started to sing.

What prep work and techniques went into this sculpture and how did they contribute to the success of the finished piece?

Before I could create this piece I had to know all about birchbark canoes. How long were they? How were they made? How much did they weigh? Could one man carry it as I depicted? I conducted a great deal of research to come up with an accurate and authentic depiction.

What was your greatest challenge in creating this piece?

Creating the armature of the canoe was my biggest challenge. I contemplated this problem for years. It held me back. But with a bit of metal screen, bailing wire, metal plates and angle iron welded together, I made it work. I have also found rocks to be one of the most difficult things to create in sculpture. The secret is to realize the perfection in the chaos of Mother Nature. No two rocks are the same, and yet a symmetry exists.

What is your favorite part of this piece and why?

I love how the abstract shape of the rocks mimic the shape of the canoe and how the Native American ties them together. It is very subtle. I also like how the composition of the rocks and canoe work together to form an abstract point to the upper right. This point adds to the tension of the Indian's precarious venture down the cliff face and leads the viewer to wonder "Will he make it?"

Did this sculpture turn out the way you had envisioned, or were there some unexpected yet pleasant surprises?

None of my sculptures ever turn out the way I envision them in the *divine concept* phase. If I held to a rigid idea, it would stop inspirations that come during the creative process. One of my strengths is listening to others' input. One artist told me it would work better if I put an organic element (dead tree) in the back. Another artist told me to pull the shapes of the rocks together into larger masses—I did both.

THE PORTAGE Scott Rogers *Bronze* 41" × 29" × 22" (104cm × 74cm × 56cm)

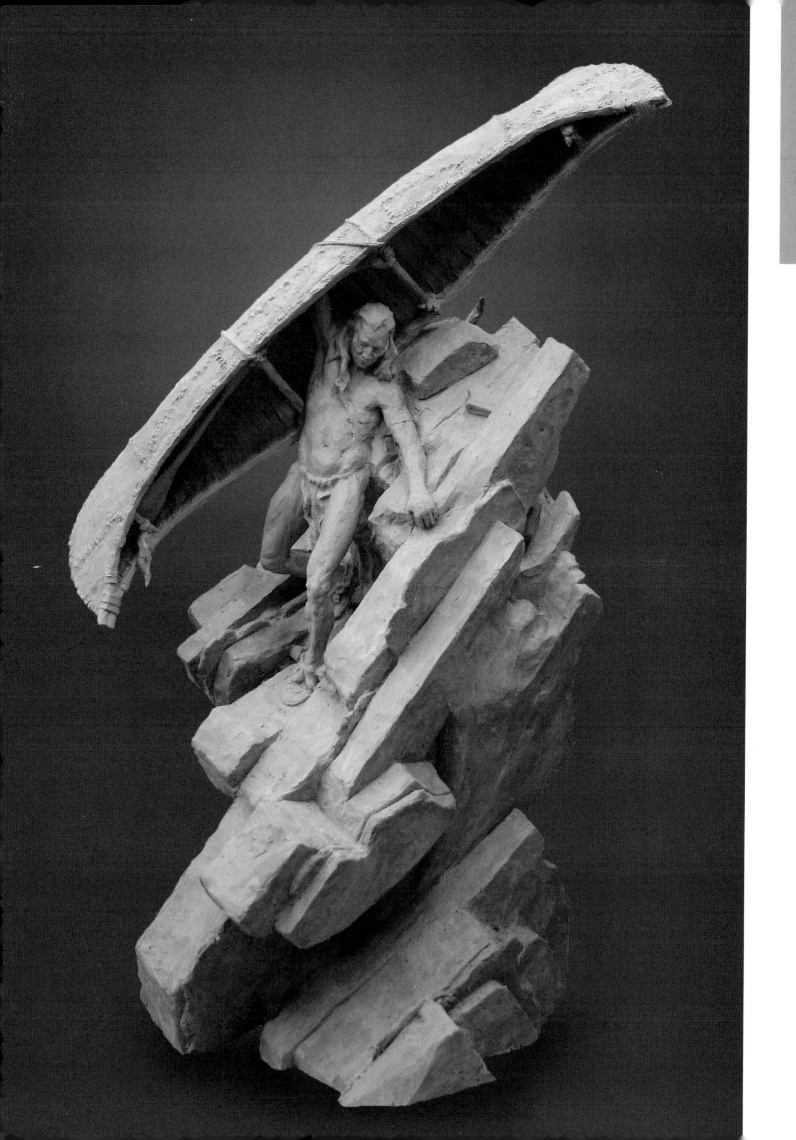

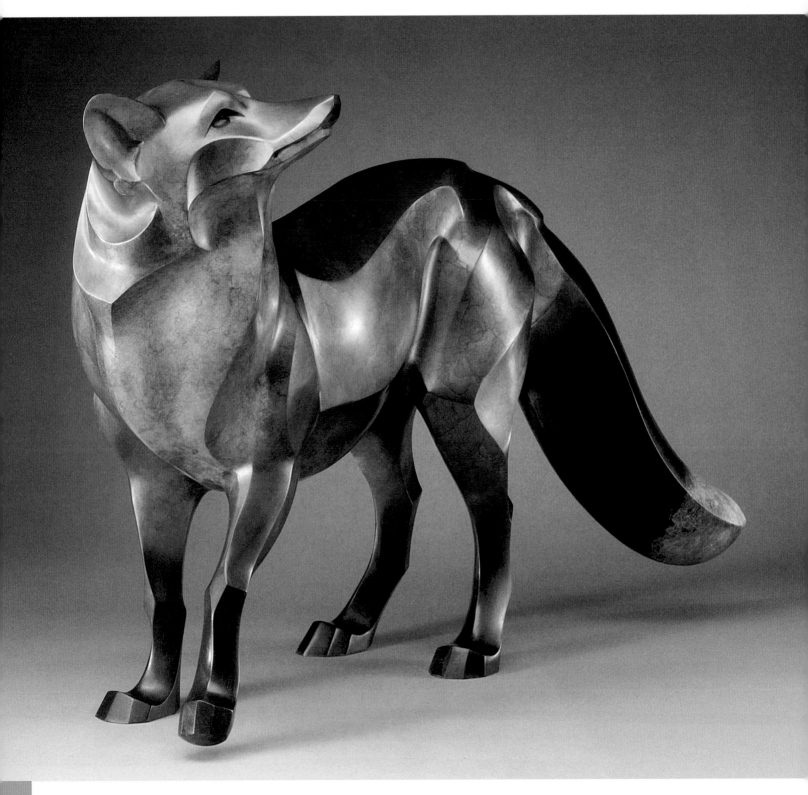

RED FOX Rosetta *Bronze* *21½" × 35" × 12½" (55cm × 89cm × 32cm)*

photo courtesy of Mel Schockner Photography

ROSETTA

Sculpture has always been something Rosetta has done for the pure joy of it. "I don't consider creating to be a part of my job," she explains. "Whether it was carving animals out of soap as a child, or carving building scraps into decorative elements for the house my husband and I designed, I've always enjoyed the chance to create." But it wasn't until computer technology put an end to her successful freelance career designing and hand-lettering logos and packaging that Rosetta thought perhaps she could actually make sculpture her livelihood. Enrolling in her first bronze casting workshop shortly thereafter, Rosetta would soon earn critical acclaim that would encourage her to pursue her "real first love": Working in three-dimensions.

Making animals the focus of her work, Rosetta's style has been described as hard-edged yet soft, sensitive and powerful. "It is a combination of great appreciation for the wondrous qualities and profound innocence that I sense in the animals, and the blending of realism and abstraction in my visual interpretations, that imbues my sculpture with these qualities," she says. In her piece simply titled *Red Fox*, Rosetta showcases this true talent for communicating her unique vision to the viewer, while still capturing the very essence of the subject.

What inspired this piece?

One of the things I missed the most when I moved from my California home among the Redwoods, to a Colorado bungalow in town, was seeing wildlife in my yard. Deer, raccoon, skunk and possum were all regular visitors when I lived in the forest, but now that I'm in a more developed setting, I'm mostly relegated to just squirrels. However, I do occasionally spy red foxes crossing through my yard, taking temporary shelter under a huge Blue Spruce on their rounds of the neighborhood. What a joy! This is one animal I didn't see in the Redwoods! He is both beautiful and benign, and it is these serendipitous glimpses that inspired my sculpture.

What prep work and techniques went into this sculpture and how did they contribute to the success of the finished piece?

Ever since I discovered casting in bronze in 1984, I have been in love with the medium. My techniques for working in this medium are fairly standard when it comes to casting. It is in the creation of the clay original where I've developed my own personal techniques. In particular, other sculptors often ask me how I get my surfaces so smooth. Though I do use a solvent at the very end on the larger shapes, I avoid using it where it might obliterate the crispness of the ridges and subtleties of smaller shapes. Thus, refining each shape and line simply requires many ever-lighter passes with the metal tools , along with infinite concentration and patience to persist until the desired configuration is reached.

What was your greatest challenge in creating this piece?

The challenge in creating *Red Fox* was the same one I face with every piece—to design a series of pleasing abstract shapes and forms that, when put together in a cohesive design, will capture the spirit of the animal, maintain its proper proportions and anatomy, and strike a pose that is both dynamic and true to the character of the animal.

What does this sculpture mean to you personally?

Although I grew up in the suburbs with little exposure to wildlife, I have always related to animals very intensely and feel a personal affinity for them as sentient and sensitive creatures. I relish the opportunity to be near animals, so it was truly a thrill for me when this red fox honored me with his presence. As such, this sculpture reserves a special place in my life.

What do you hope it says to the viewer?

In my heart, I cannot understand the insensitivity so many have toward animals. To do them justice, I strive to make each sculpture a treasure—an inspiration to others to cherish these creatures as I do.

RYSZARD

Involved in the arts most of his life, abstract sculptor Ryszard discovered his talent for carving stone thirteen years ago, when a chance meeting with a fellow sculptor at the Art Student League in Denver would spark his interest in the medium. "I had created art in wood, leather and raku," Ryszard says, "But when I discovered the fulfillment of sculpting in stone, I knew this was my medium." This newfound passion ultimately led Ryszard to relocate to Denver—a place that many like-minded stone carvers call home, where fine marble and alabaster are readily available to the artist. Since then, there has been no looking back for this sculptor, as stone remains the only medium for bringing his unique visions to life.

Carving directly onto stone, Ryszard's figuratively abstract style explores the twists and turns of the human body, often examining complex relationships, mythical stories and social commentary. He says of his technique, "I transfer the idea directly onto the stone and work from the lines; this allows me to change the direction of the idea while I carve." This often leads to interesting discoveries for Ryszard. For example, in his piece *Metamorphosis*, inspired by Kafka's short story, Ryszard saw an opportunity to make the piece his own. He says, "I took literary license and had the protagonist become a moth—I think Kafka would approve."

What inspired this piece?

This sculpture started out as a sliver of Yule marble that I shaped and then added a hole. Two years later, I started to re-work the piece and saw what appeared to be a moth with a human face. Adding the wings completed the sculpture. I initially named it *Kafka's Moth* with the subtitle *Metamorphosis*. However, since only a few people could relate to this title, I changed it to *Metamorphosis*. This helped in giving the piece a more universal feel.

What was your greatest challenge in creating this piece?

The delicacy of line and folds of the final sculpture were prone to cracking, which meant I had to pay special attention when using my inline hammer and file to define the form. The greatest challenge, though, was to not overdo the design and keep it abstract.

What is your favorite part of this piece and why?

I really like the back of the sculpture. The wings come together in a flowing manner around the body, creating an encasing around the figure. This is both simple and stunning at once.

Why do you consider this one of your most significant works?

It was a turning point in my abstract works. By re-working the form from a flat abstract plane, it slowly evolved to flowing shapes. So, not only did the piece itself metamorphosize, but so did the direction of my work as a sculptor. In both regards, the title of the piece is perfectly appropriate and suggestive.

Did this sculpture turn out the way you had envisioned, or were there some unexpected yet pleasant surprises?

I think the final sculpture is the product of an evolutionary process that occured over several tries. After the second evolution, it became one of my favorites. It spoke to me in a way that no other piece has.

What does this sculpture mean to you personally?

I think I like the concept of *Kafka's Moth* and the final *Metamorphosis* because it parallels my life in art and my journey of personal growth.

What do you hope it says to the viewer?

I think the juxtaposition between my sculpture and the process of metamorphosis (either physical or psychic) is interesting. People who know Kafka's story respond with feeling and a confirming nod.

METAMORPHOSIS Ryszard *Colorado Yule Marble* 21" × 17" × 3" *(53cm × 43cm × 8cm)*

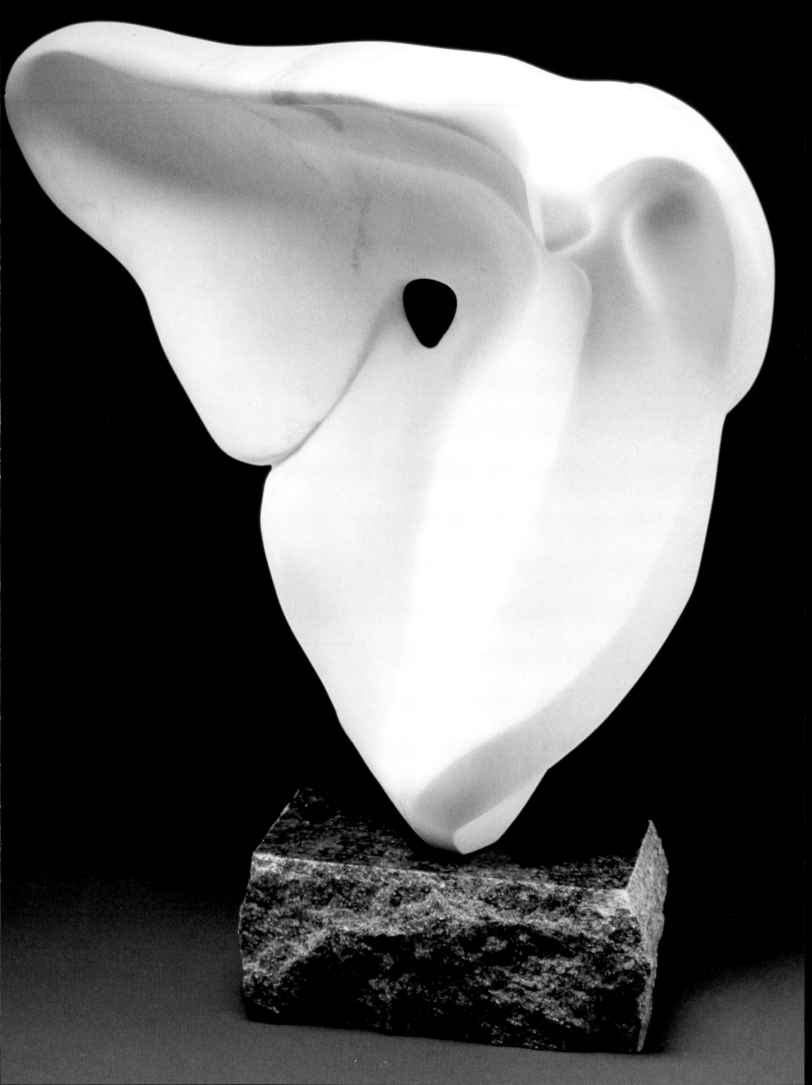

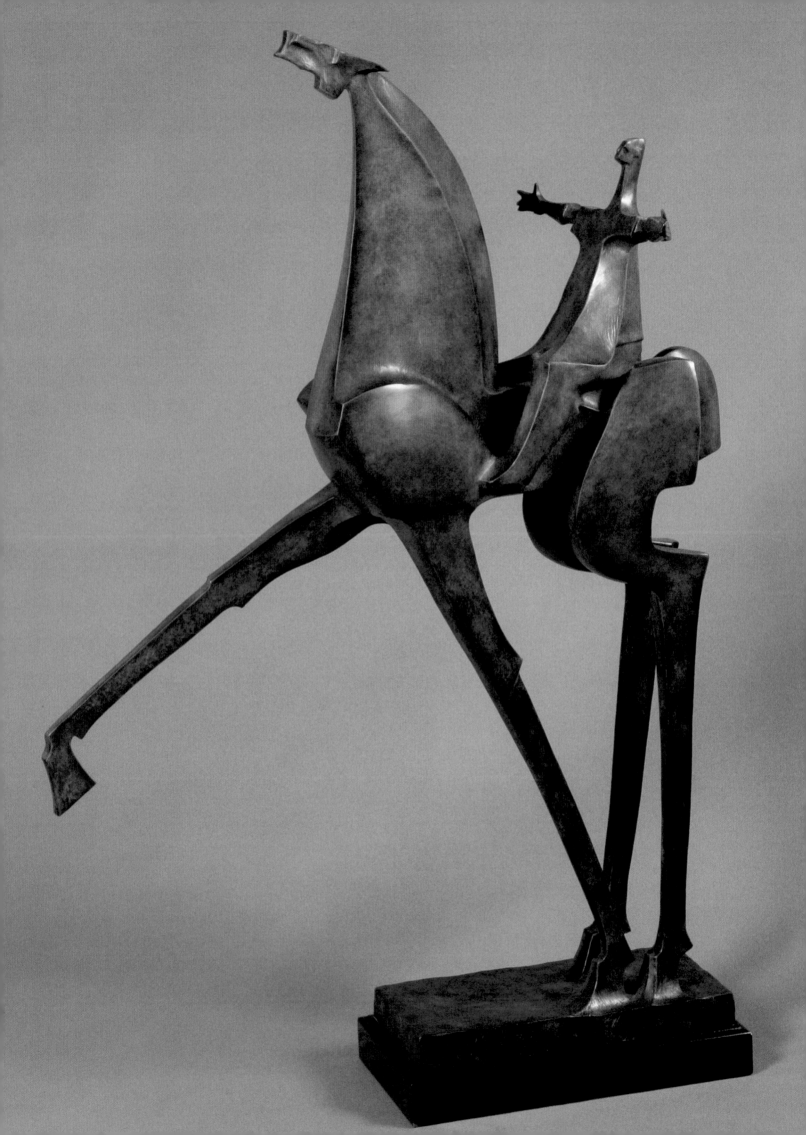

WAYNE SALGE

A self-proclaimed man of few words and many pictures, lifelong artist Wayne Salge can't place his finger on what inspires him to create—he just knows that it happens over and over again. In 1961, when Salge began a career in graphic arts, his college art professor suggested that he try sculpting as a departure from two-dimensional work. His curiosity ignited, Salge did just that, discovering the world of three-dimensional form through stone. But it wasn't until 1997 that Wayne would take up sculpting full time, using bronze as his preferred medium. When asked how he has grown as an artist since this time, Salge says, "Progression is my continual challenge, and I have been most fortunate to not run out of ideas; my work just gets stronger and better with time."

While Wayne's subject matter has certainly been influenced by the interesting people and animals he's come across in his lifetime, his sculptures represent his own uniquely abstracted depiction of these forms. Using what he calls "a Salge blend" of classical and contemporary elements, he utilizes line, shapes and textures to reveal the nature of his subject. "I am not concerned with precise anatomy," he says, "instead, I focus on the expression of attitude or emotion." His striking piece *Giddyap* is the perfect example of this original style, expressing what horse and rider look like through Salge's eyes.

What inspired this piece?

Images of future works come into my head while I am at work on a piece. I have no idea where they come from, and they are not accompanied by stories. As an image appears, I take a moment to do a quick sketch on a scrap of paper and throw it in the drawer of my taboret so I don't lose the thought. Sometimes I dream of new pieces in my sleep, but the majority of images occur while I am sculpting, and *Giddyap* was one strong image.

What prep work and techniques went into this sculpture and how did they contribute to the success of the finished piece?

From my simple line drawing, I saw how to fashion the interior armature with steel rods, tape and styrofoam. Then I formed the piece out of oil-based clay by completely covering the armature, building it up and carving it away again and again, until the piece was completed. I employ these techniques because they produce the best result for my style, as evidenced in *Giddyap's* long thin lines.

What was your greatest challenge in creating this piece?

The challenge for this piece was to keep the extended leg from sagging as I worked so that I didn't have to use an outside armature, which would obstruct my vision. I overcame this obstacle after rethinking the engineering aspect of the armature. I ended up using a ¼-inch steel rod from the base upward and curved it out.

Why do you consider this one of your most significant works?

I consider it significant because it melds horse and rider and expresses both motion and emotion in a strong design. The size and complexity of this piece elevated my progression with this subject matter, which I still continue to explore.

What does this sculpture mean to you personally?

Horses and humans, separately and in combination, comprise a majority of my subject matter. The nuance of body language remains the most important focus for me in all of my work.

What do you hope it says to the viewer?

I hope *Giddyap* grabs the viewer with its intense joy. My abstracted style leaves something to the imagination and interpretation of the viewer, and I am always interested to see and hear a person's reactions, whether positive or negative—it's a great learning experience for both artist and client!

GIDDYAP Wayne Salge *Bronze 44" × 30" × 8" (112cm × 76cm × 20cm)*

SHERRY SALARI SANDER

With her home and studio nestled on a 300-acre wildlife preserve in Montana's beautiful Flathead Valley, animal sculptor Sherry Salari Sander is surrounded by the very subjects that inspire her to create. She says of this ideal setting, "Montana is paradise; there's so much to see. When sculpting a piece, I like to provide the viewer with a glimpse into where and how that animal lives—Montana is a perfect environment to accomplish that." Sculpting now for over forty years, Salari Sander began her career as a potter, sculpting animals on the side as time allowed. But when her love for animals began to overwhelm her creative thoughts, she knew it was time to turn her sights toward sculpting full time.

Now living her dream, Salari Sander enjoys the challenge of working with forms to achieve the essential compositional continuity that makes a piece of sculpture "work." This drive is evident in pieces like *The Lily Pond*, which reflects the beauty, nature and wonder of Sherry's world. She says of this piece, "I believe it contains a measure of the success I hope to achieve, offering a visual statement of interest that conveys my love of animals and fosters an appreciation for wildlife." And while she feels no sculpture is 100 percent successful in achieving this goal, she is confident that each piece serves as a building block for the next one.

What inspired this piece?

Inspiration for everything wildlife is a second-nature, everyday part of living in Montana. Moose can be found throughout Montana from Yellowstone National Park in the south to Glacier National Park in the northwest. I have had the thrill of viewing and studying moose numerous times; in fact, a moose sighting within our community is not unusual, and I have developed a strong intimacy with this magnificent creature. The remains of a large pond that occasionally fills with water is found on our property. I cannot pass this pond without imagining the moose that might stop to drink there; thus, the inspiration for *The Lily Pond*.

What prep work and techniques went into this sculpture and how did they contribute to the success of the finished piece?

Homework and drawing are the underpinnings of my work. Knowing an animal, its environment and habits are crucial. The feeling for the composition evolved through numerous drawings, which gave me confidence in my ability to accurately depict the nature and beauty of the moose and its environment. Because of its very large head and pond-grazing nose, the moose is often depicted in caricature form. With this piece, I appreciate the opportunity to depict the moose as the truly proud, magnificent animal it is.

What was your greatest challenge in creating this piece?

The greatest challenge in this sculpture, as is the case in all my work, is combining all the elements—shapes, planes, forms and textures—to accomplish an honest rendering that *works* and presents a cohesive statement. I am most respectful of my audience. Although they may not know all the properties that go into creating a composition, they are very visually aware if something isn't quite right or doesn't feel sincere.

What is your favorite part of this piece and why?

What I like most about any sculpture I complete is when I am successful in naturally fitting the animal to the environment. I believe *The Lily Pond* is an accurate glimpse into where the moose lives, hopefully creating an interest in this creature and the importance of preserving it, along with its environment.

Did this sculpture turn out the way you had envisioned, or were there some unexpected yet pleasant surprises?

The ideas for my sculptures are never in concrete form, they evolve through the entire sculpting process. I try to think laterally, working and hoping for the accidents that may take me in new directions, exploring and capitalizing on what feels right. Parts of *The Lily Pond* were a delightful result of this process.

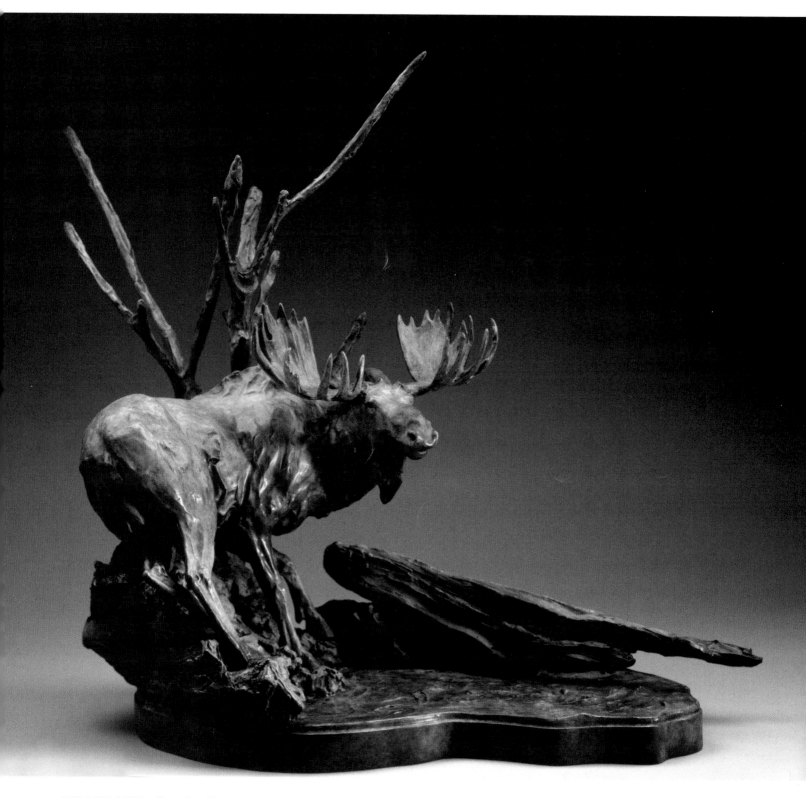

THE LILY POND Sherry Salari Sander *Bronze 34" × 30" (86cm × 76cm)*

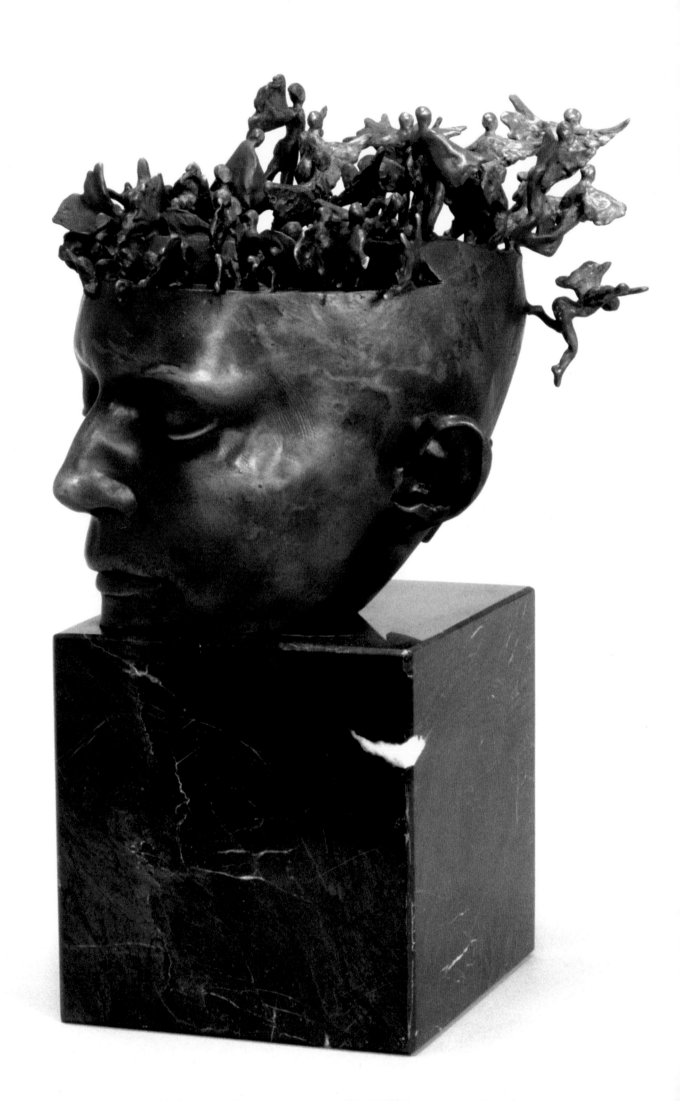

RIK SARGENT

Born and raised in Denver, Colorado, artist Rik Sargent moved to the San Francisco Bay area in 1970, influenced by the California comic book masters of this golden age in graphic storytelling. Just two years later, during a Christmas trip home to Colorado, Sargent would see the Western artwork of Michael Garman for the first time in Stapleton Airport—an experience that would change the direction of his career ambition and his life. He says of this pivotal moment "I did not fly back to San Francisco; instead, I went on to Colorado Springs to meet Mr. Garman, a decision that would lead me to the masters that were forming underground at that wonderful moment. Then I met the sculpture of Fritz White and Glenna Goodacre and thought, 'I can do this! I have to do this!'"

First teaching himself to sculpt with a pocketknife and candle wax, Sargent embarked on a slow process of self-discovery that is still ongoing today. When reflecting on how he's progressed during this time, Rik says, "As I have looked at sculpture over the years, it has taught me to see the assent of man and civilizations through the expression of the arts and not empires. War and conquest tell one story—art and philosphy describe another." It is this unique vision that informs brilliant pieces like *Free Mind*, a piece that came to Sargent providentially in a dream.

What inspired this piece?

Most of my works come from conscious thinking and ideas that inspire me to create three-dimensional descriptions of a particular thought. *Free Mind* is very unique in my career. It came to me in a dream that remains as clear in my mind as the night it was dreamt. There was a limitless plain spreading out to the center of the universe. The light was spectacular—an earthly light, not heavenly. Suddenly, angels walking, laughing, marching as if on parade, came over the plain and spilled into the void of infinity. My out-of-body camera pulled back, and I saw that the plain was my own mind and the joyful leagues of angels were my thoughts, infinite and spilling like a cup running over into the light. The next morning, I was early to work and the piece demanded its own creation. Two days later while completing the sculpture, we watched the planes hit the buildings in New York City and change our world forever.

What prep work and techniques went into this sculpture and how did they contribute to the success of the finished piece?

Free Mind became the first of twelve consecutive spontaneous ideas that demanded expression at that moment. These twelve pieces comprise the 911 series. Each sculpture in the series starts with the same universal head, which I created first. I attempted to sculpt an expression that was either male or female, providing me a blank canvas for the angel illustration. Then I allowed whatever needed to be expressed to come forth. I continued until I was content with the complete series.

Why do you consider this one of your most significant works?

There are other works in my portfolio that may be more successful public works or more finely crafted, but few works in my twenty-five years as a professional sculptor are as personal and honest as reflections of what I love about my life as an artist.

What does this piece mean to you presonally?

Free Mind is who I was at the beginning and before 9/11. All the rest are after the fact and in response to 9/11. *Free Mind* remains the truest reflection of me as an artist and a dreamer.

What do you hope it says to the viewer?

I hope the audience of *Free Mind* will celebrate that part of all of us that is not limited in their thinking to good and bad or the laws of man, but to the limitless possibilities of an open and free mind.

FREE MIND Rik Sargent *Bronze with Stone base* 14" × 12" × 14" (36cm × 30cm × 36cm)

TED SCHAAL

For the past seventeen years, Ted Schaal has found himself obsessed with creating unique three-dimensional visions. "With my art there really is no historical research or background; I'm simply trying to make sculptures that have never been seen or done before," he says. Creating his first bronze in 1992, while still a student at Colorado State University, Schaal immediately went on to work in a foundry after graduation. Here, Ted would learn more about the process, using the facility and support of the foundry to build a substantially-sized portfolio. By 2003, Schaal would begin aggressively pursuing galleries and fine art shows, forging his own way in the professional art world.

Casting his sculpture in bronze and stainless steel, Schaal is attracted to the permanence of metal. "In a world where everything is disposable, I make art that will last thousands of years," he says. Constantly carrying a sketchbook to jot down ideas, Ted latches onto a concept or natural phenomena, later trying to express it in three-dimensions. Halved Thricell was such a sculpture. Ted says of this piece, "The original looked like a meteorite or an alien seedpod; this sculpture was a progression or evolution toward trying to express that concept. For me it's all about the art and creating the best piece I can. I want to push myself in creativity and technical skills."

What inspired this piece?

Halved Thricell was inspired by a smaller sculpture I had completed that I wanted to enlarge and make more interesting. The first creation was all one piece and only about ten-inches tall. I was curious to see how it would look cut in two and arranged differently, and I wanted to make the negative space play against the sharp points and planed surfaces. The term *Thricell* is a conglomeration of three words: Thrice, cell and thistle. I chose these words because the piece has three points on each side, and it both seemed cellular and reminded me of a thistle seedhead at once.

What was your greatest challenge in creating this piece?

My greatest challenge was resolving the flat planes between the two halves. When I first started working on the piece the two flat planes were totally blank and boring, so it sat around for almost a year unfinished. One day I was cutting an avocado when, Eureka! It hit me that I needed to make a pit and its negative to finish the sculpture. Sometimes the hardest part is being patient enough to let the solution come to me before I scrap or prematurely finish a piece.

What is your favorite part of this piece and why?

My favorite part of the *Halved Thricell* is the way that the two halves rest against each other in a way where only three points touch the base. This kind of configuration creates a tremendous amount of tension and motion. As the viewer moves around the sculpture it opens and closes. The negative spaces between the points, facets and base change with every vantage point. I have found that when the viewer sees the piece for the first time, they have to look at it from every angle, as there is a sense of discovery in walking around the sculpture. When it was only on paper and in my head, I couldn't fully realize how interactive this sculpture would end up being.

Why do you consider this one of your most significant works?

This sculpture represents a major departure from the vessel forms that I had been producing up to this point. It is a move toward a purely sculptural body of work. I decided I wanted to start sculpting in a way that the pieces could be enlarged for public placements. *The Halved Thricell* is the first sculpture where the experimentation with negative space combined with the hard-edged geometric forms began. This was also the first piece where the flat, smoother plane makes its' appearance. Adding a smooth surface creates an element of precision, which is juxtaposed against the primitive rough corrugated texture. As a result of this new direction, I was awarded a large public commission for the City of Cerritos in California.

HALVED THRICELL Ted Schaal *Bronze* *24" × 30" × 24" (61cm × 76cm × 61cm)*

photo courtesy of Jafe Parsons

KIM SHAKLEE

Spending her childhood summers secluded in a family cabin located within the sylvan confines of Rocky Mountain State Park, Kim Shaklee has always felt drawn to animals. Whether it was showing Arabian horses in national competitions, aspiring to a career as a Marine Biologist, or simply viewing the wildlife from her back stoop, Shaklee immerses herself in the natural world around her. An unlikely sculptor, Kim's career started the minute she set eyes on some lifelike sculptures at a horse show. "I was totally consumed by the sculptures and felt a true connection and desire to become a sculptor," she recalls. Though doubted by some members of her family, it was the support and inspiration she drew from her father and grandfather that drove her to develop her artistic talent.

Though evolving personally and artistically, her love of marine life and maritime subjects remains constant and characterizes her work. Usually working with extra-hard Classic Clay, Shaklee gets the details and smooth finish she desires by creating natural textures with her fingers. "I love to use my fingers when preparing my surfaces. They are the conduit for my soul." *Homeward Bound* is her soulful expression of the plight of the sea turtle, gently warning us that these graceful creatures could soon be lost forever.

What inspired this piece?

Long ago, there were several million Green Sea Turtles on the planet. Today, there are fewer than 200,000 nesting females remaining worldwide. Added to the endangered species list in 1978, current estimates conclude there are less than 1,100 females nesting on our beaches in the United States. Because I have a strong passion for creatures of the sea, I wanted to help draw attention to endangered and threatened species. Creating a poignant composition helps draw the viewer into my piece, and hopefully evokes an interest in the turtle's life cycle.

What prep work and techniques went into this sculpture and how did they contribute to the success of the finished piece?

In addition to striving for anatomical accuracy in my subject—which requires thorough research—I like to create an artistry that goes well beyond the subject matter portrayed. I consistently use simple flowing curves and lines in my sculptures, so the turtles were a perfect subject. One characteristic reflected in my creative style is my ability to produce a glassy smooth surface with my clay. I was able to depict their rugged, aged appearances while drawing special awareness to their beautifully patterned shell. The patina was also crucial to this piece. I wanted to give depth to the turtle's shells while additionally portraying a strong representation

of water. The variegated shades of amber, red and black look like an actual tortoise shell, while the hints of green give the feeling and appearance of the turtles swimming underwater.

Why do you consider this one of your most significant works?

This is my favorite work of all time. I think it is very evocative and represents many different things to many different people. Though my initial sculptural intent was to portray the underwater mating rituals of a male and female turtle, it evolved into a much more thought-provoking sculpture. Many people have shared personal stories about how this piece invoked the image of someone dear to them. Two different individuals who had lost teenage sons related to *Homeward Bound* as a symbolic representation that their sons would someday be reunited with their siblings. The sculpture was truly a comfort to their emotional pain.

What does this sculpture mean to you personally?

This piece is a representation of the evolution of life in general. I've always held the belief that every person has the power within to accomplish whatever they envision as most important to themselves. Becoming a sculptor has allowed me to share my perceptions of why wildlife is so important and how it continually contributes to my life.

HOMEWARD BOUND Kim Shaklee *Bronze* 84" × 61" × 39" (213cm × 155cm × 99cm)
from Howell Gallery, Oklahoma City, Oklahoma
photo courtesy of Mel Schockner Photography

TIM SHINABARGER

Since childhood, Tim Shinabarger has been an explorer at heart, enthralled with wilderness and the wildlife therein. His art— whether it be painting, taxidermy or sculpting—serves as an extension of this passion, leading Tim to make regular pilgrimages into the wild in order to capture the essence of his elusive subjects. He says of his artistic aim, "My intention is not to imitate life, but to interpret it in my own personal way and share it with the viewer."

Focusing his efforts singularly on sculpting since 2003, Shinabarger is constantly learning new ways to handle the medium, as well as the technical aspects involved in making his works, such as the casting and patination processes. Recently, though, he has begun to concentrate more on the conceptual side of his art, figuring out ways to communicate his message through slightly abstracted yet authentic designs. He says of his perpetual state of growth as an artist, "I find that the longer I am involved with creating art, the more sensitive I have become to the subtleties of everyday life; this has led me to look at the abstract shapes in nature and the energy and movement of all things natural." Forever inspired by these observations, Tim has gone on to create pieces like *Push Comes to Shove*, taking his sculpture to a higher level of complexity.

What inspired this piece?

Most of my inspiration, in general, comes from time spent in the wilderness— a place where I can always recharge my creative energy. *Push Comes to Shove* was particularly inspired by an experience watching moose rut in Alaska. I wanted to capture the essence or feeling of two large bulls engaged in combat.

What prep work and techniques went into this sculpture and how did they contribute to the success of the finished piece?

I spent many sessions at the Beartooth Nature Center creating clay studies of a captive moose named Luther. My intent was to learn fully the moose's anatomy and form. It is impossible to get wild animals to pose for sculpture or painting the way human models can, so it is very important to observe them in the flesh, gleaning as much knowledge as you can. The time I spent studying Luther helped me sculpt with authority when it came to make my studio piece.

What was your greatest challenge in creating this piece?

My greatest challenge was basically working out the gestures and creating a sculpture that embodied drama and excitement while retaining a sense of authenticity. Like I said before, it is impossible to get moose to pose in this fashion, so gaining the familiarity and understanding necessary to sculpt with confidence was very important. I roughed this sculpture in and let it gestate for several months. During this period, I would make adjustments to the gestures until I finally arrived at a composition that pleased me.

What is your favorite part of this piece and why?

I enjoy the way it conveys a sense of unbridled power and the drama of the moment captured. I view this piece as a free-for-all, in which the victor is not yet determined.

What does this sculpture mean to you personally?

At the time, this was the most complex piece I had taken on. So to be able to pull it off fairly successfully was very fulfilling. This was also the first piece of mine that got a lot of recognition as far as awards and accolades. As such, it marked a step up for my career and helped me feel more comfortable in my ability to take on complex pieces.

What do you hope it says to the viewer?

This piece is about the exhilaration of witnessing two evenly matched bull moose in a battle to determine dominance. I want the viewer to feel the raw power of this moment, and the power of nature. I also want the piece to stand up as a good sculpture, containing all the elements of a well-executed design.

PUSH COMES TO SHOVE Tim Shinabarger

Bronze 18" × 55" × 20" (46cm × 140cm × 51cm)

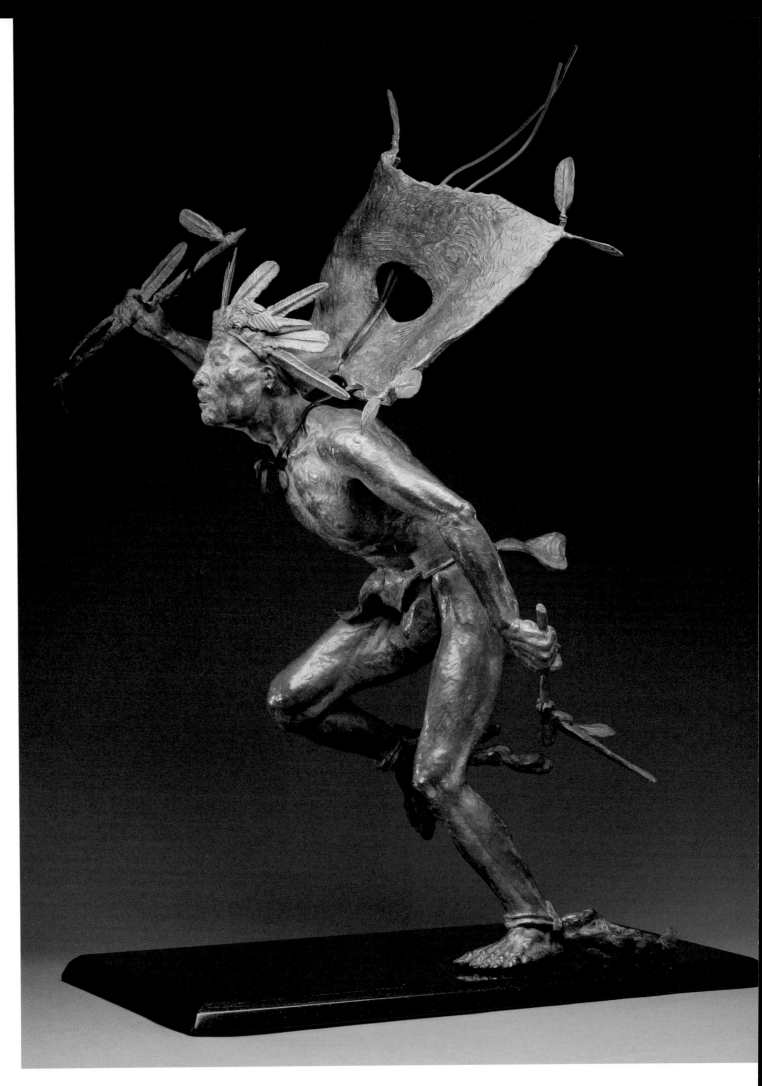

SPIRIT OF THE DANCE Gerald Anthony Shippen *Bronze* *30" × 20" × 12" (76cm × 51cm × 30cm)*

GERALD ANTHONY SHIPPEN

Growing up on the Wind River Indian Reservation, Gerald Anthony Shippen's heart unconditionally belongs to the West. Surrounded as a child by the nearly limitless beauty of national parks, forests and expanses of public lands, Shippen first began sculpting by digging native clay from springs on the reservation, and fired his creations in pits he dug in the ground. "I appreciate the great sense of freedom one has with all the public lands available," he says. "Historical events have shaped the landscape and provide rich imagery for an artist such as myself."

A professional since 1976, Gerald primarily uses oil-based clay and the lost wax method of casting. It was necessity that drove him to clay, and he fervently embraced the process unreservedly. "Good stone was not available, so I naturally gravitated toward clay and the bronze casting process. I find all aspects of the process fascinating." His career has taken him—at home and abroad—through the lands of the Old Masters that inspire his work. This classical influence is clearly evident in his work, as he blends native thematic elements with the European casting techniques. *Spirit of the Dance* displays this union with the quiet intensity that ever characterizes the nature of the Native American.

What inspired this piece?

This piece came about during a time in my career when I was researching Native American cultural items through the Smithsonian Institution. I found historical documentation for the Crazy Dance—something that was part of Plains Indian culture prior to contact with European cultures—and this inspired a small study called *Crazy Dancer*, which later yielded *Spirit of the Dance*. Its matrix included rich visual imagery combined with folk traditions similar to other Native cultures. The movement of the dance contained freedom of expression, independence with a release from everyday life and an opportunity to rise in tribal society. While much is known about the Crazy Dance, much more remains unknown, now lost in time.

What was your greatest challenge in creating this piece?

The greatest challenge in any work involving ethnological material is in its presentation. Since members of my family are Native American, I am sensitive to the respectful presentation of cultural items.

What is your favorite part of this piece and why?

My favorite part was sculpting the human figure. I built up the anatomy from bones to muscles to skin, and then dealt with the surface and the play of light thereon. I like the drama and character that exists in human facial structure and expression, as well as the color and movement in the trappings.

Why do you consider this one of your most significant works?

This work carried me into a new stage in my career. Very quickly it gained attention in the galleries, and soon made its way to the cover of *Southwest Art* magazine, where it created a flourish of activity for my studio. While other pieces in my body of work seek to bring out the nobility of the North American Plains Tribes, this work is documentary. The narrative image and expressive form combine to create the composition, placing my imagery in a new realm.

What do you hope it says to the viewer?

I hope that the viewer might get a sense of the drama in early Native American art forms and the role of those art forms in everyday life. In a similar way, I hope this work reveals how very different the Native American spirit world was from today's science driven society.

DENNIS SOHOCKI

Sculpting now for thirty-five years, Dennis Sohocki likens his work method to the way a child plays with rocks, sticks and mud: Free from the constraints of intention. "Children do not say I am going to make this or that—they just play around with it," Sohocki says. "When I start a sculpture, I don't do any sketches, I don't do any drawings, and I don't do any models. I just start working. The end result comes from my subconscious. I am working from a vision of which I am not aware until it is completed. It is only at that point that, like you, I begin to see the completed work and try to understand it."

With woks varying from non-objective to abstract, with an occasional realistic piece thrown in for good measure, Sohocki finds it crucial to utilize a full gamut of materials to communicate his visions. Whether it be stone, bronze, hardwoods, stainless steel, found objects or clay, Dennis chooses the best medium available to express a given concept or articulate a specific form. Particularly drawn to simple representations that capture the essence or spirit of their subjects rather than attempting to copy their outward appearance, Sohocki sculpts using very few lines. Such subtle nuances are showcased in his work *Torso*, an elegantly simplified rendering of the female figure.

What inspired this piece?

The female form simplified to its essence was my inspiration for *Torso*. I work largely from my subconscious because I find it to be the most universal of languages and feel it best captures the spirit of things. So, when I started to carve the marble original of *Torso*, I did not know what would ultimately come out. I am often asked if I used a live model for the form, but this woman already existed in the stone—she was just waiting for me to bring her out.

What prep work and techniques went into this sculpture and how did they contribute to the success of the piece?

Most sculptors make their originals in clay. However, the majority of my bronzes begin with either a stone or wood original. I chose stone over clay for this piece to keep the curves and lines perfectly smooth. It is tougher to work with a hard material, but if you want a plane surface or a perfect curve, you can shape it that way. If you have a soft material like clay, it doesn't form the perfect lines I like to achieve. Once the original was complete, I cast the piece in silica bronze. Patina artist Pat Kipper created the patina in a rich, layered brown and gold, almost like old leather books.

What was your greatest challenge in creating this piece?

The greatest technical challenge with any of my bronzes is finishing the surface of the bronze flawlessly to match the stone original. The finished bronze must be seamless, which can only be accomplished as a result of painstaking welding, grinding and finishing. Most large bronzes are cast in sections that the sculptor has to piece together. The challenge from an artistic standpoint is that I need to make sure my subconscious, not my intellect, directs the creative process. Intellect is reserved to resolve the more technical issues.

What is your favorite part of this piece and why?

I believe *Torso* captures the essence of the female form and is a successful example of what I call "classic modernism." Classic because I believe it will be timeless and will not become outdated as a period piece. Perhaps two of the most difficult forms to try to capture are the torso and the mother and child.

What does this sculpture mean to you personally?

Torso reflects my respect and admiration for women. Women are beautiful. The lines and curves of their bodies are both attractive and universally recognizable, so I wanted to create a piece that transcended time and culture. I think the piece successfully reflects the natural beauty and elegance women create in all of our lives.

TORSO Dennis Sohocki *Bronze* *21" × 9" (53cm × 23cm)*

PATI STAJCAR

A transplant to the West from Pennsylvania, Pati Stajcar's art was born out of the need to liberate the mental and physical tension she experienced working for a major airline. Little did she know, relief would come in the form of sculpting. "I had always sketched and painted," Stajcar recalls, "but after taking a decorative woodcarving class in 1980, I turned the corner into 3-D and knew this was where I wanted to live for the rest of my life." Now, constantly inspired by the abundant wildlife and expansive vistas that surround her Golden, Colorado, home, Pati uses her art as a vehicle to express her love of all things natural.

Devoting herself full time to sculpting in 1985, Stajcar credits generous teachers like Gerald Balciar and a supportive artistic community with converting her from a hobbyist to a professional. Though she specializes in wildlife figurative sculpture, Pati doesn't feel her art strictly reflects any particular style. "I started in tight realism, but loosened to stylized and impressionistic representations, and try to incorporate a bit of abstract along my journey," she says. "I simply try to give each piece what it needs to tell its own story." *Surrender* is just one example of Stajcar's talent for depicting animal forms while eschewing the limitations of working in any one style.

What inspired this piece?
When I look at a piece of wood I try to see what it can be in my imagination. In this I saw the ruffled feathers of a flamingo.

What prep work and techniques went into this sculpture and how did they contribute to the success of the finished piece?
I was quite fortunate with this piece. Other than flattening the bottom for orientation, there really was no prep work involved. I did stop often during the process to closely examine the wood and try to find the piece inside the piece. I used chain saws, grinders, chisels, knives—whatever would remove the excess wood, leaving me with the desired form.

What was your greatest challenge in creating this piece?
Showing the delicacy without showing the support structure required patient and careful handling on my part. At times, I had to revert to precision tools like tiny knives, gouges and pencil grinders to achieve the desired effect. I also found creating the transitional spaces and knowing where to stop a big challenge. I continued to look for subtlety, so as not to push the piece too far too fast and lose the flow.

What is your favorite part of this piece and why?
I always like to save the part of the wood that inspired the piece in the first place. A gentle transition from the raw wood into the polished shows both where my thought process began and where it ended.

Why do you consider this one of your most significant works?
This sculpture is a graceful interplay between two entities in more than one way: First, between the two birds, and second, between myself and the wood. As one half of the equation, I hope that I can maintain this nuanced relationship between artist and medium.

Did this sculpture turn out the way you had envisioned, or were there some unexpected yet pleasant surprises?
I will gladly admit that I have never made a piece that ended up the same way I envisioned it. I call them *happy accidents*. Whatever the piece presents, it makes me work harder to create an even better sculpture than I perceived. Actually, when I work in clay, I start with a quick clay sketch, and maybe ten to fifteen clay sketches later the piece evolves into the start of the final product. It's always a work in progress—just like us.

SURRENDER Pati Stajcar *Wood* 50" × 37" × 16" *(127cm × 94cm × 41cm)*
from Saks Gallery, Denver, Colorado

BILL STARKE

Earning his degree in Drawing and Printmaking in 1973, Bill Starke got his professional start in the art world as an Intaglio printmaker—a craft that required technical expertise as well as an artistic vision. During this time, Starke continued to pursue his passions of drawing and painting; however, as he progressed as an artist, he found that certain concepts simply fell flat when expressed in two-dimensions. It was in 1999, while working unsuccessfully on a large painting, that Bill had an idea about incorporating three-dimensional figures into his compositions. Inspired by this epiphany, Starke immediately began making his first sculpture, casting it in bronze upon completion. He was so elated with the end result that, in his own words, "I've been hooked ever since."

Today, as he reflects on this transition to creating in three-dimensions, Starke says, "While I didn't realize it at the time, making sculpture was a logical progression, and the best way to express ideas I had that weren't working two-dimensionally." Now, striving to portray the themes of human interaction in his sculpture—whether it be confrontation, cooperation or achievement—Starke often bases his work on a particular maxim prevalent in society. Such is the case with *The SkyDivers*, Starke's symbolic expression of the widely known aphorism: Taking a leap of faith.

What inspired this piece?

I've always loved the concepts *taking a leap of faith* and *working without a net*. *The SkyDivers* are my visual metaphor for these adages. They are bold in both form and delivery, expressing the exhilaration one feels in the pursuit of one's dreams. These figures aren't waiting for opportunity to find them—they know that to achieve greatness, one has to take risks. This work now appears in the Heritage Plaza Building in Houston, Texas.

What prep work and techniques went into this sculpture and how did they contribute to the success of the finished piece?

To create cast metal sculpture light enough to hang by a slender cable, aluminum was chosen. It's one-third the weight of bronze, so each of the figures weigh 60 lbs. each as opposed to 180 lbs. This enables them to hang in the air and create the illusion of flight.

What was your greatest challenge in creating this piece?

Creating life-size figures in the studio from nothing more than an idea in my head was quite challenging. Luckily, my studies in anatomy gave freedom to my imagination.

What is your favorite part of this piece and why?

Most sculpture is heavy and rooted to the earth. I really enjoy the fact that such large pieces of work are light and airborne.

Why do you consider this one of your most significant works?

My original idea for *The SkyDivers* was to create small 6-inch personal-sized sculptures. It was both exciting, and very significant, to have the freedom to take this concept and produce it on a monumental scale. Seeing the actual sculptures installed in the huge atrium of the Heritage Plaza Building far exceeded my expectations.

What does this sculpture mean to you personally?

All of my sculptures, including this one, are an expression of the experiences I've had in my life. I think I connect with others because we share these same journeys, and I'm grateful for the opportunity to tell my stories through the expression of art.

What do you hope it says to the viewer?

Simply put: I want these figures to be symbols of freedom and bravery.

THE SKYDIVERS Bill Starke *Aluminum* *Three figures, each 78" (198cm)*

photo courtesy of Sylvester Garza, Garza Photography

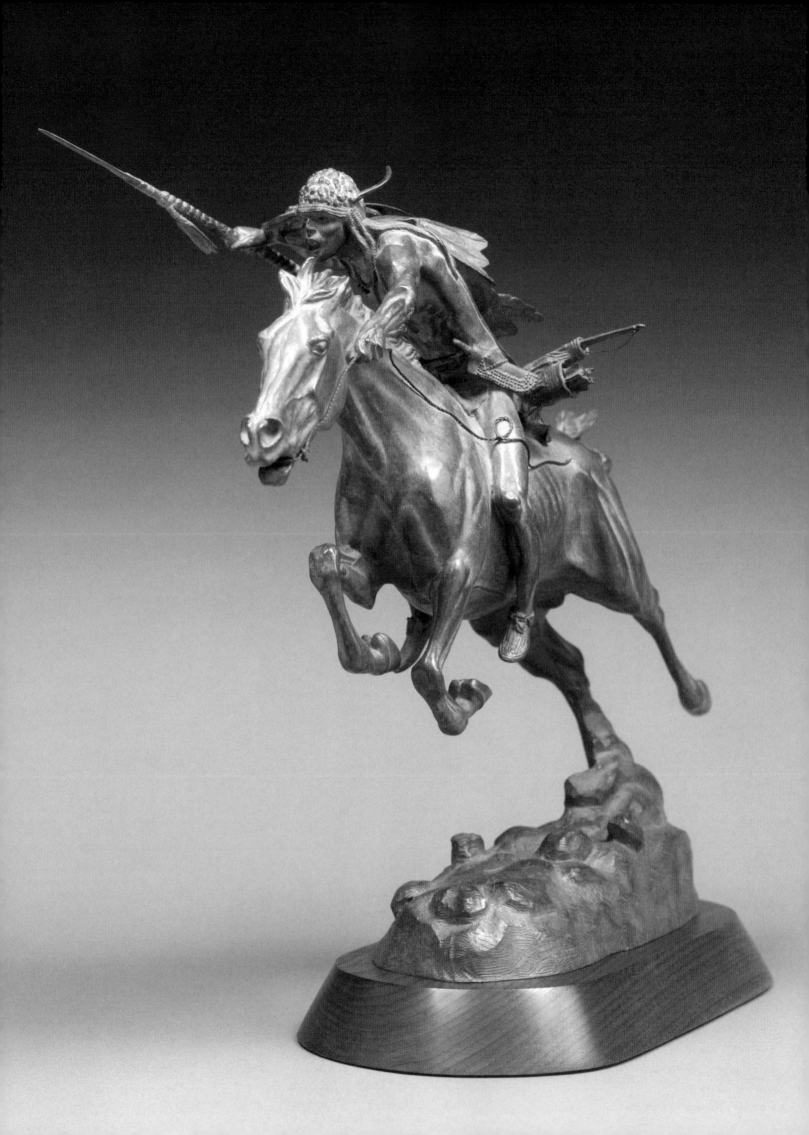

KEN SULLIVAN

During a fifteen-year career in the oil industry, Texas native Ken Sullivan taught himself to sculpt by modifying the figures from historical miniature kits he painted as a hobby. "I started out simply adjusting an arm, re-sculpting a face, or modifying a horse," he recalls. This quickly progressed to sculpting miniatures from scratch using plumber's putty—an accomplishment that would convince Sullivan he could produce works worthy of fine art stature. As Ken's confidence in his art grew, he realized it was time to leave the big business of oil and pursue a career in the arts. He says of this decision, "I initially saw sculpting as the chance to avoid working for a corporation, and instead, make a living doing what I loved," he says. "However, I feel like I've been given a gift, and believe that I'll be held accountable if I don't use it."

By choice, Sullivan creates using what he calls the "simple standards": Oil-based clay and wire. "I like the flexibility of the clay and the ability to manipulate my pieces as I go," Ken says—a process with which he becomes more comfortable every day. Now, earning national recognition for his meticulous nature and commitment to accuracy, pieces like *Defender of His People* show just how far Sullivan has come from his lump of plumber's putty.

What inspired this piece?

We'd just had our first baby, a boy. Like most new fathers, I was feeling very protective of my family. I wanted to put my feelings into a Western context, and started thinking about the universality of a father's protective nature. *Defender of His People* was the result of this inspiration.

What prep work and techniques went into this sculpture and how did they contribute to the success of the finished piece?

This sculpture portrays a Blackfeet warrior on the verge of attack. To accurately capture this moment, I needed to research the weapons and attire that such a warrior would have used. I also wanted to include a horned war bonnet, so I had to conduct some special research to render this element successfully. I felt that the horned bonnet would especially contribute to the fierceness I was trying to capture, and I was very pleased with the final outcome.

Did this sculpture turn out the way you had envisioned, or were there some unexpected yet pleasant surprises?

Even though my work is very realistic, I didn't want to limit or stifle myself when it came to rendering what I had envisioned. I know that a horse doesn't run as I have portrayed it here; however, I think that the liberties I took convincingly depict the force and energy I was after. There's a raw power to it that was unexpected.

What was your greatest challenge in creating this piece?

I was looking to create something with explosive forward movement. To me, this meant leaving as much negative space under the horse as I possibly could to create the illusion of motion and suggest the feeling of flight. The weapon I originally sculpted for this piece—the spear—also contributed to the forward motion of the piece. However, because it's a pretty sharp point, some collectors saw it as a safety hazard. As such, I now produce the piece with a gunstock club as an option.

What is your favorite part of this piece and why?

What I like best about this piece is that the horse and rider are really one being. It's not so much a rider on a horse, or a horse with a rider. They're equally important and relevant to the story. It's almost like a centaur.

What do you hope it says to the viewer?

I've always felt it would appeal to those who serve by protecting others—lawyers, members of law enforcement and, of course, fathers. I hope that it reflects that universal sense of honor, commitment and the drive to protect and love one's own.

DEFENDER OF HIS PEOPLE Ken Sullivan *Bronze* *14" × 12" × 8" (36cm × 30cm × 20cm)*

REVEN MARIE SWANSON

When one of Reven Marie Swanson's works are exhibited, the viewer instinctively knows they are seeing something special. Focusing on themes like change, movement, balance and growth, Swanson's sculpture reflects life in a fanciful manner. Often suspended or mounted above ground to suggest flight, Reven's generally colorful work successfully implies motion and transition, even though most of her installments remain static—a feat that she finds especially gratifying. She explains, "The static steel construction of my sculpture 'springs' into life and appears to be 'on the move' rolling down the parkway—almost as if it's dancing with nature and the viewer."

Working as an artist since 1989, Swanson uses her sculpture as a means of reconciling the experiences of her past with the influences of her present. Reven's *Dancing Moon* series does just this, utilizing steel plates and lively color schemes to portray her ideas about the relationship between the natural, *instinctual self* and the contemporary, *modern-day self*. Her piece *Dancing Moon Roller* stands particularly triumphant in this series, and it's easy to see why: The vibrant hues and suggestion of infinite motion keep the viewer engaged, encouraging them to actively participate with her creation.

What inspired this piece?

The *Dancing Moon* series is an extension of my figurative work in which I have reduced the female figure to its simplest form. The shapes, cut-outs and colors are vibrant and full of energy, creating visually kinetic finished pieces like *Dancing Moon Roller*.

What prep work and techniques went into this sculpture and how did they contribute to the success of the finished piece?

This sculpture began with large sheets of ¼-inch plate steel and a desire to encapsulate happiness, whimsy and lightheartedness. I used a plasma cutter to carve the basic geometric shapes of the sculpture, then I applied heat to force the cut-outs into a construction resembling a giant spring.

What is your favorite part of this piece and why?

There are so many aspects of this sculpture that I enjoy. First, I find it to be highly three-dimensional—at every angle, I see a new and unique sculpture filled with whimsical movement. I was also pleased with the success of my experimentation with powdercoating, and how the seamless construction of the two plates combined to make the sculpture appear seamless, without any open ends.

Did this sculpture turn out the way you had envisioned, or were there some unexpected yet pleasant surprises?

Though every work begins with a solid idea, I always allow for spontanaeity to occur in the studio. This is hard for some people to imagine, considering I work with heavy power equipment and oversized pieces of steel; however, keeping an open mind and letting the material suggest its own shape is part of what makes sculpting so fulfilling.

What does this sculpture mean to you personally?

This sculpture represents personal growth, as it helped me express my experiences as a woman making her way through contemporary culture. It also expresses my appreciation for my childhood experiences, living in a rural setting watching the natural events of sun, moon and waving prairie grass.

What do you hope it says to the viewer?

Without knowing my story or my sculptures, I'd like the viewer's curiosity to draw them into the shapes and explore the many facets of the piece. More importantly, though, I'd like the viewer to leave with a sense of happiness. Modern culture can be too burdensome and complicated—I hope my sculpture emanates a piece of spiritual sunshine and joy.

DANCING MOON ROLLER Reven Marie Swanson *Steel* 72" × 48" × 42" (183cm × 122cm × 107cm)

UNTIL WE MEET AGAIN D. Michael Thomas *Bronze* *144" × 90" × 48" (366cm × 229cm × 122cm)*

D. MICHAEL THOMAS

D. Michael Thomas is a true child of the West. Growing up on a cattle ranch in Wyoming, Thomas profoundly understands the irresistible charm of the region's history and geography, something that shines through in his work today. Though constantly tinkering with wax and creating simple sculptures of cowboys, it wasn't until sixteen years after graduating college, while working at an agri-business job, that he came into his own as a sculptor. Michael finally made the plunge to dedicate himself full time to his art in 1993, when a local bank commissioned a historical piece. Since then, "Every day is a Saturday to me," says Thomas.

With the mantra "patience, persistence and striving to improve," Thomas certainly lives up to this philosophy artistically. "I've never tried another medium—I'm still trying to figure out the one I'm in," he muses. But the medium serves him well, and he is inspired by his subjects, both historical and ones drawn from his own life. "Not only does history help me create, but the everyday life and chores of childhood memories—the smell of a horse that worked all day, or relaxing at cow camp in the late afternoon with friends telling stories of the day." *Until We Meet Again* embodies this genial sentiment, as it looms over the comers and goers at the University of Wyoming.

What inspired this piece?

The University of Wyoming Alumni Association contacted me to request that I create a bronze that would *tie* the university together. They weren't exactly sure what they wanted this unifying symbol to be, so they allowed me to use an idea of my own. It didn't take me long to come up with the concept for *Until We Meet Again*. Since Wyoming is the "Cowboy State," and the University opened its doors in 1886, it made sense to me to sculpt an 1890s cowboy as both a welcoming and farewell gesture. When I presented a thumbnail sketch (in clay) of this idea just days later, the board unanimously approved the sculpture.

What was your greatest challenge in creating this piece?

My biggest technical challenges came in getting proportions accurate and in maintaining the twisting, turning lines in both horse and man. On a more personal level, it was a challenge for me to get used to working on something this large without feeling intimidated by the massive undertaking at hand.

What is your favorite part of this piece and why?

I'm very proud of how this sculpture turned out. I was especially pleased with how confident the cowboy is in the saddle, and how some of the more elaborate detail really contributes to the piece. Over the years, I've concentrated on horse anatomy, putting human anatomy at a secondary level. I've just now begun to concentrate on improving the human aspects in my work. I'm pleased with how this effort shows through in this bronze, especially the cowboy's facial features.

Why do you consider this one of your most significant works?

At the time I sculpted *Until We Meet Again*, it was the largest piece of all my works. Today, it still holds up as one of my finest, as it explores the main subjects depicted in my sculptures—cowboys and horses. It took many long hours of standing back and observing the sculpture before I felt it was worthy of the image I had in my mind. I never patted myself on the back for what was right; rather, I continually looked for what I could do to make it better. As a result, the piece turned out just as well as I had imagined, which still gives me a certain sense of satisfaction.

What does this sculpture mean to you personally?

I'm proud of the fact that I created a monument that is on prominent display at my Alma mater. I feel like I've given back in some way.

What do you hope it says to the viewer?

I hope that this sculpture either welcomes or bids farewell to all that view it.

JAMES VILONA

Sculptor James Vilona's interpretive and natural style has evolved in the thirty years since he began sculpting—much like the bronze in which he casts. Vilona explains, "Not only is bronze sustainable and durable, but it is ever-changing; life, to me, is just like that." Drawing on his experiences as a sculpture and gem cutting apprentice, as well as owning his own foundry, Vilona has virtually boundless creative possibilities at his fingertips. This, coupled with his enthusiasm and love for the artistic process is what drives his work. Vilona says, "Using what I have learned in metalsmithing together with my passion for natural minerals, I have found the inspiration to see where I can take my work. I am passionate about creating communication within each piece of sculpture."

Though James works exclusively in hard metals—namely bronze and stainless steel—he forever strives to create the illusion of softness in his work. Depicting the complexity of life in deceptively simple shapes, Vilona's use of flowing lines and curves challenges the viewer to look past the apparent minimalism of the piece and delve into the spiritual movement that is implied. His piece *Ascension* does just this, suggesting a rising motion that keeps the viewer involved by inspiring them to find the forward progress in their own lives.

What inspired this piece?

This piece was inspired by the birth of my first grandson, Caden. I titled it *Ascension*, recalling how nature brings things into life.

What prep work and techniques went into this sculpture and how did they contribute to the success of the finished piece?

This piece was totally hand-fabricated. I started by making cardboard models of the design until I achieved the final desired form. My goal was to show the upward, energetic movement to life.

What was your greatest challenge in creating this piece?

Heating and bending the metal into the softness of the form was my greatest challenge. It is always a trying process to make hard metal look, and more importantly *become*, soft and flowing in nature.

What is your favorite part of this piece and why?

This piece represents everything in life moving upward and onward. If we stay the same and don't embrace the forward movement of life, we're denying ourselves the opportunity to evolve and grow.

Why do you consider this one of your most significant works?

Ascension is both complex yet free and flowing. It's different from other works I have done because it is abstract and simple. Sometimes it's a challenge to keep it simple, but I find this piece significant because it is able to say a lot and yet says nothing.

What does this sculpture mean to you personally?

Not only was this piece inspired by a personal joy in my life, but it means a great deal to me because it truly reflects the creative process I endured. When I began the piece, I had no way of knowing in advance how the flow would ultimately come out. However, by working through the complexities and looking for the simplicity, I believe the wisdom of the form really shines through in the finished piece.

What do you hope it says to the viewer?

The sculpture does not pretend to be more than it is. It becomes yin and yang, cold and hot, going with and going against. My method relies on a steady unfolding of material and intent, and I hope the viewer recognizes this.

ASCENSION James Vilona Stainless Steel *104" × 23" × 18" (264cm × 58cm × 46cm)*

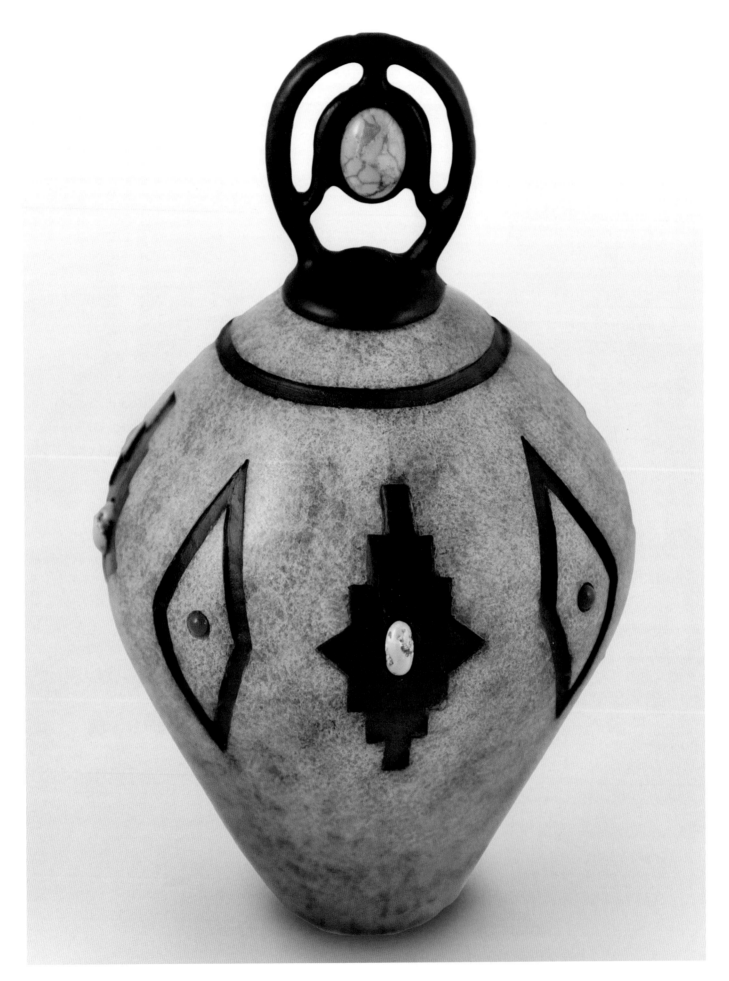

ARROWHEAD TRAIL George Walbye *Bronze 7" × 4" (18cm × 10cm)*

GEORGE WALBYE

For critically acclaimed artist George Walbye, sculpting began as a hobby that would eventually evolve into a highly successful career. It was over forty years ago, when he was a partner in a car dealership, that Walbye would first be introduced to sculpting. "By chance, I happened to visit an artist's studio with my brother-in-law. I enjoyed whittling and woodcarving, and thought sculpting from wax seemed similar, so I decided to give it a try." Later that day, George melted the wax, freezing it in milk cartons to make blocks from which he could carve. This not only yielded two figures, but it also brought Walbye a great sense of satisfaction—and so he continued on with his new hobby.

Over the years, as Walbye learned the proper methods of sculpting, and his work started to earn national attention, he sold the dealership to focus his full attention on sculpting. Though he continued making figures—most often the Native American men and women of the West—Walbye also found success with a series of bronze bowls and lidded pots. He says of these pieces, "Many artists try to depict a Western atmosphere in their work. It is very natural for me to portray this in my art, as I have lived a Western lifestyle." Arrowhead Trail is one such example, illustrating George's passions for the outdoors, Native American culture and the West all at once.

What inspired this sculpture?

I have a cabin on the Colorado-Wyoming border where I go to enjoy the beauty and silence of the countryside. I love surrounding myself with nature and taking exploratory walks around the property, and occassionally I'm lucky enough to stumble across remnants of old artifacts from worlds long since gone. On this particular day, I found an arrowhead, and I knew right away that I wanted to incorporate it into one of my pieces. I can still recall what a thrill it was to uncover this hidden gem. Arrowhead Trail was the result of this inspiration.

What was your greatest challenge in creating this piece?

This piece is actually quite small compared to some of my other works, so there were no real technical challenges in creating it. The only challenge I faced came during the conceptualization process. I knew that I wanted to incorporate stones and the arrowhead I had found into the piece, but I hadn't settled on a design. I decided to make a few sketches and audition potential designs until I found the right fit. I ultimately decided to make a pot with decorative designs remniscent of Native American art, and to add the stones to the center of these designs. I also added the outline of an arrowhead in the back of the lid to incorporate the artifact I had found.

What is your favorite part of this piece and why?

My favorite part is the shape of the pot and the simple yet beautiful designs. It reminds me of my youth, helping my grandfather on the ranch and finding little bits of history left behind in the soils of the earth.

Why do you consider this one of your most significant works?

Arrowhead Trail may not be significant in the way that some of my other sculptures are. It's obviously not towering in size, and it's not an installation like High Plains Warrior; but it is special in the personal value it holds. There is a great deal of investment involved in finding an arrowhead, and a great deal of joy to be experienced when the search ends successfully.

What do you hope it says to the viewer?

I sculpt because I love it! There are no philosophical reasons for it, though I've heard them all. So all I can hope is that the viewer will find the piece interesting, well done and different from other artifact-inspired creations of work. When it's all said and done, I had a great time sculpting this piece, and I hope that shines through to the viewer.

GREG WASIL

With his artistic spirit feeling stifled by his hometown of Chicago, Illinois, sculptor Greg Wasil fled to Denver thirty years ago—a move he credits withkeeping his creativity alive. Now, constantly awe-inspired by his surroundings, Wasil's sculptures aim to instill the sense of childlike wonder he feels when in the presence of the West's natural beauty. He explains, "People are too serious today. We're always connected to cell phones, instant messaging, twitters and tweets. I want my sculptures to make people stop, disconnect for a minute and remember what it's like to imagine and play. To feel again the sense of wonder that anything is possible."

Having welded and shaped metal most of his life as a body and fender technician, Wasil had a revelation to pursue sculpture seriously after seeing large-scale architecture at the Burning Man Festival in 2003. Evolving from rough vases and bowls in high school to the large metal creations he's known for today, Greg's true artistic passion is sculpture. "No other medium gives me the variety and flexibility of materials with which to create the large complex pieces that move and interact with light, wind, sound and people's touch." *Searching For !!!* is the culmination of Wasil's artistic philosophy. From the glowing eyes visible at night, to the rough textures that invite touch, to the mysterious expression on the sculpture's face, this piece achieves the complexity and interaction for which Wasil's art continually strives.

What inspired this piece?

The statues of Easter Island inspired this piece. My first encounter with the Moai was as a boy watching Saturday morning cartoons. Later, I came across a *National Geographic* about Easter Island and its stone giants. My fascination grew. Here were massive stone structures quarried and sculpted by hand, miles away from where they now stand on the shore, waiting and watching. Years later, after watching *Night at the Museum*, my interest in the Moai was re-kindled. I was ready to do another large piece. I wondered what those statues were gazing at and what the people who made them were looking for. I realized, then as today, we're all searching for something. The larger-than-life faces would fit both my need to create in a grand scale and my desire to create art with which people could interact. *Searching For !!!* evolved during the planning stage. It's my interpretation of the Easter Island statues.

What prep work and techniques went into this sculpture and how did they contribute to the success of the finished piece?

My art is meant to be interacted with. I want people to climb on it, sit on it, touch it and play with it however they feel inclined to. That's why my pieces need to be structurally sound and as safe as possible, yet light enough to move. For the Moai, this meant welding a reinforced sub-frame, using one to three-inch pipe and then bending and shaping a skin of eighteen and twenty gage steel to fit over the frame. Texture and definition is added last using a mig welder.

What is your favorite part of this piece and why?

The glowing eyes at night is my favorite part of the piece because it's just something different. It draws attention to the piece and makes people stare and wonder. In the day time, the piercing eyes gaze off into the horizon, begging the question, "What are you searching for?"

What does this sculpture mean to you personally?

All of my pieces speak to me; this one, though, speaks on a deeper level. I think it's a reflection of my own need to find my place in the universe, and my need for validation and acknowledgment that I was here and I made a difference. It's made me take an introspective look at my life to figure out exactly what I'm looking for. While my other large sculptures are fanciful extensions of childhood imagination, I think *Searching For !!!* has a more intellectual quality to it.

SEARCHING FOR ! ! ! Greg Wasil *Steel* *110" × 48" (279cm × 122cm)*

TOO BIG FOR HER BRITCHES Dawn Weimer

Bronze 88" × 108" × 36" (224cm × 274cm × 91cm)

DAWN WEIMER

When she was just seven-years-old, Dawn Weimer enthusiastically announced to her parents that she was going to be an artist when she grew up—and she was going to own horses. As fate would have it, Weimer has lived to see both of these dreams realized; and though they may seem entirely unrelated on the surface, Dawn's two passions are so inextricably connected that one could not exist without the other. In fact, Dawn received her *art education* riding on the back of a quarter horse. It was twenty years of raising and training the animals she loved best that equipped her with an extraordinary understanding of horse anatomy and behavior—something that informs some of Dawn's most celebrated sculptures today.

Though Weimer began her art career by painting commissioned animal portraits, she experienced an awakening one day: "I caught myself flipping over a photograph to see the opposite side of a dog I was painting. It was then I realized I was seeking more . . . the third dimension." Inspired by this breakthrough, Weimer put down her paintbrush in favor of sculptor's tools. With a style that is both realistic in detail and expressive of the subject's true spirit, Dawn's ability to draw from personal experiences to create touching, authentic sculpture is showcased in her piece *Too Big for Her Britches*.

What inspired this piece?

For twenty years, Dawn and I raised and trained quater horses. Dawn also had the pleasure of giving riding lessons to children, so she had plenty of time to observe the many different ways children get on a horse. She wanted to capture this endearing yet humorous moment through sculpture. For this piece, she chose to show the little girl using a bucket to help her mount her dad's riding horse.

What prep work and techniques went into this sculpture and how did they contribute to the success of the finished piece?

Dawn told me that she could always see a finished sculpture in her mind before she started the sculpting process. Her experience in the field of horsemanship was her prep work for *Too Big for Her Britches*.

Did this sculpture turn out the way you had envisioned, or were there some unexpected yet pleasant surprises?

This was Dawn's very first Equine sculpture, and she was very pleased with the end result. She was even more excited when the piece was chosen as the centerpiece monument for our local fairgrounds in 2004.

What was your greatest challenge in creating this piece?

Perfecting the details of the roping horse's gear was the most difficult task Dawn faced with this piece. She felt at ease sculpting the horse itself, as she knew these creatures inside and out. But the technical challenges of depicting (in an accurate fashion) the skit boots on the rear fetlock joints and the rope attached to the sattle horn took extra attention to get just right.

What is your favorite part of this piece and why?

Dawn really enjoyed the way this piece illustrates the special relationship between a person and her horse. Notice the care the horse shows for his young rider. His head is slightly turned toward the little girl, looking back to make sure she has safely situated herself to mount. You can see how relaxed the horse is, and how patient he is with the little girl. It's truly a beautiful bond the two share.

Why do you consider this one of your most significant works?

This piece is the only Equine sculpture to include a person that Dawn had the chance to complete. This sculpture is Dawn's signature piece, exhibiting her immense talent to tell a story and bring out the personalities of both animal and child.

What does this sculpture mean to you personally?

To Dawn, this sculpture represented the life she loved and the heritage she was so proud of—the West, where she was born and raised.

{QUESTIONS ANSWERED BY TOM WEIMER}

CAROL WHITAKER

After leading a successful business career for twenty years, Colorado native Carol Whitaker distinctly felt the West pulling her back. And though exposed to some of the greatest museums and artwork the world has to offer, it was her need for connection to the mountains and Western culture that drew her finally to Denver—the place where Whitaker would devote herself full time to the arts. Now, centering her art on the relationship that women have to vessels—bowls, baskets and other items that have been crucial to women's role throughout history—Carol's desire to portray a gentleness of spirit in her work continues to garner much recognition from the artistic community.

Actively sculpting since 1996, Whitaker believes her talent for drawing and painting is crucial to her success. "I believe that drawing and painting are essential to understanding anatomy and perspective. These fundamental skills enhance the three-dimensional element of sculpture," she says. Focusing on facial expressions and hands to relate emotion, Carol believes that oil-based clay gives her the freedom to continually refine the emotions she's trying to relate. As such, pieces like *Grandmother Watching* successfully tell the story of enduring love—thanks to both the materials used and the care with which they are rendered.

What inspired this piece?

I am always inspired by the natural formations found in the dunes of southeast Utah. *Grandmother Watching* was inspired by the Native American legends of Grandmother Spiderwoman, who created the world, as well as by the strength and power of my own grandmothers. This piece is also a tribute to one of the greatest of all female vessels, Mother Earth. *Grandmother Watching* is one of a series of my sculptures depicting women as vessels and women with vessels (a vessel being both a container as well as a person who embodies a certain emotion or quality).

What was your greatest challenge in creating this piece?

Overcoming my fears about transitioning from a maquette to a greater-than-life-size piece for the first time proved challenging. In life-size or monumental sculpture, every imperfection becomes magnified, and the point of viewing becomes extremely important. With smaller sculptures, the artist can step back a few feet to gain perspective. With a monumental sculpture, the artist must step away twenty to one hundred feet to gain a true perspective of scale and proportions, and then step back toward the work to view details. I constantly questioned my ability to make this transition, but I believe that overcoming the fear of a blank canvas or a single block of clay is a part of every artist's life.

What is your favorite part of this piece and why?

I love *Grandmother Watching* because she was inspired by so many of the things I love. In the sculpture, Grandmother rises from the mountains and petrified sand dunes that form the desert landscape along the San Juan River and the Navajo Reservation. Her skirts represent the geological formations, and the folds have been carefully sculpted to allow water to run down and off the sculpture, like mountain streams. She also follows the Lakota tradition of watching the sky—its sun, moon and stars—for portents of the future. At the same time, she is also watching and guarding the precious grandchild cradled in her arms.

Why do you consider this one of your most significant works?

This piece ties together so many aspects of my life: my love of the Southwest, its mountains, valleys and deserts; my respect for Native American cultures; the love for my own grandmothers; my respect for women as vessels of emotions and philosophy; and my love of stone and rocks. While she is cast in bronze, she is like most of my sculptures in that I use patinas that reflect the patterns of geology, whether it be marble, granite or sandstone. *Grandmother Watching's* patina is a subtle granite, which makes the viewer wonder if it was carved from stone.

GRANDMOTHER WATCHING Carol Whitaker *Bronze* 72" × 48½" × 48" (183cm × 123cm × 122cm)

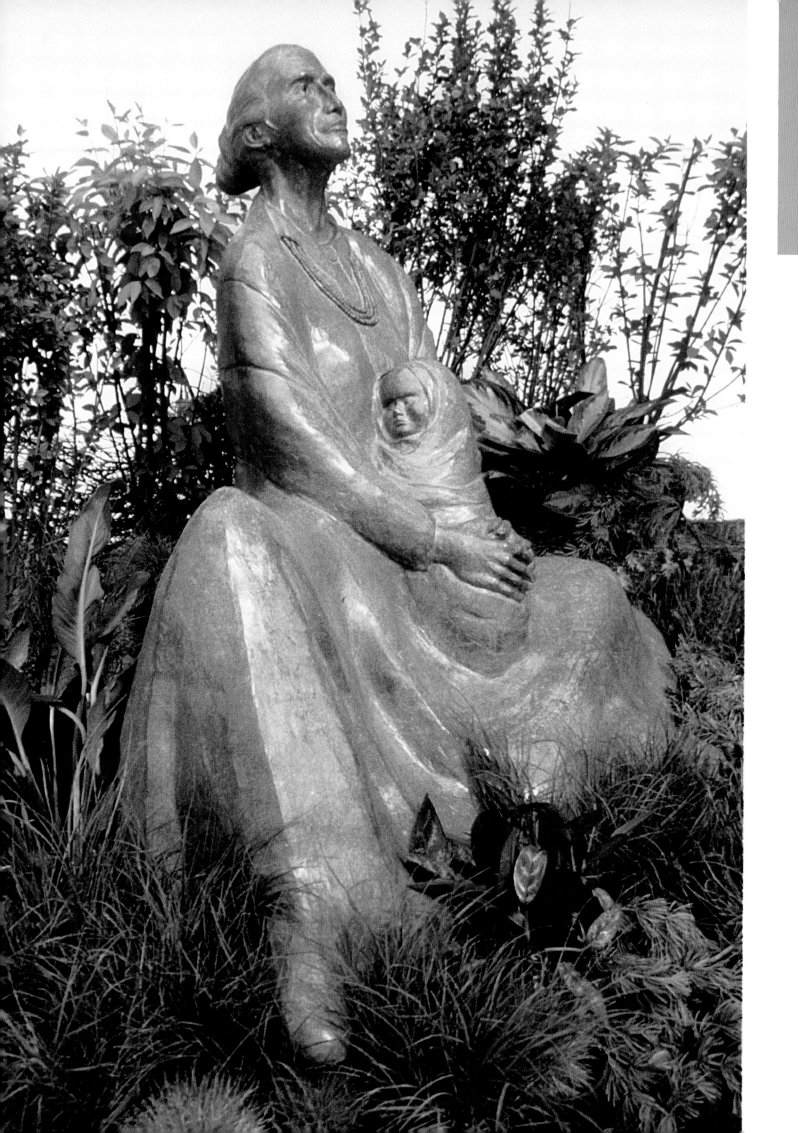

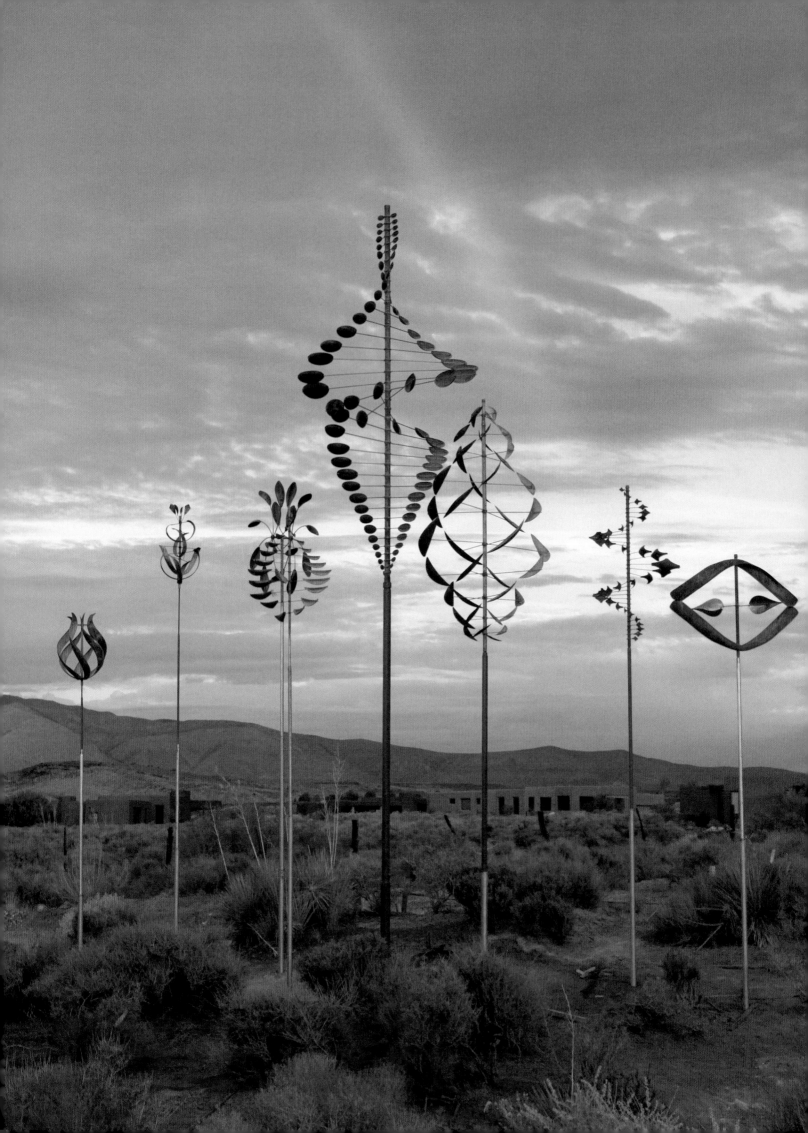

LYMAN WHITAKER

Lyman Whitaker is no stranger to the natural forces that shape the Western landscape. Currently living just outside of Zion National Park, Whitaker is surrounded by a multitude of contrasting environmental elements. "I love my desert environment," he says. "It rewards me with sometimes subtle and often dramatic shapes, colors and conditions." It is this wealth of physical diversity that inspires Lyman to create his unique kinetic sculptures—works that not only combine materials in a meaningful and interesting way, but that also utilize the unpredictable nature of the wind to express themselves fully.

Though Whitaker currently relies on copper and stainless steel to fashion his kinetic masterpieces, he began sculpting with motionless materials like clay, plaster and bronze. He explains, "If one were to follow my art career, one would see it is full of twists and turns. My art has not been sequential, but it has been a constant force in my life." And one sees these twists and turns in his art. The malleable and changeable nature of the copper Whitaker uses complements the ever-changing nature of the wind upon which his kinetic sculptures depend, while the stainless steel provides both a strong foundation and a striking color-contrast to the earthy hues of the copper. *Wind Symphony* serves as the perfect example of this artistic vision, allowing nature to communicate with the viewer through the varying components of Whitaker's sculpture.

What inspired this piece?

As I child, I found myself captivated by the mysterious, exciting and sometimes dangerous nature of the wind. Now, as an artist, my love for this mysterious force inspired me to translate the invisible moving air into visual abstract shapes. I feel I am in a partnership with the wind. It suggests which forms will work, and I do the work to translate the suggestions into a moving sculpture. It is my hope that the visual will reflect, on some level, the air as it relates to breath, wind and climate.

What prep work and techniques went into this sculpture and how did they contribute to the success of the finished piece?

I believe that a kinetic sculpture needs to be responsive to the gentlest breeze, yet be able to withstand hurricane-force winds. As such, I needed to make sure the wind would propel my sculptures in a balanced fashion, yet I also needed to construct the individual elements in such a way as to guarantee their stability. With this in mind, I chose copper for its malleability and stainless steel for its strength. Both these materials do well outside in the elements.

What is your favorite part of this piece and why?

I like the way that the individual sculptures respond to the currents of the wind. The wind is composed of small, intricate currents that often go unnoticed. These currents act differently on each individual sculpture; thus, each piece moves at a different tempo. When all of these tempos are viewed simultaneously, a sort of visual music results. What's more, the motion of the group is always new, keeping the music fresh and exciting.

Did this sculpture turn out the way you had envisioned, or were there some unexpected yet pleasant surprises?

I look at building a sculpture as a collaboration of my tools, my materials and myself. The process of *not* envisioning where I am going with a sculpture as I am working allows me to proceed in a more natural way. By letting the process guide me, I can seize opportunities along the way and let the piece establish its own direction.

What do you hope it says to the viewer?

My hope is that the rhythm of these evolving shapes will have a calming and mesmerizing effect on the viewer. I also hope that my art will act as a medium for the most primal of natural forces—the wind—and thereby create a harmony between the viewer and the natural world that he or she is a part of.

WIND SYMPHONY Lyman Whitaker *A mass sculpture consisting of eight individual Copper and Stainless Steel pieces* 148"–238" × 16"–74"

FRITZ WHITE

Originally hailing from the Midwest, legendary sculptor Fritz White's interest in Native American culture was sparked when he was just a young boy living near the banks of the Little Miami River in Ohio. A region filled with rich artifacts of its Shawnee, Miami and Mingo inhabitants, a wide-eyed Fritz would walk along the river paths, imagining the lives of those who came before him. Years later—after relocating to Loveland, Colorado—his passion for native cultures would only intensify, as Colorado afforded him endless access to the mythologies of Western Native Americans. It was here that White would ultimately come into his own as a sculptor, gaining great notoriety and praise for his works depicting the American West.

Though he drew as far back as he can remember, and later did a great deal of pen and ink in advertising art, watercolors and full-color illustrations, Fritz found true artistic fulfillment only when he discovered sculpting. He says of this epiphany, "Only sculpting gave me the joy of creation and completion of concept. Now, I envision the thoughts that have taken root in my imagination to a point where I must try to produce them three-dimensionally." Now, at the age of seventy-nine, Fritz is still inspiring fellow sculptors, young and old alike, sharing his talents with aspiring artists and leaving an undeniably prominent mark on the map of American sculpture with pieces like *Out of the Mystic Past*.

What inspired this piece?

In sculpting *Out of the Mystic Past*, I had a strong desire to communicate to the viewer that *American* people existed long before 1492. In fact, innumerable Native tribes, each with its own rich and unique culture and history, had been thriving on the North American continent for centuries before explorers arrived to *discover* them. I wanted this piece to speak for the America that existed prior to colonization, settlments and westward expansion, and to show the powerful role the shaman played in the life of this time. When conceiving this piece—a process that lasted over a ten-year period—I held fast to the thoughts of religion and ancestors.

What prep work and techniques went into this sculpture and how did they contribute to the success of the finished piece?

The study of anatomy is an ongoing scientific endeavor, and is one of the largest contributors to capturing the flow of action in my sculpture.

What was your greatest challenge in creating this piece?

Incorporating all the dynamics of movement into a tight design that illustrates the shaman's urgent message was my greatest challenge. In particular, it is the use of line and the negative space beneath the figure's limbs that help propel him forward and contribute to the grand illusion of movement.

What is your favorite part of this piece and why?

When viewing my works, I have no favorite part. I believe that a sculpture is a whole, and to be appreciated fully, it must be viewed as such. With each subsequent examination, fresh perspective is gained, and surveying the piece from every possible angle yields new meaning with every view.

Why do you consider this one of your most significant works?

Out of the Mystic Past was the first successful opening to the direction that I wanted to pursue as an artist. I appreciate it as such.

Did this sculpture turn out the way you had envisioned, or were there some unexpected yet pleasant surprises?

The sketches looked good and translated well, but as the three-dimensional work intensified, the piece exceeded my expectations and became much better than my earliest concept.

What do you hope it says to the viewer?

The message is simple yet astounding: This is you and your beliefs in their earliest form.

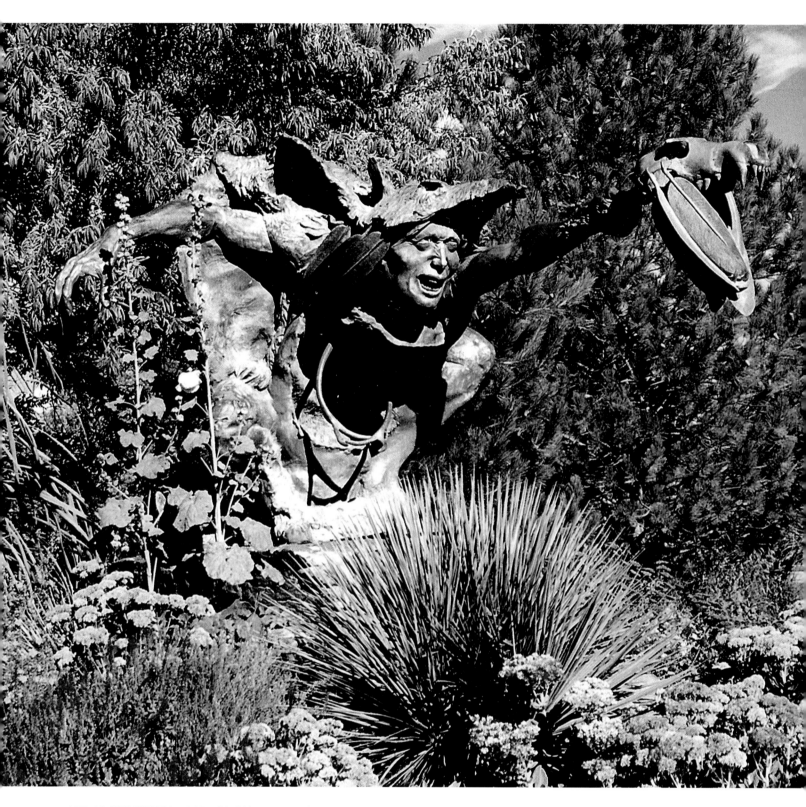

OUT OF THE MYSTIC PAST Fritz White *Bronze 60" × 144" (152cm × 366cm)*

ELEVATION Joshua Wiener *Limestone/Moss 14" × 14" × 7" (36cm × 36cm × 18cm)*

photo courtesy of Efrain Cruz

JOSHUA WIENER

Growing up surrounded by sculptors, it's no surprise that Joshua Wiener went on to become an artist himself. He began his journey into the world of carving fifteen years ago at the Marble Institute of Colorado, a summer symposium which was founded by his mother, sculptor Madeline Wiener. Here, Joshua learned how to manipulate the tools and materials of the trade, while simultaneously developing his unique artistic vision. But it was several years later, while working with a group of landscape architects, that Wiener believes helped him gain a clear understanding of how to design and build. As a direct result of this experience, Joshua would discover his innate talent for creating living sculpture—innovative pieces that incorporate living organisms into the compositions, encouraging the viewer to commune with nature.

Now, using organic materials like stone and vegetation, Wiener's art raises his audience's awareness of the role they play in the ecosystem. "I elevate a small, manageable part of the environment that can be taken care of. By isolating that interaction into a dynamic work of art, I am drawing the viewer into the process and elevating the way they see their participation." His stunning piece *Elevation* shows that if we properly manage humanity's interaction with nature, we will have a beautiful world to enjoy for generations to come.

What inspired this piece?

Over the past few years, I have been inspired to create artwork that is iconic for sustainability. We are in a time of transition where cohesion with nature is becoming a major effort. I created this piece while an artist resident at Platte Forum. This eight-week residency provided me the chance to collaborate with a group of students. We all worked on pieces that paralleled my living sculpture series, which is about physically and conceptually elevating nature. We talked about the state of the world and explored ways of stimulating interaction with nature. This sculpture was made to demonstrate the utility and beauty that comes from working with living systems.

What prep work and techniques went into this sculpture and how did they contribute to the success of the finished piece?

Working with plants requires creating the correct habitat for the organism, as well as providing it with enough space to survive. Light, soil and water were all critical. In this piece, I used moss, which has 15,000 different species. I had to find a species that could be watered with tap water and that didn't need direct light. I relied heavily on expert horticulturalist advice to find the right organisms. This collaborative approach was critical to the conceptual side of the artwork. I am drawn to working in design teams because a continued dialogue sustains a broad perspective. It is common to continually narrow one's perspective as you focus on a subject, especially when working in stone. It is easy to spend hours on a single square inch of space; by getting that close to the subject there is a danger of over focusing and missing the most significant aspects to the process or piece.

What was your greatest challenge in creating this piece?

Executing and clearly articulating the concept was certainly a challenge. Simple designs are much more difficult to accomplish in stone than intricate designs. Error can be concealed in a face or flower quite easily, yet a circle or square with the slightest imperfection will shout to even the least critical viewer. When you do something with right angles and consistent curves it has to be executed perfectly or else the entire surface has to be redone.

What does this sculpture mean to you personally?

This piece expresses how I want to contribute to a bright future. I am a dedicated volunteer and a passionate environmentalist, seeking to align my efforts with uplifting, inspiring, nurturing stewards of the land. I feel this piece expresses the personal approach I have. I want to be part of the solution, and I see all of the dynamics that guide our sustainable future in this piece.

MADELINE WIENER

Madeline Wiener has come a long way from her days as a young woman sketching sculpture in the Metropolitan Museum of Art in New York City. As an artist starting out in the late 1960s, Wiener knew she faced a world dominated by male artists. "At first, I was really challenged to do things I thought only men could do," she recalls. "It was a personal challenge to my womanhood." But the artistic gender barrier was no match for Madeline's talent and tenacity, as she went on to become one of the most prominent female stone carvers in the country. Today, as the founder and director of the Marble Institute of Colorado in Marble, Colorado, Wiener aims to use art to foster cultural dialogue and share her unyielding passion for stone.

With more than forty years of experience behind her, Wiener still enjoys realizing her visions through sculpting stone. "I am a stone carver for many reasons," she says. "I love the physical and mental challenge of this material. For me, carving stone and exploring its potential is what gives me energy." It is this outpouring of energy that effortlessly draws the viewer into her work time and again. Wiener's interactive piece *The Conversation*—whose title itself suggests her ongoing mission to inspire discussion about art—serves as the perfect example of her creative gift, encouraging the viewer to participate in the dialogue of life.

What inspired this piece?

The Conversation was created when the Loveland High Plains Arts Council reviewed my slides and saw a sculpture I'd created for The Scripps Memorial Hospital in LaJolla, California. They wanted that piece; however, all of my work is unique, so I created something similar. This sculpture is part of my *Bench People* series, which consists of interactive, functional sculptures. If the viewer were to sit on the lap of one of the figures, he or she *becomes* the sculpture, and as such, can engage in conversation with the work. In this particular piece, the child appears to be aloof, yet she might be listening to the conversation. I wanted to demonstrate how important the father/child relationship is, while showing the mother as the strength that holds the unit together.

What was your greatest challenge in creating this piece?

Carving life-sized stone sculptures brings a unique set of challenges to the table. For this piece, I gathered a team of sculptors to help with roughing out the form. We worked with a hydraulic diamond chain saw and cut enormous hunks off of a block that started out at over 32,000 lbs. The logistics of carving such a large stone are very challenging, and we had to prep the area so that it was suitable for storing the blocks and build a shelter under which we could work when it rained or snowed. Transporting the block from Marble to my downtown Denver studio was another challenge, requiring an enormous forklift at both ends And, of course, transporting the finished piece to Benson Park in Loveland was another worrisome but successful process.

What is your favorite part of this piece and why?

When I create a sculpture, no matter the size, I inadvertently create what I call a *magic line*. In the case of this form, I'd say that the continuous magic line is what enchants me most of all. Standing at either end and letting my eye follow the line around the sculpture never fails to amaze me. And I absolutely adore the Colorado Yule marble and crystalline structure of this stone.

Why do you consider this one of your most significant works?

Perhaps the fact that it is in a place where it can be showcased forever, or more specifically, that it is unique to most of the other sculptures in that park, is what makes this piece so significant. It is enormous, sparkling white marble and it is so inviting to the viewers—it is constantly being used by those who recognize it as interactive.

What does this sculpture mean to you personally?

This sculpture confirmed that my functional work is successful, as it is definitely enjoyed by those who experience it.

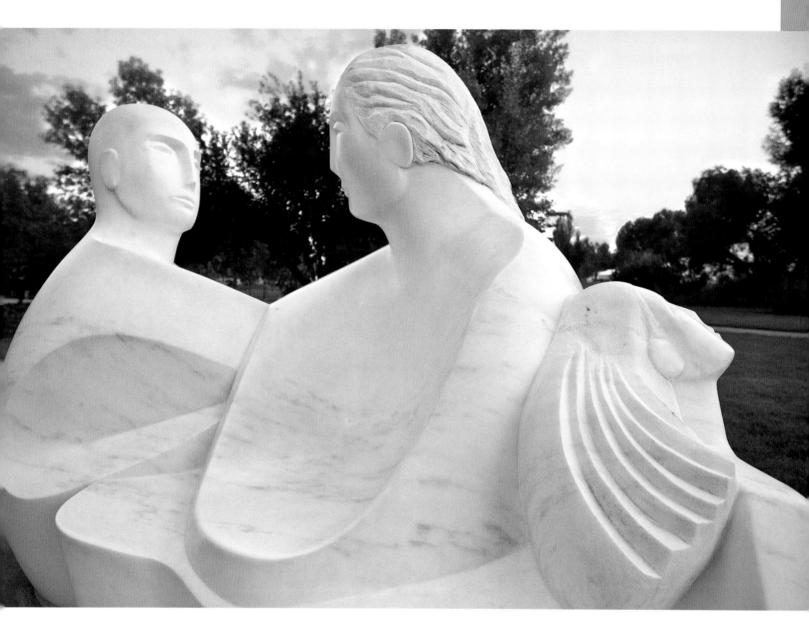

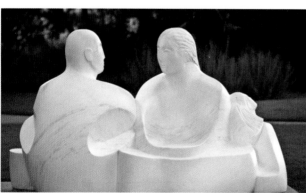

THE CONVERSATION Madeline Wiener

Marble *60" × 108" × 60" (152cm × 274cm × 152cm)*

photo courtesy of Chris Shinn

JEANNINE YOUNG

Though she modeled birds in her mother's paraffin canning wax as a small child, cast her first bronze by high school, and learned to carve wood, make molds and cast cement while a student at Utah State University, sculptor Jeannine Young never considered art as a career. But when her aunt brought a gallery owner friend by her mother's home to see Jeannine's work, a seed would be planted—perhaps art was a viable occupation after all. At this time, Young was in the midst of a successful career in physical therapy, making sculpture in her free time. Though she managed to make and sell a few pieces, and a Santa Fe gallery would host a major presentation of her work, it wasn't until her youngest child started school that Jeannine found the freedom to concentrate on sculpture full time.

Now, fourteen years after her "first show" in a hair salon, Young still enjoys the challenge of creating a form that will look good from all angles and heights. Known for her simple yet striking style, Jeannine says, "I can't say why, but I really enjoy simplifying shapes. I am not a details person; I want to use what is essential and no more." As such, Young doesn't add features to the faces of her figures, yet somehow they still manage to feel very real. Her sculpture *Dusty* serves as the perfect example of how Jeannine so deftly makes more from less.

What inspired this piece?

I admire the strength, determination and courage of the women who helped tame the West. I have heard stories from my mother and grandmother about these women. *Dusty* is an interpretation of these strong-willed, independent and capable women.

What prep work and techniques went into this sculpture and how did they contribute to the success of the finished piece?

Before I began welding this sculpture, I tapped into the feeling I wanted the piece to have. I wanted the finished result to portray confidence, capability, grace, femininity and strength. I asked myself what posture would best convey these feelings, and pondered on how I could use shapes and lines to communicate my message. I also looked at photographs of clothes, boots and hats to see how I could simplify the forms. I made a few rough sketches of my ideas, but once I found my concept, I put the sketches away and began working.

What was your greatest challenge in creating this piece?

The greatest challenge of this piece were *Dusty's* very long legs. I wanted her to have long legs, but they had become the major focal point, which wasn't my intention. I wanted the viewer's eye to travel all over the piece, not just be drawn to one area. After trying different positions of the legs and still not being satisfied, I decided to put a long coat (duster) on her. I had to keep trying different placements of the folds in the coat until it looked believable.

What is your favorite part of this piece and why?

I love her positive energy. She is strong, yet graceful, and ready for the challenges coming her way.

Why do you consider this one of your most significant works?

First, I feel like this piece helped me connect to my heritage as well as my love of the West. Second, my previous female sculptures had been of women in elegant dresses. It was exciting to create a piece with a woman wearing Western work clothes. This was my first experience with making pants as well. Because I wasn't sure how to make slacks with the flat angles I use in my sculptures, I had never portrayed a man. Since making *Dusty*, however, I have already made two sculptures with men, and plan to do more.

What does this sculpture mean to you personally?

I will always remember my father's reaction to this sculpture. He has always been supportive of my art, but hasn't always really liked it. So when I saw a huge smile spread across his face at the sight of *Dusty*, I couldn't have been happier.

DUSTY Jeannine Young *Carved/Painted Wood* 30½" × 12" × 10" *(77cm × 30cm × 25cm)*

CURTIS ZABEL

Born in Athol, Kansas, Curtis Zabel relocated to Northwestern Colorado's Yampa Valley with his family when he was just two-years-old. Here, he would discover a passion for the arts, drawing and painting scenes from his life on the ranch. Surrounded by work teams, cattle, horses and cowboys, Curtis found no shortage of inspiration for his art, and by the 1960s, he was gaining stature as a painter. Within several years, however, his ambitions would shift to creating in three-dimensions. Zabel recalls, "I met a college art teacher, and we started talking about sculpture and both decided we would like to give it a try. One day he sent me some beeswax—I've been sculpting ever since."

Now, using both clay and wax to sculpt his work, there is an urgency to Zabel's passion for his subject matter, brought on by the growing realization that development and the rising costs to operate a ranch may very well result in the extinction of his lifestyle. Even so, Curtis is confident that nothing can erase his lifetime of experiences, both as a rancher and an artist—the very experiences that so deeply inform his sculpture. He muses, "I have been sculpting for a long time, but every time I see a horse, a deer, an elk—I see things I've never noticed before." It is perhaps, more than anything, this fresh perspective and undying appreciation for his subject matter that make pieces like *Lazy Days* so exceptional.

What inspired this piece?

I wanted to make a new horse sculpture, and the idea of portraying a few horses turned out to pasture appealed to me. Showing these creatures at their leisure, enjoying their time off from the ins and outs of a daily work routine, inspired the title of the piece. Perhaps it is a Sunday—or just a *lazy day*.

What prep work and techniques went into this sculpture and how did they contribute to the success of the finished piece?

I used a piece of PVC pipe for the armature, and placed wadded up aluminum foil along the top of the structure to take up space and help support the clay. I use medium-soft clay, which lends itself well to my realistic style.

What was your greatest challenge in creating this piece?

Positioning the horses in a way that would create strong visual appeal and a solid composition, while still suggesting that the horses were enjoying a moment of rest, was a challenge for me. I made several sketches before deciding on this pose.

What is your favorite part of this piece and why?

I enjoy this piece not only because I love horses, but because they remain a way of life for my family to this day. Growing up around work teams, cattle, horses and the abundant wildlife surrounding the mountains has provided me with endless inspiration to create. My proximity to these wonders of nature has also served as an invaluable reference in re-creating true-to-life forms. I enjoy the process of making my sculpture look like the type of horses that I like to ride. I know the curvature of the horse's body, the definition of its muscles, the stances it assumes, the gestures and body language it exhibits—I draw on all of this firsthand knowledge to depict the horse's form as accurately as possible. After all, I'd hate for someone to visit the studio and ask, "What kind of goats are those?"

What does this sculpture mean to you personally?

Horses have always been a part of my life. I love to feel them, look at them and interact with them as much as I love to sculpt, draw and paint them. To me, this sculpture represents a way of life.

What do you hope it says to the viewer?

I hope this sculpture conveys a relaxed, quiet, lazy day.

LAZY DAYS Curtis Zabel *Bronze* *15" × 16" (38cm × 41cm)*

photo courtesy of Jafe Parsons

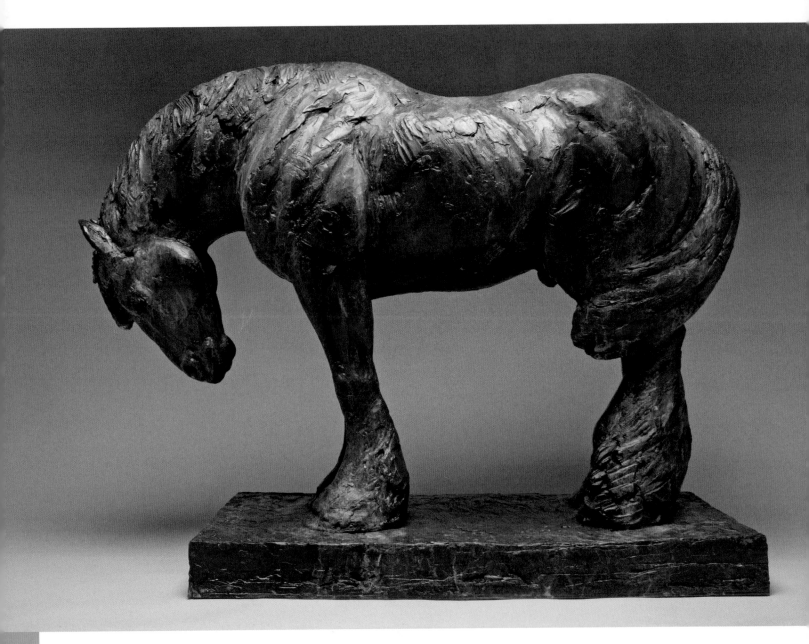

ODE TO THE WEST WIND II Rod Zullo *Bronze 40" × 30" (102cm × 76cm)*

ROD ZULLO

One might say that residing among the Northern Rockies of Montana would inspire any artist to create; Rod Zullo is no exception. Drawn to the area by art school, Zullo discovered his passion during childhood. He recalls, "When I was a boy, my grandmother, who was a painter, inspired my creative processes. The feeling of warm clay in my hands was like an addiction." It was at his grandmother's urging that Rod first took art lessons to satisfy his creative curiosity—an urging that would lead him to travel, exposing him to many masters of the craft. Though he absorbed many different styles and techniques while abroad, Zullo is most grateful for the sage auspices of his mentor Floyd DeWitt, who inspired him to infuse traditional methods with contemporary concepts.

Allowing his medium to work through him, Zullo says, "The permanence of bronze inspires me to slow down, take each concept seriously, and aspire to only cast that which is worthy of a long-term presence in our society." This philosophy is at the heart of his artistic mission, and it reveals to him one truth: "Creating art makes me as happy as a person can be. It's not what I do, it's who I am." Using Classical-Realist style, *Ode to the West Wind II* shows this love of craft, while simultaneously displaying his affection for the natural world.

What inspired this piece?

The inspiration for my sculpture *Ode to the West Wind II* comes from the last stanza of the Percy Shelley poem that shares the same title. It reads: "The trumpet of a prophecy, O'Wind, If winter comes can spring be far behind?" I interpret this stanza to mean that no element can exist without a polar opposite to define exactly what the element is. That is to say, there can be no spring without winter, just as there can be no good without bad. I am reminded of this when I witness the enduring spirit of a workhorse braving the winter storms. With his rear to the wind, he toughs out the hardest of days to be rewarded with the warming of the sun that comes with spring.

What was your greatest challenge in creating this piece?

My greatest challenge was finding the patience to sculpt this piece exactly as it needed to be done. When working on the clay model, I tried very hard not to rush through the process; rather, I wanted to allow myself the time necessary to grow. I spent four years working on this sculpture. I believe the end result was well worth the time and effort.

What is your favorite part of this piece and why?

My favorite part of this piece is the overall concept. It goes far beyond the literal image, transcending into a metaphorical concept that speaks a language of hope and prosperity. At the same, however, it doesn't claim to be above any single personal interpretation.

Did this sculpture turn out the way you had envisioned, or were there some unexpected yet pleasant surprises?

It actually turned out better than my initial vision, most likely due to the duration of time spent working on it. I never settled for anything that wasn't the absolute best I could do at the time. I feel it is the most successful marriage of my mind and my hands to date.

What does this sculpture mean to you personally?

Simply put, it guides my life. This piece has given me the ability to endure very tough times. I have learned that without bad, one cannot fully appreciate all that is good. Understanding the relationship between these binary opposites has given me the strength to endure bad times.

What do you hope it says to the viewer?

This is certainly my favorite piece to date because I feel I successfully translated my language into form. Speaking in form transcends all that is verbal, allowing the viewer to enjoy and interpret the piece as they see fit.

JOAN ZYGMUNT

Born and raised in Brooklyn, New York, Joan Zygmunt came to Missoula, Montana thirty-five years ago with nothing but a backpack and a desire to find her way as an artist. She says, "I knew from age twelve that I would pursue my passion to create art. Growing up in New York gave me unlimited access to museums and galleries, which fueled this desire even more." In fact, the only thing that matched Joan's love for art was her intrigue with birds. Living in a time when so many birds were on the extinction list—from the Bald Eagle to the Peregrine Falcon—Zygmunt wondered if she'd ever have the chance to observe these creatures in the wild. Today, she is grateful to live in a place that affords her frequent sightings of her favorite subjects.

Throughout her life, Zygmunt has tried all types of self-expression through art, from abstract drawings and paintings to ultra-realistic bird carving events, all of which ultimately led her to sculpting. She says of this journey to the perfect medium, "Through these experiences, I have learned much about the shapes of birds and other wildlife, as well as creative design. Making vessels has allowed me to put all of these things together and to create a mood as well." This is apparent in Joan's piece *Odyssey*, a vessel that elegantly depicts her love of birds and their natural habitat.

What inspired this piece?

The inspiration for *Odyssey* was both a personal experience and a desire to convey a feeling. My husband and I have seen the Sandhill and Whooping Crane migration from Texas to Alberta, and we often see these birds in Montana. The fantastic experience of seeing Sandhills on the Clearwater Game Range one spring was a direct inspiration for the piece. We were walking in the woods high on top of a ridge and heard the wild calls of the cranes from deep within the woods. We followed the calls until we found the cranes, and then we watched as they flew over the great expanse of the Clearwater and Blackfoot River valleys on their northward journey. That day on the side of the mountain, the sheer immensity of their pilgrimage struck me, and though I had no thought about creating a piece of art at the time, the feelings of grandeur and mystery that surrounded the migration stayed with me. About a month later, the vision in my mind's eye came to me, complete with the clouds, trees and birds. I knew I had to do this piece.

What is your favorite part of this piece and why?

One of the things I really enjoy about *Odyssey* is the grandness of the expansive mountain and valley views. Because it is in the round, I can turn it and see a different view. I also love the way the light plays on the patina and form at different times of the day. I feel drawn into the piece. My own wish is to fly with those amazing birds.

Did this sculpture turn out the way you had envisioned, or were there some unexpected yet pleasant surprises?

The shape of this piece and the view that I first envisioned came out very true to my original sketches. The rest of the landscape was worked out in the clay. As I sketched on the clay, each scene flowed smoothly into the next with the cranes flying through the expansiveness as the vase is turned. The trees became the anchoring point that created a foreground and added depth and perspective to the piece. The irregular shape of the clouds at the top implies that the piece continues and is not limited by a lip of a vase. Also, it was an extraordinary surprise to see how the patina and the play of light on the relief would add so positively to the piece.

What does this sculpture mean to you personally?

Odyssey is about a journey. As in our lives, this journey is amazing, new and surprising. We don't know exactly what lies ahead, but we continue on just the same, possessing faith and believing that, ultimately, through some inner-guidance, we will find our way.

ODYSSEY Joan Zygmunt *Bronze 27" × 17" (69cm × 43cm)*

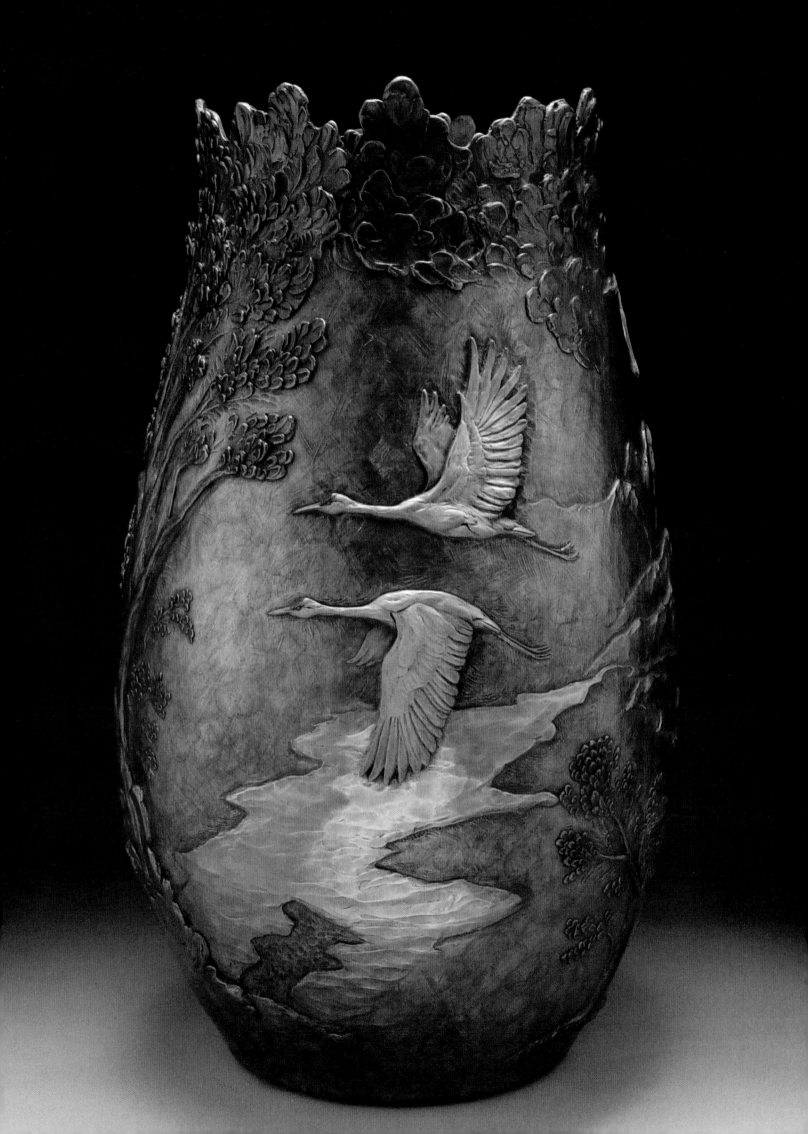

CONTRIBUTOR LISTINGS

A

Lorri Acott-Fowler

Aspen Fine Art Gallery, Aspen, CO
Walnut Street Gallery, Fort Collins, CO
Phoenix Gallery, Park City, UT
Blackhawk Gallery, Saratoga, WY
Art Pic, Los Angeles, CA
Stoneheart Gallery, Evergreen, CO
Smith-Klein Gallery, Boulder, CO
Bella Vista Art, Ashville, NC

Gary Alsum

www.garyalsum.com
Columbine Gallery, Loveland, CO
The Knox Galleries, Beaver Creek, CO; Denver, CO;
* and Harbor Springs, MI*
Pitzer's Fine Arts, Wimberley, TX
SonRise Gallery, Monterey Peninsula, CA

B

Gerald Balciar

Big Horn Galleries, Cody WY and Tubac, AZ
The Knox Galleries, Beaver Creek, CO and Denver CO
Trailside Galleries, Jackson Hole, WY
Whistle Pik Galleries, Fredericksburg, TX
Sorrel Sky Gallery, Durango, CO
The Sylvan Gallery, Charleston, SC
Montgomery Lee Fine Art, Park City, UT
Dodson Galleries, Oklahoma City, OK

Carolyn Barlock

(303) 322-4741
carolynbarlock@msn.com
Columbine Gallery, Loveland, CO

Mike Barlow

1106 W. Park St., Suite 234
Livingston, MT 59047
(406) 223-1064
www.mikebarlow.com
Paderewski Fine Art, Beaver Creek, CO
Astoria Fine Art, Jackson Hole, WY
Collectors Covey Gallery, Dallas, TX
F.M. Allen, New York, NY

Errol Beauchamp

Evergreen Fine Art, Evergreen, CO
Terzian Galleries, Park City, UT

Jim Budish

www.jimbudish.com

George Bumann

George Bumann Sculpture LLC.
P.O. Box 505
Yellowstone Park, WY 82190
(406) 848-9982
www.georgebumann.com

Blair Buswell

The Legacy Gallery, Jackson, WY
Breckenridge Gallery, Breckenridge, CO
Nedra Matteucci Fine Art Gallery, Santa Fe, NM
Texas Art Gallery, Dallas, TX
Wilcox Gallery, Jackson, WY

C

Kathleen Caricof

www.caricofsculpture.com

George Carlson

www.georgecarlson.com

Reno Carollo

12598 E. Bates Circle
Aurora, CO 80014
Gallery East Fine Art, Loveland, CO
James Ratliff Gallery, Sedona, AZ

Vanessa Clarke

V. Clarke Studio
P.O. Box 895
Denver, CO 80201
www.vclarkestudio.com
The Art Source, Denver, CO
Progressive Fine Art, Toronto, ON, Canada
Corporate Artworks, Chicago, IL
Art Dallas, Dallas, TX
RSFA, Mooresville, NC
Hot Shots USA Inc., Batavia, IL

Dee Clements

135 W. 4th Street
Loveland, CO 80537
(970) 669-0735
dandjclements@msn.com
www.deeclements.com

Will Clift

will@willclift.com
www.willclift.com
Gerald Peters Gallery, Santa Fe, NM
Melissa Morgan Fine Art, Palm Desert, CA
Galerie Ora-Ora, Hong Kong

Michael Coleman

2822 Rolling Knolls Dr.
Provo, UT 84604
(801) 375-1259
www.michaelcolemanart.com
J.N. Bartfield Galleries, New York, NY
The Legacy Gallery, Jackson, WY and Scottsdale, AZ

Melissa Cooper

5101 S. Van Gordon St.,
Littleton, CO 80127
(303) 425-3629
melissajcooper@comcast.net
www.melissajcooper.com

D

Silvia Davis

Box #1
Teasdale, UT 84773
(435) 425-3075
Coda Gallery, Palm Desert, CA
The Meyer East Gallery, Santa Fe, NM
Gallery B, Lexington, KY
The Torrey Gallery, Torrey, UT

Jane DeDecker

www.dedeckersculpture.com

photo courtesy of Mike Bucher

Robert Deurloo
11 Deurloo Lane
Salmon, ID 83467
(208) 756-6000
rdeurloo@custertel.net
www.rdeurloo.com

Floyd DeWitt
Floyd DeWitt Fine Art
1900 Nelson Rd.
Bozeman, MT 59718
(406) 586-1603
floyddewittfineart@gmail.com
www.floyd-dewitt.com

Jim Dolan
Dolan Studio
3501 Airport Rd.
Belgrade, MT 59714
(406) 570-4713
jim@jimdolanart.com
www.jimdolanart.com

E

Barry Eisenach
www.barryeisenach.com
Altermann Galleries, Santa Fe, NM
DeMott Gallery, Vail, CO
Germanton Gallery, Germanton, NC
Mountain Trails Gallery, Park City, UT
Saks Galleries, Denver, CO
Wilcox Gallery, Jackson, WY
Wild Horse Gallery, Steamboat Springs, CO

F

Felicia
Pablo Milan Gallery, Santa Fe, NM
Rogoway's Turquoise Gallery, Tubac, AZ
The Artist's Collection Gallery, Edwards, CO

Kendra Fleischman
17512 W. 59th Ave.
Golden, CO 80403
(303) 271-0656
www.kendrafleischman.com

Gail Folwell
Folwell Studios
731 Crescent Dr.
Boulder, CO 80303
(720) 334-1164
www.folwellstudios.com
Claggett/Rey Gallery, Vail, CO
Walker Fine Art, Denver, CO
Hunter Kirkland Contemporary, Santa Fe, NM
Denise Roberge Art Gallery, Palm Desert, CA
I. Wolk Gallery, St. Helena, CA
Rhodes Stringfellow Gallery, Cannon Beach, OR

Edward J. Fraughton
10353 South 1300 West
South Jordan, UT 84095
(801) 254-3303
www.edfraughton.com

G

Jim Gilmore
3731 South 105 Rd.
Alamosa, CO 81101
www.jimgilmoreart.com
Passionate Eye Gallery, Santa Fe, NM
Breckenridge Gallery, Breckenridge, CO
Wild Horse Gallery, Steamboat Springs, CO
Blackhawk Gallery, Saratoga, WY
Galleries West Fine Art, Jackson, WY

Daniel Glanz
P.O. Box 370
Masonville, CO 80541
(970) 690-8425
glanz@lpbroadband.net
www.glanzsculptures.com
Cogswell Gallery, Vail, CO
Saks Galleries, Denver, CO
The Squash Blossom Gallery, Colorado Springs, CO

Veryl Goodnight
44255 Road L
Mancos, CO 81328
(970) 533-1177
very@verylgoodnight.com
jamie@verylgoodnight.com
www.verylgoodnight.com
Goodnight Trail Gallery, Mancos, CO
Trailside Galleries, Jackson Hole, WY and Scottsdale, AZ
Mark Sublette Medicine Man Gallery, Santa Fe, NM
* and Tuscon, AZ*
Whistle Pik Galleries, Fredericksburg, TX

Richard Greeves
The Legacy Gallery, Jackson, WY and Scottsdale, AZ
Simpson Gallagher Gallery, Cody, WY
Settlers West Galleries, Tuscon, AZ

Laurel Peterson Gregory
(303) 663-4185
www.laurelpetersongregory.com
Waxlander Gallery, Santa Fe, NM
Borsini-Burr Gallery, Montara, CA
Gallery Two-Ten, Colorado Springs, CO
Courtyard Gallery, LaConner, WA

Bruce Gueswel
1231 Riverview Dr.
Loveland, CO 80537

H

Denny Haskew
540 Grant Ave
Loveland, CO 80537
dphaskew@comcast.net
Columbine Gallery, Loveland, CO
Sorrel Sky Gallery, Durango, CO

Tony Hochstetler
www.tonyhochstetler.com
The Grapevine Gallery, Oklahoma City, OK
Simpson Gallagher Gallery, Cody, WY
Wilcox Gallery, Jackson, WY
Modern Bungalow, Denver, CO
Bishop Gallery, Scottsdale, AZ and Allenspark, CO

Eli Hopkins
Mark Hopkins Sculpture
P.O. Box 7659
Loveland, CO 80537
(970) 613-0332
www.elihopkins.com

Mark Hopkins
Mark Hopkins Sculpture
P.O. Box 7659
Loveland, CO 80537
(970) 613-0332
markhopkinssculpture@webaccess.net
www.markhopkinssculpture.com

K

Karryl
(303) 666-8582
www.karryl.com

Greg Kelsey
(970) 563-0417
www.gregkelsey.com
The Legacy Gallery, Jackson, WY and Scottsdale, AZ

Kirsten Kokkin
www.kokkinsculpture.com
Michael Wigley Galleries, Santa Fe, NM
Saks Galleries, Denver, CO

L

Darlis Lamb
Darlis Lamb Studio
5515 S. Kenton Way
Englewood, CO 80111
(303) 779-4527
www.darlislamb.com
The Peterson-Cody Gallery, Santa Fe, NM
Riverbend Fine Art, Marble Falls, TX
Abend Gallery, Denver, CO
Howard/Mandville Gallery, Kirkland, WA
Gallery East Fine Art, Loveland, CO
The Squash Blossom Gallery, Colorado Springs, CO

Craig Lehmann
Shidoni Gallery, Tesuque, NM
Leslie Levy Fine Art, Scottsdale, AZ

Mark Leichliter
Exocubic Studio
www.exocubicstudio.com
Columbine Gallery, Loveland, CO

Bets Holland Lundeen
Lundeen Studios
338 E. 4th St.
Loveland, CO 80537
www.betslundeen.com
www.lundeensculpture.com

Cammie Lundeen
Lundeen Studios
338 E. 4th St.
Loveland, CO 80537
The Knox Galleries, Beaver Creek, CO and Denver, CO
Pitzer's Fine Arts, Wimberley, TX
The Legacy Gallery, Jackson, WY and Scottsdale, AZ
Westbrook Galleries, Carmel, CA

George Lundeen
Lundeen Studios
338 E. 4th St.
Loveland, CO 80537
The Knox Galleries, Beaver Creek, CO and Denver CO
Pitzer's Fine Arts, Wimberley, TX
Scottsdale Fine Art, Scottsdale, AZ
Nedra Matteucci Fine Art Gallery, Santa Fe, NM

Mark Lundeen
Lundeen Studios
338 E. 4th St.
Loveland, CO 80537

M

Philip Maior
Gallery 1261, Denver, CO

Jan Mapes
Jan Mapes Artistry
98800 Co. Rd. 56 #3
Kim, CO 81049
(719) 980-6089
www.janmapes.com
Mark Sublette Medicine Man Gallery, Santa Fe, NM
and Tuscon, AZ

Andi Mascareñas
3199 Nova Rd.
Pine, CO 80470
(303) 838-7237
claybrush@yahoo.com
www.andimascarenas.com
Smith Klein Gallery, Boulder, CO
Evergreen Fine Art Gallery, Evergreen, CO
LeKAE Gallery, Scottsdale, AZ

Diane Mason
Blackhawk Gallery, Saratoga, WY
Deselms Fine Art, Cheyenne, WY
Galleries West Fine Art, Jackson, WY
Scarlett's Gallery and Antique Shop, Santa Fe, NM
The Master's Fine Art of Loveland, Loveland, CO

Claire McArdle
www.cmsculpture.com
Darnell Fine Art, Santa Fe, NM
Carla Massoni Gallery, Chestertown, MD
Martin Gallery, Charleston, SC

Georgene McGonagle
McGonagle Studio
3297 S. Oneida Way
Denver, CO 80224
(303) 757-8897
tjmagoo2@aol.com
www.gmcgonaglestudio.com
Richard Danskin Galleries, Palm Desert, CA

Herb Mignery
Claggett/Rey Gallery, Vail, CO
Nedra Matteucci Fine Art Gallery, Santa Fe, NM
Trailside Galleries, Scottsdale, AZ
Settlers West Galleries, Tuscon, AZ

Eugene Morrelli
Bronze Coast Gallery, Cannon Beach, OR
Cogswell Gallery, Vail, CO
Exposures International, Gallery of Fine Art, Sedona, AZ
Howard/Mandville Gallery, Kirkland, WA
The Legacy Gallery, Jackson, WY and Scottsdale, AZ
New Masters Gallery, Carmel, CA
Sage Creek Gallery, Santa Fe, NM
Southwest Gallery, Dallas, TX
Valley Bronze Fine Art Gallery, Joseph, OR
Wild Horse Gallery, Steamboat Springs, CO

N

Chris Navarro
Navarro Studio
5231 Squaw Creek Rd.
Casper, WY 82604
(303) 259-7305
www.chrisnavarro.com
Navarro Gallery, Sedona, AZ

R. Scott Nickell
P.O. Box 6523
Jackson Hole, WY 83002
www.rscottnickell.com
Galleries West Fine Art, Jackson Hole, WY

O

Dan Ostermiller
Nedra Matteucci Fine Art Gallery, Santa Fe, NM
Claggett/Rey Gallery, Vail, CO
The Gallery at Freshfields, Johns Island, SC

P

Richard Pankratz
pankratz@divide.net
www.richardpankratz.com
Mary Martin Gallery of Fine Art, Charleston, SC
Exposures International Gallery of Fine Art, Sedona, AZ
S.R. Brennen Galleries, Palm Desert, CA

Victoria Parsons
Victoria's Fine Art
5120 Morningside Way
Parker, CO 80134
(303) 699-2631
vrparsons@comcast.net
Bronze Coast Gallery, Cannon Beach, OR
Blackhawk Gallery, Saratoga, WY
Paderewski Fine Art, Beaver Creek, CO

Dustin Payne
Dustin Payne Studio, Inc.
www.dustinpayne.com
Mountain Trails Galleries, Jackson, WY; Park City, UT and Sedona, AZ
J. Willott Gallery, Palm Desert, CA
Sage Creek Gallery, Santa Fe, NM
The Plainsmen Gallery, Clearwater, FL

Vic Payne
Vic Payne Studio
115 W. Yellowstone Ave.
Cody, WY 82414
vicpaynestudio@msn.com
www.vicpaynestudio.com
Mountain Trails Galleries, Cody, WY; Jackson, WY and Sedona, AZ
Booth Western Art Museum, Cartersville, GA

Louise Peterson
www.danesculptor.com
Columbine Gallery, Loveland, CO
Phoenix Gallery, Park City, UT
Giacobbe-Fritz Fine Art, Santa Fe, NM
Sisko Gallery, Seattle, WA
Cavalier Galleries, Nantucket, MA

Gary Lee Price
767 N Main St.
Springsville, UT 84663
(801) 489-6852
www.garyleeprice.com
Cavalier Gallery, Nantucket, MA
Chasen Galleries of Fine Art & Glass, Richmond, VA
DeMott Gallery, Vail, CO
Dodson Galleries, Oklahoma City, OK
Karin Newby Gallery, Tubac, AZ
Mountain Trails Gallery, Park City, UT
New Masters Gallery, Carmel, CA
Wild Horse Gallery, Steamboat Springs, CO

Linda Prokop
Bronze Coast Gallery, Cannon Beach, OR
Meyer Gallery, Park City, UT and Salt Lake City, UT

R

Linda Raynolds
Big Horn Galleries, Cody, WY
Smith Klein Gallery, Boulder, CO
Visions West Galleries, Livingston, MT

Jim Rennert
www.jimrennert.com
Cavalier Galleries, Nantucket, MA and Greenwich, CT
The Meyer East Gallery, Santa Fe, NM
CODA Gallery, Palm Desert, CA
Meyer Gallery, Park City, UT and Salt Lake City, UT

Kevin Robb
Kevin Robb Studios, LLC
7001 W 35th Ave.
Wheat Ridge, CO 80033
(303) 431-4758
3d@kevinrobb.com
CODA Gallery, Palm Desert, CA
The Knox Galleries, Denver, CO
Kodner Gallery, St. Louis, MO

Scott Rogers
Trailside Galleries, Scottsdale, AZ
Sage Creek Gallery, Santa Fe, NM
Southwest Gallery, Dallas, TX

Rosetta
(970) 667-6265
www.rosettasculpture.com
Blue Heron Gallery, Wellfleet, MA
Bronze Coast Gallery, Cannon Beach, OR
Howard Mandville Gallery, Kirkland, WA
InSight Gallery, Fredericksburg, TX
Wilcox Gallery, Jackson, WY

Ryszard
Purple Door Studio
(720) 394-4442
www.ryszardsculpture.com

S

Wayne Salge
Giacobbe-Fritz Fine Art, Santa Fe, NM
Hayden Hays Gallery, Colorado Springs, CO
Galorie Kornye, Dallas, TX
Lagerquist Gallery, Atlanta, GA
Lovetts Gallery, Tulsa, OK
Saks Galleries
Smith Klein Gallery, Boulder, CO
Visions West Galleries, Livingston, MT

Sherry Salari Sander
www.sherrysanderstudio.com
Trailside Galleries, Jackson Hole, WY and Scottsdale, AZ
Meyer Gallery, Park City, UT
Greenhouse Gallery of Fine Art, San Antonio, TX
Wadle Galleries, Santa Fe, NM
Cogswell Gallery, Vail, CO
Kneeland Gallery, Ketchum, ID
Big Horn Galleries, Cody, WY
Collectors Covey, Dallas, TX

Rik Sargent
Sargent Studio
5995 S. Race St.
Greenwood Village, CO 80121
(303) 795-9131
sargentstudio@aol.com
www.riksargent.com

Ted Schaal
Schaal Arts Inc.
1633 S. Estrella Ave.
Loveland, CO 80537
www.schaalarts.com

Kim Shaklee
Howell Gallery, Oklahoma City, OK
Cody Fine Art Gallery, Cody, WY
The Maritime Gallery at Mystic Seaport, Mystic, CT
Gallery on Merchants Square, Williamsburg, VA
Fountainside Gallery, Willmington, NC
Scissortail Gallery, Owasso, OK

Tim Shinabarger
www.timshinabarger.com
The Legacy Gallery, Jackson, WY and Scottsdale, AZ
J.N. Bartfield Galleries, New York, NY
Collectors Covey, Dallas, TX
Ponderosa Art Gallery, Hamilton, MT
Tierney Fine Art, Bozeman, MT
Fox Gallery Fine Arts, Woodstock, VT

Gerald Anthony Shippen
Big Horn Galleries, Cody, WY
Bradford Brinton Memorial Museum, Big Horn, WY
Sage Creek Gallery, Santa Fe, NM
Trailside Galleries, Jackson Hole, WY

Dennis Sohocki
947 S. Williams St.
Denver, CO 80209
(303) 777-2028
dvanhusen@msn.com
www.sohocki.blogspot.com
Evergreen Fine Art, Evergreen, CO
Center Street Gallery, Jackson Hole, WY

Pati Stajcar
www.stajcar.com
Saks Galleries, Denver, CO
The Link Gallery, Cheyenne, WY
Evergreen Fine Art, Evergreen, CO
Arlene's, Tombstone, AZ
Philinda Gallery, Edwards, CO
Mark-Finberg, Lancaster, PA

Bill Starke
(303) 750-7059
www.billstarkesculpture.com
Gallery 1261, Denver, CO
Vail Village Arts, Vail, CO
The Vickers Collection, Beaver Creek, CO
VC Gallery of Fine Art, Sedona, AZ
Nüart Gallery, Santa Fe, NM
The Arts Company, Nashville, TN
Miller Gallery, Cincinnati, OH
Left Bank Gallery, Orleans, MA
Grand Bohemian Gallery, Savannah, GA

Ken Sullivan
www.kensullivanfineart.com

Reven Marie Swanson
China Cat Sunflower, LLC
2616 Eudora St.
Denver, CO 80207
artist@chinacatsunflower.net
www.revenswanson.com
Artyard Contemporary Sculpture, Denver, CO
RosettaStone Fine Art Gallery, Palm Beach Gardens, FL
Evergreen Fine Art, Evergreen, CO

T

D. Michael Thomas
dmichaelthomas@collinscom.net

photo courtesy of Mike Bucher

V

James Vilona
James Vilona Sculpture Ranch
890 E. Hwy 56
Berthoud, CO 80513
(970) 532-9801
www.jamesvilona.com
Dolce, Telluride, CO
LeKAE Gallery, Scottsdale, AZ
Phoenix Gallery, Park City, UT
InArt Santa Fe, Santa Fe, NM
Smith Klein Gallery, Boulder, CO
Westwater Patterson, Chicago, IL

W

George Walbye
Walbye Art Studio
344 E. 4th St.
Loveland, CO 80537
(970) 663-2027
www.walbyeartstudio.com
Toh-Atin Gallery, Durango, CO
Blackhawk Gallery, Saratoga, WY
Wild Horse Gallery, Steamboat Springs, CO
The Adobe Fine Art, Ruidoso, NM

Greg Wasil
8415 W. Belmar Ave.
Lakewood, CO 80226
waz1a@netzero.net
justsomethingdifferent.com
Stoneheart Gallery, Evergreen, CO

Dawn Weimer
Dawn Weimer Studios
2727 Eldorado Springs Dr.
Loveland, CO 80538
(970) 222-3994
www.dawnweimer.com

Carol Whitaker
Abiquiu Studios
3385 S. Clayton Blvd.
Englewood, CO 80113
(303) 806-8484
cwhitaker@whitko.com

Lyman Whitaker
www.whitakerstudio.com
Bennington Center for the Arts, Bennington, VT
CODA Gallery, Palm Desert, CA
District Gallery, Park City, UT
Envision Gallery, Taos, NM
El Prado Gallery, Sedona, NM
Evergreen Fine Art, Evergreen, CO
Fine Line Designs Gallery, Ephraim, WI
Freed Gallery, Lincoln City, OR
Grovewood Gallery, Asheville, NC
Hogan Trading Company, Moab, UT
Leopold Gallery, Kansas City, MO
Maine Art Gallery, Kennebunk, ME
Studio E Gallery, Palm Beach Gardens, FL
The Torrey Gallery, Torrey, UT
Vail Village Arts, Vail, CO
Worthington Gallery, Springdale, UT
Wiford Gallery, Sante Fe, NM

Fritz White
P.O. Box 804
Loveland, CO 80539
www.fritzwhite.net
Nedra Matteucci Fine Art Gallery, Santa Fe, NM
Big Horn Galleries, Cody, WY and Tubac, AZ

Joshua Wiener
(303) 908-2396
flowcus@gmail.com
www.joshuawiener.com

Madeline Wiener
Evergreen Fine Art, Evergreen, CO

Y

Jeannine Young
P.O. Box 520876
Salt Lake City, UT 84152
www.jeannineyoung.com
Alexandra Stevens Gallery, Santa Fe, NM
CODA Gallery, Palm Desert, CA and Park City, UT
Smith Klein Gallery, Boulder, CO
Walden Fine Art, Taos, NM

Z

Curtis Zabel
39510 RCR 44
Steamboat Springs, CO 80487
(970) 879-0144
The Knox Galleries, Beaver Creek, CO
Hayden Hays Gallery, Colorado Springs, CO
Wild Horse Gallery, Steamboat Springs, CO

Rod Zullo
The Legacy Gallery, Jackson, WY
The Meyer East Gallery, Santa Fe, NM
Visions West Galleries, Livingston, MT
Collectors Covey, Dallas, TX
Highlands Art Gallery, Chester, NJ

Joan Zygmunt
Bronze Coast Gallery, Cannon Beach, OR
Cogswell Gallery, Vail, CO
Exposures International Gallery of Fine Art, Sedona, AZ
Howard/Mandville Gallery, Kirkland, WA
The Legacy Gallery, Jackson, WY and Scottsdale, AZ
New Masters Gallery, Carmel, CA
Sage Creek Gallery, Santa Fe, NM
Southwest Gallery, Dallas, TX
Valley Bronze Fine Art Gallery, Joseph, OR
Wild Horse Gallery, Steamboat Springs, CO

ABOUT SOUTHWEST ART

Since its founding in 1971 in Houston, Texas, Southwest Art magazine has been the foremost chronicler of the western American art movement. Originally conceived as a local art guidebook, it quickly evolved into an important force in the emerging market for art produced in Santa Fe, Scottsdale, and other southwestern destinations that quickly became popular in the 1970s and 1980s. As an authoritative voice, Southwest Art has conferred legitimacy to legions of artists, collectors and others who believe that art doesn't have to come from New York City or Los Angeles in order to be valuable and important.

As the art market in the West has evolved, the magazine has continued to evolve with it, maintaining its role as the primary source of information and inspiration for art collectors and art enthusiasts. With a monthly readership of more than 215,000, Southwest Art showcases paintings, sculpture and other original fine artworks in a wide range of artistic styles, from traditional and representational to contemporary and modern. It features artists both established and emerging and reports on a wide array of art events throughout the West and beyond, including gallery openings, museum exhibitions, annual invitational shows and more. The editors spotlight the most accomplished artists working today, and in turn their attention has become an important hallmark of artistic achievement. Southwest Art continues its mission of highlighting the finest art of today's West.